Camera Work

COVER: Alfred Stieglitz The Steerage, detail, 1907
BACK COVER: Eduard J. Steichen On the House-boat – "The Log Cabin", 1908
SPINE: Gertrude Käsebier Portrait (Miss N.), detail, 1903

All photographs are taken from the complete set of *Camera Work*
owned by The Royal Photographic Society, Bath.
The publisher would like to thank The Royal Photographic Society
and the staff who were essential to the production of this publication:
Pam Roberts (text), Debbie Ireland (coordination), Gill Thompson,
Kate Rouse and Lars Spengler.

Edited by Simone Philippi, Ute Kieseyer, Cologne
Design: Mark Thomson, London
French translation: Frédéric Maurin, Paris
German translation: Gabriele-Sabine Gugetzer, Hamburg

Printed in Italy
ISBN 3–8228–8072–8

Alfred Stieglitz

Camera Work

The Complete Illustrations 1903–1917

TASCHEN

KÖLN LISBOA LONDON NEW YORK PARIS TOKYO

Contents/Inhalt/Sommaire

Alfred Stieglitz, 291 Gallery and Camera Work
Pam Roberts

Alfred Stieglitz had the multifold abilities of a Renaissance man. A visionary of enormously wide perspective, his accomplishments were remarkable, his dedication awe-inspiring. A photographer of genius, a publisher of inspiration, a writer of great ability, a gallery owner and exhibition organiser of both photographic and modern art exhibitions, a catalyst and a charismatic leader in the photographic and art worlds for over thirty years, he was, necessarily, a passionate, complex, driven and highly contradictory character, both prophet and martyr. The ultimate maverick, he inspired great love and great hatred in equal measure.

His own photography alone earns him one of the major places in the history of photography and it was solely by this, rather than by his multiple activities, that he himself finally wished to be judged. But, the energy, dedication and commitment he put into establishing the Photo-Secession in the USA and getting photography accepted as an art form in its own right, rather than as a mimetic medium, was undertaken at the expense of his own work. He succeeded in changing photography irrevocably and gave it acceptability as a major twentieth century art form. At the end of the nineteenth century, Stieglitz grabbed American photography by the scruff of the neck and shook it screaming into the twentieth century, from obscurity to centre stage, a position which it has held ever since.

The shockwaves generated by Stieglitz's personal volcano of energy channelled into American photography were felt in England and commented on in 1904 by Alfred Horsley Hinton, Editor of *The Amateur Photographer*: "American photography is going to be the ruling note throughout the world unless others bestir themselves; indeed, the Photo-Secession pictures have already captured the highest places in the esteem of the civilized world [...]. It is Stieglitz who arranges terms, gets the pictures together, is responsible for their return. What an influence then he must have become. As one sees him today he is a man of highly nervous temperament, of ceaseless energy and fixed purpose [...]."[1]

He created the Photo-Secession from a group of American photographers who had begun by emulating European pictorial ideals with a sense of underdog apology, but who rapidly developed their own confident photographic language which eventually became photography's lingua franca.

Around the turn of the century, for a period of some 20 years as photography became increasingly available to everyone, thanks to the proliferation of easy-to-use Kodak products and the massive growth in the commercial photography market, photography ruptured in several directions. Amateur pictorial photographers in Europe began to use ever more elaborate manipulative techniques like platinum, gum bichromate, carbon, etc. which resulted in an end product as far removed from the work of the despised "snapshotters" as possible, looking more like pastel sketches or charcoal drawings than photographs. Although Stieglitz began by embracing and encouraging this unreal and labour intensive form of pictorial photographic production, he was able to assimilate and absorb photography's other less tortuous and more immediate possibilities and produce a purity and simplicity of vision and technique which eventually became known as "straight photography", the photography of the future.

The pictorialist groups eventually fragmented, owing to petty infighting and over stringent adherence to achieving painterly effects, for the excessive concentration on the minutiae of technique led to a loss of overall photographic vision. They wandered into an inspirational dead-end, their photographic vision channelled down to such a small perspective that it was as if they were looking at the world through the wrong end of a telescope. Stieglitz's vision, by comparison, never ceased to widen, doubtless because of the complexity and interplay of the many different activities he pursued and the ease with which he embraced new ideas and interests.

Born in Hoboken, New Jersey on January 1, 1864, Stieglitz moved to New York in 1871 to live in a sizeable brownstone on East 60th. St. His father was a successful wool merchant and although Stieglitz often complained bitterly about poverty in later life, the family seemed to be fairly affluent. He studied mechanical engineering, in which he was profoundly disinterested, at the Technische Hoch-

schule in Berlin from 1882–1890. In 1883, he learnt photography from Hermann Wilhelm Vogel and rapidly became obsessed with mastering its technical possibilities. Only by perfect technical control of the medium would Stieglitz be able to tap its full potential to realise his vision.

He was influenced by Europe's soft-edged pictorialism, especially the naturalistic photographs of the Norfolk Broads by Dr. Peter Henry Emerson, who used the photogravure process when printing albums of his photographs. Stieglitz won the The Amateur Photographer First Prize of the Year in 1887, presented by Dr. Emerson. It is difficult to see many similarities between his work during this period and his work twenty years later, the early work being so thoroughly European in style, so lacking in any signs of the Stieglitz hallmarks of clarity and modernism.

The change came on his return to New York in 1890, when Stieglitz was faced with an altogether harsher, grittier, more realistic subject matter. The aggression, life and movement on the New York streets and the drama of the soaring architecture offered none of the easy comforts of the rolling European landscapes populated by peasants in photogenic costumes. But, after some rapid readjustment, Stieglitz found the subject matter exhilarating and challenging, and continued to photograph New York for the rest of his life; one of the first photographers to realise the vast photographic potential of the energy and rapid growth of a city. He thus took on a larger, more hard-edged confrontational and realistic world, composed of graphic shapes and geometric patterns, than that photographed by his contemporaries, many of whom never abandoned the microcosm of softly focused landscapes, misty domestic scenes and fragrant, beautiful women, gazing into crystal balls and yearning sorrowfully for some mythical past. Pictorialism captured an often specially created subjective moment whereas straight photography captured reality with unqualified objectivity.

Funded by his father, Stieglitz became one of the partners in the Heliochrome Company, later the Photochrome Engraving Company, along with student friends from Berlin, Louis Schubart and Joseph Obermeyer, later his brothers-

in-law. Business was poor initially, which gave Stieglitz time to learn the intricate process of photogravure from the company's skilled workforce, and he learnt it with exceeding exactitude. Although the company eventually became commercially successful, Stieglitz was never interested in the business or commercial side of this or any venture, an attitude which persisted all his life. Indeed, he left the company after five years by which time he had acquired a perfectionist's knowledge of the photogravure process and the technical skills required to produce beautiful work. Again, he was influenced by the high quality photogravure portfolios being produced in Vienna, Paris and London in the 1890s but was soon producing higher quality work than any.

The commercial world's loss was photography's gain as Stieglitz determined to revive American amateur photography and bring it out of the doldrums and into the twentieth century, using all the photographic expertise and contacts he had gained whilst in Europe. Stieglitz initially took his cue from the photographic secession groups which were springing up all over Europe, initially inspired by a similar split in the art world in Austria and Germany. To these groups, the words "amateur" and "artist" were synonomous. Only an amateur, unshackled by the chains of commerce such as bound professional photographers, had the freedom to produce truthful and meaningful work.

In the 1890s, the photographic world underwent radical change. In 1891, the Viennese Photographic Secessionists exhibited at the Viennese Salon, amid great controversy. In 1892, the Linked Ring Brotherhood was formed as a breakaway group initially comprising 15 ex-members of The Photographic Society (in 1894 The Royal Photographic Society) and started to hold their own meetings and exhibitions, wearying of the rigid technical and commercial emphasis that the Society was then demanding. In 1894, the Photo-Club de Paris was established by Robert Demachy and Constant Puyo, both having quit the Société Francaise de Photographie. All these groups were looking for the same thing: To free photography from its documentary and technical stranglehold and to use it as a more impressionistic and flexible tool to realise a valid form of artistic expression, much as a painter used paint, brushes and canvas and a sculptor marble, stone and chisels.

The pictorialists believed that photography was not about the recording of documentary facts nor was it a vehicle for trying to recreate works of art (something many Victorian photographers had attempted), but was a means of creating a new, purely photographic reality. This was a reality that could only be made to exist in a photograph, experienced through the photographer's own personal vision and sublimated and brought into existence by his mastery of the specific technology. The technology served the photographer, not the other way round. The camera was merely the implement used to transfer the photographer's vision onto the world. It was the be-all, not the end-all. To record the photographer's impressions of these facts, a wide variety of lenses, negatives and manipulated techniques were used, including drawing, etching, painting and scratching both negatives and prints. Stieglitz had exhibited with all the above groups, many of whom made him an honorary member, and had won an abundance of prizes and medals, over 150 in all.

For the next few years, he seemed to possess the energy of ten men, bringing about a revolution in American photography. From 1892, he edited *The American Amateur Photographer*, strongly believing that only the true amateur had the artistic freedom to follow his vision of truth, untrammelled by any baser economic motives. His greatest challenge came when the Amateur Photographers of New York and the New York Camera Club merged in 1897 to form The Camera Club. In 1897, Stieglitz was appointed vice president as well as editor of the Club's new quarterly journal, *Camera Notes*, which was to be the Club's window on the world and record of club proceedings as well as reflect the new energy and confidence in American photography. Both positions were unpaid.

Over the next five years, the Camera Club only paid $ 1,850 of the running costs for *Camera Notes*. This amount did not even cover the cost of copies of *Camera Notes* for the Club to give away to its paying members and was only a tenth of the total running costs of $ 18,000, paid for by advertising revenue or from Stieglitz's own pocket. However, under Stieglitz's editorship, from 1897–1902, it became the most influential photographic journal in the country, attracting a read-

ership far beyond the Camera Club's somewhat insular boundaries. He reprinted articles, critical essays and exhibition reviews from European publications and commissioned home-grown artists and photography critics to write provocative and controversial articles. American writers like Sadakichi Hartmann (Sidney Allan)[2] and Charles H. Caffin, provoked discussion on photography, the like of which had not been read before. However, the triumph of Camera Notes was the superb quality of its illustrations, photogravures produced to Stieglitz's exact specifications. For American work, he used his old company, the Photochrome Engraving Company in New York, and for European work, he used Walter L. Colls, the printer of Sun Artists in London.

Camera Notes went, artistically, from strength to strength and featured the work of Stieglitz's chosen band of pictorial photographers such as George Seeley, Gertrude Käsebier, Eduard Steichen[3] and Clarence White, all of whom would later become members of the Photo-Secession, exhibit in Stieglitz's galleries and have their work reproduced in Camera Work. He also featured the work of Fred Holland Day, his equal, and occasional rival, in leading the resurgence of American photography.

In March 1902, Stieglitz organized an exhibition at the National Arts Club in New York entitled American Pictorial Photography Arranged by The Photo-Secession, outside the boundaries of The Camera Club. It was the first use of these words, in a public sense, to describe the grouping of a number of like-minded photographers and took many of its ideas on subject matter, presentation and attitude from the European Secession groups. Stieglitz had, in effect, declared a secession from The Camera Club as the Linked Ring Brotherhood had from The Royal Photographic Society, thus making his position untenable. After reviewing the exhibition and writing a long editorial on the Photo-Secession in Camera Notes, July, 1902, as his departing gesture, Stieglitz resigned his editorship.

As Camera Notes had dramatically widened its scope under Stieglitz's editorship to appeal to a more diverse international audience of art and photography lovers, so it had become less domestic in its recording of The Camera

Club meetings, exhibitions and agendas. Camera Club members supplied very little in the way of articles or text and Stieglitz was commissioning articles from ever more expensive contributors. It had never become the cosy house journal the Club had originally envisaged but became a state-of-the-art publication and put the Club on a centre stage that it felt uneasy inhabiting. After Stieglitz's departure, *Camera Notes* was discontinued after three issues.

Stieglitz's fights for editorial control, both at *The American Amateur Photographer* and *Camera Notes* became a constant irritant and, after his resignation from the latter in June, 1902, he was determined that he would only work for himself in the future. He had tried, and partially succeeded, in changing the direction of American photography from within one of its established structures but realised that the only route for him to take was that of an independent maverick and change photography from outside the system.

He had been planning a new journal along the lines of *Camera Notes* for some time. Indeed, *Camera Notes* was, in many ways, a trial run for *Camera Work*, the first issue of which, dated January, 1903, was published in December, 1902. The title came from the phrase used then to describe photographers, "camera workers". The simple, familiar title was no preparation for the avant-garde contents. Stieglitz must have relished the contradiction.

It was funded, edited and largely designed by Stieglitz with his own choice of writers, photographers, artists etc. although Joseph T. Keiley, Dallett Fuguet and John Francis Strauss acted as associate editors, as they had at *Camera Notes*. Eduard Steichen designed the cover and typography. *Camera Work* was, from the beginning, a non-profit making venture. Indeed it was a profit-losing venture and was never intended as a commercial publication. Stieglitz saw a dedication to making money as the ultimate loss of artistic freedom.

Wholly controlled by Stieglitz, the journal would act as the voice of the Photo-Secession, but be independent of it: "*Camera Work* owes allegiance to no organization or clique, and though it is the mouthpiece of the Photo-Secession that fact will not be allowed to hamper its independence in the slightest degree."4

This was a typical Stieglitz equivocation which proved impossible to fulfil and led to some degree of confusion. *Camera Work* would reproduce work by Stieglitz's approved colleagues, discuss photography and art, and review exhibitions in which the Photo-Secessionists, and their European allies, had work exhibited. After the establishment of the Little Galleries of the Photo-Secession in 1905, usually known simply by the street number on Fifth Avenue at which they were located as 291, *Camera Work*, from number 14 onwards, acted increasingly as a non-concurrent exhibition catalogue and a symposium for airing press commentary about the exhibitions. Stieglitz initially tried to keep the magazine and the gallery as separate entities. Possibly, he did not want *Camera Work* to be seen merely as a public relations exercise for the gallery although this is what it eventually became. But, it is more likely that concurrent deadlines between what was on the walls at 291 and what was on the pages of *Camera Work* were impossible to meet as many exhibitions were on show for only two weeks whereas *Camera Work* was, initially, published every three months and could not possibly keep up with or meet the exhibition schedules.

However, its main function was to reproduce, as faithfully as possible and in a way that had never been done before – sparing neither time, expense, nor in any way compromising on standards – the work of the Photo-Secession photographers as portfolios of exquisitely printed photogravures. At the same time, loans of original prints by Photo-Secession photographers were made to both national and international exhibitions with very strict provisos from Stieglitz about choice and about how work should be hung and attributed. These exhibitions would then be reviewed in the pages of *Camera Work* making the whole process cyclical.

Camera Work primarily presented stunning reproductions of the best available photography (in Stieglitz's eyes), supported by the best possible critical writing. The mission statement was made in the first issue in January, 1903: "Photography being in the main a process in monochrome, it is on subtle gradations in tone and value that its artistic beauty so frequently depends. It is, therefore, highly necessary that reproductions of photographic work must be made with exceptional care and discretion if the spirit of the originals is to be retained, though

no reproductions can do full justice to the subtleties of some photographs. Such supervision will be given to the illustrations which will appear in each number of *Camera Work*. Only examples of such work as gives evidence of individuality and artistic worth, regardless of school, or contains some exceptional feature of technical merit, or such as exemplifies some treatment worthy of consideration, will find recognition in these pages. Nevertheless, the pictorial will be the dominating feature of the magazine."⁵

However important and provoking the texts were, often written by artists to give photography credence, *Camera Work* was the first photographic journal to be visual in focus. It was illustrated by the highest quality hand-pulled photogravure illustrations printed onto exquisitely delicate Japanese tissue to achieve maximum tonal quality and texture. These were then mounted onto high-quality deckle-edged art paper in a shade sympathetic to the tonal variations of the images in order to further enhance inherent subtleties. Every step of the photo-gravure process was overseen, frequently retouched and any imperfections corrected, by Stieglitz himself, who also attached the photogravures onto the pages if necessary. He exercised quality control with a vengeance and with dedication.

Stieglitz had advanced the process of photogravure to such a state of perfection that he frequently used it for his own exhibited photographs rather than the previous platinum and carbon processes that he had favoured. He considered it an equally legitimate form of photographic print-making and submitted Photo-Secession prints in photogravure form to international exhibitions. Photo-gravure was the best and most perfect way of bringing photographs and words together, to communicate with a wider public, and, in Stieglitz's hands, went far beyond a photomechanical printing process.

In the early numbers, there were also half-tone reproductions of photographs which had the attraction of costing half the price of gravures – but perfection once again triumphed over economics and, after 1906, they were gradually discontinued in favour of all gravure for the reproduction of photographs. However, half tones were necessarily retained for the reproduction of art and sculpture in later

issues, gravure being, basically, a monochrome process. Stieglitz also used mezzo-tint-gravure, duogravure, hand-toned photogravure, three and four-colour halftone and collotype to achieve reproductions as near to his ideal as possible. One can only wonder at the drain on Stieglitz's pocket. Exact costs are unavailable as he kept no detailed accounts. However, the size and format of *Camera Work* meant that everything was necessarily reduced down to a proportion that would fit on a page. Thus the huge, highly coloured gum bichromates of Theodor and Oskar Hofmeister and the tiny platinum prints by Stieglitz himself were reproduced at the same size, losing the scale and textures which made the originals so vastly different.

The first issues were printed by the Photochrome Engraving Company but later issues were produced by the Manhattan Photogravure Company (an offshoot of the same company and run by Stieglitz's brother-in-law), by T. & R. Annan & Sons in Glasgow, and by Frederick Goetz at F. Bruckmann Verlag in Munich. The Manhattan Photogravure Company produced photogravures from the negatives of American photographers from 1904–1917. James Craig Annan supplied photogravures from British photographers' work, including his own, pieces by George Davison and, in later issues, prints from the original paper negatives of David Octavius Hill and Robert Adamson. Frederick Goetz provided photogravures from the negatives of European photographers such as Heinrich Kühn[6] and Frank Eugene but also printed colour half tones from Eduard Steichen's autochromes in April 1908. Eventually, Stieglitz came to trust his European gravure suppliers more than the Manhattan Photogravure Company, especially Goetz who was eager to keep *Camera Work* in production long after Stieglitz had decided it should close.

Other printing houses such as J. J. Waddington in London were used for the Frederick H. Evans issue (*Camera Work* number 4, October, 1903) but failed to reach Stieglitz's standards. He castigated himself in print for accepting a less than perfect end product: "Imagine our consternation upon the arrival of the edition to find that the work was uneven, not up to proof, and in most cases, far below that standard which we had every reason to expect. It was then too late to do aught than make the best of a bad job, feeling that we have only ourselves to blame

for having broken our rule [...] we feel disappointed that this number should leave our hands and we not satisfied with it. It shall never happen again."7

Gravures were produced, preferably, from the photographers' original negatives, or, failing that, from the original prints. If from negatives, the fact was noted in the accompanying text and these gravures were considered to be original prints. This insistence on original negatives led, in the case of non-American work, to shipping, customs and insurance problems as well as over-extended deadlines and delays in production. Perfection of product mattered more to Stieglitz than producing *Camera Work* on its expected publication date; thus many issues were several months late whilst he travelled in Europe or was suffering from one of his frequent bouts of illness. If Stieglitz had not minutely inspected every page of *Camera Work*, it did not go out. With all photographers, Stieglitz sought their involvement in the choice, reproduction and presentation of their work and was exhaustive in accomodating the photographers whose work he really wanted.

The house style was established in *Camera Work* number 1, January, 1903, which featured six gravures of the work of Gertrude Käsebier, one by Stieglitz, a nature study by A. Radclyffe Dugmore and a couple of half tones of work by D. W. Tryon and Puvis de Chavannes. The gravures were separated from the text by blank pages and given prominence at the front of the journal. Written pieces supported the photographers' work with two appreciative reviews on Käsebier by Charles H. Caffin and Frances Benjamin Johnston, plus articles on aesthetics in photography and painting by Joseph T. Keiley, Sidney Allan (Sadakichi Hartmann), and Otto Walter Beck respectively. The technical aspect of photography was covered by a piece about lighting for bird photography by Dugmore. Exhibition reviews included one by Will Cadby on the London Salon exhibition, with an additional piece on the American presence there by the *Camera Work* editors, plus brief reviews on the Turin Decorative and Fine Arts Exhibition and the Yorkshire Union of Artists. Shorter articles by Eva Watson-Schütze, Dallett Fuguet and Eduard Steichen, along with reprinted articles from other publications (on this occasion, from *The International Studio*), plus a brief review of new products on the market

and a sprinkling of short poems from the editorial team set the tone for future issues. This balance largely continued with generous doses of "in" jokes and often far too clever satirical articles, their nuances lost to all but the truly committed Photo-Secessionist.

Even the 26 advertisements at the back of the journal were simply and creatively designed and presented, often by Stieglitz himself, and rigorously separated from the serious content. Most advertisers stayed over many issues and included Kodak Films, Schering's photographic chemicals, Bausch & Lomb Optical Co., and Graflex Cameras. Eastman Kodak took the outer back cover of practically every issue, using the same typeface designed for the front cover by Eduard Steichen, at Stieglitz's insistence. Many of the companies involved in the physical production of *Camera Work* chose to advertise on these back pages, a true vote of confidence in their work. Stieglitz's insistence on the non-profit making aspects of *Camera Work* meant that the number of advertisements was always kept under steady control.

The text pages were printed by The Fleming Press until July, 1908 and afterwards, by Rogers and Company. Stieglitz favoured heavy black text with red introduced in the first heavily ornamented letter of each article, set within wide margins, based on the designs of William Morris. Each issue was bound in a grey-green paper cover with the title, publishing and edition details in a lighter grey. These design elements never changed throughout 50 issues giving a complete set of *Camera Work* a coherence rare in journal publishing. Binding was by the Knickerbocker Bindery, New York.

Camera Work was intended to be a quarterly publication, although this occasionally faltered, with an annual subscription of $ 4.00 for all four or $ 2.00 for a single issue. Registered post and cardboard packing cost an extra fifty cents per copy. The annual price soon doubled and, in an effort to encourage subscriptions and provide some sort of working capital, the price for individual back issues, such as the *Steichen Supplement* could cost as much as an annual subscription. By the 1920s, the *Special Stieglitz* number 36, 1911 was selling for $ 15.00 whilst the Paul Strand double issue, numbers 49/50, 1917, was fetching the highest price of $ 17.50.

Even as soon as July, 1903, the first four issues were being sold by Tennant and Ward in New York for $ 10.00, more than twice the annual subscription.

Initially, Stieglitz printed 1,000 copies of every issue and had almost 650 paying subscribers. By 1912, the subscriptions had dropped to 304 and by 1917 when *Camera Work* closed, only 500 copies of each issue were produced with only 36 paid subscriptions. The shift away from pure photography to art and some photography from 1910 onwards lost him many subscribers. Stieglitz mainly perfected limited edition selling by eventually destroying remaining issues of *Camera Work* after he had made sure that relevant organisations such as the New York Public Library and The Royal Photographic Society had complete, freely given and, in the latter's case, usually signed, sets. He also gave a set to The Camera Club Library, which he had largely been responsible for building up during his time as editor there from 1897–1902, and was highly offended when they sold off odd copies for as little as $ 1.00, when the market rate was ten times the price.

In a letter to The Royal Photographic Society's Secretary and Librarian, J. McIntosh in 1911, Stieglitz wrote: "I shall see whether it will be possible for me to duplicate those *over-appreciated* numbers of *Camera Work* – No's 2, 11 & 12 when I send you the bound numbers 17–32 to complete the set up-to-date. I may have some trouble in getting No. 2 as it is one of the very rare ones & brings as much as £ 6·0·0 on the open market. But I feel that by hook or crook the Royal must have a complete set of the publication which is really part of my life-blood. But I do hope you will impress your members with the fact that in destroying the completeness of *Camera Work* in any way is robbing their Society of a genuine and valuable asset in more sense than one. The publication is doing Trojan work for the "Cause" and it has been instrumental in winning over some of the bitterest opponents of photography not only in this country but in the rest of the world."[8]

On publication, *Camera Work* was greeted with great appreciation by the British photographic press: "When *Camera Notes* was at its height, it seemed impossible for it to be surpassed. We can only say in this case that it has been passed, that Stieglitz has out-Stieglitzed Stieglitz, and that, in producing *Camera*

Work he has beaten that record which he himself held, which no one else has ever approached."9

"There can be no other verdict but that *Camera Work* beats all previous records for dignity, good taste, and actual value [...]. Public taste too often demands that serial photographic literature shall be of a trivial and superficial kind, but here those who are interested in the artistic side of photography will find reading matter that will last and make them think, and pictures which are famous today and will probably continue. For *Camera Work* as a whole we have no words of praise too high, it stands alone; and of Mr. Alfred Stieglitz American photographers may well be proud. It is difficult to estimate how much he has done for the good of photography, working for years against opposition and without sympathy and it is to his extraordinary capacity for work, his masterful independence which compels conviction, and his self-sacrificing devotion that we owe the beautiful work before us."10

Throughout its 50 numbers over 14 years of production, many issues of *Camera Work* were devoted to the work of a single photographer or a school of photographers. These were usually members of the Photo-Secession, friends or supporters. Very little space was given to discovering new talent. The star performer was Eduard Steichen whose photographs were most frequently reproduced in *Camera Work* and whose critical texts on art and colour photography appeared regularly. Over 14 years, Steichen had 68 prints reproduced in all, mostly photogravures, with five one-man editions; number 2 in April, 1903; number 14 in April, 1906; a special un-numbered *Steichen Supplement* also in April, 1906; number 22 in April, 1908 and number 42 in April/July, 1913. Number 14 in April, 1906 was shared with four installation shots by Stieglitz of the newly opened Little Galleries, in part designed by Steichen and showing his work on the walls. The *Steichen Supplement* was later published as a limited edition of 65 portfolios by Stieglitz.

Other photographers given a whole number to themselves were Alvin Langdon Coburn (number 21, January, 1908); Clarence H. White (number 23, July, 1908); Frank Eugene (numbers 30 and 31, April and July, 1910); Heinrich Kühn (number 33, January, 1911); the rediscovered David Octavius Hill and Robert

Adamson from the 1840s, although the latter was not credited (number 37, January, 1912). The photogravures of their work were produced from their original paper negatives owned by James Craig Annan. Baron Adolf de Meyer (number 40, October, 1912); James Craig Annan (number 45, January, 1914, published June, 1914); Paul Strand (number 49/50, June, 1917).

Stieglitz never quite allowed his own work the luxury of a whole issue although he got very close with number 12 in October, 1905 with 10 gravures shared with Renaissance paintings and number 36 in October, 1911, featuring 16 of his gravures and one half-tone of a Picasso etching which he had bought after exhibiting it. However, with 47 of his own works reproduced and four joint works with Clarence H. White, Stieglitz was the second best represented photographer in *Camera Work*.

Whole, or almost whole issues were given up to groups of photographers like the Vienna Trifolium, Heinrich Kühn, Dr. Hugo Henneberg and Hans Watzek (number 13, January, 1906) The French edition, featuring work by Robert Demachy, Constant Puyo and René Le Bègue (number 16, October, 1906) and women photographers, Annie W. Brigman, Ema Spencer and Alice Boughton (numbers 25 and 26, January and April, 1909). Many photographers appeared frequently in the early years and then disappeared as Stieglitz's interests swung elsewhere and the former friendly relationships fractured, owing to photographic rivalries.

Dissatisfaction with the lack of galleries displaying photography in New York and the urge to create a perfect space for Photo-Secession work urged Stieglitz to look for a potential gallery space. The Little Galleries of the Photo-Secession opened at 291 Fifth Avenue in November, 1905. Adequate space was found by Steichen in the same building in which he had his studio. The rent was $ 50 a month and Stieglitz spent an extra $ 300 on carpentry and electrical fittings. Annual subscriptions from Photo-Secession members of $ 5.00 paid some of the bills but the rest seem to have been wholly borne by Stieglitz.

The opening of the gallery was announced, with a certain degree of pride, in *Camera Work* number 14 of April, 1906. "In looking at the illustrations

on another page our readers can form an idea of the decorative arrangement of the Photo-Secession exhibitions. Heretofore, with but two or three exceptions, photographs have not been shown to their best advantage; the crowding of exhibits, the garish, or, still worse, insufficient light, the incongruous color-scheme have certainly not helped in affording the public an opportunity of satisfactorily studying pictorial photographs. With these facts in mind, the Secession Galleries were arranged so as to permit each individual photograph to be shown to the very best advantage. The lighting is so arranged that the visitor is in a soft, diffused light while the pictures receive the direct illumination from a skylight; the artificial lights are used as decorative spots as well as for their usefulness. One of the larger rooms is kept in dull olive tones, the burlap wall-covering being a warm olive gray; the woodwork and moldings similar in general color, but considerably darker. The hangings are of an olive-sepia sateen, and the ceiling and canopy are of a very deep creamy gray. The small room is designed especially to show prints on very light mounts or in white frames. The walls of this room are covered with a bleached natural burlap; the woodwork and molding are pure white; the hangings a dull ecru. The third room is decorated in gray-blue, dull salmon and olive-gray. In all the rooms the lamp-shades match the wall-coverings."[11]

The inaugural exhibition of the first five month season from November, 1905 to April, 1906 was work by members of the Photo-Secession including 100 prints by 39 different photographers. Best represented were Steichen with 11 prints, White with nine, Käsebier with eight and Keiley and Stieglitz with seven. This was followed by seven exhibitions of individual photographers, like Steichen, Käsebier and White. The gallery was open from 12.00–6.00 pm, six days a week excluding Sunday, and was free. The first season attracted 15,000 visitors. Of the 384 prints hung, 249 were for sale and 61 actually sold at an average price of $ 45.86 per print with Stieglitz himself being the heaviest buyer. The gallery became the meeting place for members of the Photo-Secession and interested adherents. Previously, they had only been able to meet at restaurants or clubs although this social element of the group continued to be emphasised and practised.

In the second and third seasons, the photographic mix was much the same but non-photographic exhibitions were gradually introduced, first with the addition in 1907 of an exhibition of drawings by Pamela Colman Smith, an American Symbolist artist, 33 of which sold, and then with the controversial introduction of French art. Stieglitz continued to acquire photographs, thus subsidising his own gallery twice over.

In 1907 and 1909, Stieglitz visited Europe and met Matisse and Rodin. He had been alerted to their work and that of Cézanne, Van Gogh and Braque by Eduard Steichen during his years spent moving in artistic circles in Paris. In January, 1908, 291 showed, for the first time in New York, 58 original drawings by Rodin, selected by Rodin and Steichen in Paris, rapidly followed by the first showing of lithographs, paintings, drawings and etchings in the USA by Matisse, hand carried to New York by Steichen. It was ironic that the introduction of contemporary French art to an American public was financed and organised through the enthusiasm of two photographers.

The phenomenal success of the gallery, 50,000 visitors in three seasons, caused the landlord to double the rent and insist on a four year lease. As the Photo-Secession's annual income was less than $ 300 per annum, coming from the $ 5.00 annual subscription, this would have led to a huge monetary involvement by Stieglitz which, even he, was not willing or able to give. The gallery was therefore closed down and reverted to its former use. But, a new gallery, subsidised by a new Photo-Secession member, Paul B. Haviland, was soon opened in a new, smaller space, just 15 foot square, across the hallway. As membership and subscriptions to the Photo-Secession eventually fell away this gallery proved more than adequate for the showing of smaller, more intimate art-based exhibitions rather than the former group-based photography shows.

Stieglitz's personal taste and evolving aesthetics led him further away from photography and the exhibition programme became ever more eclectic. Over the next few years, he often featured work by new young American painters, many of whom had spent time working in Paris, especially Marsden Hartley and

John Marin. Over the next few years, from 1911–1916, he showed the first exhibition in the USA of Picasso's drawings and watercolours; Braque, Picabia, Brancusi and Severini, Mexican pottery and African sculpture. Also Georgia O'Keeffe. During the years 1910–1917, only four photography exhibitions were shown at 291.

Stieglitz's relationships with the rest of the photographic world during this period were generally explosive and began to fragment around 1908. Although he inspired intense loyalty and admiration for his championing of photography, he equally inspired anger and distrust for his dictatorial and arrogant attitude. Sadakichi Hartmann frequently left the literary ranks of *Camera Work*, although he always returned, accusing Stieglitz of dictatorship and despotism. Both accusations were undoubtedly true. In 1908, Stieglitz was expelled from membership of The Camera Club for working against the Club's interests, and, extremely hurt, he published the ensuing politely vitriolic correspondence in *Camera Work*, thus using the journal as a personal manifesto of justification.

In 1909, the Linked Ring Brotherhood in London finally dissolved in a welter of mutual antipathy; indeed, other European secession groups had already collapsed, usually with bitterness. Stieglitz's increasing stranglehold on the Photo-Secession photographers was that of a man desperately clutching at straws. He was trying to salvage an organisation that had outgrown his ministrations. Gertrude Käsebier and Clarence White successfully embraced the dreaded "commercial" world and, with alternative agendas, joined other photographic organisations, as did many others who believed that photography ought to have a wider brief than that which Stieglitz allowed it or which met his remit.

Typically, Stieglitz sloughed off the past, although still bearing great resentments, and began to channel his energies into art rather than photography. During the next years of 291's existence, until it closed in 1917, he only showed four photography exhibitions, dramatically changing the gallery's programme to art-based work, mainly European modernism. *Camera Work* might have been better renamed "Art Work" at this stage in its existence. From 1910 onwards, Stieglitz began to illustrate a much larger percentage of contemporary art in its

pages. *Camera Work* was always intended to cover both art and photography, but now the balance shifted dramatically.The whole ethos of *Camera Work* changed and the exhibition policy of 291, the text and illustrations of *Camera Work* became constituent parts of Stieglitz's constantly evolving philosophy on art and photography, with photography now assuing a back seat. 291 showed a mixed programme. Drawings by Walkowitz followed caricatures by Frueh and de Zayas, a Mexican intellectual and caricaturist who rapidly became very important in the Stieglitz circle.

The mainstay, however, of 291's programme, and what influenced the younger generation of American artists, was French modernist art. Over the next few years, Stieglitz showed one-man and mixed shows of Cézanne, Toulouse-Lautrec, Rousseau and Renoir, all firsts in the USA, as well as more Matisse and Rodin drawings and sculptures. The Matisse show attracted 4,000 visitors despite the tiny 15-foot-square room. Another coup came in April, 1911, with the first ever showing in the USA of 83 of Picasso's water colours, chosen by de Zayas in Paris and so popular it was extended until May.

These exhibitions were all organised by Stieglitz, and often Steichen, in the tiny gallery, on a shoestring budget, years before the Armory Show of Modern Art in New York in 1913, for which Stieglitz was asked to act as a consultant, gave Modern art a sizeable venue. One of the few photographic exhibitions during this period, of Steichen's work, sold $ 1,500 worth of prints and attracted 2,500 visitors. 160,000 visitors went to 291 in the seven year period 1905–1912. Whilst World War I eventually affected the seemingly effortless ease with which Stieglitz seemed able to import art works from France, he was able to show in the gallery two rooms of works of Eli Nadelman over Christmas 1915. The final season of exhibitions at 291, 1916–1917, began with an exhibition of water colours by Georgia Engelhard, Stieglitz's self-taught ten-year-old niece. He twice featured the watercolours, oils, charcoals and statuary of Georgia O'Keeffe, with whom he lived from 1918 and whom he married in 1924. In O'Keeffe's work, Stieglitz found the overwhelming naturalism, truth, honesty and reality for which he had long been searching and everything else seemed to pale into insignificance. 291 closed in June, 1917.

This emphasis on art had begun to create some rather strange juxtapositions in the issues of *Camera Work*. George H. Seeley's 10 photogravures with high pictorialist values of the domestic, mysterious female type in *Camera Work* number 29, January 1910 sat rather uneasily with four bizarre caricatures by Marius de Zayas.

In October, 1910 (number 32), Stieglitz featured gravures of drawings of nudes by Matisse. The Matisse nudes caused a frisson amongst subscribers. Undaunted, number 34/35, April/July, 1911, was a special Rodin issue with four gravures by Steichen of Rodin himself and his sculptures of Balzac, with nine gravures and coloured collotypes of Rodin's drawings, all nudes. Most of the text in this issue related specifically to Rodin in particular and French art in general. At this stage, almost half *Camera Work*'s remaining subscribers cancelled their subscriptions, worried about the high ratio of nudes. Photographs of real women, nude, were acceptable, paintings of nude women were not.

Anticipating the reaction, Stieglitz wrote: "To those of our readers who fail to see why these drawings have been introduced into *Camera Work*, we would say that, apart from the importance of the originals, the reproductions are beautiful and interesting examples of what can be accomplished by one of the most useful and far reaching branches of camera-work: namely the photo-mechanical processes. Thus they are of value in a double sense. These prints make it possible for those who cannot see the originals to enjoy an acquaintance with some of the great artists' most intimate studies, while at the same time they bring us a fuller understanding of the capabilities of photographic reproduction when it is directed by artistic feeling and technical knowledge. Furthermore, we beg to remind our readers that one of the objects of *Camera Work* is to reflect the activities of the Photo-Secession and its gallery. What these are has been frequently referred to in recent issues of the magazine."[12]

In number 36, October, 1911, the Stieglitz issue, an etching by Pablo Picasso confirmed, if confirmation was still necessary, that Stieglitz was now tired of pictorialism. Most of the text in this, and subsequent issues, is made up of press reviews of the last few 291 exhibitions with little in the way of original com-

missioned articles and even less on photography. Articles are reproduced from art journals, exhibition reviews from newspapers etc. Stieglitz was tired and ill and publication became increasingly spasmodic.

A special number in August, 1912 was devoted equally to seven nudes by Matisse and seven Picasso paintings and sculptures including a repeat showing of Picasso's 1911 etching. This was the first issue of *Camera Work* not to reproduce a single photograph and clearly signalled the direction of Stieglitz's interests. It also used critical texts about Matisse and Picasso by Gertrude Stein, whose writing appeared again in the *Special Number* in June, 1913. Again, it was a very definite departure in style and content from the more familiar, often florid articles by the likes of Caffin, de Casseres and de Zayas. Modernist art now got Modernist text.

After 1913, several factors conspired to bring about the eventual demise of *Camera Work*. Plummeting subscriptions meant that little money was coming in, although financial considerations had never stopped Stieglitz from doing what he wanted. World War I meant that the supply of high quality gravures from Goetz in Berlin all but dried up. Stieglitz was becoming more involved in 291 which took up an increasing amount of time, as did preparations for the 1913 "Armory Show of Modern Art in New York" and his involvement with de Zayas in another short-lived journal and gallery.

Over the next four years, there were only six more issues of *Camera Work*, the final two, numbers 49 and 50, being bound together as one. *Camera Work* number 47 was particularly self-justifying, featuring no photogravure illustrations at all or paintings but instead printing a selection of 68 letters answering the question "What is 291?" Visitor figures were falling and this issue could be seen as a cynical ploy to re-interest the public or a money-saving exercise, photogravures being the most expensive part of the *Camera Work* budget. However, it is likely that Stieglitz also wanted reassurance that both *Camera Work* and 291 had meant something to more people than himself and wanted those opinions in print before both the journal and the gallery were closed down. It is also likely that he was increasingly bored with the aggravation, workload and expenses involved, which increas-

ingly came almost entirely from his own pocket. Even he was not immune from the depressing reality of the First World War.

Some of the letters were strangely moving; some pretty grovelling. Replies were invited from all walks of life; from Hodge Kirnon, the West Indian elevator boy at 291 Fifth Avenue since 1912, to Man Ray, painter, designer, writer (later photographer); from Adolf Wolff, sculptor, poet, anarchist of New York to Francis Picabia, French painter. In answer to the question, "What does 291 mean to you?", a somewhat cynical Clara Steichen wrote: "I sewed and hemmed and hung the first curtains for 291. Since then, others have hemmed and hawed and hung there."[13]

An even more cynical Eduard Steichen, who had long since had his own altercations with Stieglitz and had advised him to discontinue both *Camera Work* and 291 years earlier, wrote: "During the past year, possibly two years, 291 has seemed to me to be merely marking time. [...] I also fail to see any reason [...] that explains to me the attitude leading to the publishing of this number of *Camera Work* unless it is simply the result of 291's finding itself with nothing better to do. Again arrives the unforeseen-came the War."[14]

The penultimate issue of *Camera Work* (number 48, October, 1916) was a résumé of the past, present and future. It was a summation of the last 13 years of Stieglitz's life. The past was represented by the pictorial *The Cat* by Frank Eugene, *Winter* by Arthur Allen Lewis, *Portrait* by Francis Bruguière and an installation shot of German and Viennese Photography, shown at 291 in March, 1906.

The present and future, by the installation shots of the 291 exhibitions of Brancusi Sculpture, March, 1914; Negro Art, November, 1914; the Picasso-Braque exhibition, January, 1915; and the Nadelman exhibition – 2 rooms, December, 1915. The only future for photography was the work of Paul Strand – who was then given the whole of the two final issues and whose photography was the first to excite Stieglitz for many years. Stieglitz decided to go out with a bang and not a whimper and show there was life in the old dog yet. He saw Strand's work as representing a photographic version of the abstraction that he found in Picasso's work and now he had found it again in his first passion, photography.

The Strand issue was the final nail in the coffin of pictorialism. Printed with a hard and harsh strength on a thicker paper and with a different, more resonant ink, they were far removed from the fragile transparent delicacy of the previous subtle Japanese tissue. This final issue was Stieglitz's vademecum for the future of photography. He had found it pictorial and soft and left it straight and hard. Strand's photographs, like Stieglitz's accompanying text, were the epitome of strong and direct communication: "His work is rooted in the best traditions of photography. His vision is potential. His work is pure. It is direct. It does not rely upon tricks of process. In whatever he does there is applied intelligence [...]. The eleven photogravures in this number represent the real Strand. The man who has actually done something from within. The photographer who has added something to what has gone on before. The work is brutally direct. Devoid of all flim-flam; devoid of trickery and of any 'ism'; devoid of any attempt to mystify an ignorant public, including the photographers themselves. These photographs are the direct expression of today. We have reproduced them in all their brutality."[15]

Stieglitz rediscovered photography and art through Strand and O'Keeffe, and for the next few years, devoted himself to his own work, after a lapse of many years given up to the Photo-Secession, which had eventually given up on him and itself. He photographed O'Keeffe obsessively, worked out his belief in "equivalents" and worked "sharp and straight" enhancing and emphasising the photographic purity and naturalism apparent in much of his earlier work. "My photographs are ever born of an inner need – an Experience of Spirit. I do not make 'pictures' [...]. I have a vision of life and I try to find equivalents for it sometimes in the form of photographs. It's because of the lack of inner vision amongst those who photograph that there are really very few true photographers. The spirit of my 'early' work is the same spirit of my 'later' work. – Of course, I have grown, have developed, 'know' much more, am more 'conscious' perhaps of what I am trying to do. So what I may have gained in form-in maturity – I may have lost in another direction. There is no such thing as progress or improvement in art. There is art or no art. There is nothing inbetween."[16]

He no longer needed the Photo-Secession, *Camera Work*, or 291 to occupy his time and energy, whilst he had his own photography and O'Keeffe. O'Keeffe, in effect, became the embodiment of all the art he had ever wanted or could need. It seems possible, that, for the first time in his life, Stieglitz was truly happy and at peace, that he had formed an "equivalent" with himself. He had occasionally thought of putting together further issues of *Camera Work*, on Charles Sheeler and Georgia O'Keeffe and even the younger pictorialists, but this never happened. He wrote to the President of the Royal Photographic Society, John Dudley Johnston in 1923: "It had been, and still is, in my mind to devote an issue of *Camera Work* to the work of the 'later' British Workers, you, Bennington & Arbuthnot, & maybe one other. As *Camera Work* is a 'history' – an idea – a spirit – call it what you will – I of course always have it in mind. It's not only a question of a great deal of money but where to have work done these days to satisfy one like myself."[17]

In 1924, Stieglitz, who had been made an honorary Fellow of The Royal Photographic Society in 1905, was awarded the Society's Progress Medal, its highest distinction, "in recognition of his great work in founding and fostering the American school of pictorial photography, and for the initiation and publication, over a period of fourteen years, of *Camera Work*, the most artistic record of photography ever attempted."[18]

He began to smooth over some of the fractured relationships of the past, becoming a frenetic letter writer. During his last twenty years, he ran the Intimate Gallery and the gallery An American Place, showing mainly art but some photography if it intrigued him enough, by Paul Strand, Ansel Adams and Eliot Porter. In 1930, he burned the 1,000 remaining copies of *Camera Work*, having satisfied himself that he had donated sets to most major institutions.

In 1933, he gave his collection of over 600 photographs by members of the Photo-Secession and other pictorial photographers to the Metropolitan Museum of Art in New York. By this time, he had come to see little value in this style of photography, a style he had almost single-handedly nurtured in America, and now wanted to be rid of it.

Stieglitz was always more interested in the present and the future than the past. He had encouraged an understanding of and response to Modernist art and established new standards of judgement that killed the tenets of pictorialism, to which he had given life, stone dead. In effect, he killed his own child. He always sought growth and development, vitality and intensity rather than habit and stagnation, and looked for the ultimate truth to be found in freedom of experience, whatever the medium. Art had to add something new to what had gone before. It had to change things, otherwise it was not art. Every man with a message deserved to be heard. Stieglitz had more messages than most.

Camera Work fulfilled many functions. On one level, it began as the last outpost of the confluence of Symbolist art, photography and literature, and ended as a messenger of Modernism. On another level, it was a non-concurrent exhibition catalogue for 291 and the publicity machine for the Photo-Secession. Whilst it inspired many photographers, it was seen as an anachronism by others. Walker Evans could only remember one Paul Strand image from the 559 reproductions. Ansel Adams and Eliot Porter recalled Strand, Stieglitz and Steichen, but the mass of pictorial work seemed to them of another era, as indeed it was. Most of all, it was the autobiography of the creative life of one man, its editor, financier, and inspiration. A man who got things done. A man variously known as a despot, a dictator, a guru, a prophet and a messiah. Alfred Stieglitz.

"If only England had had a Stieglitz! But Stieglitzes are rare. It suffices that one Stieglitz has been born in our generation, and our debt to him is enormous. He is not only, as those who know his work have long been persuaded, the greatest living photographer; he has been (and solely for the love of it) the greatest propagandist for photography."[19]

Not a bad epitaph.

1 A. Horsley Hinton, "The Work and Attitude of the Photo-Secession of America", in: *The Amateur Photographer*, vol. XXXIX, no. 1026, June 2, 1904, pp. 426–428.

2 Sadakichi Hartmann is the real name, Sidney Allan the pseudonym used only in the photographic writings.

3 Steichen later changed the spelling of his name from the French Eduard Jean to the anglicised Edward John.

4 Alfred Stieglitz, Introduction, in: *Camera Work 1*, January, 1903, pp. 15–16.

5 Alfred Stieglitz, Introduction, in: *Camera Work 1*, January, 1903, pp. 15–16.

6 The spelling of the name Kühn varies throughout the text of different issues of *Camera Work*. However, his photographs reproduced in the magazine are all labelled Kuehn. This spelling has, therefore, also been used for the captions to pictures printed in the present book.

7 Alfred Stieglitz, "Our Illustrations", in: *Camera Work 4*, October, 1903, pp. 25–26.

8 Letter from Alfred Stieglitz to J. McIntosh, Secretary and Librarian of The Royal Photographic Society, August 31, 1910, The Royal Photographic Society Archives, Bath.

9 R. Child Bayley, "Camera Work", in: *Photography*, vol. XV, January 3, 1903, p. 738.

10 A. Horsley Hinton, "Camera Work", in: *The Amateur Photographer*, vol. XXXVII, no. 953, January 1903, p. 4.

11 The editors from *Camera Work*, "The Photo-Secession Galleries" in: *Camera Work 14*, April, 1906, p. 48.

12 The editors from *Camera Work*, "Our Illustrations", in: *Camera Work 34/35*, April/July, 1911, p. 70.

13 Letter from Clara Steichen, in: *Camera Work 47*, dated July 1914, published January, 1915, p. 20.

14 Letter from Eduard Steichen, in: *Camera Work 47*, dated July 1914, published January, 1915, pp. 65–66.

15 Alfred Stieglitz, "Our Illustrations", in: *Camera Work 49/50*, June, 1917, p. 36.

16 Letter from Alfred Stieglitz to John Dudley Johnston, Past President of The Royal Photographic Society, April 3, 1925, The Royal Photographic Society Archives, Bath.

17 Letter from Alfred Stieglitz to John Dudley Johnston, President of The Royal Photographic Society, October 15, 1923, The Royal Photographic Society Archives, Bath.

18 *The Photographic Journal*, vol. LXV, New Series vol. XLIX, May, 1925, p. 250.

19 Ward Muir, "Camera Work and its Creator. A Historical Note", in: *The Amateur Photographer*, vol. LVI, no. 1829, November 28, 1923, pp. 465–466.

Alfred Stieglitz, Galerie »291« und Camera Work
Pam Roberts

Alfred Stieglitz verfügte über die facettenreichen Fähigkeiten eines Humanisten der Renaissance. Er war ein Visionär mit ungewöhnlich weitem Horizont. Seine Leistungen waren bemerkenswert, seine Hingabe ehrfurchtgebietend. Als Photograph war er ein Genie, als Verleger besaß er Inspirationskraft, als Autor große Stärken. Er war Galerist und Ausstellungsorganisator für Photographie und moderne Kunst und, über einen Zeitraum von 30 Jahren, Vermittler und charismatischer Führer in beiden Welten. Er war ein leidenschaftlicher, komplexer und höchst widersprüchlicher Charakter – er mußte es sein, Prophet und Märtyrer zugleich. Er war der Einzelgänger schlechthin und wurde ebensosehr geliebt wie gehaßt.

Allein durch seine eigenen Photographien hat er einen bedeutenden Rang in der Geschichte der Photographie erworben, und eine Bewertung seiner Person, so war es der Wunsch von Stieglitz selbst, sollte über diese erfolgen und nicht über seine vielen anderen Aktivitäten. Doch die Energie, Hingabe und das Engagement, mit dem er die Gründung der Photo-Secession in den USA vorantrieb und für die Anerkennung der Photographie als eigenständige Kunstform kämpfte, anstatt sie als Mimesis, als nachahmendes Medium zu betrachten, ging zu Lasten seiner eigenen Kunst. Es gelang ihm, die Photographie unwiderruflich zu verändern und ihr Akzeptanz als eine der bedeutendsten Kunstformen des 20. Jahrhunderts zu verschaffen. Wie eine Katzenmutter ihr protestierendes Junges am Nacken packt, so griff Alfred Stieglitz am Ende des 19. Jahrhunderts die amerikanische Photographie beim Schopfe und zerrte die Widerstrebende schreiend aus dem Nichts ins Rampenlicht des 20. Jahrhunderts, wo sich die Photographie seither in dieser exponierten Stellung hat behaupten können.

Stieglitz löste mit seiner dynamischen, explosiven Persönlichkeit Schockwellen aus, die die amerikanische Photographie zutiefst beeinflußten, die aber auch in England spürbar waren. Im Jahr 1904 kommentierte dies der Herausgeber von *The Amateur Photographer*, Alfred Horsley Hinton: »Die amerikanische

Photographie wird zum Vorbild für die ganze Welt werden, so sich nicht andere dazu durchringen können, aktiv zu werden; und in der Tat haben sich die Arbeiten der Photo-Secession bereits den höchsten Rang in der Wertschätzung der Kunstwelt erobern können [...]. Es ist Stieglitz, der die Bedingungen ausmacht, die Photographien zusammenträgt und für ihre Rückgabe zuständig ist. Welch eine einflußreiche Position muß er innehaben! Wenn man ihn heute sieht, so sieht man einen äußerst angespannt wirkenden Mann voll unerschöpflicher Energie und von großer Zielstrebigkeit [...].«[1]

Alfred Stieglitz gründete die Photo-Secession mit einer Gruppe amerikanischer Photographen, die zunächst aus Europa stammende Ideale der Bildkomposition noch widerspruchslos übernahmen, jedoch bald zu einer eigenen, selbstbewußten Sprache fanden, die zur *lingua franca* der Photographie wurde.

Um die Jahrhundertwende wurde die Photographie dank der Verbreitung von Kodak-Produkten, die eine einfache Handhabung ermöglichten, und der bedeutenden Erschließung des Marktes für kommerzielle Photographie in zunehmendem Maße jedermann zugänglich. Während der nächsten 20 Jahre, als sich in Europa Amateurphotographen, die dem Piktorialismus anhingen, mit immer verfeinerteren Techniken wie Platin-, Karbon- und Gummidruck soweit wie möglich vom verachteten »Schnappschuß« entfernten und Arbeiten schufen, die eher an Pastellskizzen oder Kohlezeichnungen erinnerten, teilte sich die Photographie in verschiedene Richtungen. Obwohl Stieglitz zunächst diese arbeitsintensive Form der bildlichen Photoreproduktion übernahm und propagierte, gelang es ihm, die weniger aufwendigen und direkteren Wege und Möglichkeiten, welche die Photographie bot, für sich zu nutzen und in seine Arbeit zu integrieren. So entwickelte er eine besondere Klarheit und Einfachheit von Sichtweise und Technik, die später als »straight photography«, als »reine Photographie« bekannt werden sollte und zum Ausdrucksmittel der Zukunft wurde.

Auseinandersetzungen innerhalb der Gruppe und ein zu starres Festhalten an dem Versuch, malerische Effekte zu erzielen, führten zu einer Überkonzentration auf technische Details und zum Verlust einer übergreifenden photo-

graphischen Vision. Die Piktorialisten verschwanden. Ihre Suche nach Inspiration endete in einer Sackgasse, ihre photographische Vision wurde auf eine so schmale Perspektive eingeengt, daß es schien, als würden sie die Welt durch das falsche Ende eines Teleskops betrachten. Stieglitz' Horizont hingegen erweiterte sich ständig, zweifellos ein Resultat der Komplexität und des Zusammenspiels der von ihm verfolgten, ganz unterschiedlichen Aktivitäten und der Leichtigkeit, mit der er neue Ideen und Anregungen aufnehmen konnte.

Alfred Stieglitz wurde am 1. Januar 1864 in Hoboken, New Jersey, geboren. 1871 zog seine Familie in ein geräumiges Stadthaus in der 60th East Street in New York. Sein Vater war ein erfolgreicher Tuchhändler, und obwohl sich Stieglitz in seinem späteren Leben oft bitterlich über die Armut beklagte, scheint die Familie recht wohlhabend gewesen zu sein. Stieglitz studierte in Berlin Maschinenbau, eine Fachrichtung, die ihn nicht im geringsten interessierte, und war zwischen 1882 und 1890 als Student an der Technischen Hochschule eingeschrieben. 1883 studierte er bei Hermann Wilhelm Vogel Photographie und konzentrierte sich bald wie besessen darauf, deren technische Herausforderungen zu meistern. Nur durch vollkommene technische Kontrolle würde er in der Lage sein, sich des ganzen Potentials dieses Mediums für die Realisierung seiner Vision zu bedienen.

Beeinflußt wurde Alfred Stieglitz durch den europäischen, weichen Piktorialismus, besonders von den naturalistischen Photographien der Norfolk Broads von Dr. Peter Henry Emerson, der sich der Photogravuretechnik bediente. 1887 gewann Alfred Stieglitz »The Amateur Photographer First Prize of the Year«, der ihm von Emerson überreicht wurde. Es fällt schwer, in Stieglitz' Arbeiten dieser Zeit Ähnlichkeiten mit den Photos zu entdecken, die 20 Jahre später entstanden, denn die frühen Aufnahmen sind völlig vom europäischen Stil geprägt und lassen gänzlich die für Stieglitz später so kennzeichnende Klarheit und Modernität vermissen.

Eine Veränderung bahnte sich 1890 mit seiner Rückkehr nach New York an, als Stieglitz sich mit einer viel härteren, raueren und ungeschönten

Umgebung konfrontiert sah. Die Aggression, das Leben, die Bewegung auf den Straßen New Yorks und die den hoch aufragenden Bauwerken innewohnende Dramatik hatten nichts gemein mit den lieblichen europäischen Hügellandschaften, die von Bauern in pittoresker Tracht bevölkert waren. Doch Stieglitz brauchte nicht lange, um sich wieder an die Stadt zu gewöhnen und sie als Anregung und Herausforderung zu begreifen. Für den Rest seines Lebens sollte Stieglitz New York auf seine Filme bannen. Er war einer der ersten Photographen, der das enorme photographische Potential erkannte, das in der Energie und der Rasanz liegt, mit der eine Stadt wächst. So wandte er sich einer größeren Welt zu, einer realen mit Ecken und Kanten und Disharmonien, aus graphischen Formen und geometrischen Mustern bestehend, während viele seiner Zeitgenossen nie den Mikrokosmos der weichgezeichneten Landschaften, der leicht verschwimmenden häuslichen Szenen und der verlockend schönen Frauen, die in Kristallkugeln blickten und wehmütig einer mythischen Vergangenheit nachhingen, verließen. Von den Piktorialisten wird häufig ein speziell arrangierter, subjektiver Moment eingefangen, während die »straight photography« die Realität mit ungeschönter Objektivität wiedergibt.

Stieglitz und seine Berliner Studienfreunde (und späteren Schwäger) Louis Schubart und Joseph Obermeyer wurden Partner in der Heliochrome Company, später der Photochrome Engraving Company, die Stieglitz' Vater finanzierte. Das Geschäft ging anfangs schlecht, und Stieglitz fand Zeit, den komplizierten Prozeß der Photogravure vom Fachpersonal in seiner Firma zu erlernen, was er mit äußerster Sorgfalt tat. Obwohl die Firma später Erfolge verzeichnen konnte, interessierte sich Stieglitz doch nie für den geschäftlichen oder kommerziellen Aspekt seiner Unternehmungen, eine Einstellung, die er sein ganzes Leben lang beibehielt. Als er die Firma nach fünf Jahren verließ, hatte er seine Kenntnisse der Photogravure perfektioniert und sich die technischen Fähigkeiten angeeignet, die ihm zu großartigen Ergebnissen verhelfen sollten. Auch hier wurde er durch die hochwertigen Photogravure-Portfolios, die in den neunziger Jahren des letzten Jahrhunderts in Wien, Paris und London geschaffen wurden, beeinflußt, doch hat er diesen Standard bald weit übertroffen.

Der Verlust für die Geschäftswelt war ein Gewinn für die Photographie, denn Stieglitz hatte beschlossen, die amerikanische Amateurphotographie wiederzubeleben, und nutzte seine photographischen Kenntnisse und die in Europa erworbenen Kontakte, um sie aus ihrem Dornröschenschlaf zu erwecken und erfolgreich ins 20. Jahrhundert zu führen. Ursprünglich wurde Stieglitz dabei von den photographischen Sezessionsgruppen beeinflußt, die sich als erste Reaktion auf eine vergleichbare Spaltung in der österreichischen und deutschen Kunstwelt überall in Europa gebildet hatten. Für diese Gruppen waren die Begriffe »Amateur« und »Künstler« Synonyme. Nur ein Amateur, den die Zwänge des Kommerzes nicht einengten, die einem professionellen Photographen auferlegt waren, hatte die Freiheit, wahre und bedeutende Kunst zu schaffen.

In den neunziger Jahren des 19. Jahrhunderts unterlag die Welt der Photographie einem radikalen Wandel. 1891 stellte die Wiener Photographische Sezession im Salon unter großen Kontroversen aus. 1892 gründeten 15 ehemalige Mitglieder der Photographic Society in London (ab 1894 Royal Photographic Society) die Splittergruppe der Bruderschaft des »Linked Ring«, da sie der strengen Orientierung an Technik und kommerziellem Erfolg müde waren, die die Photographic Society damals von ihren Mitgliedern verlangte. Sie hielten eigene Versammlungen ab und organisierten eigene Ausstellungen. So verließen auch Robert Demachy und Constant Puyo die Société Française de Photographie und gründeten 1894 den Photo-Club de Paris. All diese Gruppierungen hatten dasselbe Ziel: Sie wollten die Photographie aus dem Würgegriff der Technik und dem Zwang zum Dokumentarischen befreien und sie verstärkt als impressionistisches, flexibles Medium einsetzen. Sie wollten eine Form des künstlerischen Ausdrucks schaffen, die die gleiche Daseinsberechtigung hat wie die Ausdrucksform eines Malers, der Farbe, Pinsel und Leinwand verwendet, oder diejenige eines Bildhauers, der mit Marmor, Stein und Meißel arbeitet.

Die Piktorialisten waren der Auffassung, daß die Photographie weder dokumentarisch Fakten aufzeichnen, noch als Mittel zur Nachschaffung von Kunstwerken dienen sollte, wie es vormals viele der viktorianischen Photo-

graphen angestrebt hatten. Vielmehr wollte man mittels der Photographie eine neue, rein photographische Realität schaffen, die nur in einer Photographie erfahrbar ist, entstanden durch die persönliche Sichtweise des jeweiligen Photographen und realisiert durch die Beherrschung der speziellen Technik. Die Technik sollte dem Photographen dienen, nicht umgekehrt. Und die Kamera war nur das Werkzeug, das die Vision des Photographen umsetzte. Ein Mittel zum Zweck also, kein Selbstzweck. Für die Wiedergabe seiner Vorstellung von Realität stand dem Photographen eine große Auswahl an Objektiven, Filmmaterial und manipulativen Techniken zur Verfügung, etwa Zeichnung, Radierung oder die mechanische Bearbeitung des Filmmaterials oder des Photos. Stieglitz hatte mit allen zuvor genannten Gruppen ausgestellt und war von vielen zum Ehrenmitglied ernannt worden. Für seine Arbeiten sind ihm mehr als 150 Preise und Medaillen überreicht worden.

In den nächsten Jahren schien Stieglitz die Erneuerung der amerikanischen Photographie mit zehnfacher Energie voranzutreiben. Ab 1892 war er Herausgeber von *The American Amateur Photographer* und ein vehementer Verfechter der Idee, daß nur ein echter Amateur über die künstlerische Freiheit verfüge, seinen Vorstellungen von Wahrheit zu folgen, da ihn dabei keine niederen finanziellen Beweggründe einschränkten. Die größte Herausforderung war allerdings der Zusammenschluß der Amateur Photographers mit dem New York Camera Club, die ab 1897 den Camera Club bildeten. Im gleichen Jahr wurde Stieglitz ehrenamtlicher Herausgeber und Vizepräsident der neuen Clubzeitschrift *Camera Notes*, die vierteljährlich erschien und die Ideen der Mitglieder artikulierte. Sie sollte Tätigkeitsberichte enthalten und darüber hinaus die neue Energie und das Selbstvertrauen der amerikanischen Photographen deutlich machen.

In den folgenden fünf Jahren bezahlte der Camera Club nur die laufenden Kosten für *Camera Notes* in Höhe von 1850 Dollar. Der Betrag deckte nicht einmal die Kosten für die Zeitschriftenexemplare der zahlenden Mitglieder und entsprach nur einem Zehntel der Gesamtkosten in Höhe von 18 000 Dollar, die entweder durch Anzeigen gedeckt oder von Stieglitz selbst beglichen wurden. Doch unter seiner Leitung wurden die *Camera Notes* zwischen 1897 und 1902 zum

einflußreichsten Photomagazin des Landes, und sie erreichten auch eine Leserschaft außerhalb der etwas eigenbrötlerischen ›Enklave‹ Camera Club. Man druckte Artikel, kritische Essays und Ausstellungsbesprechungen aus europäischen Zeitschriften ab und beauftragte einheimische Künstler und Photographiespezialisten mit provokanten und vieldiskutierten Artikeln. Amerikanische Autoren wie Sadakichi Hartmann (Sidney Allan)[2] und Charles H. Caffin provozierten Diskussionen über Photographie, wie man sie bisher noch nicht erlebt hatte. Doch die außergewöhnliche Leistung der Camera Notes lag in ihren qualitativ herausragenden Illustrationen, den Photogravuren, die nach Stieglitz' exakten Vorgaben angefertigt wurden. Für amerikanische Arbeiten bediente er sich seiner früheren Firma, der Photochrome Engraving Company in New York; mit europäischen Arbeiten betraute er Walter L. Colls, den Drucker von Sun Artists in London.

Künstlerisch erzielte Camera Notes einen Erfolg nach dem anderen und präsentierte die Arbeiten der von Stieglitz ausgewählten piktorialistischen Photographen wie George Seeley, Gertrude Käsebier, Eduard Steichen[3] und Clarence H. White, die später alle Mitglieder der Photo-Secession werden sollten, in Stieglitz' Galerien ausgestellt wurden und deren Arbeiten in Camera Works publiziert wurden. Stieglitz veröffentlichte auch Photos seines zeitweiligen Konkurrenten Fred Holland Day, der ebenso wie er um ein Wiederaufleben der amerikanischen Photographie bemüht war.

Im März 1902 organisierte Stieglitz unabhängig vom Camera Club im New Yorker National Arts Club eine Ausstellung mit dem Titel »American Pictorial Photography Arranged by The Photo-Secession«. Zum ersten Mal wurde dieser Begriff offiziell zur Kennzeichnung einer Gruppe gleichgesinnter Photographen verwendet, die viele ihrer Ansichten über Motivsuche und Präsentation und ihre theoretischen Grundlagen von den europäischen Sezessionsgruppen übernommen hatten. Stieglitz hatte damit im Grunde seine Trennung vom Camera Club erklärt, ähnlich derjenigen der Bruderschaft des »Linked Ring« von der Royal Photographic Society. Damit wurde seine Position unhaltbar. Nachdem er eine Besprechung der Ausstellung und einen langen Leitartikel über die Photo-

Secession für die Juliausgabe 1902 von *Camera Notes* geschrieben hatte, trat Stieglitz als Chefredakteur zurück.

Unter der Ägide von Stieglitz hatte sich das Spektrum von *Camera Notes* beträchtlich erweitert. Es wurde ein breitgefächertes, internationales Publikum von Kunst- und Photographieliebhabern angesprochen und im Gegenzug die »private« Berichterstattung über die Treffen des Camera Club, seine Ausstellungen und Aktivitäten eingeschränkt. Mitglieder des Camera Club steuerten nur selten Artikel oder Rezensionen bei, und Stieglitz beauftragte immer teurere Autoren damit, diese zu schreiben. Die Hauspostille, die dem Club ursprünglich vorgeschwebt hatte, war *Camera Notes* nie gewesen, sondern eine höchst aktuelle Zeitschrift, die den Club in eine exponierte Stellung rückte, in der dieser sich jedoch nicht wohl fühlte. Nach Stieglitz' Weggang erschienen nur noch drei Ausgaben von *Camera Notes*, bis das Magazin ganz eingestellt wurde.

Stieglitz Kampf um die redaktionelle Kontrolle war sowohl bei *The American Amateur Photographer* als auch bei *Camera Notes* eine Quelle ständiger Irritationen, und nach seinem Rücktritt als Herausgeber der *Camera Notes* im Juni 1902 beschloß er, in Zukunft nur noch für sich selbst zu arbeiten. Sein Versuch, die Entwicklung der amerikanischen Photographie aus einer Position innerhalb ihrer etablierten Institutionen heraus zu verändern, war teilweise erfolgreich gewesen, doch Stieglitz hatte erkannt, daß für ihn als einziger Weg der des unabhängigen Einzelgängers in Frage kam, der die Photographie von außen veränderte.

Bereits seit einiger Zeit plante Stieglitz, eine neue Zeitschrift zu gründen, ähnlich den *Camera Notes*. In vielerlei Hinsicht war *Camera Notes* sogar ein Testlauf für *Camera Work* gewesen, deren erste Ausgabe, datiert auf den Januar 1903, im Dezember 1902 erschien. Der Titel bezog sich auf die damals gängige Bezeichnung für den Photographen als »Kamera-Arbeiter«. Der schlichte, vertraute Titel bereitete allerdings nicht auf den avantgardistischen Inhalt vor. Stieglitz muß diesen Widerspruch genossen haben!

Finanziert, herausgegeben und zum größten Teil gestaltet wurde die Zeitschrift von Stieglitz, der dafür mit einem Team von Autoren, Photographen

und Künstlern seiner Wahl zusammenarbeitete, obwohl Joseph T. Keiley, Dallett Fuguet und John Francis Strauss, wie vorher bei den *Camera Notes*, als Mitherausgeber fungierten. Eduard Steichen war für den Titelentwurf und die Typographie zuständig. Von Beginn an war *Camera Work* nicht auf finanziellen Gewinn ausgerichtet. In der Tat machte die Zeitschrift Verluste und war nie als kommerzielles Produkt geplant gewesen. Mit Kunst Geld zu verdienen war für Stieglitz gleichbedeutend mit dem Verlust künstlerischer Freiheit.

Die Zeitschrift, über die Stieglitz uneingeschränkte Kontrolle besaß, war zwar Sprachrohr der Photo-Secession, doch von ihr unabhängig:»*Camera Work* ist keiner Organisation oder Gruppe verpflichtet, und obwohl sie Sprachrohr der Photo-Secession ist, wird die Zeitschrift dadurch nicht im geringsten in ihrer Unabhängigkeit eingeschränkt.«4 Diese unklare Formulierung war typisch für Stieglitz, sie erwies sich als unrealisierbar und führte daher zu einer gewissen Verwirrung. *Camera Work* sollte Arbeiten von Photographen zeigen, die Stieglitz schätzte, sollte Photographie und Kunst diskutieren und Ausstellungen von Mitgliedern der Photo-Secession und ihren europäischen Verbündeten besprechen. Nach der Gründung der»Little Galleries of the Photo-Secession« im Jahre 1905 – den meisten unter der Hausnummer»291« auf der Fifth Avenue bekannt – wurde *Camera Work* ab ihrer 14. Ausgabe in verstärktem Maße zu einem inoffiziellen Ausstellungskatalog und einem Forum, in dem man die Ausstellungen und deren Resonanz in der Presse diskutieren konnte. Zunächst versuchte Stieglitz, Zeitschrift und Galerie voneinander getrennt zu halten. Möglicherweise wollte er vermeiden, daß *Camera Work* als ein bloßes PR-Organ für die Galerie»291« gesehen würde, obwohl genau dieses eintreten sollte. Wahrscheinlicher ist jedoch, daß die Termine nicht aufeinander abgestimmt werden konnten. Was an den Wänden von »291« zu sehen war, hing dort oft nur für zwei Wochen, während *Camera Work* anfangs vierteljährlich erschien. Das Ausstellungsprogramm wiederzuspiegeln war damit einfach unmöglich.

Die wichtigste Aufgabe der Zeitschrift war die exakte Reproduktion. Ohne Rücksicht auf Kosten oder Zeitaufwand und kompromißlos hinsicht-

lich der Qualität sollten die Arbeiten der Photographen der Photo-Secession als Photogravure-Portfolios in überragender Originaltreue abgedruckt werden. Gleichzeitig wurden Originalabzüge von Photos der Mitglieder an nationale und internationale Ausstellungen verliehen, wobei Stieglitz strenge Bedingungen bezüglich Auswahl, Hängung und Anordnung der Arbeiten stellte. Diese Ausstellungen wurden dann in *Camera Work* besprochen und gaben dem Arbeitsprozeß einen zyklischen Charakter.

Camera Work war gleichbedeutend mit atemberaubenden Reproduktionen der – in Stieglitz' Augen – besten Photos, die verfügbar waren, bereichert durch die besten Kritiker, die darüber schrieben. Dieses Ziel wurde in der ersten Ausgabe im Januar 1903 definiert: »Photographie ist in erster Linie ein monochromer Prozeß, und auf ihren feinen Abstufungen von Tönung und Werten beruht oft ihre künstlerische Schönheit. Deshalb ist es von äußerster Wichtigkeit, daß Reproduktionen photographischer Arbeiten mit außerordentlicher Sorgfalt und Fingerspitzengefühl angefertigt werden, um den Geist des Originals zu bewahren, obwohl bei einigen Photographien keine Reproduktion die Nunaciertheit des Originals erreicht. Eine solche Sorgfalt wird auf die Illustrationen jeder Ausgabe von *Camera Work* verwandt. Es werden sich nur solche Arbeiten auf diesen Seiten finden, die von Individualität und künstlerischem Wert, unabhängig von einer bestimmten Schule, zeugen, die ein besonderes Merkmal oder technische Brillanz aufweisen, oder solche, die eine bestimmte Arbeitsweise veranschaulichen, die es abzubilden lohnt. Jedoch wird das Piktorialistische das dominierende Element dieses Magazins sein.«[5]

Unabhängig von der Bedeutung und dem provokanten Inhalt der Texte, die oft von Künstlern geschrieben wurden, um den Glauben an die Photographie zu stärken, war *Camera Work* jedoch das erste Photomagazin, das vom Visuellen bestimmt war. Die Illustrationen waren von Hand abgezogene Photogravuren von höchster Qualität, gedruckt auf feinstes Japanpapier, um alle Feinheiten der Tonwerte und Struktur zu erfassen. Dann wurden sie auf hochwertiges Kunstdruckpapier mit Büttenrand aufgezogen. Dabei wurden Farben ausgewählt, die zur

Tönung der Bilder paßten, um die ihnen innewohnenden Feinheiten noch besser zur Geltung zu bringen. Stieglitz selbst überwachte jeden einzelnen Schritt bei der Photogravure, retuschierte oftmals selbst und korrigierte auch die kleinsten Fehler. Falls nötig, zog er auch selbst die Photogravuren auf. Er widmete sich der Qualitätskontrolle mit äußerster Hingabe.

Stieglitz hatte die Herstellung der Photogravure zu einem solchen Grad der Perfektion gesteigert, daß er ihr auch bei seinen eigenen Ausstellungsphotographien vor dem früher von ihm geschätzten Platin- und Karbondruck häufig den Vorzug gab. Die Photogravure war für ihn ein ebenso legitimer Reproduktionsprozeß des Drucks, und er reichte in dieser Technik gefertigte Drucke der Photo-Secession bei internationalen Ausstellungen ein. Die Photogravure war der beste, der perfekteste Weg, Photographie und Text zu kombinieren und ein größeres Publikum anzusprechen, und ging unter Stieglitz' kundigen Händen weit über einen photomechanischen Druck hinaus.

In den ersten Ausgaben der Zeitschrift wurden auch Halbtonbilder reproduziert, die gegenüber den Photogravuren den Vorteil besaßen, daß sie halb so teuer wie diese waren – doch wieder einmal siegte der Perfektionismus über wirtschaftliche Erwägungen. Nach 1906 wurde dieses Verfahren immer seltener eingesetzt, während sich die Gravure bei den Reproduktionen immer stärker durchsetzte. Die Halbtontechnik fand allerdings in späteren Ausgaben weiterhin Einsatz bei der Reproduktion von Gemälden und Skulpturen, da die Gravure im wesentlichen ein monochromer Prozeß ist. Stieglitz arbeitete auch mit Mezzotinto-Gravure, Duogravure, der Tönung per Hand, dem Drei- und Vierfarben-Halbtondruck und der Kalotypie, um einen Reproduktionsstandard zu erreichen, der seinen Idealvorstellungen am nächsten kam. Welche finanzielle Belastung diese aufwendigen Verfahren für Stieglitz bedeuteten, kann man nur vermuten. Eine genaue Kostenberechnung ist jedenfalls nicht möglich, da Stieglitz darüber nicht im Detail Buch führte. Jedoch erforderten Umfang und Format von *Camera Work*, daß alle Abbildungen in einem bestimmten Maßstab verkleinert wurden. Somit erhielten die großen, nuancenreichen Gummidrucke von Theodor und Oskar Hofmeister

dasselbe Format wie Stieglitz' winzige Platindrucke, so daß die starken Unterschiede zwischen den Originalen hinsichtlich Größe und Struktur verlorengingen.

Die ersten Ausgaben wurden von der Photochrome Engraving Company gedruckt, doch spätere Nummern übernahmen die Manhattan Photogravure Company (ein Ableger der Firma, die von Stieglitz' Schwager geführt wurde), die T. & R. Annan & Sons in Glasgow und der in München ansässige Frederick Goetz beim F. Bruckmann Verlag. Die Manhattan Photogravure Company fertigte zwischen 1904 und 1917 von den Negativen der amerikanischen Photographen Photogravuren an. James Craig Annan war zuständig für die Photogravuren der britischen Photographen, d. h. für die Arbeiten von George Davison, seine eigenen Arbeiten und für die Abzüge, die von den originalen Papiernegativen von David Octavius Hill und Robert Adamson hergestellt wurden. Frederick Goetz lieferte die Photogravuren europäischer Photographen wie Heinrich Kühn[6] und Frank Eugene, druckte aber im April 1908 auch farbige Halbtonarbeiten von Eduard Steichens Autochromplatten. Mit der Zeit vertraute Stieglitz seinen europäischen Gravure-Lieferanten mehr als der Manhattan Photogravure Company. Insbesondere schätzte er Goetz, der noch bestrebt sein sollte *Camera Work* am Leben zu erhalten, als Stieglitz bereits beschlossen hatte, die Zeitschrift einzustellen.

Andere Druckereien, wie das Haus J. J. Waddington in London, wurden mit der Frederick-H.-Evans-Ausgabe (Nr. 4 vom Oktober 1903) beauftragt, doch blieben sie hinter Stieglitz' Qualitätsanforderungen zurück. Stieglitz ging soweit, sich selbst öffentlich dafür anzuklagen, ein Endprodukt abzeptiert zu haben, das nicht absolut perfekt war:»Sie können sich die Bestürzung nicht vorstellen, die uns befiel, als wir die Ausgabe in Händen hielten. Die Qualität der Arbeit war nicht gleichbleibend hoch, entsprach nicht den Vorlagen, und das Ergebnis lag in den meisten Fällen weit unter dem, was wir hätten erwarten können. Zu diesem Zeitpunkt blieb uns keine andere Wahl, als das Beste daraus zu machen. Schließlich konnten wir die Schuld nur bei uns selbst suchen, weil wir unsere eherne Regel gebrochen hatten [...], und wir sind sehr enttäuscht, diese Ausgabe nun in einer Form,

mit der wir nicht zufrieden sind, auf den Markt bringen zu müssen. Es wird nicht wieder vorkommen.«7 Vorzugsweise wurden die Gravuren direkt von den Originalnegativen des Photographen erstellt oder, wenn dies nicht möglich war, von den Originalabzügen. Im ersten Fall wurde dann im Text auf das Verfahren hingewiesen und die Photogravuren wie Originalabzüge behandelt. Das Beharren auf Originalnegativen führte bei Arbeiten, die außerhalb der Vereinigten Staaten entstanden, zu Problemen beim Versand, der Verzollung und der Versicherung. Das führte zu Terminverschiebungen beim Redaktionsschluß und zu Verzögerungen in der Produktion. Doch ein höchstmöglicher Grad an Perfektion war Stieglitz wichtiger, als *Camera Work* zum angestrebten Veröffentlichungstermin auf den Markt zu bringen. Viele Ausgaben verzögerten sich um mehrere Monate, weil er Europa bereiste oder – was häufig vorkam – erkrankt war. Und solange Stieglitz nicht jede einzelne Seite von *Camera Work* im Detail begutachtet und abgenommen hatte, wurde die Zeitschrift nicht veröffentlicht. In der Zusammenarbeit mit Photographen interessierte sich Stieglitz für deren Meinung bezüglich der Auswahl, Reproduktion und Präsentation ihrer Arbeiten und ging bei den Künstlern, deren Arbeiten er unbedingt abdrucken wollte, auf deren Wünsche ein.

Der Stil des Hauses wurde mit der Nr. 1 von *Camera Work* vom Januar 1903 festgeschrieben: Sechs Gravuren von Arbeiten von Gertrude Käsebier, eine von Stieglitz, eine Naturstudie von A. Radclyffe Dugmore und mehrere Halbtonbilder von D. W. Tryon und Puvis de Chavannes. Die Gravuren wurden durch Leerseiten vom Text getrennt und auffällig am Heftanfang plaziert. Die Abbildungen waren von Textbeiträgen begleitet: Zwei anerkennende Besprechungen über Käsebier von Charles H. Caffin und Frances Benjamin Johnston, Artikel über die Ästhetik der Photographie und der Malerei von Joseph T. Keiley, Sidney Allan (Sadakichi Hartmann) und Otto Walter Beck. Den technischen Aspekt der Photographie behandelt ein Artikel über Dugmores Belichtung beim Photographieren von Vögeln. Will Cadby lieferte eine Besprechung des Londoner Salons; und über die Präsenz der amerikanischen Photographen auf dieser Ausstellung berichteten darüber hin-

aus die Herausgeber von *Camera Work*. Ebenfalls kurz vorgestellt wurden die Turiner Ausstellung der Angewandten und Schönen Künste sowie die Yorkshire Union of Artists. Eva Watson-Schütze, Dallett Fuguet und Eduard Steichen steuerten kürzere Artikel bei; außerdem wurden mehrere Artikel aus anderen Publikationen abgedruckt, in diesem Fall aus *The International Studio*. Zusammen mit Kurzbesprechungen von Produktneuheiten und einer kleinen Prise Lyrik war diese Mischung auch für zukünftige Ausgaben maßgeblich. Gewürzt wurde der Inhalt mit zahlreichen »In«-Witzen und satirischen Artikeln, die oft viel zu spitzfindig waren und deren Pointen nur die wirklich engagierten Photo-Secessionisten verstanden.

Selbst die 26 Werbeanzeigen im hinteren Teil der Zeitschrift waren einfach und originell gestaltet und häufig von Stieglitz persönlich entworfen. Vom redaktionellen, ernsthaften Teil blieben sie streng getrennt. Die Mehrzahl der Anzeigenkunden, unter ihnen Kodak, Scherings Photochemikalien, Bausch & Loms Optiken und Graflex-Kameras, blieb dem Magazin über viele Ausgaben hinweg treu. Eastman Kodak buchte bei fast jeder Ausgabe die Rückseite des Magazins und verwandte dabei auf Drängen von Stieglitz den gleichen Schrifttyp, den Eduard Steichen für das Cover entworfen hatte. Viele der Firmen, die an der Herstellung von *Camera Work* beteiligt waren, entschlossen sich zu Anzeigenbuchungen im Magazin: ein Beweis ihres Vertrauens in die eigene Arbeit. Da Stieglitz darauf bestand, daß *Camera Work* nicht auf Gewinn ausgerichtet war, unterlag die Anzahl der geschalteten Anzeigen einer steten Kontrolle.

Die Textseiten wurden bis zum Juli 1908 von der Fleming Press gedruckt, später dann von Rogers and Company. Stieglitz bevorzugte schweren Schwarztext mit Roteinfärbung der detailreich verzierten Initiale jedes neuen Artikels, der mit breiten Rändern gesetzt war – eine Gestaltungsweise, die auf William Morris zurückging. Jede Ausgabe war in ein graugrünes Papiercover gebunden; Titel und andere Angaben erschienen in einem helleren Grauton. Diese Elemente blieben während der gesamten 50 Ausgaben von *Camera Work* unverändert; eine seltene Kontinuität im Zeitschriftenbereich. Gebunden wurde die Zeitschrift bei der Knickerbocker Bindery in New York.

Camera Work war als vierteljährliche Publikation konzipiert, doch nicht immer konnte dieser Rhythmus eingehalten werden. Der jährliche Abonnementpreis belief sich auf vier Dollar; eine Einzelausgabe kostete zwei Dollar. Der Postweg per Einschreiben und der Schutzumschlag aus Pappe kosteten pro Zeitschrift zusätzlich 50 Cents. Bald wurde der jährliche Abonnementpreis verdoppelt, und um etwas Arbeitskapital zu erwirtschaften, wurde der Preis alter Ausgaben, wie des *Steichen Supplement*, teilweise auf den Preis eines Jahresabonnements hochgesetzt. In den zwanziger Jahren kostete das *Special Stieglitz*, Nr. 36 aus dem Jahr 1911, 15 Dollar, während die Doppelausgabe Nr. 49/50 über Paul Strand von 1917 zum Höchstpreis von 17,50 Dollar gehandelt wurde. Bereits im Juli 1903 verkauften Tennant und Ward in New York die ersten vier Ausgaben der Zeitschrift für zehn Dollar, d. h. zu einem Preis, der mehr als doppelt so hoch war wie der jährliche Subskriptionspreis.

Ursprünglich druckte Stieglitz von jeder Ausgabe 1000 Hefte und hatte einen Abonnentenstamm von fast 650 Personen. 1912 waren die Abonnenten um die Hälfte auf 304 zurückgegangen, und als man *Camera Work* 1917 einstellte, wurden bei 36 zahlenden Abonnenten nur noch 500 Hefte pro Ausgabe gedruckt. Ab 1910 veränderte sich das Magazin und war keine reine Photozeitschrift mehr, sondern eine Kunstzeitschrift mit Photographien. Diese Entwicklung kostete Stieglitz langfristig viele Abonnenten.

Stieglitz beherrschte die Kunst des beschränkten Auflagenverkaufs gut und ließ viele Ausgaben von *Camera Work* einstampfen, nachdem er sichergestellt hatte, daß die relevanten Organisationen wie die New York Public Library und die Royal Photographic Society in London über kostenlose Gesamtausgaben verfügten. Die Ausgaben für die Royal Photographic Society waren normalerweise signiert. Einen kompletten Satz überließ er auch der Bibliothek des Camera Club, die er während seiner Tätigkeit als Redakteur zwischen 1897 und 1902 selbst aufgebaut hatte. Als die Bibliothek einzelne Ausgaben für einen Dollar pro Heft verkaufte, obwohl der Marktpreis zehnmal so hoch lag, war Stieglitz darüber äußerst verärgert.

In einem Brief an J. McIntosh, den Sekretär und Bibliothekar der Royal Photographic Society, schrieb Stieglitz 1911:»Ich werde eruieren, ob es mir möglich ist, von den sehr geschätzten, geradezu *überschätzten* Ausgaben von *Camera Work* (Nr. 2, 11 und 12) ein zweites Exemplar beizulegen, wenn ich Ihnen die gebundenen Ausgaben 17–32 übersende, um das Gesamtwerk auf den aktuellen Stand zu bringen. Möglicherweise werde ich Schwierigkeiten haben, die Nr. 2 zu bekommen, da sie zu den äußerst seltenen gehört und auf dem Markt bis zu sechs Pfund Stirling bringen kann. Doch ich will unter allen Umständen, daß die Royal Photographic Society einen vollständigen Satz der Zeitschrift besitzt, die mir so sehr am Herzen liegt. Gleichzeitig hoffe ich, daß Sie Ihre Mitglieder davon überzeugen können, daß ein Teilverkauf der Gesamtausgabe die Gesellschaft in mehr als einem Sinne eines wertvollen Schatzes berauben würde. Die Redaktion unternimmt wahrhaft übermenschliche Anstrengungen für die Sache, und ihr ist es zu verdanken, daß einige der härtesten Gegner der Photographie auf unsere Seite übergelaufen sind; nicht nur in unserem Land, sondern in der ganzen Welt.«[8]

Die Veröffentlichung von *Camera Work* wurde von der britischen Photopresse äußerst wohlwollend kommentiert:»Als die *Camera Notes* auf ihrem Höhepunkt waren, schien es unmöglich, sie zu übertreffen. Doch in diesem Falle können wir nur sagen, daß es doch gelungen ist, daß Stieglitz Stieglitz ausgestieglitzt hat. Mit *Camera Work* hat er seinen eigenen Rekord gebrochen, einen Rekord, den niemand je auch nur annähernd gefährden konnte.«[9]

»Es kann kein anderes Urteil geben. *Camera Work* schlägt alle früheren Publikaktionen hinsichtlich des guten Geschmacks, des Ansehens, der tatsächlichen Bedeutung [...]. Der Publikumsgeschmack erwartet zu oft, daß Photozeitschriften trivial und oberflächlich sind, doch hier werden diejenigen, die sich für die künstlerischen Aspekte der Photographie interessieren, auf Lesestoff stoßen, der überdauern wird, der sie zum Nachdenken anregen wird, gleichfalls auf Bilder, die heute berühmt sind und es wohl auch in Zukunft sein werden. Man kann *Camera Work* nicht genug loben, denn es gibt nichts Vergleichbares. Auf Herrn Alfred Stieglitz können die amerikanischen Photographen zu Recht stolz

sein. Eine Beurteilung dessen, was er in seinem jahrelangen Kampf gegen seine Widersacher in einer Auseinandersetzung, in der er keinerlei Sympathien erntete, für die Photographie geleistet hat, ist fast unmöglich. Seiner außerordentlichen Arbeitsmoral, seiner bewundernswerten, vorbildhaften Unabhängigkeit und seiner bis zur Selbstaufgabe gehenden Hingabe ist es zu verdanken, daß wir dieses wunderbare Werk nun in Händen halten.«[10]

Von den in einem Zeitraum von 14 Jahren erschienenen 50 Nummern waren viele Ausgaben von *Camera Work* einem einzelnen Künstler oder einer photographischen Richtung gewidmet. Dabei handelte es sich meistens um Mitglieder der Photo-Secession, deren Freunde oder Mitstreiter. Nur wenig Aufmerksamkeit wurde der Entdeckung neuer Talente gewidmet. Der unbestrittene Star war Eduard Steichen, dessen Photos am häufigsten in *Camera Work* abgebildet waren und dessen Kunstkritiken und Besprechungen zur Farbphotographie in regelmäßigen Abständen gedruckt wurden. In 14 Jahren wurden insgesamt 68 Photographien von Steichen reproduziert, die meisten als Photogravure. Fünf Ausgaben waren ausschließlich ihm gewidmet, die Ausgabe 2 vom April 1903, die Ausgabe 14 vom April 1906, die Sondernummer *Steichen Supplement*, die unnumeriert im gleichen Monat erschien, die Nr. 22 vom April 1908 und die Nr. 42 vom April/Juli 1913. Die Ausgabe 14 teilte er sich mit vier Installationsaufnahmen von Stieglitz aus den neueröffneten »Little Galleries«, deren Einrichtung Steichen teilweise selbst entworfen hatte und auf deren Innenaufnahmen seine Arbeiten zu sehen waren. Das *Steichen Supplement* veröffentlichte Stieglitz später als limierte Auflage von 65 Portfolios.

Andere Photographen, denen eine Gesamtausgabe gewidmet wurde, waren Alvin Langdon Coburn (Nr. 21, Januar 1908), Clarence H. White (Nr. 23, Juli 1908), Frank Eugene (Nr. 30 und 31, April und Juli 1910) und Heinrich Kühn (Nr. 33, Januar 1911). In der Ausgabe 37 vom Januar 1912 ging es ausschließlich um die wiederentdeckten Photographen David Octavius Hill und Robert Adamson aus den vierziger Jahren des 19. Jahrhunderts; bei letzterem fehlte allerdings der Verweis auf den Namen. Die Photogravuren ihrer Arbeiten wurden von den originalen Papiernegativen, die sich im Besitz von James Craig Annan befanden,

erstellt. Baron Adolf de Meyer wurde in der Ausgabe 40 (Oktober 1912) vorgestellt, und weitere Hefte waren James Craig Annan (Nr. 45, Januar 1914/erschienen im Juni 1914) und Paul Strand (Nr. 49/50, Juni 1917) gewidmet.

Seinen eigenen Arbeiten ließ Stieglitz nie den Luxus einer Einzelausgabe zuteil werden, obwohl er mit zehn Gravuren in der sonst von Renaissancegemälden dominierten Ausgabe 12 (Oktober 1905) und mit 16 seiner Gravuren im Heft 36 (Oktober 1911) einem Sonderheft recht nahekam; letzteres teilte er sich mit dem Halbtonbild einer Radierung von Picasso, die er ausgestellt und danach erworben hatte. Jedoch war Stieglitz mit 47 seiner Arbeiten derjenige Photograph, der in der Zeitschrift am zweithäufigsten vertreten war.

Ganze Ausgaben oder große Teile einzelner Hefte waren Photographengruppen wie dem Wiener Kleeblatt, Heinrich Kühn, Dr. Hugo Henneberg und Hans Watzek gewidmet (Nr. 13, Januar 1906). Die französische Ausgabe zeigte in der Ausgabe 16 (Oktober 1906) Arbeiten von Robert Demachy, Constant Puyo und René Le Bègue und bot auch den Photographinnen Annie W. Brigman, Ema Spencer und Alice Boughton in den Ausgaben 25 und 26 (Januar und April 1909) ein entsprechendes Forum. Viele Photographen, die während der ersten Jahre häufig vertreten waren, tauchten jedoch später, als sich Stieglitz' Interessen verlagerten und vormals enge Beziehungen durch Rivalitäten unter den Photographen zerbrachen, nicht mehr auf.

Da Stieglitz unter dem Mangel an Galerien, die in New York Photographie zeigten, litt und den Wunsch hegte, ein adäquates Präsentationsforum für die Künstler der Photo-Secession zu schaffen, begab er sich selbst auf die Suche nach geeigneten Räumlichkeiten für eine Galerie. »The Little Galleries of the Photo-Secession« öffneten im November 1905 ihre Pforten an der Fifth Avenue, Hausnummer 291, wo Steichen auch sein Studio hatte. Die Miete betrug monatlich 50 Dollar; Handwerker und Elektroarbeiten kosteten Stieglitz noch einmal 300 Dollar. Die Jahresabonnements von Mitgliedern der Photo-Secession in Höhe von fünf Dollar trugen einen Teil dieser Kosten, doch der Rest scheint aus Stieglitz' Privatschatulle beglichen worden zu sein.

Mit gewissem Stolz wurde in der Ausgabe 14 vom April 1906 in *Camera Work* die Eröffnung der Galerie bekanntgegeben:»Betrachtet der Leser eine andere Seite dieses Heftes, kann er sich einen Eindruck von der Ausstattung der Ausstellungen der Photo-Secession verschaffen. Bis dato wurden Photographien, von zwei oder drei Ausnahmen abgesehen, noch nie in ihrem besten Licht gezeigt. Der Andrang bei den Ausstellungen, die unvorteilhafte Innenausstattung, schlimmer noch, die schlechte Beleuchtung oder ein farblich nicht passender Rahmen haben dem Besucher sicherlich nicht geholfen, piktorialistische Photographien wirklich mit Genuß zu betrachten. Diese Aspekte waren bei der Konzeption der Secession-Galleries wichtig, und nun kommen die einzelnen Photographien wirklich zur Geltung. Die Beleuchtung ist so ausgerichtet, daß der Betrachter in einem weichen, diffusen Licht steht, während die Bilder direkt von oben von einem Oberlicht beleuchtet werden. Kunstlicht wird als dekorative Lichtquelle eingesetzt, findet aber auch aufgrund seiner praktischen Vorteile Verwendung. Einer der größeren Räume ist in matten Olivtönen gehalten. Für den über die Wände gespannten Rupfen wurde ein warmes Olivgrau gewählt, während Holzwerk und Profile in einem ähnlichen, dunkleren Ton gehalten sind. Die Vorhänge bestehen aus Baumwollsatin in einem Oliv-Sepiaton, Decke und Lampenschirme sind in einem tiefen, cremigen Grau gehalten. Der kleine Raum ist speziell für Photographien auf sehr hellen Passepartouts oder in weißen Rahmen konzipiert. Seine Wände sind mit gebleichtem Naturrupfen bespannt, Holzwerk und Profile rein weiß, die Vorhänge in einer stumpfen Eierschalenfarbe gehalten. Der dritte Ausstellungsraum hat eine graublaue Farbgebung mit Akzenten in zartem Lachsrosa und Olivgrau. Die Lampenschirme sind in allen Räumen farblich auf die Wandbespannung abgestimmt.«[11]

Eröffnet wurde die Galerie für die erste fünfmonatige Saison zwischen November 1905 und April 1906 mit Arbeiten von Mitgliedern der Photo-Secession; insgesamt 100 Photographien von 39 verschiedenen Photographen. Mit elf Arbeiten war Steichen der am häufigsten gezeigte Photograph, gefolgt von White mit neun Aufnahmen, Käsebier mit acht und Keiley und Stieglitz mit je

sieben Arbeiten. Die Galerie war von Montag bis Samstag zwischen 12.00 und 18.00 Uhr geöffnet, und man verlangte keinen Eintritt. In der ersten Saison kamen 15 000 Besucher. Von den 384 gezeigten Photographien wurden 249 zum Verkauf angeboten; 61 von ihnen verkauften sich zu einem Durchschnittspreis von 45 Dollar und 86 Cents, wobei Stieglitz selbst die meisten erwarb. Die Galerie wurde zum Treffpunkt der Mitglieder der Photo-Secession und ihrer interessierten Anhänger, die sich vormals nur in Restaurants oder Clubs hatten treffen können, obwohl dieses gesellige Element von der Gruppe weiterhin gepflegt und gefördert wurde.

In den beiden folgenden Ausstellungsperioden änderte sich diese Zusammenstellung der gezeigten Photographien nicht wesentlich, allerdings wurde nach und nach auch anderen Kunstformen Raum gegeben. 1907 fand eine Ausstellung mit Zeichnungen der amerikanischen Symbolistin Pamela Colman Smith statt, auf der 33 ihrer Arbeiten verkauft wurden. Es folgte eine äußerst umstrittenen Präsentation französischer Kunst. Stieglitz kaufte auch weiterhin Photographien an und unterstützte somit in zweifacher Hinsicht finanziell seine eigene Galerie.

In den Jahren 1907 und 1909 reiste Stieglitz nach Europa und lernte Matisse und Rodin kennen. Eduard Steichen, der sich in Pariser Kunstkreisen aufgehalten hatte, hatte ihn damals auf diese beiden Künstler aufmerksam gemacht, ebenso auf Cézanne, van Gogh und Braque. Im Januar 1908 zeigte »291« in New York zum ersten Mal 58 Originalzeichnungen von Rodin, die der Künstler zusammen mit Steichen in Paris ausgewählt hatte. Kurz darauf folgte die erste Matisse-Ausstellung auf amerikanischem Boden. Eduard Steichen brachte die Lithographien, Gemälde, Zeichnungen und Radierungen persönlich in seinem Gepäck nach New York. Es entbehrt nicht einer gewissen Ironie, daß es dem Enthusiasmus zweier Photographen zu verdanken ist, daß die amerikanische Öffentlichkeit erstmals in Kontakt mit zeitgenössischer französischer Kunst kam.

Mit 50 000 Besuchern in drei Saisons war die Galerie außergewöhnlich erfolgreich. Dies nahm der Vermieter zum Anlaß, die Miete zu verdoppeln und auf einem Vierjahresvertrag zu bestehen. Da das jährliche Einkommen

der Photo-Secession aus den Jahressubskriptionen in Höhe von fünf Dollar insgesamt weniger als 300 Dollar betrug, hätte dies für Stieglitz eine gewaltige finanzielle Investition bedeutet, zu der selbst er entweder nicht bereit oder nicht in der Lage war. Daraufhin wurde die Galerie geschlossen und wieder ihrem früheren Zweck zugeführt. Doch mit Unterstützung von Paul B. Haviland, einem neuen Mitglied der Photo-Secession, konnte bald eine neue Galerie eröffnet werden. Sie lag direkt gegenüber und war mit knapp 15 Quadratmetern Ausstellungsfläche wesentlich kleiner. Doch bei der rückläufigen Mitglieder- und Abonnentenzahl der Photo-Secession eignete sich diese Galerie besser für kleinere, intimere und eher künstlerisch orientierte Ausstellungen, während sie für die früheren Gruppenausstellungen von photographischen Arbeiten unbrauchbar gewesen wäre.

Je mehr sich sein eigener Geschmack und sein Gefühl für Ästhetik entwickelten, desto weiter entfernte sich Stieglitz von der Photographie, und die Ausstellungsprogramme wurden immer eklektischer. In den folgenden Jahren zeigte er oft junge amerikanische Maler. Viele von ihnen, wie z. B. Marsden Hartley und John Marin, hatten zeitweise in Paris gearbeitet. Zwischen 1911 und 1916 organisierte Stieglitz dann die erste amerikanische Ausstellung mit Aquarellen und Zeichnungen von Picasso, und auch Braque, Picabia, Brancusi und Severini hatten dort ihren amerikanischen Einstand. Darüber hinaus zeigte »291« afrikanische Plastiken und mexikanische Töpferkunst. Und Georgia O'Keeffe. Zwischen 1910 und 1917 wurden nur vier Photographie-Ausstellungen veranstaltet.

Die Beziehung zwischen Stieglitz und den anderen Photographen war während dieser Zeit vor allem von emotionalen Ausbrüchen geprägt und verschlechterte sich ab 1908 rapide. Obwohl ihm sein Engagement für die Photographie immense Loyalität und Bewunderung einbrachte, erntete er für seine diktatorische, arrogante Art im gleichen Maß Zorn und Mißtrauen. Sadakichi Hartmann schied des öfteren aus der Reihe der Autoren von *Camera Work* aus, obwohl er immer wieder zurückkehrte und Stieglitz dann des Despotismus und der Diktatur bezichtigte. Beide Anschuldigungen hatten zweifelsohne ihre Berechtigung. 1908 wurde Stieglitz von der Mitgliedschaft im Camera Club ausgeschlossen. Man warf ihm vor, er

habe gegen die Interessen des Clubs gehandelt. Diese Anschuldigung verletzte ihn zutiefst, und er veröffentlichte anschließend höflich-bissige Briefe in *Camera Work*, das damit zu einem Sprachrohr für seine persönliche Rechtfertigung wurde. In einem Sturm gegenseitiger Vorwürfe löste sich im Jahr 1909 die Bruderschaft des »Linked Ring« in London endgültig auf; andere europäische Sezessionistengruppen waren bereits auseinandergebrochen. Stieglitz' wachsende Machtposition im Kreis der Photographen der Photo-Secession ähnelte dem Klammergriff eines Mannes, der verzweifelt nach jedem Strohhalm greift: Er versuchte, eine Organisation zu retten, die seiner Fürsorge entwachsen war. Gertrude Käsebier und Clarence H. White hatten sich mit Erfolg der verhaßten »Welt des Kommerzes« zugewandt und sich mit ihren neuen Interessen anderen photographischen Organisationen angeschlossen. Viele Photographen taten es ihnen gleich. Photographie, so glaubten sie, sollte eine viel weiter gefaßte Aufgabe haben als die, die Stieglitz ihr zuwies oder zulassen wollte.

Es war typisch für Stieglitz, daß er nun seine Vergangenheit abstreifte wie eine Schlange ihre Haut. Obwohl er noch große Verbitterung verspürte, konzentrierte er nun seine Energien auf die Kunst statt auf die Photographie. In den folgenden Jahren bis zur Schließung der Galerie »291« im Jahr 1917 organisierte er nur vier Photographie-Ausstellungen. Das Konzept der Galerie wurde einer dramatischen Veränderung unterzogen und auf Kunst ausgerichtet, hauptsächlich auf die europäische Moderne. »Art Work« wäre in diesem Entwicklungsstadium eine treffenderer Bezeichnung gewesen als *Camera Work*. Seit 1910 druckte Stieglitz in weit größerem Umfang moderne Kunst in seiner Zeitschrift ab. Daß die Zeitschrift sich sowohl mit Kunst als auch mit Photographie beschäftigen sollte, war immer das Ziel gewesen, doch nun verlagerte sich das Gleichgewicht ganz eindeutig in Richtung Kunst. Das gesamte Programm von *Camera Work* veränderte sich. Die Ausstellungspolitik von »291« und die Texte und Illustrationen der Zeitschrift wurden zu Bausteinen von Stieglitz' sich ständig weiterentwickelnder Philosophie der Kunst und Photographie. Die Galerie »291« zeigte ein gemischtes Programm. Auf Zeichnungen von Walkowitz folgten

Karikaturen von Frueh und de Zayas, einem mexikanischen Intellektuellen und Karikaturisten, der im Kreis von Stieglitz binnen kürzester Zeit zu einer äußerst wichtigen Figur wurde.

Ein tragender Pfeiler des Galerieprogramms, der auch die jüngere Generation der amerikanischen Künstler prägte, waren jedoch die französische Moderne. In den folgenden Jahren zeigte Stieglitz Einzelausstellungen und gemischte Ausstellungen von Cézanne, Toulouse-Lautrec, Rousseau und Renoir, die alle in der Galerie »291« ihr amerikanisches Debüt erlebten, sowie erneut Zeichnungen und Skulpturen von Matisse und Rodin. Die Matisse-Ausstellung zog trotz der begrenzten Ausstellungsfläche von 15 Quadratmetern 4000 Besucher an. Im April 1911 gelang Stieglitz mit der ersten Ausstellung von 83 Aquarellen Picassos in den USA ein weiterer Coup. De Zayas hatte in Paris die Exponate zusammengestellt, und die Präsentation war so erfolgreich, daß sie bis zum Mai verlängert wurde.

All diese Ausstellungen organisierte Stieglitz – oft in Zusammenarbeit mit Steichen – mit einem winzigen Budget, Jahre vor der »Armory Show of Modern Art«. Diese Ausstellung, die 1913 in New York stattfand und für die man Stieglitz als Berater gewinnen konnte, verhalf der modernen Kunst zu einem Ausstellungsforum von beträchtlicher Größe. Eine der wenigen Photoausstellungen war in diesem Jahr Eduard Steichen gewidmet. Sie zog über 2500 Besucher an, und Photographien im Wert von 1500 Dollar konnten verkauft werden. Zwischen 1905 und 1912 verzeichnete die Galerie ingesamt 160 000 Besucher.

Obwohl der Erste Weltkrieg auch der scheinbaren Leichtigkeit, mit der Stieglitz Kunstwerke aus Frankreich importieren ließ, Grenzen setzte, organisierte er doch zu Weihnachten 1915 in der Galerie eine sich über zwei Räume erstreckende Ausstellung mit Werken von Eli Nadelman.

Die letzte Saison von »291« begann 1916 mit einer Ausstellung von Aquarellen von Georgia Engelhard, Stieglitz' zehnjähriger Nichte, die sich das Malen selbst beigebracht hatte. Zweimal zeigte Stieglitz Aquarelle, Ölbilder, Kohlezeichnungen und Plastiken von George O'Keeffe, mit der er ab 1918 zusammenlebte und die er 1924 heiratete. In den Arbeiten von Georgia O'Keeffe fand Stieglitz,

wonach er so lange gesucht hatte. Ihr überwältigender Naturalismus, ihre Geradlinigkeit, ihre Aufrichtigkeit und ihr Realitätsgefühl ließen alle anderen Kunstwerke verblassen. Im Juni 1917 schloß »291« ihre Pforten.

Für die Zeitschrift *Camera Work* brachte diese Bevorzugung der Kunst einige irritierende Dissonanzen mit sich. So paßten beispielsweise die zehn Photogravuren von George H. Seeley, außerordentlich piktorialistische Darstellungen eines häuslichen, geheimnisvollen Frauentyps, die in Heft 29 vom Januar 1910 abgebildet waren, nicht unbedingt zu den vier bizarren Karikaturen von Marius de Zayas, dessen Arbeiten im Juli 1912 erneut vorgestellt wurden.

In der Oktober-Ausgabe von 1910 (Nr. 32) zeigte Stieglitz Gravuren mit Aktzeichnungen von Matisse. Obwohl die Akte von Matisse für Aufruhr unter den Abonnenten sorgten, ließ sich Stieglitz davon nicht abschrecken. Für die Rodin-Ausgabe 34/35 von April/Juli, 1911 wählte er vier von Steichens Gravuren zu Rodin und seinen Balzac-Plastiken, sowie neun Gravuren und farbige Kalotypien zu Rodins Aktzeichnungen aus. Die meisten Textbeiträge dieser Ausgabe waren Rodin im besonderen und der französischen Malerei im allgemeinen gewidmet. Zu diesem Zeitpunkt hatte fast die Hälfte der noch verbliebenen Kunden als Reaktion auf die vielen Aktdarstellungen ihr Abonnement gekündigt. Photographien unbekleideter Frauen hielt man für akzeptabel, Gemälde mit nackten Frauen als Sujet nicht.

Stieglitz ahnte diese Reaktion voraus und schrieb:»Denjenigen unserer Leser, die nicht verstehen, warum diese Zeichnungen in *Camera Work* abgebildet sind, möchten wir sagen, daß die Reproduktionen, abgesehen von der Bedeutung der Originale, wunderschöne und interessante Beispiele dafür sind, was einer der nützlichsten und weitreichendsten Bereiche der Kameraarbeit leisten kann, der photomechanische Prozeß. Daher sind sie in doppeltem Sinne wertvoll. Diese Reproduktionen lassen diejenigen, die die Originale nicht betrachten können, Bekanntschaft schließen mit einigen der intimsten Studien bedeutender Künstler. Gleichzeitig vermitteln sie uns ein besseres Verständnis der Möglichkeiten der photographischen Reproduktion, wenn sie von künstlerischem Gespür und technischem Verstand geleitet ist. Und wir erlauben uns außerdem, unsere Leser

daran zu erinnern, daß eine der Aufgaben von *Camera Work* darin besteht, die Aktivitäten der Photo-Secession und ihrer Galerie zu illustrieren. Worin diese bestehen, wurde in den letzten Ausgaben der Zeitschrift mehrfach erläutert.«[12]

In der Stieglitz gewidmeten Ausgabe 36 vom Oktober 1911 bestätigte eine Radierung von Pablo Picasso eine Tatsache, die wohl keiner Bestätigung mehr bedurfte: Stieglitz war des Piktorialismus müde. Der überwiegende Teil der Textbeiträge dieser und späterer Ausgaben waren Besprechungen der neuesten Ausstellungen von »291«. Nur wenige Artikel waren speziell für eine Ausgabe geschrieben worden, darunter fast keiner mehr über Photographie. Statt dessen handelte es sich um Nachdrucke aus Kunstzeitschriften und von Ausstellungsbesprechungen. Stieglitz war müde und krank, und *Camera Work* erschien immer unregelmäßiger.

Die *Special Number 1912* war sieben Akten von Matisse sowie sieben Gemälden und Skulpturen von Picasso gewidmet. Darunter befand sich auch die Picasso-Radierung, die bereits 1911 abgedruckt worden war. Die *Special Number 1912* war die erste, die keine einzige Photographie enthielt und damit einen eindeutigen Hinweis auf die verlagerten Interessen von Stieglitz gab. Gertrude Stein lieferte Kritiken über Matisse und Picasso. Die Tatsache, daß sie auch in der *Special Number 1913* erneut als Autorin auftauchte, zeigte den deutlichen Richtungswechsel in Stil und Inhalt von *Camera Work*. Anstelle der oft blumigen, gefälligen Artikel von Caffin, de Casseres und de Zayas hatte nun die Moderne auch im Textteil Einzug gehalten.

Nach 1913 führten mehrere Faktoren zum Zusammenbruch von *Camera Work*. Die rückläufige Zahl der Abonnenten war gleichbedeutend mit sinkenden Einnahmen. Der Erste Weltkrieg verhinderte, daß die hochwertigen Gravuren weiterhin von dem in Berlin ansässigen Goetz geliefert wurden. Stieglitz interessierte sich immer stärker für die Galerie und verbrachte einen immer größeren Teil seiner Zeit dort. Auch die Vorbereitungen für die 1913 in New York stattfindende »Armory Show of Modern Art« und seine Zusammenarbeit mit de Zayas bei einem Zeitschriften- und Galerieprojekt, dem allerdings keine lange Lebensdauer beschieden war, nahmen beständig mehr Zeit in Anspruch.

In den nächsten vier Jahren kamen nur sechs weitere Ausgaben von *Camera Work* heraus, von denen die beiden letzten als Doppelheft 49/50 erschienen. Die Nr. 47 war eine besonders selbstgefällige Ausgabe: Weder Gemälde noch Photogravuren, sondern nur Texte, nämlich eine Auswahl von 68 Antwortbriefen auf die Frage:»Was ist ›291‹?«Da die Besucherzahlen rückläufig waren, mag man dieses Heft als zynischen Trick ansehen, das öffentliche Interesse neu zu beleben oder Geld zu sparen (die Ausgaben für die Photogravuren waren der kostspieligste Posten der Zeitschrift). Aber es ist wahrscheinlicher, daß Stieglitz eine Bestätigung suchte, daß Zeitschrift und Galerie nicht nur ihm, sondern auch anderen etwas bedeutet hatten. Er wollte diese Meinungen gedruckt sehen, bevor er beide aufgeben würde. Möglicherweise zerrten der Ärger, das Arbeitspensum und die Kosten, die in zunehmendem Maße fast ausschließlich von ihm selbst getragen wurden, mehr und mehr an seinen Nerven. Selbst er war nicht immun gegen die deprimierende Realität des Ersten Weltkriegs.

Einige der Briefe waren seltsam anrührend. Andere trieften vor Lobhudelei. Man bat Menschen aus allen Schichten und Berufen um eine Stellungnahme, darunter Hodge Kirnon, ursprünglich von den westindischen Inseln und seit 1912 Liftboy im Haus, Man Ray, den Maler, Designer, Schriftsteller und späteren Photographen, Adolf Wolff, den Bildhauer, Dichter und Anarchisten aus New York, oder Francis Picabia, den französischen Maler. Eine recht zynische Antwort auf die Frage:»Was bedeutet Ihnen ›291‹?«kam von Clara Steichen:»Ich habe genäht, gesäumt und die ersten Vorhänge in ›291‹ aufgehängt. Seitdem haben andere gesäumt, gehämmert und gehängt.«[13] Ein völlig desillusionierter Eduard Steichen, der längst selbst heftige Auseinandersetzungen mit Stieglitz gehabt und ihm schon vor Jahren den Rat gegeben hatte, Zeitschrift und Galerie aufzugeben, schrieb:»Während des letzten Jahres, vielleicht der letzten zwei Jahre, schien es mir, als würde ›291‹ nur auf der Stelle treten. [...] Ich kann außerdem keinen Grund für die Veröffentlichung dieser speziellen Nummer von *Camera Work* entdecken, [...] es sei denn, ›291‹ hat schlichtweg nichts Besseres zu tun. Wiederum trat das Unvorhergesehene ein – der Krieg brach aus.«[14]

Die vorletzte Ausgabe von *Camera Work* (Nr. 48, Oktober 1916) war ein Resümee der Vergangenheit und der Gegenwart und eröffnete Zukunftsperspektiven. Sie war eine Zusammenfassung der letzten 13 Jahre im Leben von Alfred Stieglitz. Für die Vergangenheit standen das piktoralistische *The Cat* von Frank Eugene, *Winter* von Arthur Allen Lewis, *Portrait* von Francis Bruguière und ein Installationsphoto von der Ausstellung deutscher und österreichischer Photographie, die im März 1906 in »291« lief.

Für Gegenwart und Zukunft standen Aufnahmen der Ausstellungen: Skulpturen Brancusis (März 1914), Afrikanische Kunst (November 1914), Picasso und Braque (Januar 1915) und der Nadelman-Ausstellung vom Dezember 1915. Die einzige Zukunftsperspektive für die Photographie sah Stieglitz in den Arbeiten von Paul Strand, dem die beiden letzten Ausgaben gewidmet waren. Er war der erste Photograph seit langem, dessen Arbeiten Stieglitz wirklich begeisterten. Stieglitz hatte beschlossen, die Einstellung der Zeitschrift zu einem Ereignis zu machen und zu demonstrieren, daß durchaus noch Leben in ihr steckte. Für ihn waren Strands Arbeiten die photographische Version der Abstraktion, die er bei Picasso gefunden hatte und nun in seiner ersten Leidenschaft, der Photographie, wiederentdeckte.

Die Strand gewidmete Ausgabe bedeutete das Ende der piktorialistischen Photographie. Sie wurde härter und schärfer auf dickeres Papier gedruckt. Für den Druck wurde eine kräftigere Farbe gewählt, die nichts mehr mit den zarten, durchscheinenden Drucken auf Japanpapier, die man von *Camera Work* gewohnt war, gemein hatte. Diese letzte Ausgabe illustrierte Stieglitz' Vision von der Zukunft der Photographie. Bei ihrer Entdeckung war sie bildhaft und weich gewesen, nun war sie »straight«, rein und hart. Strands Photographien verkörperten wie Stieglitz' Begleittext die direkte und eindeutige Kommunikation: »Seine Arbeit wurzelt in der besten photographischen Tradition. Seine Vision ist ein Potential. Seine Arbeit ist rein. Direkt. Sie verläßt sich nicht auf die Tricks der Bearbeitung. Bei allem, was er tut, sieht man angewandte Intelligenz [...]. Die elf Photogravuren dieser Ausgabe zeigen den wahren Strand. Den Mann, dem es tatsächlich gelungen ist,

etwas von innen heraus zu schaffen. Den Photographen, der dem bereits Existierenden wirklich etwas hinzufügen konnte. Seine Arbeiten sind in ihrer Direktheit brutal. Ihnen fehlt jeglicher Schwindel, jeglicher Trick, jeglicher ›-ismus‹. Ihnen fehlt jeglicher Versuch, eine ignorante Öffentlichkeit, einschließlich der Photographen, mit Kunststückchen zu verblüffen. Diese Photos sind ein direkter Ausdruck des Hier und Jetzt. Wir haben sie in ihrer ganzen Brutalität wiedergegeben.«[15]

Durch Paul Strand und Georgia O'Keeffe entdeckte Stieglitz die Photographie und die Kunst neu. In den nächsten Jahren konzentrierte er sich auf seine eigene Arbeit, wie er sich lange Jahre der Photo-Secession gewidmet hatte, die letztendlich den Glauben an ihn und an sich selbst verloren hatte. Fast obsessiv photographierte er Georgia O'Keeffe, entwickelte sein Konzept »Äquivalente« und bemühte sich um eine »reine und scharfe« Sichtweise, mit der er die Klarheit und den Naturalismus, den viele seiner früheren Photos aufwiesen, steigerte und betonte. »Meine Photographien entspringen immer einem inneren Bedürfnis – einer geistigen, seelischen Erfahrung. Ich mache keine Bilder [...]. Ich habe eine Vorstellung vom Leben und versuche, dafür Äquivalente in Form von Photographien zu finden. Ein Mangel an innerer Vision zeichnet die meisten Photographen aus und läßt nur wenige zu echten Photographen werden. Der Geist meiner frühen Arbeiten ist identisch mit dem meiner späteren. Natürlich bin ich gewachsen, habe mich weiterentwickelt, weiß viel mehr, bin mir vielleicht dessen mehr bewußt, was ich eigentlich tun will. Was ich an Reife im Bereich der Form gewonnen habe, habe ich in anderer Hinsicht vielleicht verloren. Fortschritt oder Verbesserung existieren in der Kunst nicht. Es gibt Kunst und es gibt Nichtkunst. Dazwischen gibt es nichts.«[16]

Jetzt, wo er seine Zeit und seine Energie auf O'Keeffe und seine eigene Photographie konzentrierte, brauchte er die Photo-Secession, *Camera Work* und »291« nicht mehr. O'Keeffe wurde zur Verkörperung aller Kunst, die er je gesucht hatte und die er je hatte haben wollen. Zum ersten Mal in seinem Leben, so scheint es, war Stieglitz wirklich glücklich und hatte seinen inneren Frieden gefunden. Er schien in sich ein »Äquivalent« gefunden zu haben. Ab und zu spielte er mit dem Gedanken, weitere Ausgaben von *Camera Work* über Charles Sheeler und

Georgia O'Keeffe zu veröffentlichen oder über die jüngeren Piktorialisten, doch es kam nie dazu. Dem Präsidenten der Royal Photographic Society, John Dudley Johnston, schrieb er 1923:»Ich habe schon seit langem vor, eine Ausgabe der Zeitschrift den ›jüngeren‹ britischen Photographen zu widmen, Ihnen, Bennington & Arbuthnot & vielleicht noch einem anderen. Da *Camera Work* Geschichte ist – eine Idee, eine bestimmte Geisteshaltung – nennen Sie es, wie Sie wollen –, denke ich selbstverständlich ständig daran. Es ist nicht nur eine finanzielle Frage, sondern auch das Problem, wo man die Arbeiten noch so ausführen lassen kann, daß sie jemandem mit meinen Qualitätsansprüchen genügen.«[17]

1924 wurde Stieglitz, der im Jahr 1905 zum Ehrenmitglied der Royal Photographic Society ernannt worden war, mit der»Progress Medal«, der höchsten Auszeichnung, die die Royal Photographic Society zu vergeben hatte, ausgezeichnet. Er erhielt sie»in Anerkennung seiner bedeutenden Leistungen bei der Entstehung und Förderung der amerikanischen piktorialistischen Photographie und für seine Initiative zur Gründung und Verbreitung der Zeitschrift *Camera Work*, die über einen Zeitraum von 14 Jahren der künstlerischste Versuch einer Dokumentation der Photographie war, der je unternommen wurde.«[18]

Stieglitz war ein besessener Briefeschreiber geworden und glättete so die Wogen, die in der Vergangenheit zum Bruch von Freundschaften geführt hatten. In seinen letzten 20 Lebensjahren leitete er die»Intimate Gallery«und die Galerie»An American Place«, die in der Hauptsache Kunst ausstellten, manchmal jedoch auch Photos, so sie ihn interessierten, wie die von Paul Strand, Ansel Adams und Eliot Porter. 1930 verbrannte er die 1000 noch verbliebenen Exemplare von *Camera Work*, nachdem er sichergestellt hatte, daß er den meisten wichtigen Institutionen einen kompletten Satz überlassen hatte. 1933 stiftete er seine über 600 Werke umfassendeSammlung mit Photographien von Mitgliedern der Photo-Secession und anderen Piktorialisten dem New Yorker Metropolitan Museum of Art. Zu diesem Zeitpunkt sah er keinen großen Wert mehr in dieser Art von Photographie, in einem Stil, den er fast im Alleingang in Amerika gefördert hatte und von dem er sich nun befreien wollte.

Stieglitz interessierte sich immer stärker für die Gegenwart und die Zukunft als für die Vergangenheit. Er hatte den Zugang zur modernen Kunst geöffnet, für ihre Verbreitung gesorgt und neue Bewertungskriterien entwickelt. Die Lehrsätze des Piktorialismus, den er ins Leben gerufen hatte, waren überholt. Damit hatte er quasi sein eigenes Kind getötet. Stieglitz suchte immer nach Reife, Wachstum, Weiterentwicklung, nach Vitalität, Intensität, nach der ultimativen Wahrheit, die in der Freiheit lag, Erfahrungen zu sammeln, in welchem Medium auch immer. Ihm lag nichts an Gewohnheit und Stagnation. Kunst mußte dem, was schon vorhanden war, etwas hinzufügen. Kunst mußte Veränderungen bewirken. Sonst war sie keine Kunst. Jeder, der etwas zu sagen hatte, mußte Gehör finden. Stieglitz zählte zu denen, die mehr zu sagen hatten als die meisten anderen.

Camera Work erfüllte viele Aufgaben. Sie nahm ihren Anfang als letzte Bastion des Zusammentreffens von Symbolismus, Photographie und Literatur und endete als Botschafterin der Moderne. Sie war ein Ausstellungskatalog der Galerie »291« und das Publicity-Organ der Photo-Secession. Während sie viele Photographen inspirierte, war sie für andere ein Anachronismus. Walker Evans konnte sich unter den 559 Reproduktionen nur an ein Photo von Paul Strand erinnern. Ansel Adams und Eliot Porter erinnerten sich an Strand, Stieglitz und Steichen, doch die große Masse der piktorialistischen Arbeiten schien für sie aus einer anderen Zeit zu stammen – und das war tatsächlich der Fall. *Camera Work* war vor allem die Autobiographie eines kreativen Menschen, ihres Chefredakteurs, ihres Finanziers, ihres Mentors – eines Machers. Eines Mannes, den man als Despoten, Diktator, Guru, Propheten und Messias bezeichnete: Alfred Stieglitz.

»Wenn doch nur England einen Stieglitz gehabt hätte! Doch Stieglitze sind selten. Es genügt, daß in unserer Generation ein Stieglitz geboren wurde. Wir stehen tief in seiner Schuld. Er ist nicht nur der größte lebende Photograph, wie die, die seine Arbeit kennen, schon lange wissen, er ist auch der größte Förderer der Photographie gewesen (und zwar nur, weil er sie liebte).«[19]

Kein schlechter Nachruf!

1 A. Horsley Hinton, »The Work and Attitude of the Photo-Secession of America«, in: *The Amateur Photographer*, Band XXXIX, Nr. 1026, 2. Juni 1904, S. 426–428.

2 Sadakichi Hartmann ist der Name, Sidney Allan das Pseudonym, das nur in den Schriften über Photographie Verwendung findet.

3 Steichen änderte später die Schreibweise seines Namens von der französischen Form Eduard Jean in die englische Edward John.

4 Alfred Stieglitz, Einleitung, in: *Camera Work 1*, Januar 1903, S. 15–16.

5 Ebd.

6 Die Schreibweise des Namens Kühn variiert in *Camera Work*. Die Photographien, die in der Zeitschrift reproduziert wurden, tragen die Bezeichnung Kuehn. Diese Schreibweise wurde deshalb auch für die Bildlegenden gewählt.

7 Alfred Stieglitz, »Our Illustrations«, in: *Camera Work 4*, Oktober 1903, S. 25–26.

8 Brief von Alfred Stieglitz an J. McIntosh, Sekretär und Bibliothekar der Royal Photographic Society, 31. August 1910, Archiv der Royal Photographic Society, Bath.

9 R. Child Bayley, »Camera Work«, in: *Photography*, Band XV, 3. Januar 1903, S. 738.

10 A. Horsley Hinton, »Camera Work«, in: *The Amateur Photographer*, Band XXXVII, Nr. 953, Januar 1903, S. 4.

11 Die Herausgeber von *Camera Work*, »The Photo-Secession Galleries«, in: *Camera Work 14*, April 1906, S. 48.

12 Die Herausgeber von *Camera Work*, »Our Illustrations«, in: *Camera Work 34/35*, April/Juli 1911, S. 70.

13 Brief von Clara Steichen, in: *Camera Work 47*, datiert Juli 1914, veröffentlicht Januar 1915, S. 20.

14 Brief von Eduard Steichen, in: *Camera Work 47*, datiert Juli 1914, veröffentlicht Januar 1915, S 65–66.

15 Alfred Stieglitz, »Our Illustrations«, in: *Camera Work 49/50*, Juni 1917, S. 36.

16 Brief von Alfred Stieglitz an John Dudley Johnston, ehemaliger Präsident der Royal Photographic Society, 3. April 1925, Archiv der Royal Photographic Society, Bath.

17 Brief von Alfred Stieglitz an John Dudley Johnston, Präsident der Royal Photographic Society, 15. Oktober 1923, Archiv der Royal Photographic Society, Bath.

18 *The Photographic Journal*, Band LXV, New Series Band XLIX, Mai 1925, S. 250.

19 Ward Muir, »Camera Work and its Creator. A Historical Note«, in: *The Amateur Photographer*, Band LVI, Nr. 1829, 28. November 1923, S. 465–466.

Alfred Stieglitz, la galerie «291» et Camera Work
Pam Roberts

Alfred Stieglitz possédait les multiples talents d'un homme de la Renaissance. Ce visionnaire aux idées très larges et aux réalisations remarquables se consacrait à tout ce qu'il entreprenait avec une ferveur impressionnante. Photographe génial, éditeur inspiré, écrivain très doué, propriétaire de galeries et organisateur d'expositions de photographie et d'art moderne, catalyseur des tendances et chef de file charismatique dans les milieux photographiques et artistiques pendant plus de trente ans, il était forcément animé d'un tempérament passionné, complexe, impulsif et hautement contradictoire. Prophète et martyr à la fois, figure de l'anticonformisme poussé à l'extrême, il se fit aimer et haïr dans les mêmes proportions.

A elle seule, sa photographie suffit à lui accorder une place centrale dans l'histoire du genre; c'est à l'aune de cette activité-ci, plutôt que de toutes celles qu'il menait en parallèle, qu'il souhaitait en fin de compte être jugé. Mais c'est néanmoins aux dépens de son propre travail que s'exercèrent l'énergie, le dévouement et l'investissement dont il fit preuve pour fonder la Photo-Secession aux Etats-Unis et pour élever la photographie au statut d'un art à part entière, au lieu de la cantonner au rang d'un support purement mimétique. Il réussit à la transformer irrévocablement et à la faire accepter comme une forme artistique majeure du XXe siècle. A la fin du XIXe siècle, Stieglitz prit la photographie américaine à bras-le-corps et la propulsa en plein XXe siècle: surgie des ténèbres, elle vint occuper le centre de la scène, position dominante qu'elle n'a pas quittée depuis.

On sentit jusqu'en Angleterre les ondes de choc générées par la personnalité volcanique de Stieglitz, qui canalisa toute son énergie dans la photographie américaine. En témoigne ce commentaire d'Alfred Horsley Hinton, rédacteur en chef de la revue *The Amateur Photographer*: «La photographie américaine va s'imposer dans le monde entier, si d'autres ne se décident pas à réagir; en effet, les clichés de la Photo-Secession se sont déjà empará des plus hauts rangs dans l'estime du monde civilisé [...]. C'est Stieglitz qui fixe les conditions, rassemble les

clichés, porte la responsabilité de leur rentabilité. Quelle influence ne doit-il donc pas exercer. Il fait aujourd'hui l'effet d'un homme au tempérament des plus nerveux, mû par une énergie inflexible et par une détermination inébranlable [...].»¹

Stieglitz fonda la Photo-Secession à partir d'un groupe de photographes américains qui avaient commencé par rivaliser avec les idéaux du pictorialisme européen (non sans se sentir un tant soit peu à la traîne), mais qui eurent tôt fait d'élaborer et d'affirmer leur propre langage, lequel finit par devenir la langue véhiculaire de toute la photographie.

Grâce à la prolifération des produits Kodak faciles à utiliser ainsi qu'à la très forte croissance du marché de la photographie commerciale, on vit de plus en plus de monde avoir accès à la photographie pendant une vingtaine d'années, au tournant du siècle. La photographie éclata alors en plusieurs directions: en Europe, les photographes pictorialistes amateurs commençaient à employer des techniques de manipulation de plus en plus sophistiquées comme par exemple le platine, la gomme bichromatée, le procédé au charbon; le produit final obtenu était complètement différent du travail des «photographes à la minute», que l'on traitait par le mépris, et au reste plus proche d'une esquisse au pastel ou d'un croquis au fusain que d'un cliché photographique proprement dit. Même si Stieglitz, au départ, avait épousé et encouragé cette forme irréelle et laborieuse de production photographique pictorialiste, il fut en mesure d'assimiler et d'incorporer les autres possibilités moins tortueuses et plus immédiates qu'offrait la photographie. C'est ainsi qu'il parvint à une pureté, à une simplicité de la vision et de la technique, qui permirent de parler de photographie «directe» et qui contenaient en germe tout l'avenir du genre.

Les groupes de pictorialistes finirent par se disloquer, en proie à des querelles internes mesquines et en quête d'une adhésion trop stricte au rendu d'effets picturaux: à force de prêter une attention excessive aux détails de la technique, ils perdaient la vision photographique d'ensemble. Leur inspiration conduisait à une impasse car leur vision se réduisait à une perspective si étroite qu'ils donnaient l'impression de regarder le monde par le mauvais bout d'un télescope. En

revanche, la vision de Stieglitz ne cessa jamais de s'élargir, sans aucun doute parce qu'il menait de front de nombreuses activités complexes et complémentaires et embrassait avec beaucoup de facilité de nouvelles idées et de nouveaux intérêts.

Né le 1er janvier 1864 à Hoboken, dans le New Jersey, Stieglitz partit vivre à New York en 1871 et aménagea dans un gros immeuble en pierres de taille sur la 60e rue, à l'est de la 5e avenue. Son père avait réussi dans l'industrie lainière, et bien que le fils, par la suite, ait souvent amèrement regretté d'avoir manqué d'argent, il semble qu'il ait grandi dans une famille plutôt aisée. De 1882 à 1890, il fit des études de génie mécanique, matière pour laquelle il manifestait un profond désintérêt, à la Technische Hochschule de Berlin. En 1883, il apprit la photographie en suivant les cours de Hermann Wilhelm Vogel et il fut très vite obsédé par le désir de maîtriser les possibilités techniques du médium. Seul un parfait contrôle de la technique lui permettrait de mettre à profit tout le potentiel de la photographie pour réaliser sa vision.

Il fut influencé par le pictorialisme aux contours flous qui prévalait en Europe, en particulier par les photographies naturalistes des lacs et estuaires du Norfolk prises par le docteur Peter Henry Emerson, qui utilisait le procédé de la photogravure pour imprimer ses albums. En 1887, présenté par celui-ci, Stieglitz remporta le «First Prize of the Year» de *The Amateur Photographer*. On a du mal à percevoir beaucoup de ressemblances entre le travail qu'il effectuait à cette époque et celui qu'il allait produire vingt ans plus tard: ses premières œuvres étaient tout entières frappées au sceau du style européen et elles ne portaient aucun indice de la clarté ou du modernisme qui allaient pourtant caractériser la signature de Stieglitz.

Le changement se produisit à son retour à New York en 1890: là, il se trouva confronté à un contenu en tout point plus dur, plus résistant et plus réaliste. Il n'y avait rien, dans l'agressivité, la vitalité et le mouvement des rues new-yorkaises, dans le spectacle de l'architecture s'élevant à la verticale, qui offrît les mêmes agréments que les riantes campagnes européennes peuplées de paysans en costumes photogéniques. Mais après s'être rapidement réadapté à cet environnement, Stieglitz y trouva une matière tout à la fois passionnante et stimulante, et il continua

de photographier New York pour le restant de ses jours. Il fut l'un des premiers photographes à percevoir la richesse du potentiel photographique contenu dans l'énergie et la rapide croissance d'une ville. C'est ainsi qu'il s'attaqua à un monde plus grand, plus vif dans ses contours, plus conflictuel et plus réaliste, avec ses formes graphiques et ses motifs géométriques, que celui que photographiaient ses contemporains. Beaucoup d'entre eux n'abandonnèrent d'ailleurs jamais le microcosme de paysages vaporeux, de scènes de la vie domestique noyées dans la brume, de belles femmes parfumées qui gardaient l'œil rivé sur une boule de cristal ou exprimaient, chagrines, la nostalgie de quelque âge d'or révolu. Tandis que le pictorialisme saisissait un moment subjectif souvent créé pour l'occasion, la photographie «directe» saisissait la réalité avec l'objectivité la plus impartiale qui fût.

Grâce à l'aide financière de son père, Stieglitz s'associa à Louis Schubart et Joseph Obermeyer, deux de ses anciens condisciples berlinois qui devaient devenir ses beaux-frères, pour fonder la firme Heliochrome, plus tard rebaptisée Photochrome Engraving Company. Comme les affaires, au départ, ne marchaient guère, Stieglitz eut le temps de s'initier au procédé complexe de la photogravure auprès de la main-d'œuvre qualifiée de l'entreprise, et il eut tôt fait de s'en rendre maître avec une précision exceptionnelle. Même si la réussite finit par arriver, Stieglitz ne s'intéressa jamais à la dimension commerciale de la firme, pas plus qu'à celle de toutes les autres entreprises dans lesquelles il se lança au cours de sa vie. Il quitta sa compagnie au bout de cinq ans, après avoir acquis une parfaite connaissance du procédé de la photogravure et de toutes les techniques nécessaires à la production de belles œuvres. Là encore, il avait été influencé par les portfolios de photogravures que l'on réalisait à Vienne, à Paris et à Londres dans les années 1890, mais très vite, Stieglitz produisit des travaux d'une qualité encore meilleure.

La perte enregistrée par le monde des affaires représenta un gain pour la photographie lorsque Stieglitz, fort de sa compétence et des contacts qu'il avait établis lors de son séjour en Europe, résolut de ressusciter la photographie amateur en Amérique en la tirant de son marasme pour la projeter en plein XXe siècle. Au départ, il puisa son inspiration dans les groupes sécessionnistes qui sur-

gissaient dans toute l'Europe et qui s'étaient eux-mêmes inspirés de semblables fractures dans le monde de l'art en Autriche et en Allemagne. Ils tenaient pour synonymes les mots «amateur» et «artiste» et considéraient que seul l'amateur, dégagé des chaînes du commerce qui emprisonnent les photographes professionnels, jouit de la liberté nécessaire à la production d'une œuvre forte et véridique.

Dans les années 1890, le monde de la photographie commença à se radicaliser. En 1891, les Sécessionnistes viennois présentèrent au Salon de la photographie de leur ville une exposition qui suscita une vive controverse. En 1892, un groupe de dissidents qui rassemblait au départ quinze anciens membres de la Photographic Society (rebaptisée en 1894 Royal Photographic Society) créa la Confrérie du «Linked Ring»; lassés des exigences rigoureuses de la Society qui leur demandait de travailler la technique et de songer aux débouchés commerciaux, ils se mirent à organiser leurs propres réunions et expositions. En 1894, Robert Demachy et Constant Puyo fondèrent le Photo-Club de Paris après s'être séparés de la Société Française de Photographie. Tous ces groupes poursuivaient le même but: libérer la photographie des prérogatives documentaires et techniques qui étaient alors les siennes, l'utiliser comme un outil plus impressionniste, plus souple, afin d'atteindre à une forme d'expression artistique qui fût valable en soi, tout comme le peintre se servait de peinture, de pinceaux et de toile, et le sculpteur de marbre, de pierre et de ciseaux.

Pour les pictorialistes, la photographie n'avait pas pour mission de conserver une trace des faits documentaires et elle ne constituait pas davantage un médium chargé de recréer des œuvres d'art, contrairement à l'usage qu'en avaient fait au préalable de nombreux photographes victoriens; c'était au contraire un moyen de créer une nouvelle réalité purement photographique, une réalité qui ne pouvait accéder à l'existence que sur un cliché et dont on devait faire l'expérience à travers la vision personnelle du photographe qui l'avait conçue, puis sublimée et enfantée grâce à la maîtrise d'une technologie bien précise. C'était la technologie qui était au service du photographe, et non l'inverse. L'appareil se contentait d'être un outil qui communiquait la vision du photographe au monde. C'était un moyen,

et non pas une fin en soi. Pour fixer ses impressions, le photographe pouvait recourir à une large gamme de lentilles, de négatifs et de techniques de manipulation, parmi lesquelles on trouvait le dessin, l'eau-forte, la peinture et les retouches apportées tant aux négatifs qu'aux clichés. Stieglitz avait participé à des expositions collectives de tous ces groupes, dont la plupart lui avaient décerné le titre de membre honoraire, et il avait recueilli une moisson de prix et de médailles: plus de cent cinquante en tout.

Pendant les quelques années qui suivirent, il semble avoir décuplé son énergie pour provoquer une révolution dans le monde de la photographie en Amérique. À compter de l'année 1892, il occupa le poste de rédacteur en chef de la revue *The American Amateur Photographer*. Il était alors intimement persuadé que seulement l'authentique amateur a la liberté artistique de suivre sa vision de la vérité, hors des chaînes où l'enfermerait tout vil motif économique. Le plus grand défi qu'eut à relever Stieglitz fut la fusion, en 1897, des Amateur Photographers de New York et du New York Camera Club, qui aboutit à la formation du Camera Club. La même année, il fut nommé vice-président de ce Club et rédacteur en chef de sa nouvelle revue trimestrielle, *Camera Notes*, qui devait servir de vitrine au Club, consigner ses débats, refléter le renouveau d'énergie et de confiance de la photographie américaine. Aucune de ces deux fonctions n'était rémunérée.

Au cours des cinq années suivantes, le Camera Club ne versa que 1850 dollars en guise de participation aux dépenses courantes de *Camera Notes*. Cette somme ne couvrait même pas le prix des exemplaires que le Club distribuait gratuitement à ses adhérents et ne représentait qu'un dixième des frais totaux, qui s'élevaient à 18 000 dollars, et qui étaient payés par les recettes de la publicité ou les ressources personnelles de Stieglitz. Pourtant, pendant la période où Stieglitz en assura la direction (1897–1902), *Camera Notes* devint la revue de photographie qui exerça la plus grande influence dans le pays, s'attirant un lectorat qui dépassait de loin le noyau quelque peu confidentiel du Camera Club. Stieglitz publia des articles, des essais critiques, des comptes rendus d'exposition parus dans des publications européennes et il commanda des articles provocateurs et sujets à controverses à des

spécialistes de l'art et de la photographie en Amérique. Des écrivains américains comme Sadakichi Hartmann (Sidney Allan)[2] et Charles H. Caffin suscitèrent des débats sur la photographie comme on n'en avait jamais vu auparavant. Mais c'est à la qualité superbe de ses illustrations que *Camera Notes* dut son succès: c'étaient des photogravures dont Stieglitz supervisait de très près la production, qu'il faisait tirer soit dans sa vieille firme new-yorkaise pour les œuvres américaines (la Photochrome Engraving Company), soit à Londres par l'intermédiaire de Walter L. Colls, imprimeur de *Sun Artists*, pour les œuvres européennes.

D'un point de vue artistique, *Camera Notes* ne cessa de croître et d'embellir. On put y voir des œuvres de pictorialistes choisis par Stieglitz, comme George Selley, Gertrude Käsebier, Eduard Steichen[3] et Clarence H. White, photographes qui devaient tous devenir membres de la Photo-Secession, exposer dans les galeries de Stieglitz et voir leur travail publié dans *Camera Work*. Parmi les autres artistes à avoir eu les honneurs de *Camera Notes*, citons Fred Holland Day, qui partageait avec Stieglitz, ou parfois s'octroyait à ses dépens, la direction du mouvement qui entendait régénérer la photographie américaine.

En mars 1902, Stieglitz organisa au National Arts Club de New York, en marge du Camera Club, une exposition intitulée «American Pictorial Photography Arranged by The Photo-Secession». C'est la première fois qu'on employait publiquement ces termes pour désigner le regroupement de quelques photographes animés des mêmes convictions et qui reprenaient aux groupes sécessionnistes européens nombre d'idées communes sur le sujet, la présentation et la disposition d'esprit. Stieglitz avait en effet déclaré sa rupture avec le Camera Club, tout comme le «Linked Ring» s'était séparé de la Royal Photographic Society, au péril de sa situation. Après avoir rédigé, en guise d'adieu, un compte rendu de l'exposition et un long éditorial sur la Photo-Secession dans le numéro de juillet 1902 de *Camera Notes*, Stieglitz démissionna du poste de rédacteur en chef.

Comme, sous l'impulsion de Stieglitz, *Camera Work* avait élargi de manière spectaculaire l'ampleur des sujets couverts afin de toucher un public international plus diversifié parmi les amateurs d'art et de photographie, la dimension

nationale en avait pâti et la place accordée aux réunions, aux expositions et aux questions débattues au sein du Camera Club s'était réduite. Les membres du Club ne participaient guère, ils ne fournissaient que très peu d'articles ou de textes, et Stieglitz faisait appel à des collaborateurs extérieurs de plus en plus chers. La revue n'était jamais devenue le petit organe interne que le Club avait projeté au départ mais, tout au contraire, une publication à la pointe du progrès qui avait mis le Club en ligne de mire, position qu'il avait du mal à assumer. Après le départ de Stieglitz parurent trois numéros de plus, puis la publication fut suspendue.

Les batailles qu'avait livrées Stieglitz pour s'emparer du poste de rédacteur en chef de *Camera Notes*, comme auparavant de celui de *The American Photographer*, étaient source d'irritation constante, et après sa démission en juin 1902, il résolut de ne plus jamais travailler que pour lui-même à l'avenir. Il avait tenté, non sans y réussir en partie, de changer l'orientation de la photographie américaine en se plaçant à l'intérieur d'une structure établie, mais il s'était rendu compte que la seule voie qui s'offrait à lui consistait à assumer son anticonformisme en toute indépendance et à bouleverser la photographie tout en restant extérieur au système.

Depuis quelque temps, il envisageait de fonder une nouvelle revue sur le modèle de *Camera Notes*. Il est vrai qu'à bien des égards *Camera Notes* avait constitué un terrain d'expérimentation dont *Camera Work* allait récolter les fruits. Le premier numéro, daté de janvier 1903, parut en décembre 1902. Le titre provenait de l'expression que l'on utilisait habituellement pour désigner la «prise de vues» et sa simplicité familière ne présageait rien du contenu avant-gardiste. Nul doute que Stieglitz ait savouré cette contradiction.

Stieglitz apporta les fonds, assura la direction, se chargea en grande partie du graphisme et choisit lui-même les auteurs, photographes et artistes qui figuraient dans les colonnes. Il était cependant secondé par Joseph T. Keiley, Dallett Fuguet et John Francis Strauss, anciens membres du comité de rédaction de *Camera Notes*, et par Eduard Steichen qui s'occupait de la couverture et de la typographie. Dès le début, *Camera Work* fut une entreprise à but non lucratif. Pire: une entreprise déficitaire qui n'eut jamais pour vocation d'être une

publication commerciale. Pour Stieglitz, la volonté de réaliser des gains financiers entraînait la perte irrémédiable de la liberté artistique.

Entièrement aux mains de Stieglitz, la revue devait servir de porte-parole au mouvement sécessionniste sans pour autant aliéner son indépendance: «*Camera Work* n'est affilié à aucune organisation, à aucune chapelle, et bien que ce soit l'organe de la Photo-Secession, cela ne devra en aucun cas faire obstacle à son indépendance.»[4] Déclaration équivoque typique de Stieglitz. Un tel programme se révéla en effet impossible à satisfaire et entraîna bon nombre de confusions. On allait trouver, dans *Camera Work*, des reproductions d'œuvres dont Stieglitz approuvait les auteurs, des débats sur la photographie et l'art, des comptes rendus d'expositions qui contenaient des travaux des Sécessionnistes et de leurs collègues européens. A partir de la quatorzième livraison, après l'ouverture des «Little Galleries of the Photo-Secession» en 1905 (en général, on les connaissait simplement par le numéro de la 5e avenue où elles se situaient: le «291»), *Camera Work* servit de plus en plus de catalogue aux expositions qui y étaient organisées, mais avec un certain décalage, et de forum diffusant les commentaires que la presse leur consacraient. Au départ, Stieglitz s'était efforcé de ne pas mélanger les activités de la galerie et de *Camera Work*. Peut-être ne voulait-il pas que la revue donne l'impression de vanter les mérites de la galerie, même si c'est ce qu'elle finit pourtant par faire. Mais plus vraisemblablement, il était incapable de faire coïncider les dates des expositions et celles des parutions: un grand nombre d'expositions ne duraient que deux semaines et *Camera Work*, qui commença par paraître tous les trois mois, n'avait absolument pas les moyens de suivre ce rythme ou d'y faire face.

La principale fonction de la revue consistait néanmoins à reproduire les travaux des photographes sécessionnistes avec la plus grande fidélité possible et de manière unique à ce jour, sans lésiner sur le temps passé ni sur la dépense occasionnée, sans compromettre non plus les critères de qualité: Stieglitz imprimait les photographies par le procédé de la photogravure et les réunissait en portfolios. En même temps, il prêtait certains clichés originaux pour qu'ils soient présentés dans des expositions nationales et internationales, en donnant alors des

directives très strictes concernant leur choix, leur accrochage et leurs légendes. Le compte rendu de ces expositions paraissait ensuite dans les colonnes de *Camera Work*: la boucle était bouclée.

La revue cherchait donc avant tout à publier de splendides reproductions des meilleures photographies disponibles (selon Stieglitz) en les assortissant des meilleurs commentaires critiques qu'il pouvait se procurer. La déclaration d'intention parut dans le premier numéro de janvier 1903: «La photographie étant dans l'ensemble un procédé monochromatique, c'est sur des gradations subtiles de tonalité et de valeur que repose si souvent sa beauté artistique. Afin de conserver l'esprit des originaux, il est donc tout à fait nécessaire d'employer à la reproduction d'œuvres photographiques une minutie rare, un soin tout particulier, quand bien même nulle reproduction ne saurait rendre entièrement justice aux subtilités de certains clichés. C'est ainsi que l'on surveillera de très près les illustrations publiées dans chaque numéro de *Camera Work*. Seuls trouveront grâce, dans ces pages, des travaux témoignant d'un regard individuel et artistique, indépendamment de toute école, ou bien des travaux contenant des traits exceptionnels de mérite technique, ou encore représentant tel ou tel traitement digne de considération. Toutefois, c'est la dimension picturale qui constituera le trait dominant de la revue.»[5]

Malgré l'importance et le ton provocateur des textes, qui étaient souvent écrits par des artistes pour donner foi à la photographie, *Camera Work* fut la première revue du genre à suivre une ligne directrice visuelle. Les illustrations de qualité supérieure étaient reproduites par un procédé manuel de la photogravure et imprimées sur un papier japon extrêmement fin qui leur procurait une couleur et une texture idéales. Elles étaient ensuite collées sur un papier couché aux bords irréguliers, dont les teintes s'accordaient aux variations et aux nuances des images afin d'en rehausser encore davantage les subtilités intrinsèques. C'est Stieglitz qui surveillait en personne toutes les étapes de l'opération, effectuant souvent des retouches et corrigeant les moindres imperfections, allant même jusqu'à fixer, le cas échéant, les photogravures sur la page. Il prenait son rôle très au sérieux et ne ménageait pas ses peines pour contrôler la qualité du produit.

Stieglitz avait amené le procédé de la photogravure à un tel stade de perfection qu'il le préférait souvent, lorsqu'il exposait ses propres photographies, aux procédés du platine et du charbon qu'il avait privilégiés auparavant. C'était pour lui une forme de gravure photographique tout aussi légitime et il l'utilisait également pour les clichés de la Photo-Secession qu'il envoyait dans les expositions internationales. La photogravure était le meilleur moyen, le moyen idéal pour rassembler mots et images et communiquer avec un plus large public; elle dépassait de loin, aux yeux de Stieglitz, les procédés d'impression photomécaniques.

Dans les premiers numéros de la revue figuraient aussi des reproductions de photographies en similigravure: cette technique de photogravure en demi-teinte présentait l'intérêt de coûter deux fois moins cher que la gravure en creux mais, le souci de perfection l'emportant là encore sur les considérations économiques, la similigravure disparut peu à peu après 1906 pour laisser la place à un procédé de gravure intégrale. Néanmoins, on dut conserver les similigravures pour les reproductions d'art et de sculpture dans les numéros ultérieurs, la gravure étant à la base un procédé monochrome. Stieglitz employa aussi le mezzo-tinto, le double ton, la gravure au trait, la similigravure en trichromie et en quadrichromie, le collotype, afin de s'approcher le plus près possible de son idéal. Les sommes personnelles qu'il dut engloutir laissent bouche bée, mais comme il ne tenait pas de comptes détaillés, on ne possède pas le chiffre exact des coûts. Le format et la présentation de *Camera Work* obligeaient cependant de réduire toutes les images à des proportions correspondant aux dimensions de la page. C'est ainsi que les immenses gommes bichromatées et très colorées de Theodor et Oskar Hofmeister étaient reproduites dans le même format que les minuscules clichés au platine de Stieglitz lui-même, quitte à perdre l'échelle et la texture qui faisaient toute la différence des originaux.

Les premiers numéros furent imprimés par la Photochrome Engraving Company, les suivants par la Manhattan Photogravure Company (dérivée de la première et dirigée par le beau-frère de Stieglitz), ou par la firme T. & R. Annan et Fils de Glasgow, ou encore par Frederick Goetz chez F. Bruckmann Verlag à Munich. De 1904 à 1917, la Manhattan Photogravure Company tira des photo-

gravures à partir des négatifs de photographes américains. James Craig Annan fournit des photogravures qu'il imprimait d'abord à partir des œuvres de photographes britanniques comme George Davison et lui-même, puis, dans des numéros ultérieurs, à partir des épreuves négatives que lui confièrent David Octavius Hill et Robert Adamson. Frederick Goetz envoya des photogravures réalisées à partir de négatifs de photographes européens comme Heinrich Kühn et Frank Eugene, mais il fit aussi imprimer des similigravures en couleur effectuées à partir d'autochromes d'Eduard Steichen en avril 1908. Stieglitz finit par accorder plus de confiance à ses fournisseurs européens qu'à la Manhattan Photogravure Company – et plus particulièrement à Goetz, qui voulut à tout prix maintenir *Camera Work* en activité longtemps après que Stieglitz eut décidé de suspendre la publication.

On fit appel à d'autres imprimeurs comme J. J. Waddington, de Londres, pour le numéro spécial consacré à Frederick H. Evans (*Camera Work*, n° 4, octobre 1903), mais celui-ci ne se montra pas à la hauteur des critères de qualité de Stieglitz, lequel se fustigea par écrit de devoir accepter un résultat final loin d'être parfait: «Imaginez quelle fut notre consternation lorsqu'arriva la publication et que nous nous aperçûmes que le travail était inégal, mal revu, et dans la plupart des cas en deçà du niveau que nous avions toutes les raisons d'attendre. C'était alors trop tard pour rectifier le tir: il ne nous restait plus qu'à faire contre mauvaise fortune bon cœur et à assumer l'entière responsabilité de l'infraction à nos règles. [...] Nous sommes déçus que ce numéro nous échappe et nous laisse insatisfaits. Cela ne se reproduira plus.»7

Les gravures étaient tirées, de préférence, à partir des négatifs originaux des photographes, ou, à défaut, à partir des clichés originaux. Dans le premier cas, on le mentionnait dans le texte en regard et on tenait ces gravures pour des clichés originaux. Mais en insistant pour obtenir les négatifs, Stieglitz s'exposait souvent, dans le cas d'œuvres qui n'étaient pas américaines, à des problèmes d'acheminement, de droits de douane et d'assurance, ainsi qu'à des reports d'échéances et des retards de parution. Comme la qualité de la revue importait davantage que le respect de la date de publication prévue, de nombreux numéros de

Camera Work parurent avec plusieurs mois de retard, tandis que Stieglitz voyageait en Europe ou était malade, comme cela lui arrivait souvent. Aucun numéro ne paraissait sans qu'il n'en ait auparavant inspecté chaque page dans les moindres détails. Il cherchait à impliquer tous les photographes dans le choix, la reproduction et la présentation de leurs œuvres et il ne reculait devant rien pour contenter ceux qu'il voulait vraiment publier.

Le style maison s'imposa dès le premier numéro de janvier 1903, qui contenait six gravures du travail de Gertrude Käsebier, une reproduction de Stieglitz, une étude naturelle d'A. Radclyffe Dugmore et deux ou trois similigravures de D. W. Tryon et Puvis de Chavannes. Les gravures étaient séparées du texte par des pages blanches et mises en évidence au début de la revue. Des articles étayaient le travail des photographes, parmi lesquels figuraient deux critiques élogieuses de G. Käsebier rédigées par Charles H. Caffin et Frances Benjamin Johnston, ainsi que des essais sur l'esthétique en photographie et en peinture, signés respectivement par Joseph T. Keiley, Sidney Allan (Sadakichi Hartmann) et Otto Walter Beck. Dugmore fit paraître un texte sur l'éclairage utilisé pour la photographie ornithologique, qui couvrait l'aspect technique du genre.

Les comptes rendus des expositions comprenaient un article de Will Cadby sur l'exposition du Salon de Londres, agrémenté d'un texte écrit par les rédacteurs en chef de la revue sur la présence américaine à ce même salon, ainsi que de brèves notices sur l'exposition des beaux-arts et des arts décoratifs qui avait eu lieu à Turin et sur la Yorkshire Union of Artists. S'y ajoutaient un ensemble d'articles plus courts de la main d'Eva Watson-Schütze, de Dallett Fuguet et d'Eduard Steichen, la reprise de textes déjà parus dans d'autres publications (en l'occurrence dans *The International Studio*), un rapide survol des nouveaux produits sur le marché et quelques petits poèmes composés par l'équipe rédactionnelle: le ton était d'ores et déjà donné pour les futurs numéros. Ceux-ci reprirent en bonne part cet équilibre et multiplièrent les plaisanteries à l'usage des initiés, les articles satiriques souvent si contournés que seuls les Photo-Secessionnistes convaincus pouvaient en saisir toutes les nuances.

Même les vingt-six annonces publicitaires sur lesquelles se refermait la revue faisaient l'objet d'un graphisme et d'une présentation à la fois simples et créatifs; c'était souvent Stieglitz qui s'en chargeait, les distinguant nettement du contenu sérieux de la publication. La plupart des annonceurs revinrent dans beaucoup de numéros: ainsi les pellicules Kodak, les produits photochimiques de Schering, la firme optique Bausch & Lomb Optical Company, les appareils Graflex. Eastman Kodak occupait la quatrième page de couverture de presque tous les numéros et reprenait, sur l'insistance de Stieglitz, la police de caractère conçue par Eduard Steichen pour la première page. Beaucoup d'entreprises qui participaient matériellement à la fabrication de *Camera Work* choisissaient de faire leur propre publicité dans les dernières pages, exprimant par là un authentique vote de confiance à l'égard de leur travail. Comme Stieglitz tenait à rejeter toute dimension lucrative, il fallait toujours surveiller de près le nombre des annonces publicitaires.

Ce furent les presses Fleming qui se chargèrent d'imprimer les pages de texte jusqu'en juillet 1908, date à partir de laquelle la maison Rogers and Company prit le relais. La préférence de Stieglitz alla à un caractère gras noir, avec l'introduction de la couleur rouge pour la première lettre très ouvragée de chaque article, imprimée à l'intérieur de grandes marges et inspirée des motifs de William Morris. Tous les numéros étaient reliés par une couverture en papier de couleur gris-vert, le titre, les détails de la publication et de l'édition étant imprimés dans un gris plus clair. Comme ces éléments graphiques ne subirent aucun changement au fil des cinquante numéros, la collection complète de *Camera Work* possède une cohérence rare pour une revue. La reliure était assurée par la firme Knickerbocker Bindery, à New York.

Malgré quelques entorses à la règle, la fréquence de parution devait être trimestrielle; l'abonnement annuel coûtait 4 dollars pour quatre numéros et les numéros à l'unité se vendaient au prix de 2 dollars. L'envoi en recommandé et l'emballage en carton entraînaient une majoration de 50 cents par exemplaire. Bientôt, le prix de l'abonnement annuel doubla et, comme on s'efforçait d'encourager l'abonnement et de constituer une sorte de fonds de roulement, il arriva que d'anciens numéros se vendent au prix de l'abonnement annuel, comme ce fut le cas pour le numéro

spécial consacré à Steichen (*Steichen Supplement*). Dans les années 1920, le numéro spécial Stieglitz (n° 36, 1911) se vendait 15 dollars, tandis que le numéro double consacré à Paul Strand (n° 49/50, 1917) atteignait le record de 17,50 dollars. Dès le mois de juillet 1903, les quatre premiers numéros se vendaient chez Tennant and Ward, à New York, au prix de 10 dollars, soit plus du double de l'abonnement annuel. Au départ, la revue tirait à 1000 exemplaires et comptait presque 650 abonnés payants. En 1912, il n'en restait plus que 304, puis 36 en 1917, année où *Camera Work* tira à 500 exemplaires avant de cesser définitivement de paraître.

Lorsque, à partir de 1910, Stieglitz élargit son domaine de la photographie pure à l'art en général et ne fit plus paraître que quelques photographies par numéro, il perdit un grand nombre d'abonnés. Il paracheva la vente de l'édition à tirage limité en mettant au pilon d'anciens numéros disponibles de *Camera Work*, non sans s'être assuré que des institutions notoires comme la New York Public Library et la Royal Photographic Society en possédaient des collections complètes, offertes gratuitement et, dans ce dernier cas, presque toutes dédicacées. Il fit aussi don d'une collection complète à la Camera Club Library, dont il avait été responsable de la création à l'époque où il avait été rédacteur en chef de *Camera Notes* (1897–1902), et s'offusqua au plus haut point lorsque cette bibliothèque liquida des numéros dépareillés au prix dérisoire d'un dollar, alors que le taux officiel était dix fois plus élevé.

En 1911, Stieglitz écrivit à J. McIntosh, secrétaire et bibliothécaire de la Royal Photographic Society: «Je verrai si je peux faire un double des numéros 2, 11 et 12 de *Camera Work*, qui sont *très recherchés*, lorsque je vous enverrai les numéros 17 à 32 reliés pour compléter votre collection à ce jour. Je vais peut-être avoir du mal à trouver le n° 2: il compte parmi les plus rares et se négocie à six livres sterling sur le marché. Mais j'estime que la Royal doit posséder coûte que coûte une collection complète de la publication, dans laquelle j'ai véritablement investi toute mon âme. J'espère que vous aurez l'obligeance de signaler à vos Membres que détruire de quelque manière que ce soit l'intégralité de la collection revient à priver la Society d'un atout précieux dans tous les sens du terme. Cette revue effectue un travail de Titan pour défendre la Cause de la photographie et elle a contribué à convaincre

quelques-uns de ces adversaires parmi les plus acharnés, non seulement dans ce pays mais aussi dans le reste du monde.»[8]

La presse britannique spécialisée dans la photographie réserva un accueil très chaleureux à la sortie de *Camera Work*: «Lorsque *Camera Notes* était à son apogée, il semblait impossible de faire mieux. Que dire d'autre, sinon que le niveau a été dépassé avec *Camera Work*, que Stieglitz s'est surpassé lui-même et qu'il a, dans cette nouvelle publication, battu le record qu'il détenait et dont personne n'a jamais réussi à s'approcher.»[9]

«Le seul verdict possible est le suivant: *Camera Work* bat tous les anciens records en termes de dignité, de bon goût et de valeur réelle. [...] Trop souvent, l'attente du public exige que les périodiques consacrés à la photographie se cantonnent à un genre trivial et superficiel, mais ceux qui s'intéressent à la dimension artistique de la photographie trouveront là une lecture qui les marquera, qui les fera réfléchir, et des images qui sont aujourd'hui célèbres et continueront sans doute à le rester. A l'égard de *Camera Work* dans son ensemble, nous n'avons pas de termes élogieux trop élevés; la revue se suffit à elle-même; et de M. Alfred Stieglitz, les photographes américains ont toutes les raisons d'être fiers. Il est difficile d'évaluer tout ce qu'il a fait pour le bien de la photographie, travaillant depuis des années tout en se heurtant à une opposition farouche et sans guère susciter de sympathie; c'est à son extraordinaire puissance de travail, à son indépendance magistrale qui emporte la conviction, à son dévouement à la limite de l'abnégation, que nous devons aujourd'hui le splendide travail que nous avons sous les yeux.»[10]

Parmi les cinquante numéros échelonnés sur quatorze ans, beaucoup furent consacrés à l'œuvre d'un seul photographe ou aux travaux d'une école de photographes, en général aux membres de la Photo-Secession ou à leurs amis et défenseurs. La place réservée à la découverte de nouveaux talents était très restreinte. La vedette incontestée de *Camera Work* fut Eduard Steichen: on peut voir très souvent des reproductions de ses photographies et lire régulièrement des textes critiques qu'il écrivait sur l'art et la photographie en couleur. Sur l'ensemble des

quatorze années, Steichen eut droit à 68 reproductions de clichés et il se vit consacrer cinq numéros spéciaux: le numéro 2 d'avril 1903, le numéro 14 d'avril 1906, un numéro hors série intitulé *Steichen Supplement* (également paru en avril 1906), le numéro 22 d'avril 1908 et le numéro 42 d'avril-juillet 1913. Il partagea le numéro 14 d'avril 1906 avec Stieglitz, qui avait pris quatre photographies d'installation des «Little Galleries», ouvertes depuis peu, dont il avait en partie conçu l'aménagement et qui présentait une exposition de ses œuvres. Le *Steichen Supplement* reparut plus tard en édition à tirage limité, sous la forme de 65 portfolios réalisés par Stieglitz.

Les autres photographes qui se virent consacrer l'intégralité d'un numéro furent: Alvin Langdon Coburn (n° 21, janvier 1908), Clarence H. White (n° 23, juillet 1908), Frank Eugene (n° 30 et 31, avril et juillet 1910), Heinrich Kühn (n° 33, janvier 1911), David Octavius Hill et Robert Adamson, photographes des années 1840 dont on redécouvrait les travaux, même si le nom du second ne fut pas mentionné (n° 37, janvier 1912). C'est à partir des épreuves originales, propriété de James Craig Annan, que l'on imprima des gravures de leurs œuvres. Mentionnons enfin le baron Adolf de Meyer (n° 40, octobre 1912), James Craig Annan (n° 45, janvier 1914, paru en juin de la même année) et Paul Strand (n° 49/50, juin 1917).

Stieglitz ne s'offrit jamais le luxe de consacrer l'intégralité d'un numéro à son propre travail, même s'il s'en fallut de peu avec le numéro 12 d'octobre 1905 (où figuraient dix reproductions de lui, à côté de peintures de la Renaissance) et avec le numéro 36 d'octobre 1911 (qui contenait seize de ses gravures et une similigravure d'une eau-forte de Picasso, qu'il avait achetée après l'avoir exposée). Cependant, en reproduisant 47 travaux de sa main et quatre travaux cosignés par Clarence H. White, Stieglitz arriva en seconde position parmi les photographes les plus représentés dans *Camera Work*.

Il y eut aussi des numéros consacrés entièrement, ou presque, à des groupes de photographes comme le Trifolium de Vienne, qui rassemblait Heinrich Kühn, le docteur Hugo Henneberg et Hans Watzek (n° 13, janvier 1906). De même, un numéro fut consacré à la photographie française, avec des œuvres de Robert Demachy, Constant Puyo et René Le Bègue (n° 16, octobre 1906), et deux

autres aux femmes photographes, avec des œuvres d'Annie Brigman, Ema Spencer et Alice Boughton (n° 25 et n° 26, janvier et avril 1909). De nombreux photographes qui étaient souvent apparus dans les premières années disparurent ensuite, lorsque les intérêts de Stieglitz se portèrent ailleurs et que les anciens liens amicaux se dénouèrent à cause de rivalités.

Insatisfait du manque de galeries new-yorkaises exposant des photographies et poussé par le vif désir de créer un espace idéal pour les œuvres de la Photo-Secession, Stieglitz se mit en quête d'un lieu possible. En novembre 1905, «The Little Galleries of the Photo-Secession» ouvrirent au numéro 291 de la 5ᵉ avenue, dans un espace trouvé par Steichen dans le même immeuble où il avait installé son atelier. Le loyer était de 50 dollars par mois et Stieglitz dépensa 300 dollars de plus en frais de menuiserie et d'équipement électrique. Les abonnements des membres de la Photo-Secession, au prix de 5 dollars par an, ne permirent de couvrir qu'une partie des dépenses et Stieglitz y fut apparemment de sa poche pour payer le reste.

L'inauguration de la galerie fut annoncée, non sans une note de fierté, dans le numéro 14 de *Camera Work* paru en avril 1906: «En regardant les illustrations sur une autre page, nos lecteurs peuvent se faire une idée de la disposition et de la décoration des expositions de la Photo-Secession. Jusqu'à présent, à deux ou trois exceptions près, les photographies n'ont pas été montrées à leur avantage. L'affluence des visiteurs, l'éclairage violent ou, pire encore, insuffisant, le mélange incongru des couleurs n'ont certainement pas contribué à une approche satisfaisante des photographies pictorialistes. C'est en gardant ces faits présents à l'esprit que l'on a aménagé les ‹Secession Galleries›, afin que chaque photographie prise isolément se révèle sous son jour le plus avantageux. L'éclairage a été conçu pour plonger le visiteur dans une lumière douce et diffuse, tandis que les images exposées reçoivent la lumière naturelle grâce à une verrière; on a retenu les sources d'éclairage artificiel aussi bien pour leur caractère décoratif que pour leur utilité. Dans l'une des plus grandes salles, la tonalité d'ensemble est sans éclat, couleur vert olive: le revêtement mural est en toile gris-vert et dégage une certaine chaleur, les boiseries et les moulures reprennent les mêmes teintes, mais dans une nuance

beaucoup plus sombre. Les tentures sont en satin brun, le plafond et la voûte sont d'un gris-crème très soutenu. La petite salle a été conçue pour accueillir des clichés montés sur des armatures très légères ou dans des cadres blancs. Les murs sont recouverts d'une toile naturelle blanchie, les boiseries et les moulures sont d'une blancheur immaculée et les tentures, écrues et sans éclat. La troisième salle est décorée en gris-bleu, rose clair et gris-vert. Dans toutes les salles, les abat-jour sont assortis aux revêtements muraux.»[11]

L'exposition inaugurale de la première saison s'étendit sur cinq mois, de novembre 1905 à avril 1906, et rassembla cent œuvres de trente-neuf photographes différents, tous membres de la Photo-Secession. Les artistes le mieux représentés étaient Steichen (onze clichés), White, Käsebier, Keiley et Stieglitz (respectivement neuf, huit et sept clichés pour les deux derniers). La galerie était ouverte de midi à 18 heures, six jours par semaine sauf le dimanche, et l'entrée était gratuite. La première saison attira 15 000 visiteurs. Sur les 384 clichés exposés, il y en avait 249 à vendre et il s'en vendit effectivement 61, au prix moyen de 45,86 dollars. Stieglitz fut lui-même le plus gros acheteur. La galerie devint le lieu de rencontre des membres de la Photo-Secession et de certains adhérents intéressés. Auparavant, ils ne pouvaient se retrouver que dans des restaurants ou des clubs, mais cette dimension sociale du groupe n'en continua pas moins de se consolider sans relâche.

Au cours de la deuxième et de la troisième saison, Stieglitz conserva un choix de photographies sensiblement identique, mais il organisa peu à peu des expositions autres que photographiques. En 1907, tout d'abord, il présenta une exposition supplémentaire de dessins de Pamela Colman Smith, artiste symboliste américaine qui vendit trente-trois œuvres à cette occasion. Plus généralement, il se chargea d'introduire l'art français aux Etats-Unis, non sans susciter maintes controverses. En même temps, il continuait d'acquérir des photographies, ce qui lui permettait de financer sa propre galerie par un autre biais.

En 1907 et en 1909, Stieglitz se rendit en Europe et fit la connaissance de Matisse et Rodin. C'est Eduard Steichen qui, après avoir passé quelques années à fréquenter les milieux artistiques parisiens, avait attiré son attention sur

leur travail, ainsi que sur Cézanne, Van Gogh et Braque. En janvier 1908, la galerie «291» fut la première, à New York, à exposer 58 dessins originaux de Rodin, sélectionnés par l'artiste et par Steichen à Paris; puis, très vite, eut lieu la première exposition américaine de lithographies, de tableaux, de dessins et d'eaux-fortes de Matisse, toutes œuvres que Steichen avait lui-même rapportées dans ses bagages.

Ce fut donc grâce à l'enthousiasme de deux photographes, ainsi qu'à leurs ressources financières et leur talents d'organisateur, que le public américain découvrit l'art français contemporain.

Le gigantesque succès remporté par la galerie, fréquentée par quelque 50 000 personnes en trois saisons, poussa le propriétaire à doubler le loyer et à imposer un bail de quatre ans. Comme les revenus annuels de la Photo-Secession ne dépassaient pas 300 dollars, une fois totalisés tous les abonnements à 5 dollars pièce, ces nouvelles conditions auraient entraîné un énorme investissement financier de la part de Stieglitz. Or, celui-ci n'avait pas le désir ou les moyens d'y faire face. La galerie ferma donc ses portes et le lieu retrouva son ancien usage.

Cependant, une autre galerie ouvrit bientôt de l'autre côté du couloir: elle était subventionnée par un nouveau membre de la Photo-Secession et occupait un espace plus petit, de 14 mètres carrés à peine. Comme le nombre d'adhésions et d'abonnements allait diminuant, cette seconde galerie suffit amplement à organiser des expositions d'art plus réduites, plus intimes, qui se démarquaient des anciennes expositions de photographies centrées sur les Sécessionnistes.

A mesure que les goûts personnels et esthétiques de Stieglitz l'éloignaient de la photographie, le programme des expositions se fit éclectique. Au cours des quelques années qui suivirent, il présenta les œuvres de jeunes peintres américains, nouveaux venus sur la scène artistique. Nombre d'entre eux avaient habité et travaillé à Paris, comme Marsden Hartley et John Marin. Entre 1911 et 1916, le public américain put aussi découvrir des dessins et des aquarelles de Picasso, ainsi que des œuvres de Braque, Picabia, Brancusi et Severini, ou encore de la poterie mexicaine et de la sculpture africaine. Sans oublier Georgia O'Keeffe. Entre 1910 et 1917, le «291» n'accueillit que quatre expositions de photographie.

A cette époque, Stieglitz entretenait avec le monde de la photographie des rapports en général explosifs qui commencèrent à se disloquer vers 1908. Sa défense de la photographie avait beau susciter un mélange de loyauté et d'admiration intenses, son attitude dictatoriale et arrogante n'en inspirait pas moins tour à tour colère et méfiance.

Même si c'était toujours pour y revenir, Sadakichi Hartmann quitta à plusieurs reprises les services littéraires de *Camera Work* en accusant Stieglitz de tyrannie et de despotisme. Nul doute que ces deux chefs d'accusation aient été en partie fondés. En 1908, Stieglitz se vit refuser l'adhésion au Camera Club sous le prétexte qu'il œuvrait contre les intérêts du Club; piqué au vif, il publia dans *Camera Work* la correspondance mi-courtoise mi-acerbe qui s'était ensuivie, se servant ainsi des colonnes de la revue pour s'y justifier.

A la suite d'autres groupes sécessionnistes européens qui s'étaient déjà effondrés, en général dans l'amertume, le «Linked Ring» de Londres finit par se dissoudre à son tour en 1909, dans un imbroglio d'antipathies réciproques. En cherchant à affirmer de plus en plus sa domination sur les photographes de la Photo-Secession, Stieglitz donnait l'impression de s'accrocher désespérément à une illusion. Il tentait de sauver un organisme qui s'était désormais émancipé de sa tutelle. Gertrude Käsebier et Clarence H. White remportaient un certain succès dans le monde honni du «commerce» et, moyennant quelques changements de programme, ils allèrent grossir les rangs d'autres institutions photographiques. Bien d'autres artistes pensaient pareillement que la photographie devait s'ouvrir davantage au lieu de se limiter aux fonctions que lui attribuait Stieglitz ou à celles qui répondaient à ses propres attentes.

Stieglitz eut alors un réflexe typique: il fit table rase du passé et, non sans ressentiment, se mit à détourner ses énergies de la photographie pour les canaliser dans l'art. Pendant les neuf années qui précédèrent la fermeture du «291» (1917), il n'y organisa que quatre expositions de photographie et orienta de façon spectaculaire la mission de la galerie vers la présentation d'œuvres d'art, en particulier issues du modernisme européen. Quant à la revue *Camera Work*, elle aurait tout

aussi bien pu être rebaptisée «Art Work» à ce stade de son existence. A partir de l'année 1910, Stieglitz accorda une place bien plus grande à des illustrations d'art contemporain dans ses pages. Certes, la revue s'était toujours donné pour but de couvrir le domaine de l'art à égalité avec la photographie. Mais l'équilibre, à présent, s'inversait brusquement. C'était tout l'esprit de *Camera Work* qui changeait. La politique d'exposition du «291» et les textes et illustrations de la revue se mirent à refléter l'évolution constante de la philosophie de Stieglitz en matière d'art et de photographie, cette dernière passant désormais au second plan. Le «291» variait les plaisirs. Sur les cimaises, des dessins de Walkowitz succédèrent à des caricatures de Frueh et de De Zayas, intellectuel et caricaturiste mexicain qui acquit rapidement une très grande importance dans le cercle de Stieglitz.

Le point fort du «291», cependant, et qui inspira la jeune génération d'artistes américains, était l'art modern français. Pendant les quelques années qui suivirent, Stieglitz organisa des expositions individuelles et collectives de Cézanne, Toulouse-Lautrec, le Douanier Rousseau et Renoir (autant de premières américaines) et il revint à plusieurs reprises à Matisse et Rodin, dont il présenta davantage de dessins et sculptures. L'exposition Matisse, dont le contenu avait été sélectionné par Eduard Steichen en collaboration avec l'artiste lui même, attira 4000 visiteurs malgré l'exiguïté de la salle de 14 mètres carrés. En avril 1911, Stieglitz réussit un joli coup en montrant, pour la première fois aux Etats-Unis, 83 aquarelles de Picasso choisies par De Zayas à Paris. L'exposition connut un tel succès qu'elle se prolongea jusqu'au mois de mai.

Toutes ces expositions étaient organisées par Stieglitz, souvent avec l'assistance de Steichen; elles avaient lieu dans la minuscule galerie et représentaient un budget dérisoire. C'était des années avant que l'Armory Show de New York (1913), pour lequel on sollicita l'avis de Stieglitz, accueillît enfin l'art moderne dans un lieu aux dimensions convenables. L'une des rares expositions de photographie organisées à cette époque fut consacrée à Steichen: on y vendit pour 1500 dollars de clichés et elle attira 2500 visiteurs. Au total, ce furent 160 000 personnes qui fréquentèrent le «291» en sept ans, de 1905 à 1912.

Même si la Première Guerre mondiale allait finir par affecter la facilité apparente avec laquelle Stieglitz continuait, bon gré mal gré, à importer des œuvres d'art de France, il réussit à rassembler dans deux salles de la galerie, aux alentours de Noël 1915, des œuvres d'Eli Nadelman. Pour sa dernière saison, en 1916–1917, la galerie «291» commença par accueillir une exposition d'aquarelles de Georgia Engelhard, une nièce autodidacte de Stieglitz alors âgée de dix ans. A deux reprises furent présentés les aquarelles, les huiles, les dessins au fusain et les statues de Georgia O'Keeffe, avec laquelle Stieglitz vécut à partir de 1918 et qu'il épousa en 1924. Dans le travail de G. O'Keeffe, Stieglitz percevait l'aboutissement du naturalisme, de la vérité, de l'honnêteté et de la réalité qu'il cherchait depuis longtemps, toutes qualités devant lesquelles les autres productions artistiques faisaient pâle figure. La galerie «291» ferma au mois de juin 1917.

L'accent mis sur l'art avait commencé à provoquer des juxtapositions plutôt étranges dans les pages de *Camera Work*. Ainsi, dans le numéro 29 de janvier 1910, ce n'était pas sans un certain malaise que dix photogravures de George H. Seeley, qui perpétuaient les valeurs pictorialistes de la vie domestique et du mystère de la femme, côtoyaient quatre caricatures extravagantes de Marius de Zayas.

Dans le numéro 32 d'octobre 1910, Stieglitz fit reproduire des dessins et des nus de Matisse. Les nus de Matisse provoquèrent un frisson parmi les abonnés. Mais loin de se laisser démonter, Stieglitz consacra le numéro 34/35 d'avril-juillet 1911 à Rodin: il rassembla quatre gravures de Rodin réalisées par Steichen et ses sculptures de Balzac, ainsi que neuf gravures et phototypes en couleurs – uniquement des nus – de dessins de Rodin. La plus grande partie du texte, dans ce numéro, traitait de Rodin en particulier et de l'art français en général. A ce stade, presque la moitié des abonnés restants annulèrent leur abonnement, tant la proportion des nus les inquiétait. S'ils pouvaient tolérer des photographies de vraies femmes nues, il n'en allait certainement pas de même pour ce qui était des tableaux représentant des femmes nues.

Stieglitz avait pourtant anticipé cette réaction: «Aux quelques lecteurs qui ne comprendraient pas pourquoi nous avons fait figurer ces dessins dans

les pages de *Camera Work*, nous mettrions en avant, outre l'importance des originaux, la beauté des reproductions: elles illustrent avec intérêt ce que peut réaliser l'une des branches les plus utiles et les plus fertiles de la prise de vue, à savoir: les procédés photomécaniques. La valeur de ces images est donc double. D'une part, elles permettent à ceux qui ne peuvent voir les originaux de se familiariser avec les études les plus intimes réalisées par quelques-uns des plus grands artistes de notre époque; d'autre part, elles nous font mieux comprendre les possibilités de la reproduction photographique dès lors que président à l'opération le sentiment artistique et le savoir technique. Par ailleurs, nous voudrions rappeler aux lecteurs qu'un des objectifs de *Camera Work* consiste à refléter les activités de la Photo-Secession et de sa galerie. La nature de ces activités a souvent fait l'objet de mises au point dans les dernières livraisons de la revue.»[12]

Dans le numéro 36 d'octobre 1911 consacré à Stieglitz, la présence d'une eau-forte de Picasso confirma, si besoin était, que Stieglitz avait désormais tourné la page du pictorialisme. Ici, comme dans les numéros suivants, le texte reprenait en grande partie des articles de presse concernant les dernières expositions du «291» et il ne s'y ajoutait que peu d'articles inédits ayant fait l'objet de commandes, encore moins sur le thème de la photographie. Les articles provenaient de revues d'art et les comptes rendus d'expositions étaient parus dans des journaux [...]. Stieglitz était fatigué, malade, et la publication était de plus en plus irrégulière.

En août 1912 parut un numéro spécial consacré à égalité à sept nus de Matisse et à sept tableaux et sculptures de Picasso, parmi lesquels l'eau-forte de 1911, reproduite une seconde fois. C'était le premier numéro de *Camera Work* à ne pas contenir une seule photographie, signe manifeste de la nouvelle orientation que prenaient les intérêts de Stieglitz. Gertrude Stein y publia des textes critiques sur Matisse et Picasso, et ses articles parurent à nouveau dans le numéro spécial consacré à l'art, Special Number, en juin 1913: nouveau style, nouveau contenu. La rupture était consommée avec le ton plus familier et souvent fleuri des articles de Caffin, De Casseres et autres De Zayas. L'art moderne ne pouvait se concevoir, désormais, sans une écriture moderne en regard.

Après 1913, plusieurs facteurs convergèrent pour causer finalement la faillite de *Camera Work*. Ce furent d'abord la chute libre des abonnements et les faibles rentrées d'argent qui s'ensuivirent, quand bien même Stieglitz ne s'était jamais arrêté à des considérations financières pour agir selon ses désirs. La Première Guerre mondiale entraîna une pénurie presque totale des gravures de qualité supérieure que fournissait jusqu'alors Goetz à Berlin. Stieglitz s'impliquait davantage dans les activités du «291», qui lui prenaient de plus en plus de temps, tout comme les préparatifs en vue de l'Armory Show of Modern Art de 1913 et son engagement aux côtés de De Zayas pour fonder une autre revue et une autre galerie, qui eurent une existence éphémère.

Entre 1913 et 1917 ne parurent que six nouveaux numéros de *Camera Work*, les deux derniers (n° 49 et n° 50) sous la forme d'un numéro double. Le numéro 47 fut lancé dans un esprit de justification: il ne comportait aucune illustration de photogravure, aucune reproduction de tableau, mais à la place, un choix de 68 lettres qui répondaient à la question: «Qu'est-ce que le ‹291›?» Comme les chiffres de la fréquentation baissaient, ce numéro put faire l'effet d'une ruse cynique visant à intéresser de nouveau le public, ou bien d'une stratégie d'économie financière, les dépenses en photogravures grevant le budget de la revue. Il est pourtant probable que Stieglitz ait cherché à se rassurer sur le nombre de personnes pour lesquelles *Camera Work* et le «291» avaient compté, et qu'il ait souhaité imprimer ces opinions avant la suspension de la revue et la fermeture de la galerie. Non moins probable est le fait qu'il se soit lassé des complications, de la charge de travail et des dépenses occasionnées, auxquelles il devait presque toujours faire face seul. Même lui n'était pas épargné par la réalité déprimante de la Première Guerre mondiale.

Certaines lettres étaient parcourues d'une étrange émotion, d'autres étaient bassement serviles. On avait sollicité toutes les catégories de la population, depuis Hodge Kirnon, garçon d'ascenseur d'origine indienne qui travaillait depuis 1912 au numéro 291 de la 5ᵉ avenue, jusqu'à Man Ray, peintre, décorateur, écrivain (et plus tard photographe); depuis Adolf Wolff, sculpteur, poète et

anarchiste new-yorkais jusqu'à Francis Picabia, peintre français. En réponse à la question «Que signifie le ‹291› pour vous?», Clara Steichen écrivit sur un ton quelque peu cynique: «J'ai cousu, fait les ourlets et accroché les premiers rideaux du ‹291›. Depuis, d'autres y ont brodé en paroles et accroché leurs œuvres.»[13] Eduard Steichen prit un ton encore plus cynique. Depuis longtemps, des brouilles l'opposaient à Stieglitz et il lui avait conseillé, quelques années plus tôt, d'interrompre la publication de *Camera Work* et de fermer le «291». A la même question, il répondit: «J'ai l'impression, depuis un an ou deux, que le ‹291› piétine. [...] Je ne parviens pas non plus à expliquer [...] l'attitude qui a débouché sur la publication du présent numéro de *Camera Work*. A moins que le désœuvrement actuel du ‹291› n'en soit la cause. Retour de l'imprévu: la guerre.»[14]

L'avant-dernier numéro de *Camera Work* (n° 48, octobre 1916) consistait en un bilan du passé, du présent et de l'avenir. C'était un résumé des treize dernières années de la vie de Stieglitz. Pour représenter le passé, il avait choisi *The Cat* (Le chat) de Frank Eugene, tout empreint de valeurs pictorialistes, *Winter* (Hiver) d'Arthur Allen Lewis, *Portrait* de Francis Bruguière et un cliché d'une installation de photographies allemandes et viennoises exposées au «291» en mars 1906.

Le présent et l'avenir étaient représentés par des clichés de différentes expositions ayant également eu lieu au «291»: celle des sculptures de Constantin Brancusi (mars 1914), de l'art nègre (novembre 1914), de Pablo Picasso et Georges Braque (1915), de Eli Nadelman (deux salles, décembre 1915).

Le seul avenir qui s'ouvrait à la photographie était représenté par Paul Strand, qui se vit consacrer l'intégralité des deux derniers numéros et dont le travail fut le premier à captiver Stieglitz pendant de nombreuses années. Celui-ci décida de faire ses adieux en beauté, sans pleurnicher, et de montrer que le vieux croûton qu'il était avait encore des ressources. Dans l'œuvre de Strand, il percevait une version photographique de l'abstraction qu'il aimait tant dans la peinture de Picasso, et cette abstraction, voilà qu'il la retrouvait dans sa première passion, la photographie.

Le numéro consacré à Strand finit d'enfoncer le clou dans le cercueil du pictorialisme. Imprimé sur un papier plus épais avec force et vigueur, employant une encre différente et plus noire, il était loin de la délicatesse, de la transparence et de la fragilité du papier japon utilisé jusque-là. Avec ce dernier numéro, Stieglitz transmettait son vademecum à l'avenir du genre photographique: quand il s'en était emparé, c'était une forme tendre et picturale; quand il en prit congé, le médium s'était redressé et endurci. Les photographies de Strand, comme le texte d'accompagnement de Stieglitz, incarnaient à la perfection l'idéal d'une communication forte et directe: «Son œuvre s'enracine dans les meilleures traditions de la photographie. Sa vision est toute en puissance. Son travail est pur. Direct. Il ne repose pas sur des trucages de procédé. Tout ce qu'il fait est marqué au sceau d'une intelligence pratique. [...] Les onze photogravures reproduites dans ce numéro représentent le vrai Strand, l'homme qui a vraiment réussi à créer de l'intérieur, le photographe qui a ajouté quelque chose à ce qui se faisait avant lui. Son travail frappe par sa brutale immédiateté. Foin des balivernes, des trucages et des mots en -isme. Foin des tentatives destinées à mystifier un public ignorant, photographes compris. Ces clichés sont l'expression directe d'aujourd'hui. Nous les avons reproduits dans toute leur brutalité.»[15]

Stieglitz redécouvrit la photographie et l'art par l'intermédiaire de Paul Strand et de Georgia O'Keeffe. Pendant les quelques années qui suivirent, il se consacra à son propre travail qu'il avait longtemps mis en veilleuse, accaparé par la Photo-Secession, laquelle avait fini par le laisser en plan en refusant elle-même d'évoluer. Il photographia Georgia O'Keeffe avec obsession, mit au point sa croyance dans les «équivalents» et travailla avec fermeté et sans détour pour renforcer et rehausser la pureté et le naturalisme photographiques qui transparaissaient dans bon nombre de ses premières œuvres. «Mes photographies naissent toujours d'une nécessité intérieure, d'une expérience spirituelle. Ce ne sont pas des images que je fais [....]. J'ai une vision de la vie, à laquelle j'essaie de trouver des équivalents, parfois sous la forme de photographies. C'est parce qu'ils sont nombreux à faire de la photographie sans posséder de vision intérieure qu'il y a en réalité très peu de vrais

photographes. L'esprit est le même dans mes ‹premiers› et mes ‹derniers› travaux. Naturellement, j'ai grandi, j'ai évolué, j'en sais aujourd'hui bien davantage, je suis peut-être plus ‹conscient› de ce que j'essaie de faire. C'est ainsi que ce que j'ai pu gagner sur le plan de la forme et de la maturité, je l'ai peut-être perdu dans une autre direction. Ni le progrès ni l'amélioration n'ont de sens en art. Soit il y a art, soit il n'y a pas art. Mais il n'y a rien entre les deux.»[16]

Stieglitz n'avait plus besoin de la Photo-Secession, de *Camera Work* ou du «291» pour occuper son temps et son énergie, maintenant qu'il avait son propre travail de photographe et Georgia O'Keeffe. Celle-ci, en effet, incarnait tout l'art dont il avait jamais rêvé ou eu besoin. Il se peut même qu'il se soit alors senti, pour la première fois dans sa vie, vraiment heureux et en paix; qu'il ait formé un «équivalent» avec lui-même.

Il envisagea parfois de coordonner d'autres numéros de *Camera Work* pour y publier des œuvres de Charles Sheeler, de Georgia O'Keeffe et même de pictorialistes de la seconde génération, mais il ne passa jamais à l'acte. En 1923, il écrivit au président de la Royal Photographic Society, John Dudley Johnston: «J'ai songé, et songe encore, à consacrer un numéro de *Camera Work* au travail des British Workers: à vous, par exemple, et à Bennington, Arbuthnot, peut-être encore à un autre. *Camera Work* étant une histoire – ou une idée, un esprit, peu importe le terme – j'y songe bien sûr tout le temps. Il ne s'agit pas seulement de réunir une somme d'argent considérable, mais surtout de savoir où faire réaliser le travail aujourd'hui, pour que quelqu'un comme moi en soit satisfait.»[17]

En 1924, Stieglitz, qui était membre honoraire de la Royal Photographic Society depuis 1905, reçut la «Society Progress Medal», la plus haute distinction de l'institution, «en récompense de l'immense travail qu'il avait accompli pour fonder et soutenir l'école américaine de photographie pictorialiste, ainsi que pour lancer et publier, pendant quatorze ans, *Camera Work*, la tentative la plus aboutie de conservation artistique de clichés photographiques.»[18]

Il se mit à renouer avec des amis du passé dont il s'était éloigné et à entretenir une correspondance assidue. Pendant les vingt dernières années de sa

vie, il dirigea la galerie «Intimate Gallery» et la galerie «An American Place»: il y exposa en priorité de l'art, mais aussi de la photographie, pour peu qu'il en trouvât qui éveillât suffisamment sa curiosité: œuvres de Paul Strand, d'Ansel Adams et d'Eliot Porter. En 1930, il brûla les mille exemplaires restants de *Camera Work*, après s'être assuré qu'il avait bien fait don de collections complètes à la plupart des principales institutions. En 1933, il offrit au Metropolitan Museum of Art de New York sa collection privée, qui comprenait plus de six cents photographies prises par des membres de la Photo-Secession et d'autres photographes pictorialistes. A cette date, il en était arrivé à la conclusion que ce style photographique, dont il était pourtant seul responsable de l'ampleur qu'il avait prise en Amérique, n'avait pas beaucoup de valeur, et il voulait s'en défaire.

Stieglitz s'intéressa toujours plus au présent et à l'avenir qu'au passé. Il s'employa à faire comprendre l'art moderne et à susciter des réactions face à celui-ci; il établit de nouveaux critères de jugement qui portèrent un coup fatal aux principes du pictorialisme auxquels il avait donné naissance. C'était à vrai dire son propre enfant qu'il assassinait. Il ne cessa de rechercher le développement et l'évolution, la vitalité et l'intensité aux dépens de la routine et de la stagnation, et il se mit en quête de la vérité absolue, celle qui se trouve dans la liberté de l'expérience, quelle qu'en soit la forme d'expression. L'art devait innover par rapport à ce qui s'était produit auparavant. Il devait se donner pour but la transformation, faute de quoi ce n'était plus de l'art. Tout être porteur d'un message méritait d'être entendu, et Stieglitz avait plus de messages à livrer que la plupart des hommes.

Camera Work remplit de nombreuses fonctions. A un premier niveau, la revue fut d'abord le dernier avant-poste où se rencontrèrent l'art symboliste, la photographie et la littérature, avant de devenir, pour finir, le héraut du modernisme. A un second niveau, elle servit de catalogue d'exposition décalé au «291» et de machine publicitaire à la Photo-Secession. Tout en influençant de nombreux photographes, elle se vit reprocher sa nature anachronique par d'autres. Ainsi, Walker Evans ne pouvait se rappeler qu'une image de Paul Strand parmi les 559 reproductions qui y avaient été imprimées. Ansel Adams et Eliot Porter se souvenaient de Strand, Stieglitz et

Steichen, mais l'immense majorité des œuvres pictorialistes leur semblait appartenir à une autre époque, comme c'était d'ailleurs le cas. Par-dessus tout, la revue prit une dimension autobiographique et s'identifia à la vie créative d'un seul homme, celui qui en était le rédacteur en chef, le financier et la source d'inspiration. Un homme d'une prodigieuse efficacité. Un homme qui passa tantôt pour un despote ou un dictateur, tantôt pour un gourou, un prophète, voire un messie: Alfred Stieglitz. «Si seulement l'Angleterre avait eu son Stieglitz! Mais les Stieglitz sont denrée rare. Il suffit qu'un seul Stieglitz soit né dans notre génération, et notre dette à son égard est énorme. Il n'est pas seulement le plus grand photographe vivant, comme en sont depuis longtemps persuadés ceux qui connaissent son œuvre; il a aussi été (et de manière purement désintéressée) le plus grand propagandiste de la photographie.»[19]

Pas mal comme épitaphe.

1 A. Horsley Hinton, «The Work and Attitude of the Photo-Secession of America», *The Amateur Photographer*, vol. XXXIX, n° 1026, 2 juin 1904, pp. 426–428.

2 Sadakichi Hartmann est le nom, Sidney Allan le pseudonyme que l'on trouve uniquement dans les écrits sur la photographie.

3 Steichen changea plus tard l'orthographe de son nom Eduard Jean (forme française) en Edward John (forme anglaise).

4 Alfred Stieglitz, «Introduction», *Camera Work 1*, janvier 1903, pp. 15–16.

5 *Id.*

6 L'orthographe du nom Kühn varie dans *Camera Work*. Sur les photos reproduites dans la revue, il apparaît sous la forme Kuehn. Celle-ci a donc été choisie pour les légendes.

7 Alfred Stieglitz, «Our Illustrations», *Camera Work 4*, octobre 1903, pp. 25–26.

8 Alfred Stieglitz, lettre à J. McIntosh, secrétaire et bibliothécaire de la Royal Photographic Society, 31 août 1910, Archives de la Royal Photographic Society, Bath.

9 R. Child Bayley, «Camera Work», *Photography*, vol. XV, 3 janvier 1903, p. 738.

10 A. Horsley Hinton, «Camera Work», *Amateur Photographer*, vol. XXXVII, n° 953, janvier 1903, p. 4.

11 Equipe rédactionnelle de *Camera Work*, «The Photo-Secession Galleries», *Camera Work 14*, avril 1906, p. 48.

12 Equipe rédactionnelle de *Camera Work*, «Our Illustrations», *Camera Work 34/35*, avril/juillet 1911, p. 70.

13 Lettre de Clara Steichen, *Camera Work 47*, daté de juillet 1914 et paru en janvier 1915, p.20.

14 Lettre d'Eduard Steichen, *Camera Work 47*, daté de juillet 1914 et paru en janvier 1915, pp. 65–66.

15 Alfred Stieglitz, «Our Illustrations», *Camera Work 49/50*, juin 1917, p. 36.

16 Alfred Stieglitz, lettre à John Dudley Johnston, ancien président de la Royal Photographic Society, 3 avril 1925, Archives de la Royal Photographic Society, Bath.

17 Alfred Stieglitz, lettre à John Dudley Johnston, président de la Royal Photographic Society, 13 octobre 1923, Archives de la Royal Photographic Society, Bath.

18 *The Photographic Journal*, vol. LXV (nouvelle série, vol. XLIX), mai 1925, p. 250.

19 Ward Muir, «Camera Work and its Creator. A Historical Note», *The Amateur Photographer*, vol. LVI, n° 1829, 28 novembre 1923, pp. 465–466.

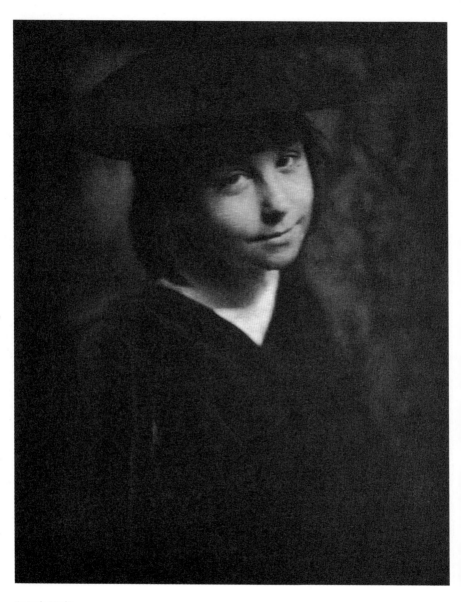

Gertrude Käsebier
Dorothy, 1903
Photogravure
20.1 x 16.2 cm

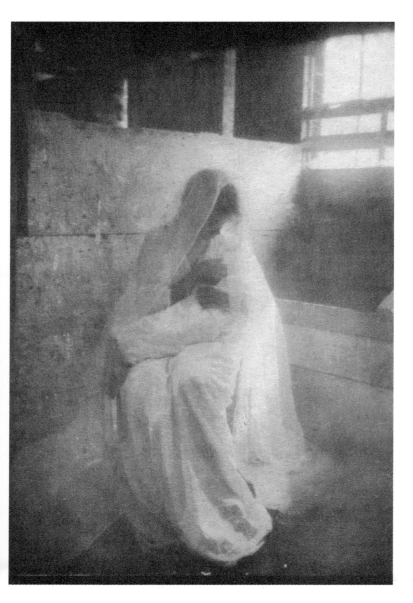

Gertrude Käsebier
The Manger, 1903
Photogravure
21.3 x 15.0 cm

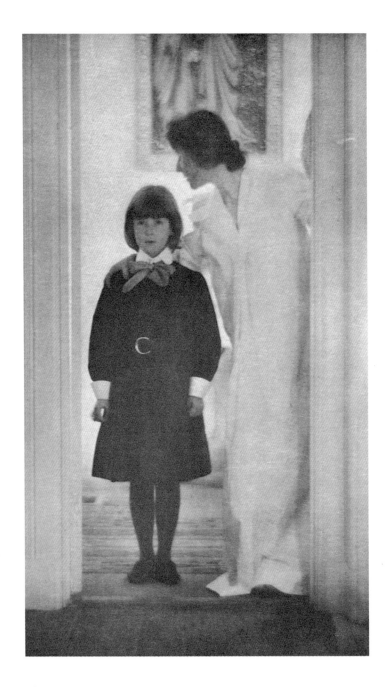

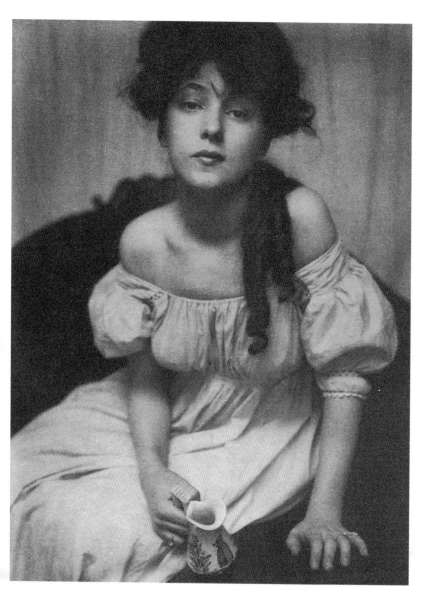

← Gertrude Käsebier
Blessed Art Thou Among Women, 1903
Photogravure
23.7 x 14.1 cm

Gertrude Käsebier
Portrait (Miss N.), 1903
Photogravure
19.7 x 14.7 cm

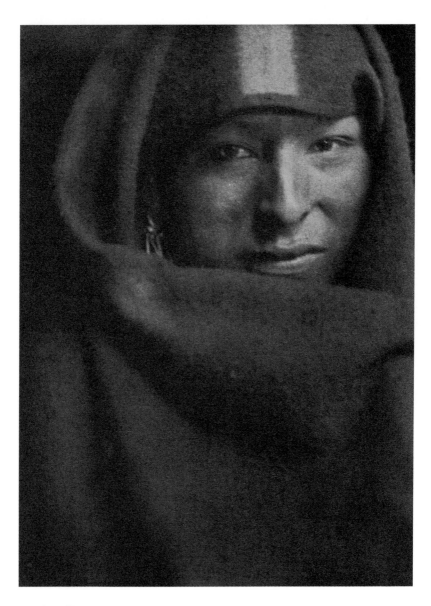

Gertrude Käsebier
The Red Man, 1903
Photogravure
18.4 x 13.6 cm

Gertrude Käsebier
Serbonne, 1903
Half-tone reproduction
18.1 x 13.9 cm

D. W. Tryon
Landscape, 1903
Half-tone reproduction
5.9 x 12.9 cm

Puvis de Chavannes
L' Hiver, 1903
Half-tone reproduction
8.3 x 12.9 cm

Alfred Stieglitz
The Hand of Man, 1903
Photogravure
15.9 x 21.1 cm

A. Radclyffe Dugmore
A Study in Natural History, 1903
Photogravure
11.2 x 17.2 cm

AN APOLOGY.

HE TIME appearing ripe for the publication of an independent American photographic magazine devoted largely to the interests of pictorial photography, "Camera Work" makes its appearance as the logical outcome of the evolution of the photographic art. IT is proposed to issue quarterly an illustrated publication which will appeal to the ever-increasing ranks of those who have faith in photography as a medium of individual expression, and, in addition, to make converts of many at present ignorant of its possibilities.

PHOTOGRAPHY being in the main a process in monochrome, it is on subtle gradations in tone and value that its artistic beauty so frequently depends. It is, therefore, highly necessary that reproductions of photographic work must be made with exceptional care and discretion if the spirit of the originals is to be retained, though no reproductions can do full justice to the subtleties of some photographs. Such supervision will be given to all the illustrations which will appear in each number of "Camera Work." Only examples of such work as gives evidence of individuality and artistic worth, regardless of school, or contains some exceptional feature of technical merit, or such as exemplifies some treatment worthy of consideration, will find recognition in these pages. Nevertheless the pictorial will be the dominating feature of the magazine.

"CAMERA WORK" is already assured of the support of photographers, writers and art critics, such as Charles H. Caffin, art editor of the American section of The International Studio and art critic of the New York Sun; A. Horsley Hinton, editor of The Amateur Photographer, London; Ernst Juhl, editor of the Jahrbuch der Kunstphotographie, Germany; Sydney Allan (Sadakichi Hartmann), the well-known writer on art matters; Otto W. Beck, painter and art instructor at the Pratt Institute, Brooklyn; J. B. Kerfoot, literary critic; A. Radclyffe Dugmore, painter and naturalist; Robert Demachy, W. B. Cadby, Eduard J. Steichen, Gertrude Käsebier Frank Eugene, J. Craig Annan, Clarence H. White, Wm. B. Dyer, Eva Watson-Schütze, Frances B. Johnston, R. Child Bayley, editor of Photography, and many others of prominence.

THOUGH the literary contributions will be the best of their kind procurable, it is not intended to make this a photographic primer, but rather a magazine for the more advanced photographer. "CAMERA WORK" owes allegiance to no organization or clique, and though it is the mouthpiece of the Photo-Secession that fact will not be allowed to hamper its independence in the slightest degree.

AN undertaking of this kind, begun with the sole purpose of furthering the "Cause" and with the intention of devoting all profits to the enlargement of the magazine's beauty and scope is dependent for its success upon the sympathy and coöperation, moral and financial, of its friends. And it is mainly upon you that the life of this magazine hangs. The many subscribers who have responded to our advance notice have encouraged us to believe that the future of the publication is assured beyond question; but we can not express too strongly the hope that you will continue your good offices in our behalf.

WITHOUT making further pledges we present the first number of "Camera Work," allowing it to speak for itself.

<div align="right">

ALFRED STIEGLITZ
Editor.

JOSEPH T. KEILEY
DALLETT FUGUET
JOHN FRANCIS STRAUSS
Associate Editors.

</div>

FROM A PHOTOGRAPH.

ALL shadows once were free;
But wingless now are we,
And doomed henceforth to be
In Light's Captivity.

<div align="center">JOHN B. TABB.</div>

GERTRUDE KÄSEBIER, PROFESSIONAL PHOTOGRAPHER.

N AUTHORITY recently summed up Mrs. Käsebier as the best portrait-photographer in the world. This is a sweeping characterization, entirely just, but to my mind it does not go quite far enough. MRS. Käsebier is great as an artist and as such her unrivaled ability is everywhere conceded, but she is greater still as a professional photographer in that she is putting the whole force of her individuality into the uplifting and dignifying of her work, which with her is both art and profession. Even the most unobservant must appreciate the fact that a new movement is stirring professional portrait-photography from one end of this country to the other.

IT is plainly evident on all sides, from the modest show-case of the humblest village photographer to the most pretentious of the lavish metropolitan establishments. Everywhere the professional photographer is breaking away from hide-bound tradition; the top-light, the head-rest, the papier-maché accessories are being thrown out on the junk-heap along with the stilted pose and other affectations of former years. Not that the photographic millennium has arrived by any means, but the professional everywhere is *reaching out* for something new—something different; sometimes blindly because it is "done" elsewhere, sometimes with a glimmer of true insight, and again with sincere appreciation of what they are really striving for. There are undoubtedly many causes at work to produce this revolution, but the frankest among the professionals admit that the chief factor in the movement is the amateur. Now the epitome of all that is best in the amateur as a class lies not only in Mrs. Käsebier's work, but through it, in her influence on other workers and on public opinion as well. With all the force of her wonderful personality she has struck the keynote of great achievement in photographic portraiture, and that keynote is absolute sincerity.

MRS. Käsebier's portraits are not always great and they are not always pleasing, but they are never insincere and she likewise never fails to place the stamp of her own individuality upon even the most commonplace and uninteresting of her sitters. A genius may evolve an occasional masterpiece and in this respect Mrs. Käsebier fully lives up to the term; but to portray with artistic insight "all sorts and conditions of men," the unwearying succession of the tall and the short, the stout and the lean, who fill the hours of the professional photographer, requires not only genius but a rare combination of other qualities—intuition, tact, sympathy and infinite patience. Gifted with such a temperament, this is what Mrs. Käsebier is doing and this is why her influence is extending in ever-widening circles to professionals everywhere, many of whom may not even know her name.

FRANCES BENJAMIN JOHNSTON.

YE FAKERS.

IT IS rather amusing, this tendency of the wise to regard a print which has been locally manipulated as irrational photography—this tendency which finds an esthetic tone of expression in the word faked.

A MANIPULATED print may not be a photograph. The personal intervention between the action of the light and the print itself may be a blemish on the purity of photography. But, whether this intervention consists merely of marking, shading and tinting in a direct print, or of stippling, painting and scratching on the negative, or of using glycerine, brush and mop on a print, faking has set in, and the results must always depend upon the photographer, upon his personality, his technical ability and his feeling.

BUT long before this stage of conscious manipulation has been begun, faking has already set in. In the very beginning, when the operator controls and regulates his time of exposure, when in the dark-room the developer is mixed for detail, breadth, flatness or contrast, faking has been resorted to. In fact, every photograph is a fake from start to finish, a purely impersonal, unmanipulated photograph being practically impossible. When all is said, it still remains entirely a matter of degree and ability.

SOME day there may be invented a machine that needs but to be wound up and sent roaming o'er hill and dale, through fields and meadows, by babbling brooks and shady woods—in short, a machine that will discriminatingly select its subject and by means of a skilful arrangement of springs and screws, compose its motif, expose the plate, develop, print, and even mount and frame the result of its excursion, so that there will remain nothing for us to do but to send it to the Royal Photographic Society's exhibition and gratefully to receive the "Royal Medal."

THEN, ye wise men; ye jabbering button-pushers! Then shall ye indeed make merry, offering incense and sacrifice upon the only original altar of true photography. Then shall the fakers slink off in dismay into the "inky blackness" of their prints.

<div align="right">EDUARD J. STEICHEN.</div>

IT is an error common to many artists, strive merely to avoid mistakes; when all our efforts should be to create positive and important work. Better the positive and important with mistakes and failures than perfect mediocrity.

FOLLOWERS manage to make of the foot-paths of a great man a wide road.

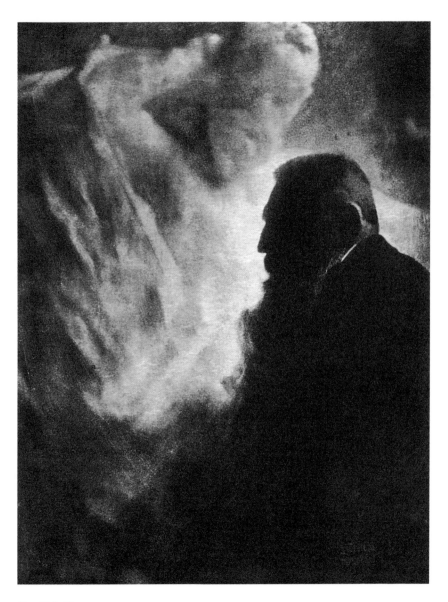

Eduard J. Steichen
Rodin, 1903
Photogravure
21.5 x 16.1 cm

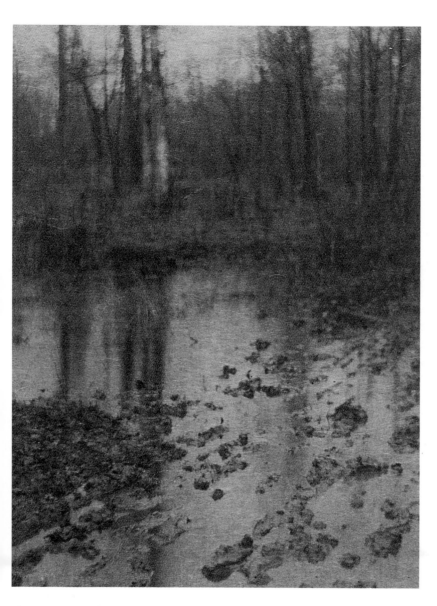

Eduard J. Steichen
The Pool, 1903
Photogravure
20.4 x 15.4 cm

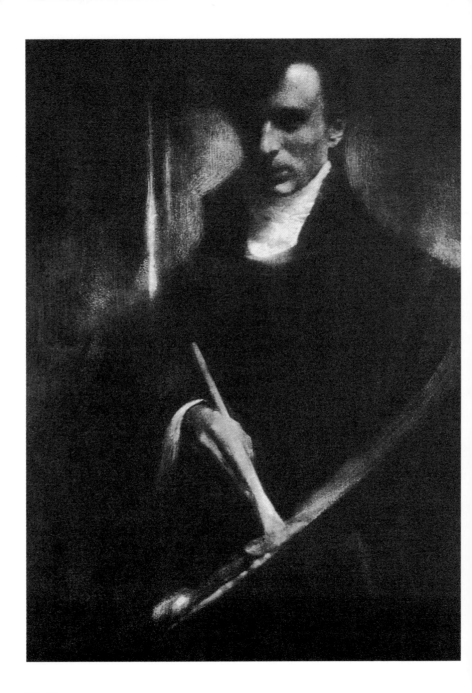

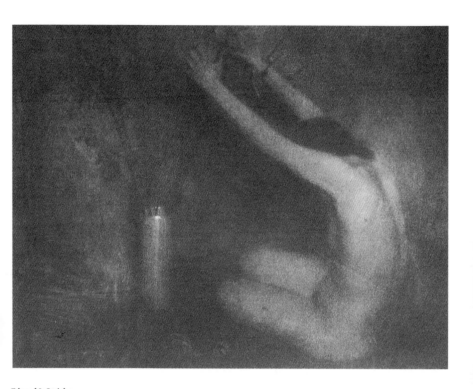

Eduard J. Steichen
Dawn-flowers, 1903
Photogravure
19.6 x 14.9 cm

←Eduard J. Steichen
Self-portrait, 1903
Photogravure
21.4 x 16.2 cm

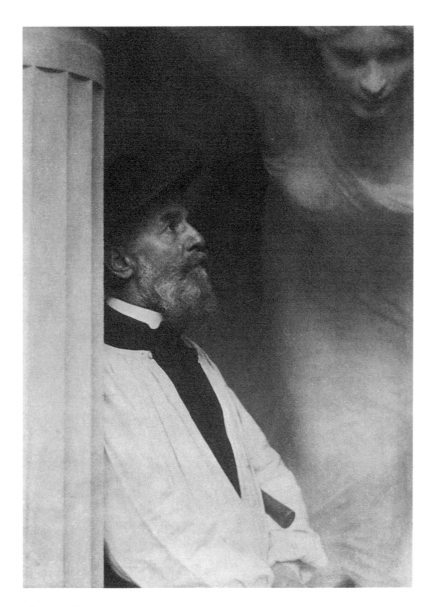

Eduard J. Steichen
Bartholomé, 1903
Photogravure
20.9 x 15.2 cm

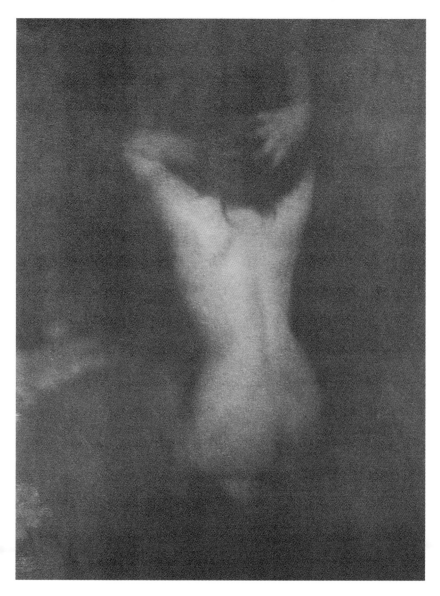

Eduard J. Steichen
Dolor, 1903
Photogravure
19.3 x 14.9 cm

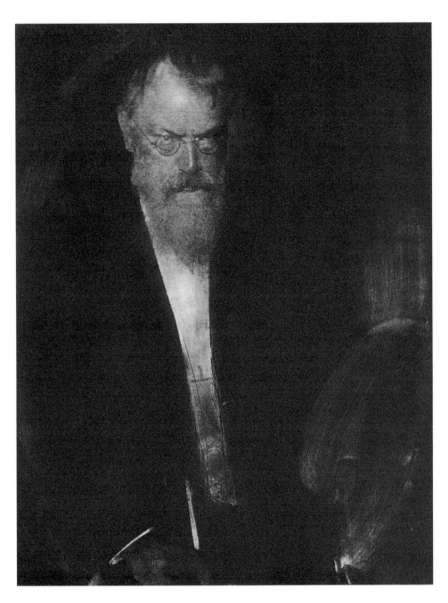

Eduard J. Steichen
Lenbach, 1903
Photogravure
19.7 x 15.3 cm

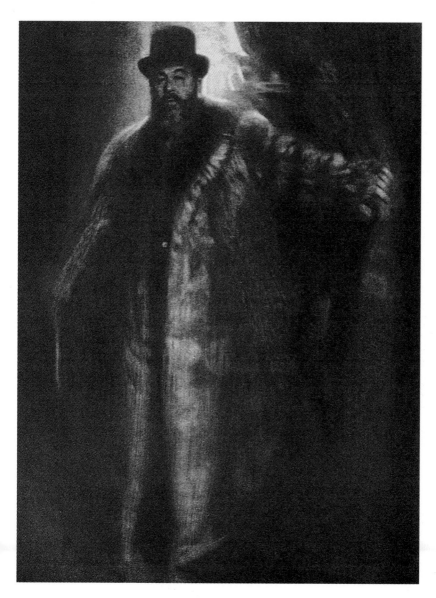

Eduard J. Steichen
Besnard, 1903
Half-tone reproduction
17.5 x 13.2 cm

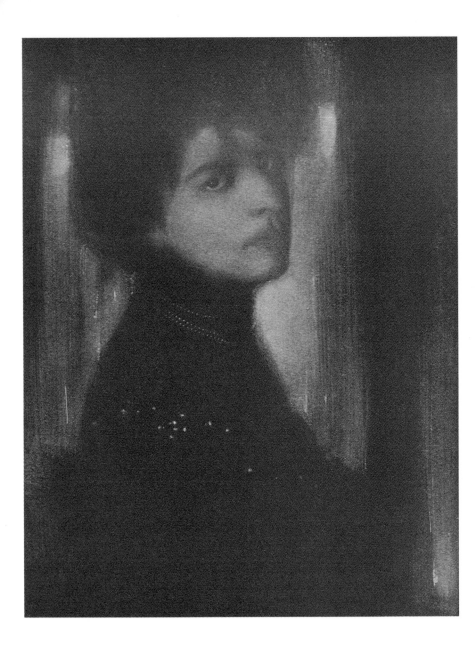

Eduard J. Steichen
Nude with Cat, 1903
Half-tone reproduction
10.8 x 13.4 cm

← Eduard J. Steichen
Portrait, 1903
Half-tone reproduction
16.9 x 13.2 cm

Eduard J. Steichen
Judgment of Paris – A Landscape Arrangement, 1903
Half-tone reproduction
15.3 x 11.6 cm

THE INFLUENCE OF ARTISTIC PHOTOGRAPHY ON INTERIOR DECORATION.

THE ELABORATE way in which the artistic photographers mount and frame their prints has attracted attention everywhere and called forth critical comment, favorable as well as the reverse, from various quarters.

NOBODY can deny that they go about it in a conscientious, almost scientific manner, and that they usually display a good deal of taste; but the general opinion seems to be that they attach too much importance to a detail which, although capable of enhancing a picture to a remarkable degree, can do but little toward improving its quality. The artistic photographers differ on this point. They argue that a picture is only finished when it is properly trimmed, mounted, and framed, and that the whole effect of print, mounts, or mat, signature, and frame, should be an artistic one, and the picture be judged accordingly.

THIS is a decided innovation. In painting, frames only serve as "boundary lines" for a pictorial representation, similar to those to which we are subjected in looking at a fragment of life out of an ordinary window.

THE frame clearly defines the painter's pictorial vision, and concentrates the interest upon his canvas, even to such an extent that all other environments are forgotten. At least, such was the original idea. But it seems that we have grown oversensitive in this respect; we would also like to see the frame harmonize with the tonal values of the picture it encloses.

BUT up to date very little has been done in this direction. The official exhibitions still insist on the usual monotony of gold frames, and the painters seem to have neither any particular inclination nor the opportunity to create frames of lovely forms and well-balanced repeating patterns of their own. The frame-makers and art-dealers are masters of the situation, and their interests are strictly commercial ones. "Attractive enough at first sight; hopelessly inartistic on further inspection," is the verdict which one has to give of the average frame of to-day. Tryon, Dewing, and Horatio Walker are the only painters I know, who seriously oppose the mechanically manufactured picture-frames. They have their frames specially designed for each picture—Stanford White being the designer of quite a number of them. Their frames are wide and flat without corners and centerpieces; the repeating pattern is generally a simple, classic ornament, with a tendency toward vertical lines. The coloring is gold, but tinted and glazed by the painter himself until it corresponds with the color keynote of the special picture the frame was designed for. This method will undoubtedly find favor with many of the younger men, but a radical change can not take place until the despotic "framing" rules of exhibitions have been abolished.

THE artistic photographers, on the other hand, had no rules to adhere to. All they wanted were artistic accessories for their prints. They could allow their imagination full sway. They obeyed every impulse and whim, and

indulged in any scheme as long as it was practical and specially adapted to the print for which it was planned. Every frame was made to order; they ransacked the frame-maker's workshops for new ideas and revolutionized the whole trade. The result was much that was bizarre and overfastidious (some photographers apparently mistook their packing paper mounts for sample-books of paper warehouses), but also a fair average of sterling quality was produced. The mounting and framing of the leading artistic photographers of America are simple, tasteful, and to the point; they go far ahead in this respect of all other black-and-white artists, and can proudly claim that they are the best mounters and frame-makers of the world.

THEIR style is largely built up on Japanese principles. The Japanese never use solid elevated "boundary lines" to isolate their pictures, but on the contrary try to make the picture merely a note of superior interest in perfect harmony with the rest of the *kake monos*, which again is in perfect harmony with the wall on which it is placed. The Japanese artist simply uses strips of beautifully patterned cloth to set off the picture, and endeavors to accentuate its lines and color-notes by the mounting and the momentary environments, which is easy enough, as the mounting is generally so artistically done that it fits in anywhere. (I refer, of course, only to Japanese homes.) Pictures in Japan are merely regarded as bits of interior decoration. The Japanese art-patron does not understand our way of hanging pictures in inadequate surroundings; he does not disregard the technical merits of a picture (which is to us always the most important point); on the contrary, he is very sensitive to them; but he always subordinates them to his inherent ideas of harmony. He would never hang a picture if it did not harmonize with the color of his screens, the form of his lacquer cabinets, etc.

THE artistic photographers try to be like the Japanese in this respect. They endeavor to make their prints bits of interior decoration. A Käsebier print, a dark silhouette on green wall-paper in a greenish frame, or a Steichen print mounted in cool browns and grays, can not be hung on any ordinary wall. They are too individual; the rest of the average room would jar with their subtle color-notes. They need special wall-paper and special furniture to reveal their true significance.

THAT is where the esthetic value of the photographic print comes in. It will exercise a most palpable influence on the interior decoration of the future. People will learn to see that a room need not be overcrowded like a museum in order to make an artistic impression, that the true elegance lies in simplicity, and that a wall fitted out in green and gray burlap, with a few etchings or photographs, after Botticelli or other old masters, in dark frames is as beautiful and more dignified than yards of imitation gobelins or repoussé leather tapestry hung from ceiling to floor with paintings in heavy golden frames.

WE have outgrown the bourgeois beauty of Rogers statuettes, and are tired of seeing Romney backgrounds in our portraits and photographs.

THE elaborate patterns of Morris have given way to wall-paper of one uniform color, and modern furniture is slowly freeing itself from the influence of former historic periods and trying to construct a style of its own, based on lines which nature dictates. Whistler and Alexander have preached the very same lesson in the backgrounds of their portraits. Everywhere in their pictures we encounter the thin black line of the oblong frame which plays such an important part in the interior decoration of to-day, and which invariably conveys a delightful division of space.

THE artistic photographer has elaborated on the black frame and white mat. He has created in his frame innumerous harmonies of color, form, and material, and if there shall ever be a demand for them, and if they shall ever serve as suggestions for interior decoration, we shall surely be able to steer clear of monotony; for I must confess that if the majority of rooms were furnished in the Whistler fashion (as suggested in "His Mother" and "Carlyle"), it would be as unbearable as the present museum style.

ALSO, the advanced professional photographers, slowly falling in with the steps of the artistic photographers, help the cause. The former way of mounting photographs on stiff board, which could only be put in albums or bric-à-brac frames on mantelpieces, etc., had no artistic pretence about it whatever. Their present way, mounting the print on large gray sheets of paper with rough edges and overlapping covers is really nothing but an invitation to buy a frame for the print and hang it on the wall. The professional print has acquired a pictorial significance.

BUT it is, after all, an open question whether these efforts will be crowned with success. We are too much interested in the utilitarian equipments of our homes, ever to give, as the Japanese do, first consideration to harmony. And harmony, perfect harmony, is necessary to adapt their style of interior decoration successfully, the elaborate details of which in turn are lost in the background, which is impossible with our present system of house-building. As long as door-jambs and window-sills and mantelpieces are manufactured wholesale, and as long as our rooms are infested with stereotype chandeliers, registers, etc., a burlap-wall, with a few "Secession" prints will not save us. And to go to the extreme, as some esthetes are apt to do—and they have to go to extremes from our view-point—will always be regarded as an eccentric, visionary accomplishment. I personally have never been sensitive to my surroundings; I like a general harmony of effect, but would tire of any room that carried out a distinct line- or color-scheme, and I would find it rather ridiculous to build a special sanctuary for a Whistler etching, a Dewing silver print, or a Steichen print. In Japan furniture is scant, and the interiors of the houses generally kept in a neutral tint, to which the details lend the color-notes. If our interiors were as simple and artistic as the Japanese ones, we should have a good basis to work on.

AS it is, the photographic prints are finger-posts in the right direction. Whether we can pursue the indicated path to the very end, is a question which the future has to decide.

SIDNEY ALLAN.

PHOTOGRAPHIC FABLES.

THE FLAMINGO AND THE CROWS.

THERE WAS once a Company of Crows who Greatly Admired the Beautiful Plumage of a Flaming Flamingo of their Acquaintance. They therefore said to one another, "Let us discover the Nature of his Food that we, also, may become Glorious." Now having Ascertained that Green Frogs, Black Tadpoles, and an occasional Gold Fish constituted their friend's Menu, they provided themselves with a like Fare at Considerable Trouble, but with Unsatisfactory Results. At last they consulted a Venerable Owl who dwelt in the Neighborhood. "You are but Fool Crows," said the Owl, "for though you should eat nothing but Cochineal Insects you would still be Black, but the Flamingo, while he might die eating Carrion, would yet die Crimson."

DO not Flatter Yourselves that if you knew the Emulsion on your Neighbor's Paper you could achieve his Results.

THE AMBITIOUS COCKATOO.

THERE once lived a Green Cockatoo whose Primitive Emotions were quite Adequately Expressed by the medium of his Native Language, which consisted of a series of Raucous Screeches. Being, however, an Ambitious Bird, and being much impressed by the Vocabulary of his two-legged but Unfeathered Neighbors, he proceeded to make Selections at Random. By these tactics and by an Unfailing Assiduity he occasionally fooled some Thoughtless Person and was thereby much Elated. But he continued to be spoken of by Unbiased Observers as "that Damned Parrot."

DO not think that copying the Idiosyncracies of your Betters will enable you to Pass for a Genius.

J. B. KERFOOT.

COLLINEAR WORK

Clarence H. White
Letitia Felix, 1903
Photogravure
21.1 x 14.5 cm

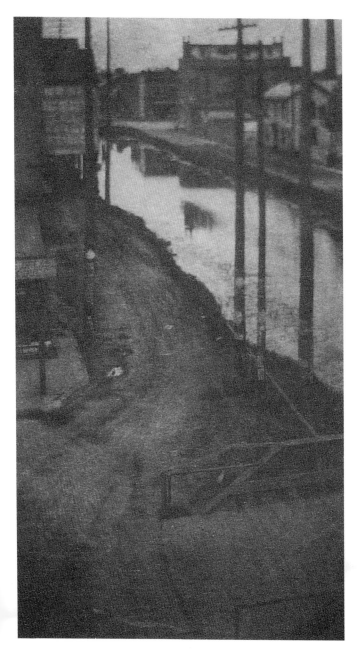

Clarence H. White
Telegraph Poles, 1903
Photogravure
18.8 x 10.5 cm

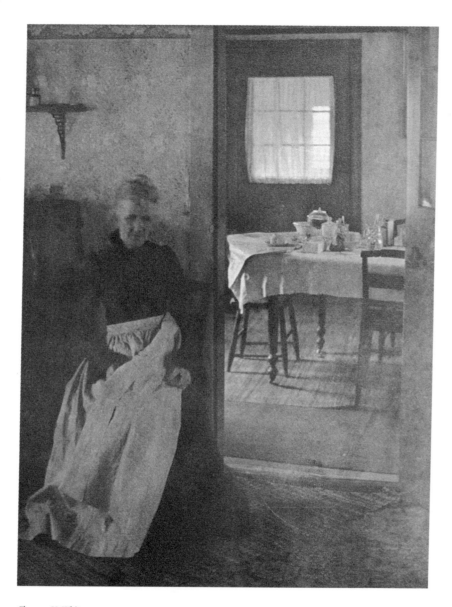

Clarence H. White
Illustration to "Eben Holden", 1903
Photogravure
19.5 x 15.1 cm

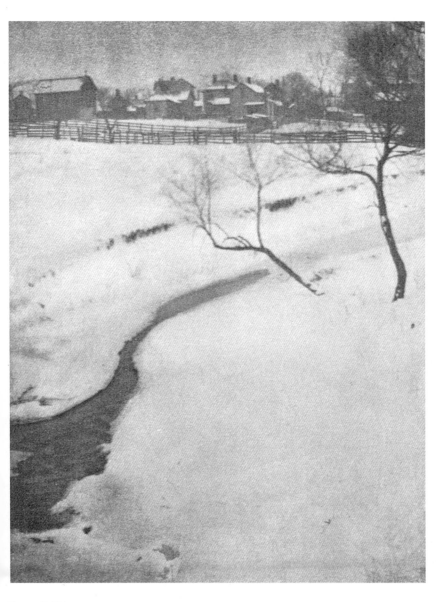

Clarence H. White
Winter Landscape, 1903
Half-tone reproduction
17.1 x 13.4 cm

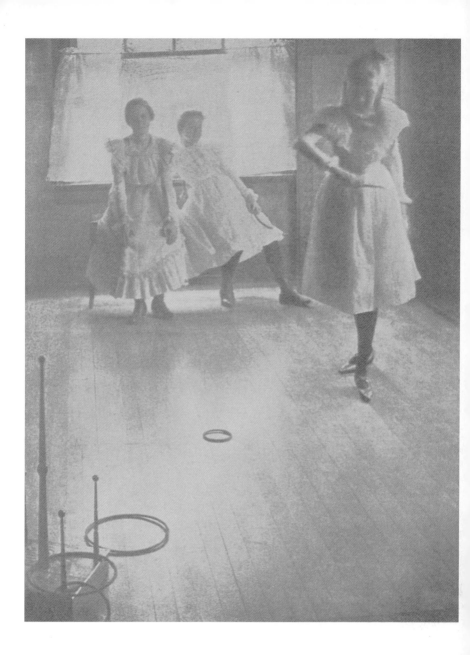

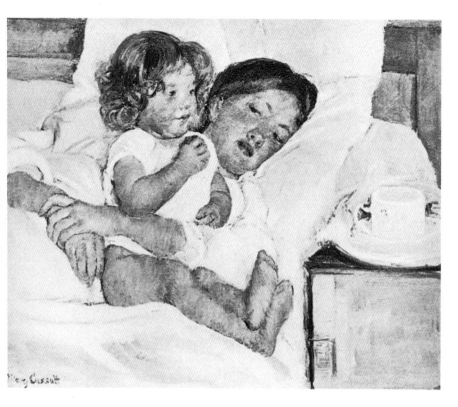

Mary Cassatt
The Breakfast in Bed, 1903
Half-tone reproduction
9.3 x 11.4 cm

← Clarence H. White
Ring Toss, 1903
Colour half-tone reproduction
17.6 x 13.8 cm

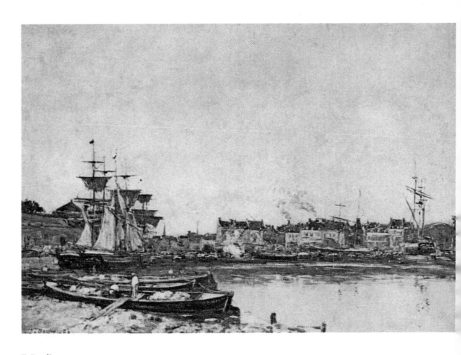

E. Boudin
The Old Basin of Dunkirk, 1903
Half-tone reproduction
7.8 x 11.4 cm

<div align="right">

Rembrandt ➔
The Admiral's Wife, 190?
Half-tone reproductior
15.9 x 12.7 cm

</div>

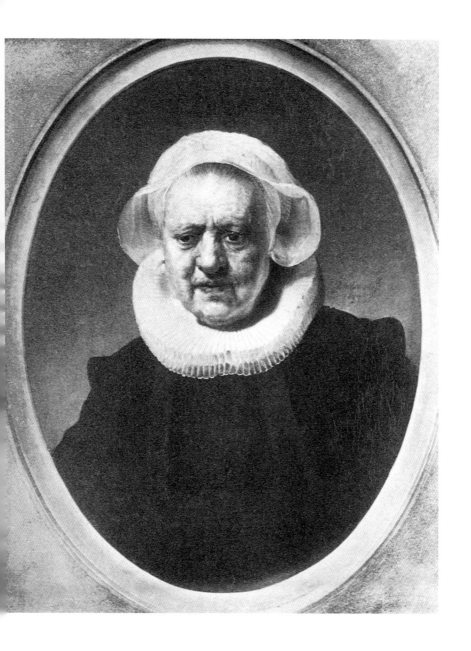

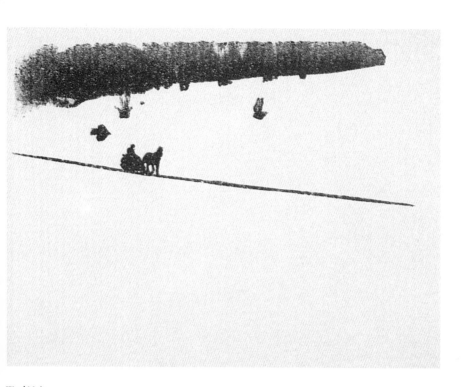

Ward Muir
Untitled (silhouette photograph), 1903
Half-tone reproduction
6.6 x 8.8 cm

← Ward Muir
Illustrations to "Silhouettes", 1903
Half-tone reproduction
9.6 x 6.7 cm

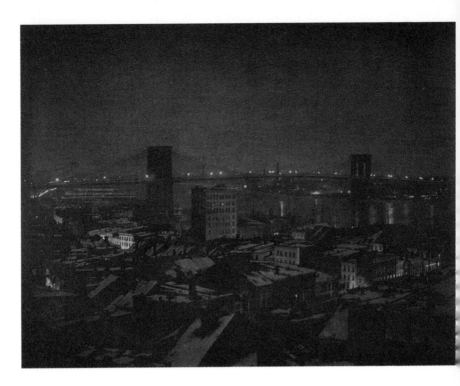

John Francis Strauss
The Bridge, 1903
Photogravure
15.9 x 20.8 cm

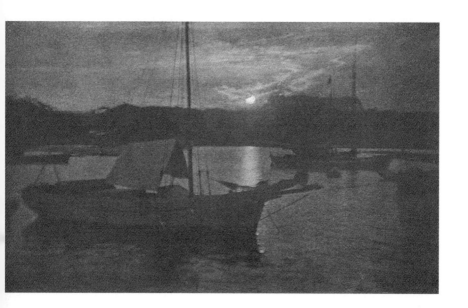

Joseph T. Keiley
The Last Hour, 1903
Half-tone reproduction
11.1 x 18.6 cm

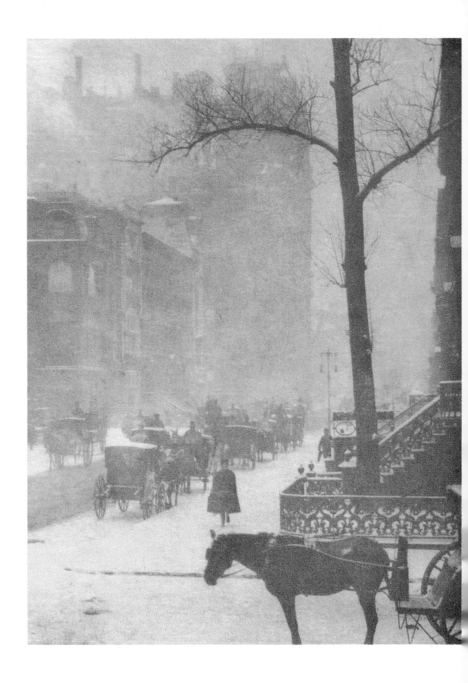

Alvin Langdon Coburn
Winter Shadows, 1903
Photogravure
14.5 x 19.2 cm

← Alfred Stieglitz
The Street – Design for a Poster, 1903
Photogravure
17.6 x 13.3 cm

I believe that here are observable the first steps, still somewhat hesitating but already significant, toward an important evolution. Art has held itself aloof from the great movement, which for half a century has engrossed all forms of human activity in profitably exploiting the natural forces that fill heaven and earth. Instead of calling to his aid the enormous forces ever ready to serve the wants of the world, as an assistance in those mechanical and unnecessarily fatiguing portions of his labor, the artist has remained true to processes which are primitive, traditional, narrow, small, egotistical and over-scrupulous, and thus has lost the better part of his time and energy. These processes date from the days when man believed himself alone in the universe, confronted by innumerable enemies. Little by little he discovers that these innumerable enemies were but allies and mysterious slaves of man which had not been taught to serve him. Man, to-day, is on the point of realizing that everything around him begs to be allowed to come to his assistance and is ever ready to work with him and for him, if he will but make his wishes understood. This glad message is daily spreading more widely through all the domains of human intelligence. The artist alone, moved by a sort of superannuated pride, has refused to listen to the modern voice. He reminds one of one of those unhappy solitary weavers, still to be found in remote parts of the country, who, though weighed down by the misery of poverty and useless fatigue, yet absolutely continues to weave coarse fabric by an antiquated and obsolete method, and this although but a few steps from his cabin are to be found the power of the torrent, of coal and of wind, which offer to do twenty times in one hour the work which costs him a long month of slavery, and to do it better.

It is already many years since the sun revealed to us its power to portray objects and beings more quickly and more accurately than can pencil or crayon. It seemed to work only its own way and at its own pleasure. At first man was restricted to making permanent that which the impersonal and unsympathetic light had registered. He had not yet been permitted to imbue it with thought. But to-day it seems that thought has found a fissure through which to penetrate the mystery of this anonymous force, invade it, subjugate it, animate it, and compel it to say such things as have not yet been said in all the realm of chiaroscuro, of grace, of beauty and of truth.

MAURICE MAETERLINCK.
(Translated.)

The Photo-Secession.

So many are the enquiries as to the nature and aims of the Photo-Secession and requirements of eligibility to membership therein, that we deem it expedient to give a brief résumé of the character of this body of photographers.

The object of the Photo-Secession is: to advance photography as applied to pictorial expression; to draw together those Americans practicing or otherwise interested in the art, and to hold from time to time, at varying places, exhibitions not necessarily limited to the productions of the Photo-Secession or to American work.

It consists of a *Council* (all of whom are Fellows); *Fellows* chosen by the Council for meritorious photographic work or labors in behalf of pictorial photography, and *Associates* eligible by reason of interest in, and sympathy with, the aims of the Secession.

In order to give Fellowship the value of an honor, the photographic work of a possible candidate must be individual and distinctive, and it goes without saying that the applicant must be in thorough sympathy with our aims and principles.

To Associateship are attached no requirements except sincere sympathy with the aims and motives of the Secession. Yet, it must not be supposed that these qualifications will be assumed as a matter of course, as it has been found necessary to deny the application of many whose lukewarm interest in the cause with which we are so thoroughly identified gave no promise of aiding the Secession. It may be of general interest to know that quite a few, perhaps entitled by their photographic work to Fellowship, have applied in vain. Their rejection being based solely upon their avowed or notoriously active opposition or equally harmful apathy. Many whose sincerity could not be questioned were refused Fellowship because the work submitted was not equal to the required standard. Those desiring further information must address the Director of the Photo-Secession, Mr. Alfred Stieglitz, 1111 Madison Avenue, New York.

List of Members.
Fellows.

JOHN G. BULLOCK Philadelphia	⎫
WM. B. DYER Chicago	
FRANK EUGENE New York	
DALLETT FUGUET New York	Founders
GERTRUDE KÄSEBIER New York	and
JOSEPH T. KEILEY New York	Council.
ROBERT S. REDFIELD Philadelphia	
EVA WATSON SCHÜTZE Chicago	
EDUARD J. STEICHEN New York	⎭

Fellows—Continued.

ALFRED STIEGLITZ New York ⎫
EDMUND STIRLING Philadelphia ⎬ Founders
JOHN FRANCIS STRAUSS New York ⎬ and
CLARENCE H. WHITE Ohio ⎭ Council.
ALVIN LANGDON COBURN Boston
MARY DEVENS Boston
WM. B. POST Maine
S. L. WILLARD Chicago

Associates.

PRESCOTT ADAMSON Philadelphia
WM. P. AGNEW New York
A. C. BATES Cleveland, O.
EDWARD LaVELLE BOURKE Chicago
ANNIE·W. BRIGMAN Oakland, Cal.
NORMAN W. CARKHUFF Washington, D.C.
WM. E. CARLIN New York
J. MITCHELL ELLIOT Philadelphia
DR. MILTON FRANKLIN New York
HERBERT G. FRENCH Cincinnati
GEO. A. HEISEY Newark, O.
SAM. S. HOLZMAN New York
MARSHALL P. KERNOCHAN New York
SARAH H. LADD Portland, Ore.
CHESTER ABBOTT LAWRENCE New York
FRED. K. LAWRENCE Chicago
OSCAR MAURER San Francisco
WILLIAM J. MULLINS Franklin, Pa.
OLIVE M. POTTS Philadelphia
HARRY B. REID New York
HARRY C. RUBINCAM Denver
T. O'CONOR SLOANE Orange, N. J.
WALTER P. STOKES Philadelphia
MRS. GEORGE A. STANBERY Zanesville, O.
KATHARINE STANBERY Zanesville, O.
GEO. B. VAUX Philadelphia
MARY VAUX Philadelphia
LILY E. WHITE Portland, Ore.
MYRA WIGGINS Salem, Ore.
ARTHUR W. WILDE Philadelphia

Frederick H. Evans
Ely Cathedral: Across Nave and Octagon, 1903
Photogravure
14.7 x 18.6

← **Frederick H. Evans**
Ely Cathedral: A Memory of the Normans, 1903
Photogravure
20 x 13.1 cm

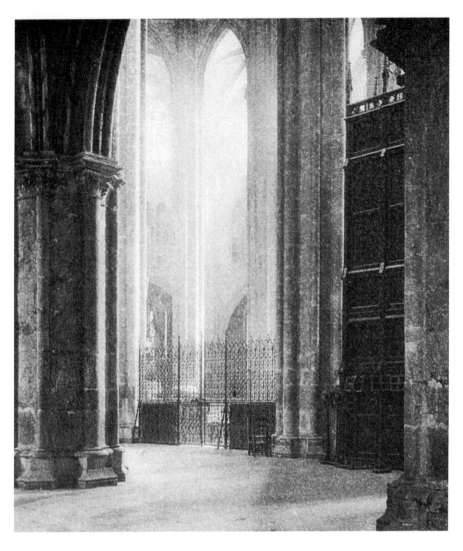

Frederick H. Evans
Height and Light in Bourges Cathedral, 1903
Photogravure
7.7 x 7.1 cm

Frederick H. Evans →
York Minster: "In Sure and Certain Hope", 1903
Photogravure
20.1 x 15 cm

Frederick H. Evans
Ely Cathedral: A Grotesque, 1903
Half-tone reproduction
20.9 x 15.2

← Frederick H. Evans
York Minster: Into the North Transept, 1903
Half-tone reproduction
20.3 x 15.1 cm

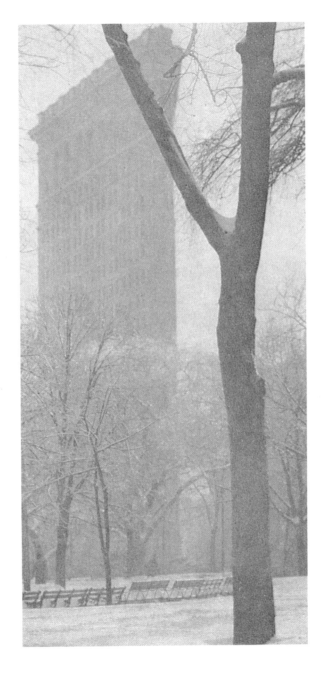

Alfred Stieglitz
The "Flat-iron", 1903
Photogravure
16.9 x 8.3 cm

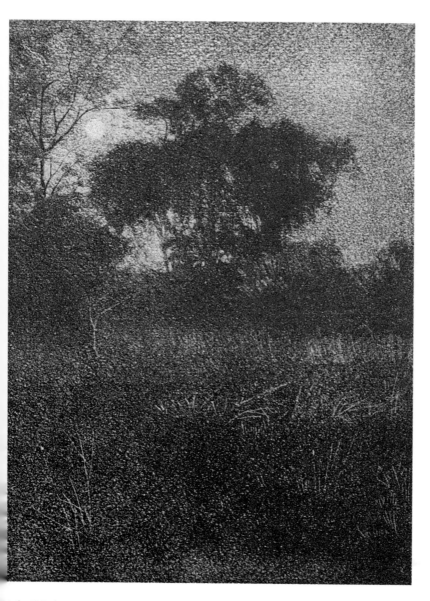

Arthur E. Becher
Moonlight, 1903
Colour half-tone reproduction
16.7 x 12.8 cm

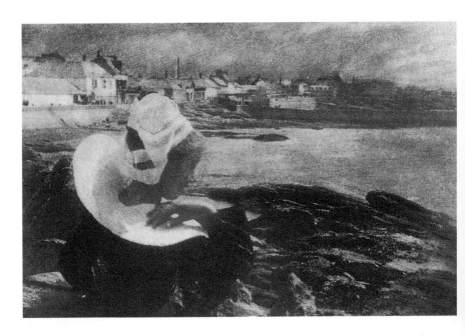

Robert Demachy
In Brittany, 1904
Photogravure
12.8 x 19.8 cm

Robert Demachy →
Street in Mentone, 1904
Photogravure
16.5 x 12.7 cm

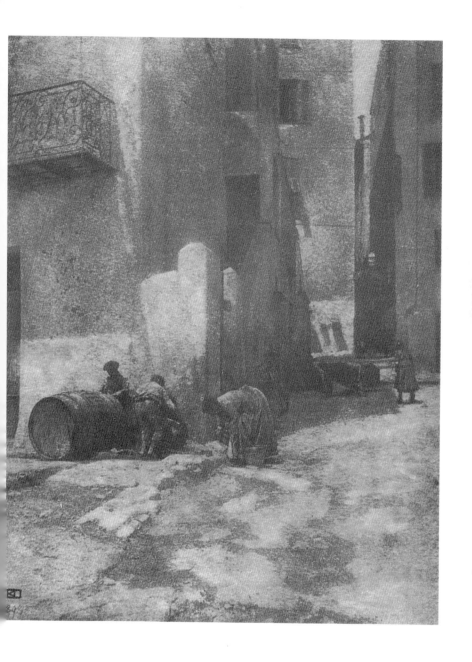

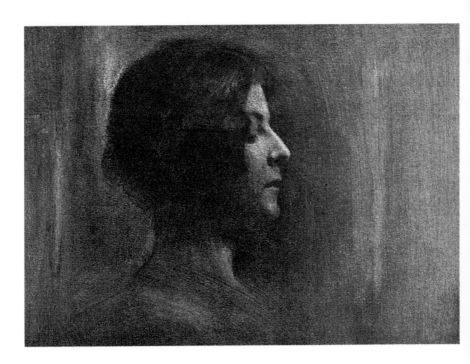

Robert Demachy
Severity, 1904
Half-tone reproduction
11.5 x 15.9 cm

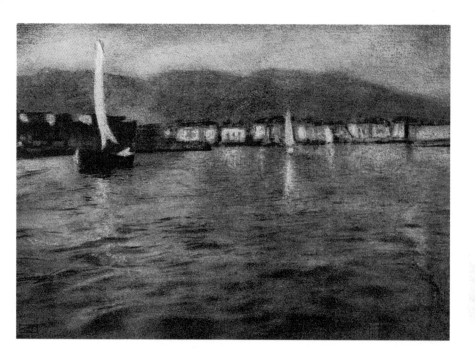

Robert Demachy
On the Lake, 1904
Half-tone reproduction
11.9 x 17 cm

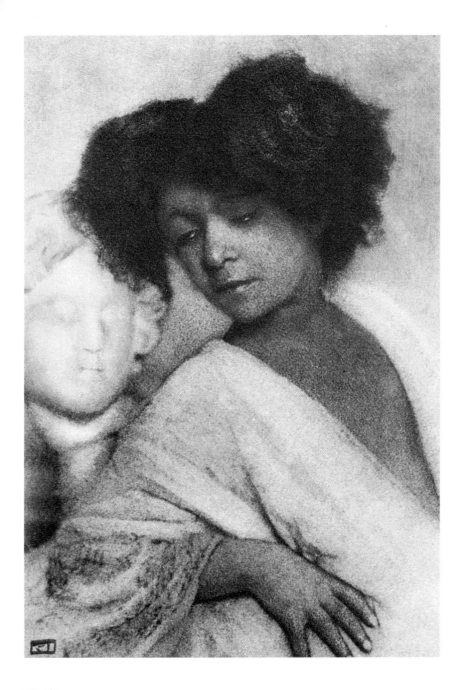

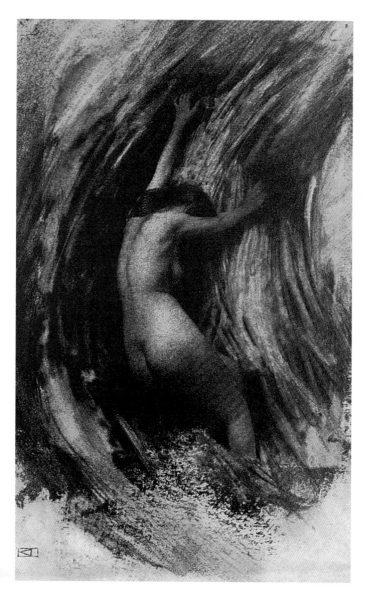

Robert Demachy
Struggle, 1904
Half-tone reproduction
19.5 x 12.2 cm

← Robert Demachy
Contrasts, 1904
Photogravure
16.7 x 11.8 cm

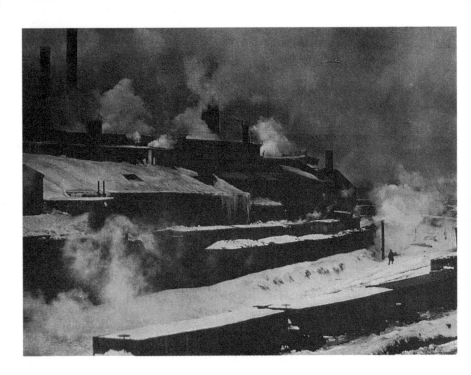

Prescott Adamson
'Midst Steam and Smoke, 1904
Photogravure
13.3 x 18.5

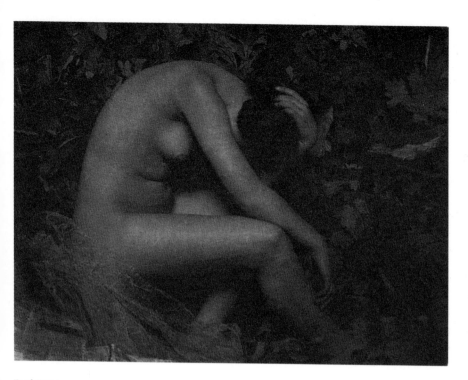

Frank Eugene
La Cigale, 1904
Photogravure
12.2 x 17 cm

ROBERT DEMACHY.

¶ THE DEVELOPMENT of any movement or cause is materially influenced or brought about through the conflict of positive and negative forces, just as the development of the individual is in like manner accomplished. The development of the pictorial movement in photography was no exception to this rule. In it the negative forces have been many and powerful the world over, more than once bringing it to the verge of ruin; yet, to be entirely just, it is a question whether without those forces it would stand where it does to-day. The conflict crystallized ideas and plans that otherwise might have remained nebulous. It tempered the positive forces as a good sword is tempered for the hand of the conqueror. Yet had those positive forces been less powerful or less masterful than they were, pictorial photography could not have risen with the rapidity that it has displayed to the convincing position it now occupies. In France, as elsewhere, positive and negative forces were at work. There was probably a greater number of negative forces there than elsewhere. Paris, long considered the home of progressive art, of untrammeled literary aspiration, of such freedom of progress in all things belonging to intellectual development that license too often was confused with liberty, was in the beginning narrow and bigoted in its attitude toward pictorial photography. With its annual painters' salon, its many art exhibitions, and its countless studios, it was intolerant with the academic pride of brush and pencil, and it could not bring itself to believe that with the camera any expression could be given to original pictorial conception. It was blind to the fact that in the hands of the artist the photographic processes were pliant tools for the production of individual ideas. Even to-day Paris, as represented by certain of its academic art cliques, is narrow and bigoted toward this movement. Because it did not know it would not admit the possibility of believing or knowing. While other centers of thought have thrown off the trammels of convention and recognize possibilities, Paris is still half asleep. But France, and especially Paris — dainty, beauty-loving, sunny Paris — could never remain asleep to anything truly related to art, and already there are signs of the splendid awakening soon to come. It was simply another phase of the old, old story of the staid and ancient contending for mastery with the progressive and new — custom blocking process. Other countries whose art-traditions were less strong were not dominated by prevalent opinion as was France. France, in consequence, whose name has ever been associated with art and pictorial matters, boasts of very few pictorial photographers. Yet among these few there stands out one whose name will ever rank among the most powerful and successful of the leaders and pioneers of the pictorial movement — Robert Demachy. It is all the more to his credit that despite the narrow attitude of the art-leaders of France, despite the opposition to the demand for serious recognition of pictorial photography and the sneers and ridicule showered upon its pretentions, he nevertheless preserved and helped so materially to place it upon the pedestal upon which it stands

to-day. In him, as in all the photographic workers, both positive and negative forces were at work. Those familiar with his productions can trace the conflict in them. The positive forces were the more powerful and his artistic individuality, as expressed in the creations of his camera, has developed and expanded till it has given us some of the finest work that the photo-pictorial world possesses to-day. Easily it towers over all the work of France; naturally it takes its place with the foremost work of the world. No serious student can afford to neglect its careful study. The historian of pictorial photography can not pass it over if he be conscientious, but must accord it considerable place in his annals. And the art-lover in general, the man who takes a real interest in the development of the beautiful, will find himself amply repaid for the time he may give to it. Not only has Robert Demachy, almost unaided, won for France a foremost place in the pictorial photographic world, but to that photographic world he has given, perhaps, its most pliable and responsive medium for the expression of its feelings and ideas—the gum process. While he is not the inventor or discoverer of the use of the gum-bichromate for photographic printing purposes, he is indisputably the originator of its present use. Taking up an almost forgotten process, his knowledge and genius pointed out its possibilities, and he it was who by his experiments and results blazed out that photographic trail along which so many have followed, at first like Indians, single file, to-day in broad and ever-extending ranks, like a modern army. A man of independence and culture, speaking and writing English with the fluency of his native tongue, in each language he has written articles and criticisms that have helped materially to shape the course of photographic progress; ever alert to the interest of pictorial photography, diplomatic, genial, vigorous, Robert Demachy is justly one of the greatest leaders and most popular men in the pictorial world. Those who differ from him, as well as those who agree, recognize entirely that the photographic world owes him a great debt, and it was with approving gratification and a sense of personal pleasure that they lately learned that he had recently been honored with membership in that distinguished association, the Legion of Honor. The honor is well earned, and it is sincerely hoped that he upon whom it was conferred will live long to enjoy it and still further to enrich the pictorial photographic treasure-house with greater and more splendid productions.

JOSEPH T. KEILEY.

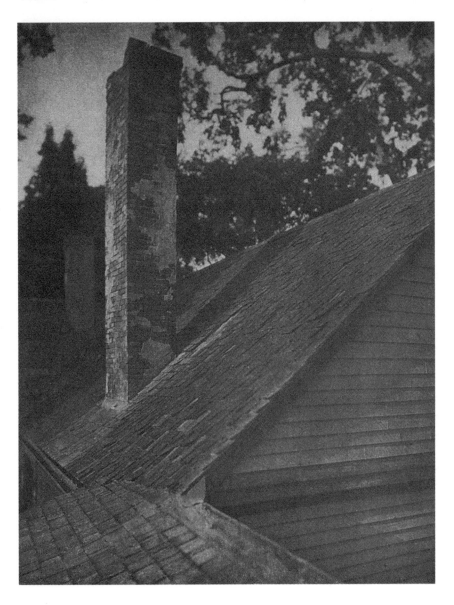

Alvin Langdon Coburn
Gables, 1904
Photogravure
19 x 14.9 cm

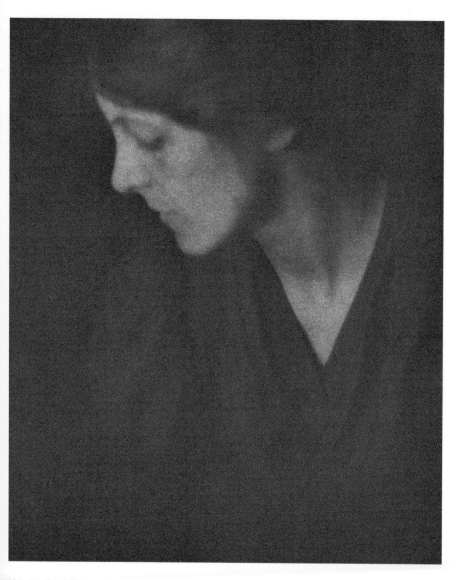

Alvin Langdon Coburn
A Portrait Study, 1904
Photogravure
17.7 x 14.8 cm

Alvin Langdon Coburn
The Dragon, 1904
Colour half-tone reproduction
13.8 x 17.7 cm

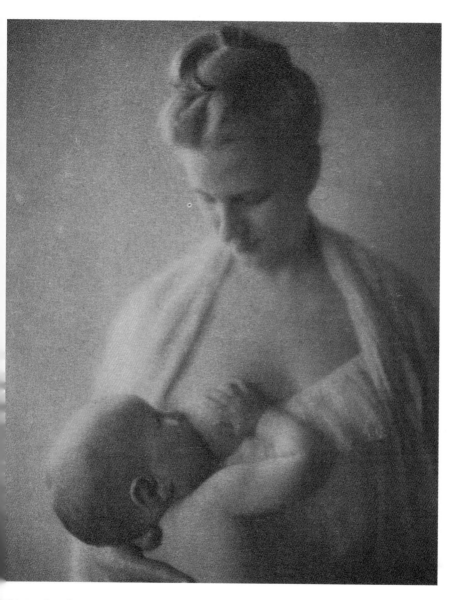

Alvin Langdon Coburn
Mother and Child – A Study, 1904
Photogravure
8.1 x 14.8 cm

Alvin Langdon Coburn
The Bridge – Ipswich, 1904
Photogravure
19.3 x 14.9 cm

Alvin Langdon Coburn
House on the Hill, 1904
Photogravure
14.9 x 18.9 cm

Will A. Cadby
Storm Light, 1904
Half-tone reproduction
9.7 x 13.1 cm

← Will A. Cadby
Under the Pines, 1904
Half-tone reproduction
18.5 x 13 cm

W. B. Post
Wintry Weather, 1904
Photogravure
15 x 16.4 cm

SOME PRINTS BY ALVIN LANGDON COBURN.

FORTUNATE IN the artistic opportunities he has experienced, Alvin Langdon Coburn is fortunate also in having some true stuff of the artist in himself. It is his further good fortune to be still a young man.

Being a cousin of F. Holland Day, he became also his pupil, working with him both in Boston and in Paris. In the latter city he enjoyed the friendship of Demachy and the chance of familiarizing himself with that distinguished photographer's methods, at the same time coming under the influence of Steichen. Returning to this country he had the further privilege of studying for some months with Mrs. Käsebier and of spending a summer with the landscape-painter, Arthur W. Dow, at the latter's studio in the country.

In each case he found himself in contact with an artist of originality, from whom he could get inspiration as well as experience in methods; while the number of the influences he has experienced and his own originality have saved him from the temptation to imitate consciously. So, the dozen prints which hang before me as I write, while they exhibit various artistic motives, which may be traced home to one or other of the artists enumerated, have yet a fair amount of personal distinction. The young artist has been influenced by others in what to look for, but has contrived to see the subject with his own eyes. Moreover, he has pursued for himself some original experiments in the technical manipulation of his prints.

They are directed to a combination of the advantages of the platino-type and gum-bichromate processes, so as to profit by the stability and solidity of the effects in the one case, and by the liberty of action and the increased richness of the dark tones allowed by the other. Thus, the results shown in many of these pictures have been obtained by double printing—by first establishing the strong foundation of the platinotype impression and then by printing over it with gum. The advantage of this method would seem to declare itself in the firm constructional quality which is still preserved in most of the compositions, notwithstanding the freedom and looseness of effect subsequently attained. For it is often too evident in a gum print that the manipulator, in losing touch with the facts of the negative, has lost his own foothold and has floundered further and further from the substance of reality into a very bog of blackness. And I believe that the more one studies pictures in these days when the temperamental quality is exalted so far above knowledge—as if the passion for making shoes were more desirable in a man than the knowing how to cut and shape and fit them—the more one comes to see how mere temperament, unenforced by knowledge, is fruitless. The poetic feeling must overlay a sound fabric of construction or the whole scheme of the picture, though at a first glance pleasant, will begin, as you study it further, to totter and flop to pieces.

Now the structural quality in these prints of Coburn's is partly due to the use of the platinotype; to the pledge which the operator thereby

imposes on himself of adhering to the facts; but that he should have thought of using the process with this intention indicates in himself a feeling for the significance of form and structure. It is the prevalence of this feeling throughout all these prints which gives them primarily a claim to very serious consideration; for it represents a firm foundation of artistic perception, on which the accessory motives of lighting, tone, and texture, and so on, may be surely developed.

An admirable example of what I am striving to express is the print of "The Dragon," a view from Mr. Dow's studio, with a curious effect of serpentine lines of water winding through the flat-lands. In the fascination of the patterning of the composition it would have been easy to lose sight of the substantial realities of the ground plan. But in this case they are. naturally, though unobtrusively, enforced; with the result, I think, that the bizarrerie of the lines receives increased interest. The effect has been produced by two printings, a trifle of green pigment having been mixed with the gum and dragged sparingly over, so as to excite a suggestion of green, which is far more agreeable and actually suggestive than would have been a grosser use of color. I doubt, however, if the treatment of the band of foliage across the foreground is satisfactory. It appears rather formless, leaving one uncertain as to whether it is a hedge or the tops of trees growing lower down the bank; a necessary point to be cleared up, since, if the latter is intended, it would indicate a deeper fall in the ground than is now evident. The ambiguity is further increased by the choice of tone in the foliage. It is too dark for tree-tops, too light for a hedge; and, as it now appears, is not in true relational value to the other tones of the picture.

It is in the regulation of the values that these prints occasionally falter, as in "Little Venice," where the reflection of the white houses on the water is too low in tone; and one effect of this is that the reflections do not keep the water up to a level. It drops down, hanging, in fact, like a blurred curtain, for in the confusion of values the form itself of the water has been lost.

The most attractive of these pictures is "The Bridge, Ipswich," strikingly handsome in composition, with a drowsy richness in the blacks and much tenderness in the scale of lights. Yet, as frequently in gum prints, I miss the charm of unexpectedness in the lighting. Surely some quiver of light would interrupt the blackness of the shadow on the water, some hint that the arch was not the entrance to a dungeon, but was open on the other side. As it is, the mass of deep shadow grows to seem a little inert; the nuances of nature have been sacrificed to force a robust and striking pictorial arrangement; and the latter in its turn suffers by some lack of animation.

I suppose this remains one of the chief difficulties in the gum-bichromate process. Even if the operator have a thorough knowledge of forms and a just feeling for values, the fact that his mind is occupied with some large and general effect may easily, in the necessary rapidity of the process,

shut from his observation those delicate surprises of effect which in nature, whether animate or inanimate, are so full of beauty. Indeed, it is in them that the very spirit of the subject is often expressed. The negative records these and a good deal else beside that is unessential, and in the endeavor to obliterate the latter, the worker in the gum will often generalize with too little discrimination—in a word, too brutally.

In these prints of Coburn's there is delicacy of expression as well as robustness, yet some of them betray either a lack of observation or imperfect skill in rendering what has been observed—defects which time and study will remove. For the vision of an artist and more than usual command of craftsmanship are apparent in all of them, and underlying these qualities an evident reverence for beauty.

CHARLES H. CAFFIN.

Theodor and Oscar Hofmeister
The Solitary Horseman, 1904
Photogravure
12.2 x 17.8 cm

Theodor and Oscar Hofmeister →
Dachau, 1904
Photogravure
18 x 12.6 cm

Theodor and Oscar Hofmeister
Meadow-brook, 1904
Photogravure
12.4 x 17.7 cm

Theodor and Oscar Hofmeister →
The Churchgoers, 1904
Half-tone reproduction
17.7 x 12.4 cm

Theodor and Oscar Hofmeister
A Village Corner, 1904
Half-tone reproduction
12.1 x 17.7 cm

Theodor and Oscar Hofmeister →

Sea Calm, 1904
Half-tone reproduction
17.7 x 12.2 cm

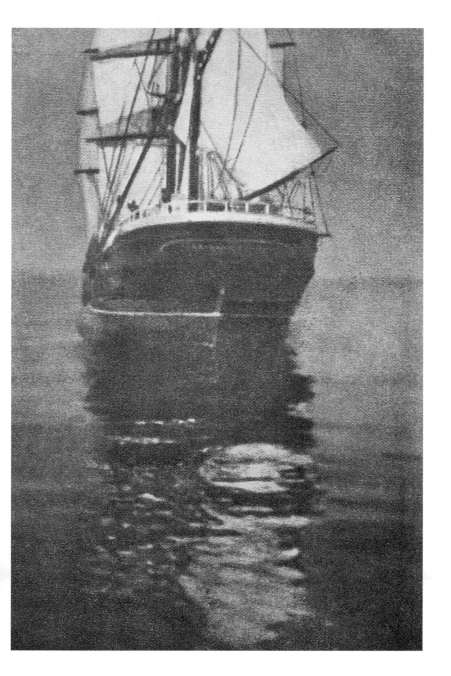

CAMERA WORK 7, 1904

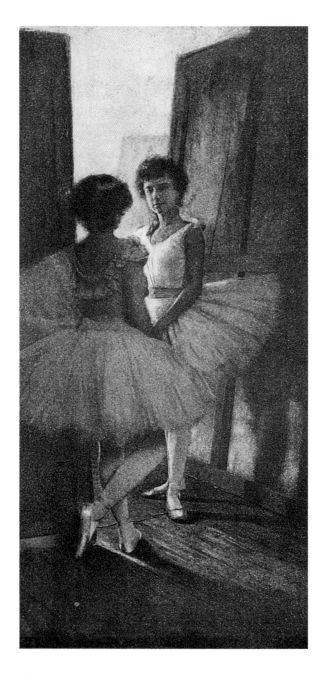

Robert Demachy
Behind the Scenes, 1904
Half-tone reproduction
19.3 x 9.6 cm

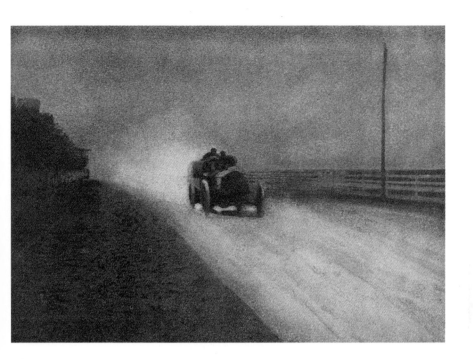

Robert Demachy
Speed, 1904
Half-tone reproduction
12.5 x 18 cm

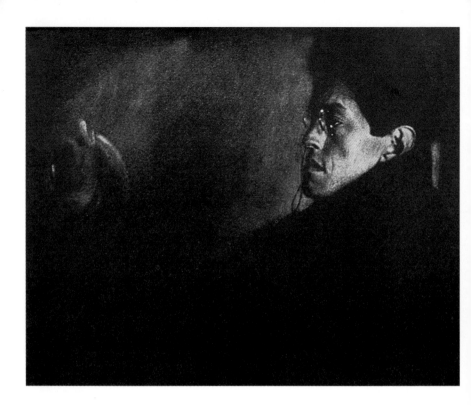

Eduard J. Steichen
Sadakichi Hartmann, 1904
Half-tone reproduction
11.9 x 15.2 cm

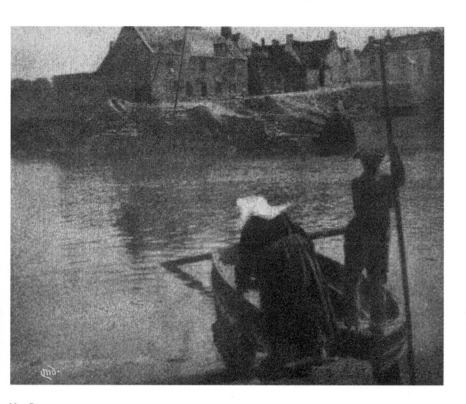

Mary Devens
The Ferry, Concarneau, 1904
Half-tone reproduction
12.4 x 15.8 cm

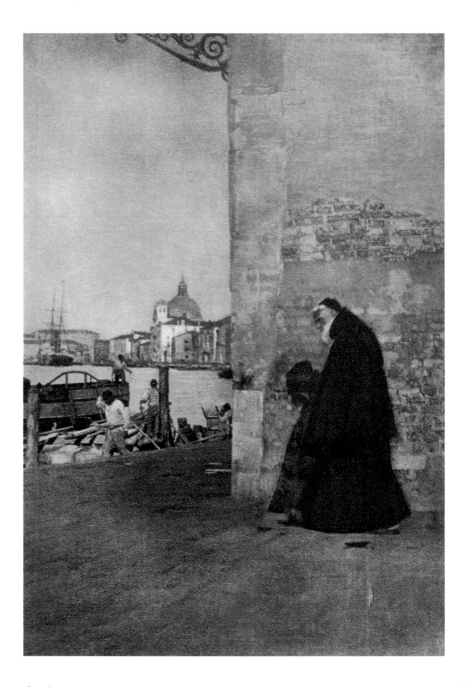

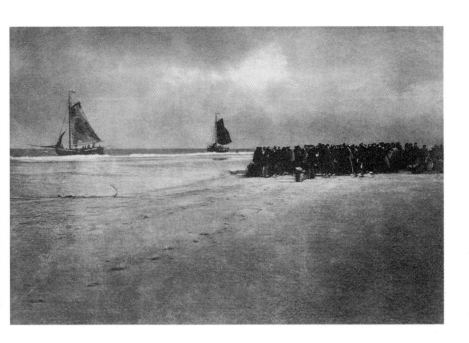

J. Craig Annan
On a Dutch Shore, 1904
Photogravure
15 x 23 cm

← J. Craig Annan
A Franciscan, Venice, 1904
Photogravure
19.7 x 13.9 cm

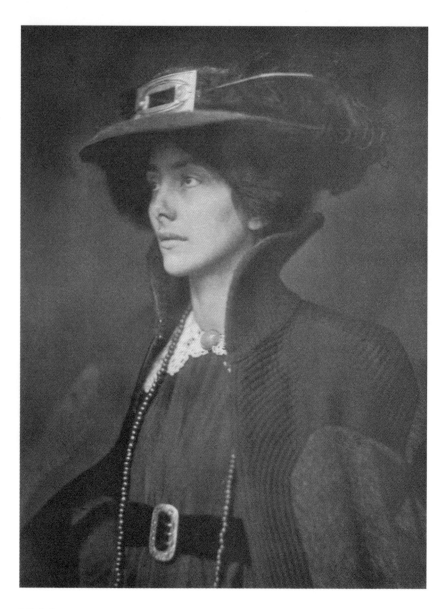

J. Craig Annan
Frau Mathasius, 1904
Photogravure
20.7 x 15.6 cm

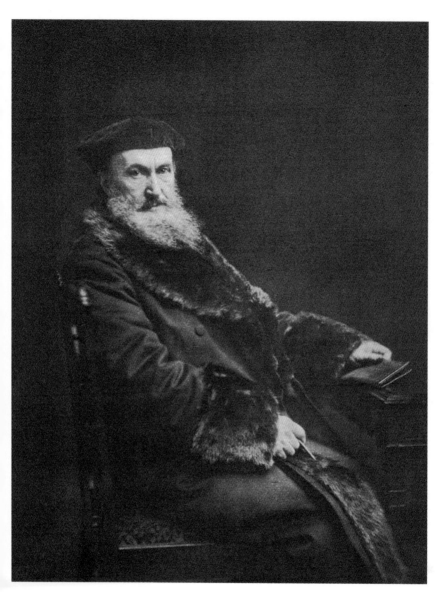

J. Craig Annan
Prof. John Young, of Glasgow University, 1904
Photogravure
19.9 x 15.5 cm

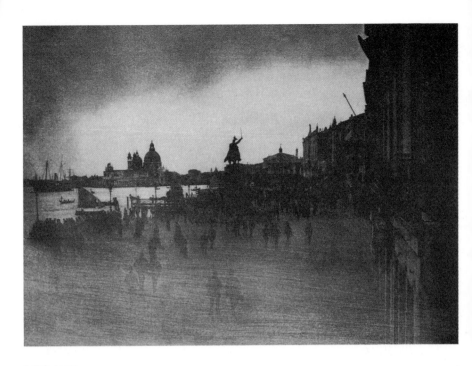

J. Craig Annan
The Riva Schiavoni, Venice, 1904
Photogravure
14.4 x 20 cm

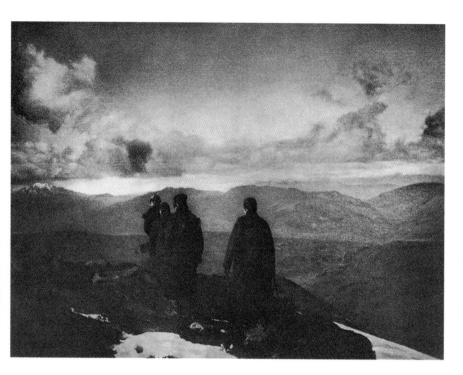

J. Craig Annan
The Dark Mountains, 1904
Photogravure
15 x 20.2 cm

J. B. Kerfoot
Untitled (inkblot), 1904
Letterpress
3.4 x 1.8 cm

J. B. Kerfoot →
Untitled (silhouette of Stieglitz), 1904
Letterpress
5.2 x 3.2 cm

J. B. Kerfoot
Untitled (silhouette of Steichen), 1904
Letterpress
4.4 x 3 cm

J. B. Kerfoot
Untitled (silhouette of Coburn), 1904
Letterpress
5.4 x 3.9 cm

J. B. Kerfoot
Untitled (silhouette of Coburn), 1904
Letterpress
4.9 x 6.2 cm

J. B. Kerfoot
Untitled (silhouette of Käsebier), 1904
Letterpress
4.2 x 7.2 cm

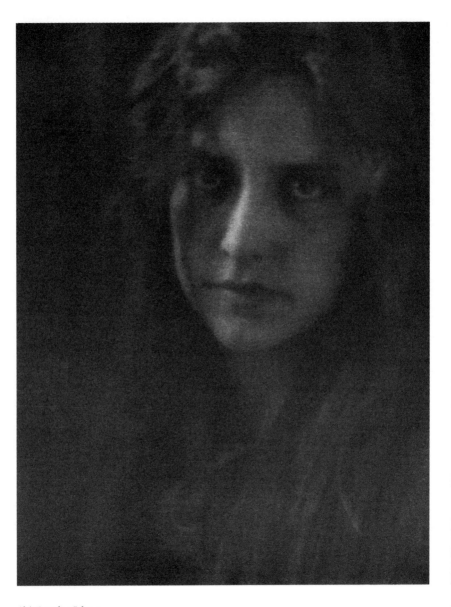

Alvin Langdon Coburn
Study-Miss R., 1904
Photogravure
21.2 x 16.3 cm

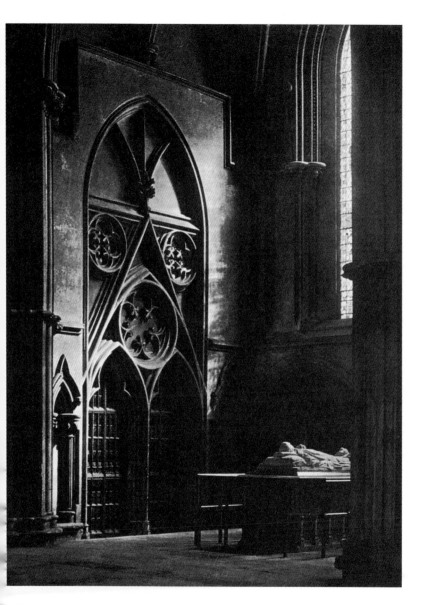

Frederick H. Evans
In Sure and Certain Hope, 1904
Photogravure
19.9 x 14.7 cm

J. CRAIG ANNAN.

EVER SINCE its initial appearance in the company of that of other leading English pictorial photographers at the First London Salon, the work of J. Craig Annan has stood out in bold relief and marked its creator as one of the foremost artists in photography, not only of England, but of the world. Executed in a manner that bespeaks a masterful knowledge of the technique of the photographic media, and such long and intimate familiarity with the classic language of art as enables him to express himself with a correctness free from stiffness or affectation, his pictures, both by their essentially original, refined, and healthy charm of theme and the mature firmness and sincere directness of their expression, have been, since first they became known, one of the most influential factors in the advancement of English pictorial photography. The convincing character of their real, original pictorial merit and the sincere honesty and ability of their expression has won many friends for the movement from the ranks of the general public on the one hand, while on the other they have been incentive and inspiration of far-reaching influence to Mr. Annan's fellow-workers through the entire photographic world. While those who love beauty for beauty's sake owe to Mr. Annan a debt of gratitude for the great pleasure that many of his pictures have given. J. Craig Annan was born in the town of Hamilton, some ten miles from the city of Glasgow, in 1864. He was educated chiefly at Hamilton Academy and Anderson College, Glasgow, where he devoted most of his time to the study of chemistry and natural philosophy. These studies appear to have absorbed his interest at first rather to the exclusion of pictorial work—somewhat, it would seem, to the disappointment of his father, Thomas Annan, a professional photographer, who was himself distinguished for his strong portrait work. Through his father's interest in art and personal connection with E. O. Hill, R.S.A., whose wonderfully fine photograph-work of over half a century ago still holds its place with the finest photo-pictorial work ever produced, and his friendly intimacy with some of the foremost artists of Glasgow, Craig Annan, from early childhood, moved in an artistic atmosphere and had constant opportunity of seeing and hearing discussed pictures and other works of art. In 1882 he went to Vienna to learn the secret of the then new process of photogravure, which later he introduced into, and was the first person to use in Great Britain; since which time it has been his chief vocation, though his recognized business is that of a general photographer.

At an early age he acquired the habit of making photographic studies for his own satisfaction, and this habit he has never allowed his profession to interfere with, making those characteristic pictures that have charmed the photographic world on the one hand, while doing straightforward professional work on the other. To all alike, no matter of what school, his pictures appeal through certain sympathetic magnetism of subject and sensitive and catholic charm of expression noticeable, as well in his portraits as his land-

scapes, and especially so in his hand-camera work. Indeed, he was one of those to whose pioneering and example the serious use of the hand-camera owes its origin. Contemporaneously with Alfred Stieglitz, and at a time when the hand-camera was looked upon as a mere toy and serious work attempted only with the tripod-instrument, he was experimenting seriously with the hand-camera, and it is to the experiments and the productions of such men that we owe some of the best of our modern work, some of the greatest of which has been done with the hand-camera, whose serious use they so materially helped to popularize by their own initial efforts. After his exhibition at its first Salon, Mr. Annan was made a member of the Linked Ring, whose cause and exhibitions he has since constantly and consistently supported in the interest of the advancement of pictorial photography.

Holding to the view that "*Art is so subtle a subject that even after very careful consideration one is apt to express convictions to-day which one's experience or imagination would cause one to renounce to-morrow, especially if one works . . . more from instinct and the impression of the moment than from any predetermined theory or principle*"; and maintaining that "*If a picture has any real merit as an esthetic work it should touch a sympathetic chord in the intelligence of the observer and give him pleasure,*" and that "*If it does so it has fulfilled its mission so far as he is concerned; but if it does not, no amount of argument will enable him to realize and enjoy the artistic intention of the producer, because the aim of a picture is not to demonstrate any theory or fact, but is to excite a certain sensory pleasure*"—Mr. Annan, with his clearly defined views of the pictorial possibilities and limitations of photography, his appreciation of the futility of academic argument on such subjects, together with a determination not to permit the calm of his own nature to be ruffled by such fruitless discussion, has consistently refrained from entering into any of the controversies that have raged from time to time through the photographic press—while a fine, innate sense of modesty, which is especially characteristic, has impelled him to keep in the background, to be one of the followers, so to speak, and makes almost impossible the task of securing his views and ideas on his calling in article or speech for publication. Yet, despite this, the character and influence of his work, his known views, his conservativeness of action and broad catholicity of taste, have all gone to make him what he is to-day, the real leader of British Pictorial Photography, and there could not be a better or more representative.

JOSEPH T. KEILEY.

CARBON AND GUM PRINTS ON JAPAN TISSUE.

ABOUT TWO years ago the writer became interested in making some carbon prints, using Japan tissue as the final support. The results were not pleasing, as the gelatine used in making the support-paper destroyed the texture of the Japan tissue, besides causing unequal shrinking in the final print.

Last April experiments in this line were resumed, resulting in the entire elimination of the former difficulties.

Assuming that the reader is familiar with the single-transfer process, directions are given herewith for making single carbon transfer-prints on Japan tissue with ease and certainty.

The Japan tissue is placed on a glass support, the paper being cut somewhat larger than the glass, when it is coated with a plain collodion made up as follows:

Alcohol, sp. gr. 0.81	1000 c. c.
Ether, sp. gr. 0.72	1000 c. c.
Pyroxyline	30 grammes.

Old celluloid films can be dissolved in amylacetate, or equal parts of alcohol and ether, and used for the same purpose.

With a camel's-hair brush, about one inch in width, commence at one edge of the paper on the glass support, and as rapidly as possible, using the collodion freely, coat the whole of the paper, at the same time pressing it into contact with the glass as intimately as the brush will permit.

This first coating should thoroughly dry, when it will be found that the paper will be drawn perfectly flat to the glass support, if the coating has been properly done.

Two or three additional coats should be applied until the pores of the paper are closed, but not enough collodion used to give the Japan tissue support too much gloss and destroy the texture of the paper.

After the paper on the glass is dry, bend back the surplus paper over the edge on to the back of the glass support, and hold it there by placing it on another glass, keeping the two together during the development of the carbon print. This will prevent the water from getting between the print and the glass, and lessen the possibility of tearing the print.

Sensitize the carbon tissue and print as usual. When ready to squeegee the printed tissue to the prepared Japan tissue support, immerse the print and the tissue support in the water at the same time and squeegee as usual. No previous soaking of the tissue support is necessary. In twenty minutes development can proceed as usual. The print during development should be examined with some white opaque substance behind it or it will probably dry out too dark.

The finely divided coloring matter can be thoroughly removed from the print, when sufficiently developed, by flooding with alcohol *once*, in the same manner in which a plate is flowed with developer.

The print can now be rinsed and placed in alum or sodium bisulphite to eliminate the bichromate, washed again, and permitted to dry on the glass support. After drying it should be carefully stripped from the glass and is ready for mounting.

The tone of the picture can be modified by backing the print with colored paper.

If old collodion is on the glass, the print will be almost sure to stick. Rubbing the glass with talc will facilitate the removal of the print.

If the collodion is *flowed* on the paper, the result will not be satisfactory, the collodion *must* penetrate the paper instead of setting on the surface.

Gum-bichromate prints can be made on Japan tissue-paper by the same method, giving but one coat of collodion, permitting this to dry thoroughly, then coating with the gum-bichromate mixture and proceeding as usual in working this process.

<div align="right">NORMAN W. CARKHUFF.</div>

SILHOUETTES.

I HAVE BEEN asked to give the details of silhouette-making with a camera. The process is simple in the extreme if one but has access to the one indispensable accessory—a window giving upon the open sky. This window is like charity. Though you speak with the tongues of men and of angels, though you have faith to move mountains and a hundred-dollar lens, if you have not the window, it is nothing. Given the window, open if possible, pose your sitter before it, focus sharply, stop down to F/32 and expose one second. Use a Contrast plate and develop with

Solution A:	Solution B:
Water 500 ccm.	10% solution of
Hydroquinone . . . 10 grammes	Carbonate potash, anhydrous.
Sodium sulphite, anhydrous, 20 grammes	

<div align="center">Using equal parts of A and B.</div>

Carry your development to the extreme limit, remembering that your object is clear glass in the shadow and high lights too dense for sunlight to print through. Having achieved your negative, remains to block out the bust. Here simplicity vanishes. There are six and ninety ways of cutting each figure and only one of them is right. Lay your negative face down on a white surface and experiment with black paper cut-outs. When you get what you want, *paste it in place* on the negative. Don't try the brush. Good models will be found on coins, medals, and the United States stamps of the 1872 issue. Study them.

<div align="right">J. B. KERFOOT.</div>

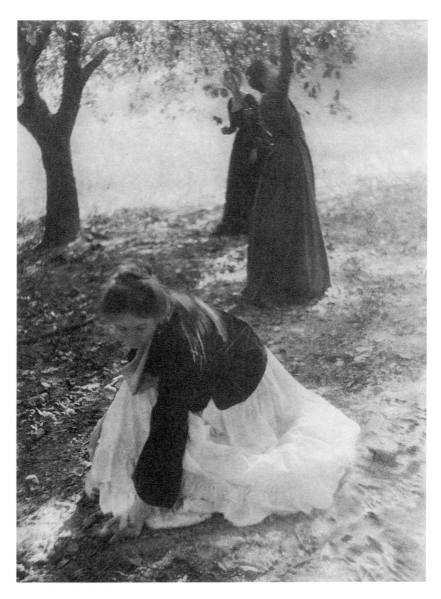

Clarence H. White
The Orchard, 1905
Photogravure
20.5 x 15.7 cm

Clarence H. White →
Illustration to "Beneath the Wrinkle", 190⁵
Photogravure
20 x 15.2 cm

Clarence H. White
Illustration to "Eben Holden", 1905
Photogravure
19.8 x 14.0 cm

Clarence H. White
Boy with Camera Work, 1905
Photogravure
19.2 x 14.6 cm

John W. Beatty Jr. · His sister Katherine.
Elizabeth · ~ · Anno Doñi 1903 · ~

Clarence H. White
The Beatty Children, 1905
Photogravure
21.6 x 14.5 cm

Eduard J. Steichen →
Portrait of Clarence H. White, 1905
Photogravure
21.5 x 16.3 cm

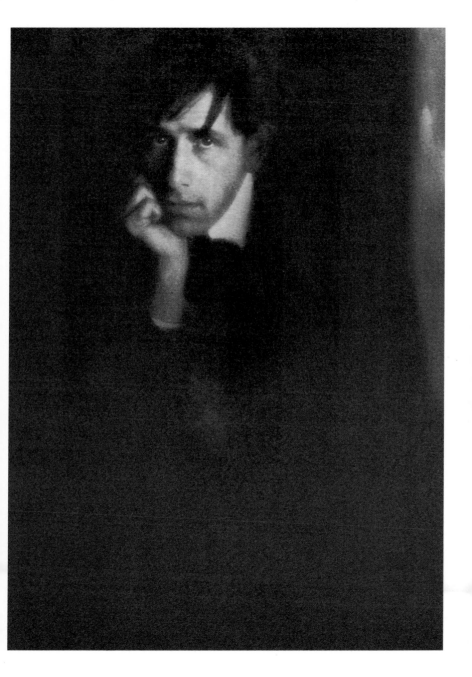

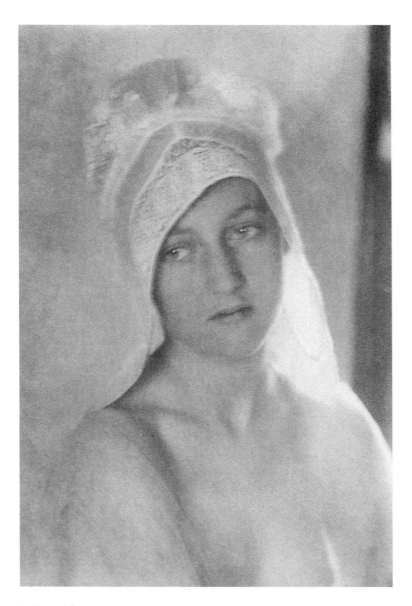

Eva Watson-Schütze
Head of a Young Girl, 1905
Photogravure
20.1 x 13.8 cm

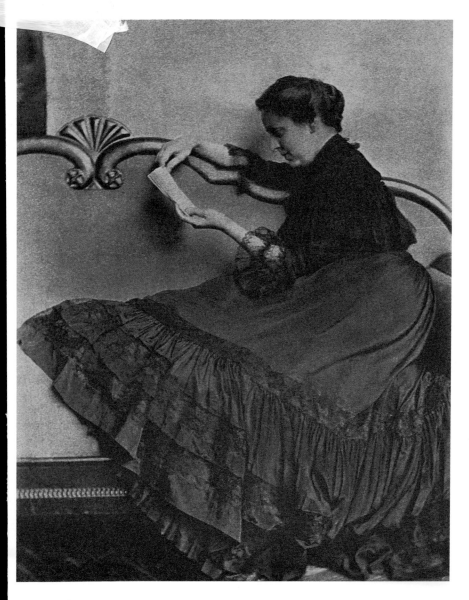

Eva Watson-Schütze
Portrait Study, 1905
Photogravure
21.2 x 16.6 cm

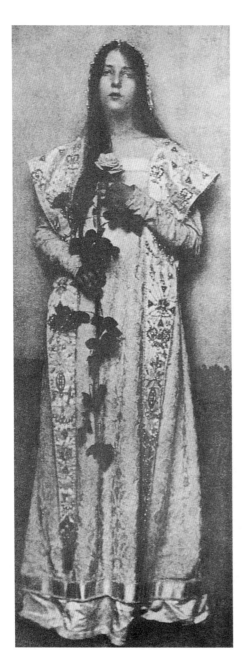

Eva Watson-Schütze
The Rose, 1905
Half-tone reproduction
21.4 x 7.9 cm

<div style="text-align: right">Eva Watson-Schütze →
Storm, 1905
Half-tone reproduction
18.6 x 14 cm</div>

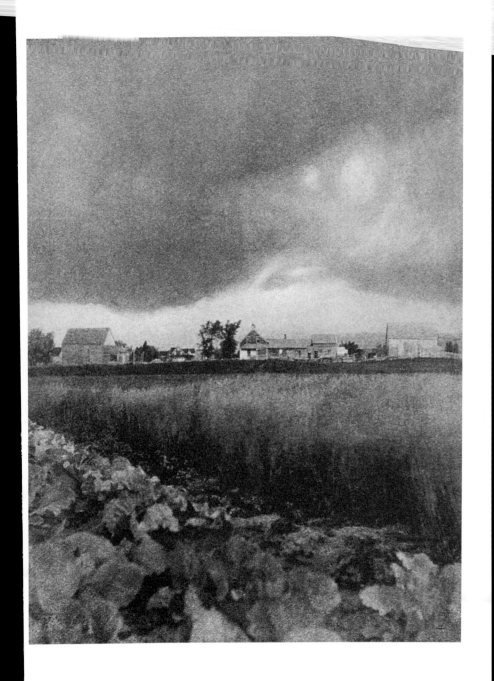

TO OUR SUBSCRIBERS.

MUCH TO our regret the coin fell tails up, and the price of Camera Work, beginning with March first, will therefore be six dollars. Had it fallen heads up the subscription price would have been seven dollars a year; thus Fate was with you, gentle reader. This is how it happened that you were saved one dollar. But, seriously speaking, we have so far succumbed to temptation of making the magazine more and more luxurious that we are compelled to raise our price. It was a question of six dollars or seven which the coin decided — yet even at this price you will receive more than the amount of your subscription could produce. In this connection we wish to impress once more upon you the advisability of having your copies registered, as we accept no responsibility after once having mailed the magazine and can not furnish extra numbers except at the single-copy price. The desire of the earnest worker to have his pictures reproduced in Camera Work is one with which we heartily sympathize, yet we must impress upon the ambitious that ours is but a Quarterly and therefore that our limited means restrict us within certain bounds. It must be remembered that Camera Work can not possibly reproduce all that is good and praiseworthy, but that one of its chief missions is to stimulate and inspire the earnest worker by placing before him the best and above all the most original. We hope in time to devote a number or two to the work of those of the newer American photographers who have done or are doing work of which we approve, but our first duty is to publish such examples of the best as will serve the general interests of the movement.

How the impression has gotten abroad, we do not know, but let us here emphasize the fact that Camera Work and the Photo-Secession are not synonymous, though they are working toward the same ends.

THE EDITORS.

VELOX

has the beauty of platinum without its difficulties

NEPERA DIVISION

EASTMAN KODAK COMPANY

ROCHESTER, N. Y.

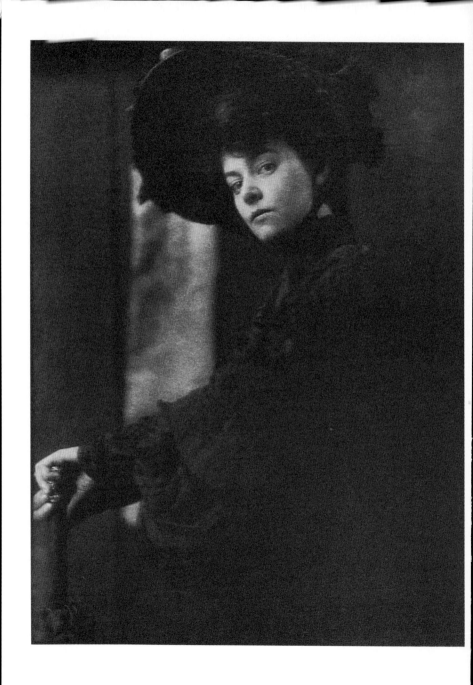

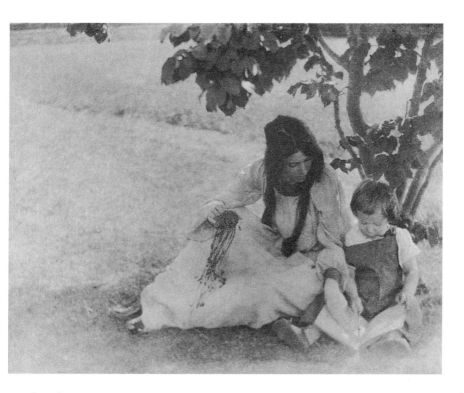

Gertrude Käsebier
The Picture-book, 1905
Photogravure
15.7 x 20.7 cm

← **Gertrude Käsebier**
Portrait – Miss Minnie Ashley, 1905
Photogravure
21.5 x 16.7 cm

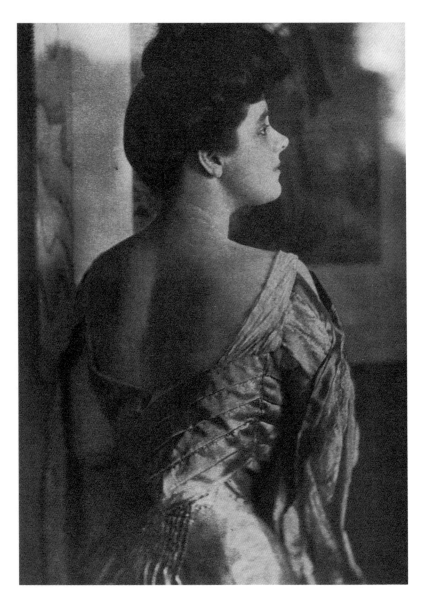

Gertrude Käsebier
Portrait – Mrs. Philip Lydig, 1905
Photogravure
20.6 x 14.7

Gertrude Käsebier
Happy Days, 1905
Photogravure
19.7 x 15.7 cm

Gertrude Käsebier
My Neighbors, 1905
Photogravure
15.9 x 20.6 cm

Gertrude Käsebier →
Pastoral, 1905
Photogravure
21.2 x 16.6 cm

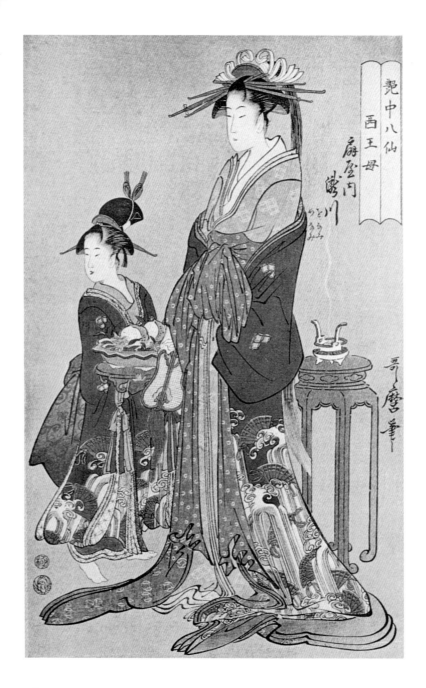

艶中八仙
西王母

扇屋内
瀧川
たきかは
のとあふみ

歌麿筆

Thomas W. Dewing
In the Garden, 1905
Half-tone reproduction
7.4 x 13.1 cm

← Outamaro
Untitled, 1905
Half-tone reproduction
18.3 x 11.5 cm

Sandro Botticelli
Spring, 1905
Half-tone reproduction
8.4 x 13 cm

C. Yarnall Abbott→
A Coryphée, 1905
Colour half-tone reproduction
17.6 x 9.9 cm

C. Yarnall Abbott
Illustration for "Madame Butterfly", 1905
Half-tone reproduction
20.2 x 14.1 cm

E. M. Bane
Untitled, 1905
Photogravure
7.8 x 12.7cm

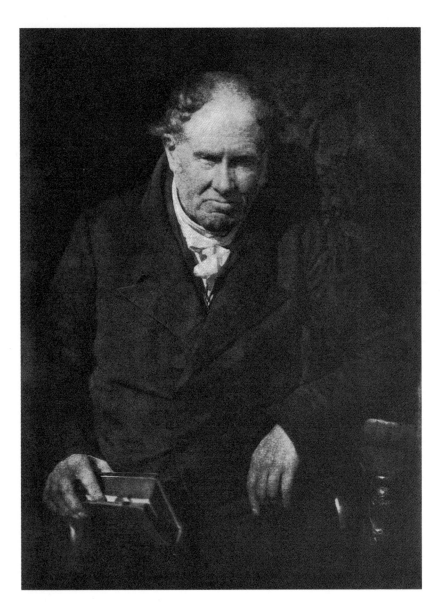

David Octavius Hill, R.S.A. – 1802 · 1870
(and Robert Adamson)
Dr. Munro
Photogravure
20.9 x 15.5 cm

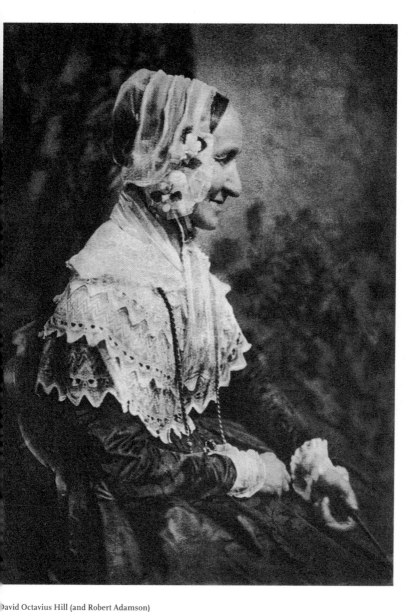

David Octavius Hill (and Robert Adamson)
Mrs. Rigby, 1905
Photogravure
20.1 x 14.8 cm

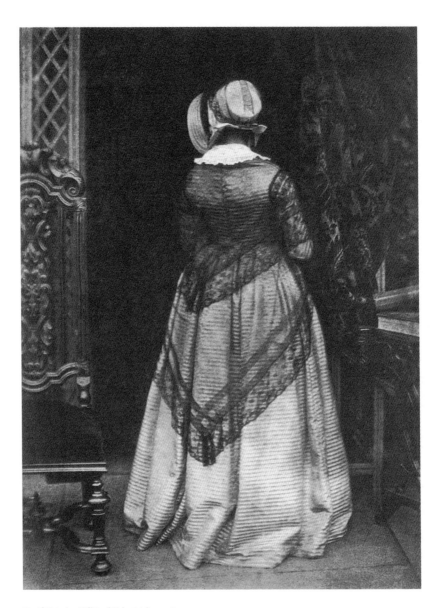

David Octavius Hill (and Robert Adamson)
Lady Ruthven, 1905
Photogravure
20 x 14.9 cm

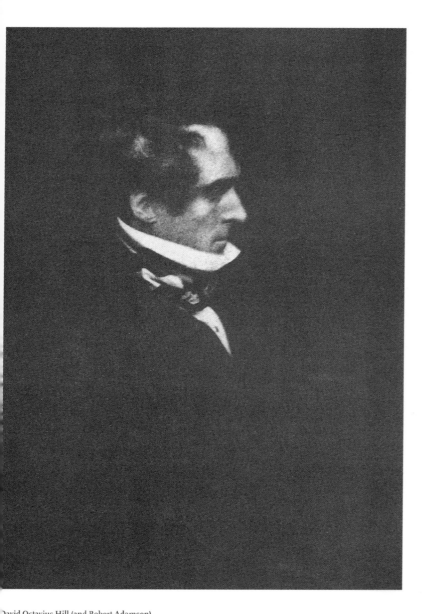

David Octavius Hill (and Robert Adamson)
John Gibson Lockhart, 1905
Half-tone reproduction
18.8 x 14 cm

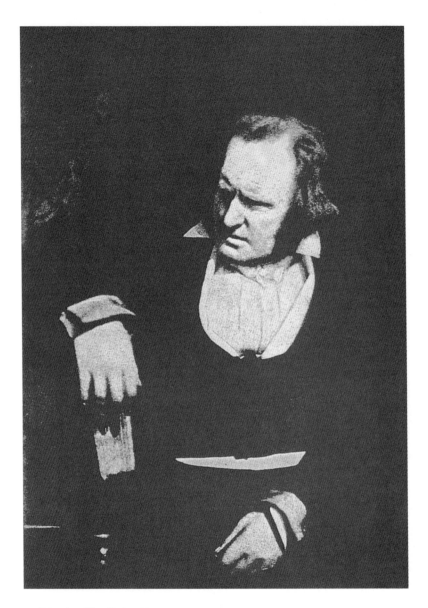

David Octavius Hill (and Robert Adamson)
"Christopher North" (Professor Wilson), 1905
Half-tone reproduction
21.5 x 15.4 cm

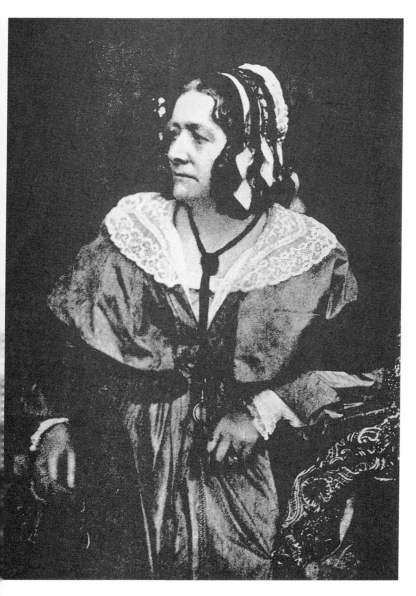

David Octavius Hill (and Robert Adamson)
Mrs. Jameson, 1905
Half-tone reproduction
19.8 x 14.6 cm

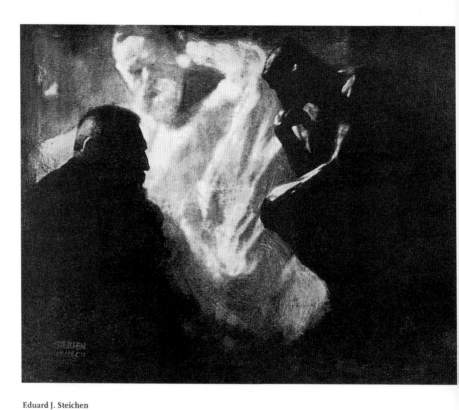

Eduard J. Steichen
Rodin – Le Penseur, 1905
Half-tone reproduction
14.7 x 18.4 cm

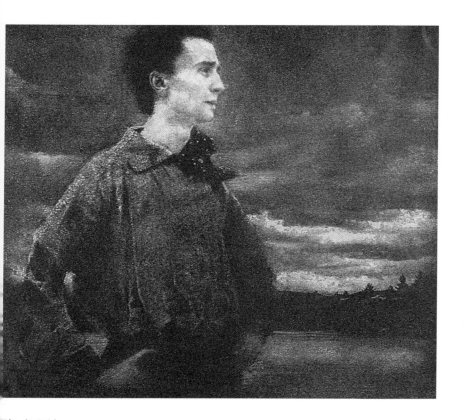

Eduard J. Steichen
Portrait of a Young man (Self-portrait), 1905
Half-tone reproduction
12.2 x 14.8 cm

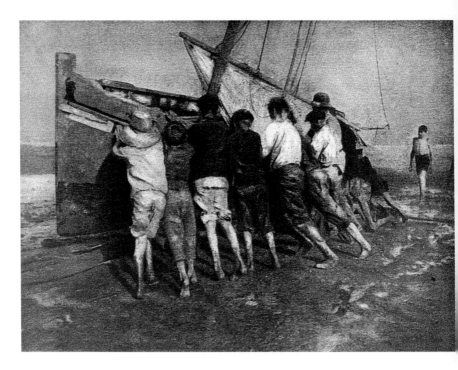

Robert Demachy
L' Effort, 1905
Half-tone reproduction
15.1 x 20.6 cm

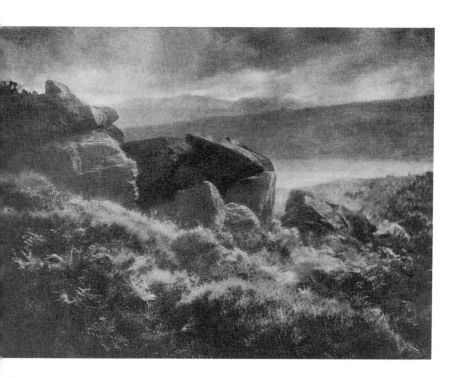

. Horsley Hinton
ain from the Hills, 1905
hotogravure
4.6 x 19.7 cm

A. Horsley Hinton
Beyond, 1905
Photogravure
14.3 x 18.8 cm

DAVID OCTAVIUS HILL, R.S.A.—1802-1870.

THE FACULTY of imitation is inherent in human nature, and up to a certain point is one of the most important factors in our intellectual development, but when one has passed the period of primary education and begun to attack his life-work he must subdue the tendency to follow the easy path of redoing what others have done, and work directly from his own self-consciousness if he is to attain any distinction.

He is indeed a fortunate man who, endowed with talent and courage, finds himself at work in a field where there are no precedents and who must simply follow the guidance of his own instincts. Art-work produced in such circumstances is generally fine and always interesting, as witness the beautiful forms created by the primeval potters, the frescos of Fra Angelico, or the paintings of the Van Eycks.

Such productions are evolved as unconsciously and as directly from nature as are the trees and flowers, and constitute a pure product; but soon there come imitators who, incompletely comprehending the work of the master, produce something resembling it in its more obvious features but lacking the subtler qualities, with the result that in course of time the pure art disappears and certain conventions and mannerisms are accepted in its place. This is true in the realm of photography also, and is strikingly exemplified in the work of the subject of this paper, David Octavius Hill, R.S.A., who, sixty years ago, produced photographic portraits which have charmed and delighted artists of every school who have had the fortune to become acquainted with them.

To present-day pictorial photographers it is extremely interesting and almost humiliating to observe that on the very threshold of the photographic era there was one doing with no apparent effort what they would fain accomplish with eager strivings, and thinking so little of his achievements that when he returned to what he considered his serious work it was with a sense of having frittered away three solid years in following a most fascinating amusement.

D. O. Hill, as he was familiarly termed by his friends, was a painter of considerable repute in Scotland in the earlier part of last century. Born in Perth in 1802 he soon showed an aptitude for art and was fortunate in having a father who encouraged him in its pursuit and sent him to Edinburgh to study in the Trustees Academy. He began to exhibit in 1823, and six years later his work was considered of sufficient merit to entitle him to full membership of the Royal Scottish Academy. During the following year he was appointed secretary to that institution and for forty years he devoted his energies and much of his time to the furtherance of its interests. In his early days he painted subjects illustrative of Scottish life and character, but for the greater part of his life he devoted himself to landscape-painting. Many of his pictures were engraved, and such an able critic as P. G. Hamerton had many appreciative things to say of his art; but "the good men do is oft interred with their bones," and had Hill only painted pictures his memory

would already be almost confined to the archives of the Academy. It is to a dramatic event which occurred in Edinburgh in 1843 that we are indirectly indebted for the wonderful work which he has done in photography, and which will undoubtedly "live after him."

The event referred to was the disruption of the Church of Scotland, when 470 ministers rose in the Assembly Hall and, resigning their churches, manses, and livings for conscience sake, left the building in a body. Hill was a witness of the striking and impressive spectacle, and in a rash moment resolved that his art should preserve a record of a scene so memorable.

Gradually the tremendous nature of the self-imposed task, which involved the painting of 500 portraits, began to dawn on the distressed painter, and it occurred to him to consult his friend Sir David Brewster, who, he knew, had been recently experimenting with the new process by which the impressions of the camera obscura could be fixed on paper. Sir David replied that calotype was the thing for his purpose and that he could recommend a clever young chemist, Robert Adamson of St. Andrews, as a qualified assistant in the technical manipulation.

Thus the partnership began which was to produce the noble and extensive series of portraits which for powerful characterization and artistic quality of uniformly high excellence have certainly never been surpassed and possibly not even rivaled by any other photographer. This may seem an extravagant appreciation of Hill's work, but it has been arrived at after mature deliberation. The great majority of the original paper negatives are still in existence and are in the hands of an Edinburgh gentleman who, it is anticipated, will shortly publish a worthy representation of the series so that the public generally may have an opportunity of studying the portraits and estimating their value.

In many respects Hill was fortunate. He had no traditional conventions to bias the natural bent of his artistic instincts. There was no ready-made photographic studio which he might have been tempted to use, fitted with all manner of devices for rendering soft and puerile the heads and hands of vital character which were so frequently possessed by his sitters. The calotype process was such that he could not obtain a clear, sharp image if he would; his exposures averaged three minutes in duration, yet the negatives retained full modeling in high light and shadow to a degree unknown to the worker with gelatine emulsion, and he was not aware of the possibility of halation.

While there were no technical conventions to misdirect him, Hill was evidently strongly impressed by the portraits of the recently deceased painter, Sir Henry Raeburn. Raeburn's portraits constitute ideal models for the study of the photographer, and it is interesting to note that this fact was appreciated by a contemporary writer and referred to as follows in a criticism of Hill's portraits:

"There is the same broad freedom of touch; no nice miniature stipplings, as if laid in by the point of a needle—no sharp-edged strokes; all is solid, massy, broad; more distinct at a distance than when viewed near at hand.

The arrangement of the lights and shadows seem rather the result of a happy haste, in which half the effect was produced by design, half by accident, than of great labor and care; and yet how exquisitely true the general aspect! Every stroke tells, and serves, as in the portraits of Raeburn, to do more than relieve the features: it serves also to indicate the prevailing mood and predominant power to the mind."

The experiments were conducted in a house on the Calton Hill, that classic monumented rock which bounds the eastern vista of Princes Street, Edinburgh, and would form a fitting Mecca for the future devotees of the art. Hill speedily became fascinated with the new process, and when he had photographed the more interesting of the ministers, and many magnificent types there were among them, he forgot the original cause of his experiments and busied himself portraying the features of the men and women of intellect in Edinburgh at a period when the northern capital rivaled the metropolis itself in the force and character of its literary activity. It was a period also when convention and cosmopolitanism had not molded the sartorial and tonsorial aspect of the civilized world in one universal characterless form. Men wore their hair as it pleased them and their clothes were soft and fitted to their form. Their collars were unstarched if their stocks were high and uncomfortable, and the general aspect was infinitely more pictorial than it is to-day. Breeding is said to be the art of concealing one's feelings, and so highly has our breeding developed nowadays that our faces have almost assumed the uniformity of our clothes. That this was not so in Hill's time is very evident from his photographs. Take, for example, the portrait of that physical and mental giant, "Christopher North" (Professor Wilson), with his great head and massive girth, instinct with power, passive for the moment, but ready to exert his tremendous force in crushing some poor "rascally Whig" who had ventured to attack him in the Edinburgh Review. Then compare with this the portrait of his co-editor of "Blackwoods," John Gibson Lockhart, the son-in-law and biographer of Sir Walter Scott. Hill has at least four portraits of him which vividly represent his keen, refined, reserved, intellectual character, and one can readily believe that the fighting articles which appeared over his nom-de-plume, "The Scorpion," were distinctly reminiscent of that creature.

One becomes so fascinated by the interest of the persons who sat to Hill and by his magnificent characterization of them that it is only as a secondary consideration that one thinks of the artistic qualities of his pictures. This is really one of the highest compliments that one could pay them if it be true that "the greatest art is that which conceals art," for there is absolutely no appearance of conscious effort in the arrangement of his compositions, nor is there any feeling of affectation in the striking attitudes in which he frequently portrayed his subjects.

He simply photographed his sitters as he did because it satisfied his instincts at the moment, and it is not unlikely that if he thought of the matter at all he would expect others to do precisely as he did. It is

abundantly evident, however, that he had an absolute genius for seeing his sitters in a grand and impressive manner. His spacing is always perfect, his masses of light and shade are always broad and simple, and his pictures possess that power and distinction so difficult to describe or explain but which is always apparent in the work of a master and distinguishes it from that of an earnest conscientious practitioner of less capacity.

The portrait of Dr. Munro illustrates very well the qualities alluded to. It is simple and powerful to a high degree. There is no evidence of conscious posing, yet the head and hands are admirably disposed and the whole picture is in excellent tone. Dr. Munro was the third of three generations who for one hundred and twenty-six consecutive years filled the chair of anatomy in the University of Edinburgh, and one could imagine that in those days, when anesthetics were little known, he would amputate a limb without having his feelings specially harrowed by the sufferings of his patient.

A volume would be necessary to treat of all the notable persons who were portrayed by Hill's camera. Nearly all his contemporary Academicians sat to him, many of them in various costumes, and one can imagine their delight in the wonderful results of the new process. They were a picturesque group, but hardly more so than the professors, literary men, lawyers, and aristocrats who also posed for him.

That he was possessed of humor is indicated by the portrait reproduced of Lady Ruthven. The pose suggests that it was not chosen for its quaint grace alone, and as a companion portrait to the full length of her liege lord, who stands in the orthodox manner, it is distinctly amusing. The Lady herself may have been, to some extent, responsible for the picture. She was one of the leaders of the intellectual society of Edinburgh for many years and was as noted for her wit as for her knowledge of literature, art, and music. She was an intimate friend of Sir Walter Scott, and her picturesque old house of Winton was the original of his Ravenswood Castle in the "Bride of Lammermoor."

But it was not only the personalities of Edinburgh who sat to Mr. Hill. Many noted visitors found their way to his studio and thus we have excellent renderings of Sir Francis Grant, P.R.A., of Etty, of Mrs. Jameson, the well-known authoress of "The Early Italian Painters," etc., and others. The photograph of Mrs. Jameson and that of Mrs. Rigby are probably Hill's finest female portraits. They both contain the qualities which we have ascribed to his male studies, and without in any way diminishing the artistic strength of the compositions he has successfully imbued them with the spirit of feminine grace and refinement. We know of no sweeter present-ment of old age by photography than this charming portrait of Mrs. Rigby. She was the mother of the gifted Lady Eastlake, and one can well imagine from her features and her beautiful head-dress that she also was possessed of considerable intellectual and artistic qualities.

Hill was certainly fortunate in his sitters, but the sitters were equally fortunate in their photographer.

Certain pictures evoke admiration in one artist and dislike in another, according as they belong to the school of realists or impressionists, but there are paintings of such merit that they command universal admiration, such as the works of Titian, Velasquez, and Rembrandt. So is it with Hill's portraits, artists of every school seem to delight in their fine qualities.

The late Sir Frederick Leighton had an intense admiration for them, and Mr. Sargent, writing to Sir James Guthrie regarding them, says, "They are simply magnificent; I have never seen more interesting photographs or more interesting types."

On one occasion the writer sent some copies to Mr. Whistler and by return of post received the following note:

110, RUE DU BAC, PARIS.

Dear Sir: How very kind and nice of you to send me those most curiously attractive photographs! I should more simply say pictures, for they certainly are pictures, and very fine ones too! Pray accept my best thanks for your present and for the flattering thought that prompted it.

Very faithfully yours,

May 26, 1893. J. McNEILL WHISTLER.

After quoting the opinions of such authorities nothing more need be said of the quality of Hill's work.

At the end of three years the studio on Calton Stairs was given up and there is no evidence that he even photographed again.

The completion of his portrait group was a severe trial to him and it was only the repeated injunction of his wife, "Stick to your guns, D. O.!" which brought it to completion twenty years later.

He died in 1870 much honored and lamented for his many fine personal and social qualities.

J. CRAIG ANNAN.

Alfred Stieglitz
Horses (1904), 1905
Photogravure
18.2 x 23 cm

Alfred Stieglitz →
Winter – Fifth Avenue (1892), 1905
Photogravure
21.9 x 15.3 cm

Alfred Stieglitz
Going to the Start (1904), 1905
Photogravure
21.3 x 19 .1 cm

Alfred Stieglitz
Spring (1901), 1905
Photogravure
12.5 cm x 15.7 cm

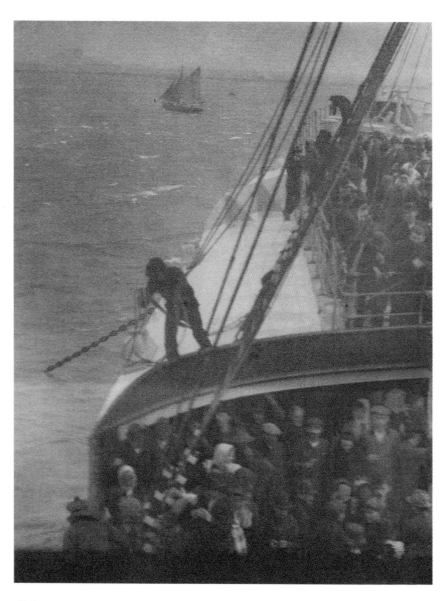

Alfred Stieglitz
Nearing Land (1904), 1905
Photogravure
21.5 x 17.5 cm

Alfred Stieglitz
Katherine (1905), 1905
Photogravure
20.9 x 16.9 cm

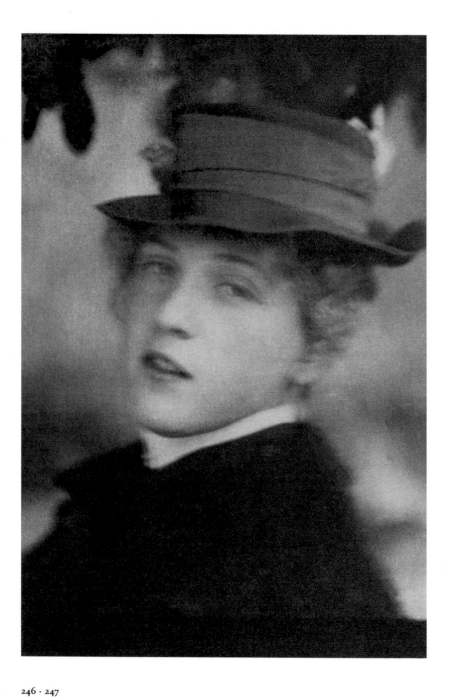

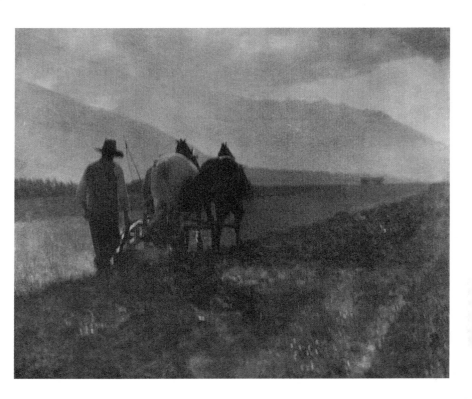

Alfred Stieglitz
Ploughing (1904), 1905
Photogravure
18.9 x 24.3

← **Alfred Stieglitz**
Miss S. R. (1904), 1905
Photogravure
20.5 x 13.9 cm

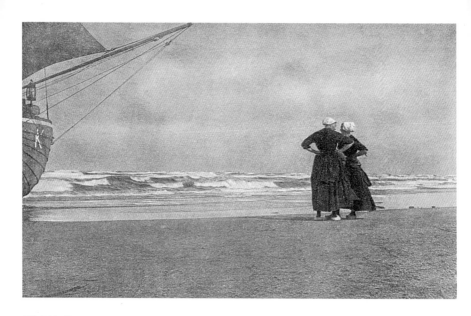

Alfred Stieglitz
Gossip – Katwyk (1894), 1905
Half-tone reproduction
12.6 x 20.5 cm

Alfred Stieglitz →
September (1899), 1905
Half-tone reproduction
15.9 x 11.5 cm

FIG. I

FIG. II

FIG. III

FIG. IV

EGYPTIAN
HIEROGLYPHICS

EGYPTIAN
HIERATIC

PHOENICIAN
ALPHABET

D *Greek* Δ

L *Hebrew*

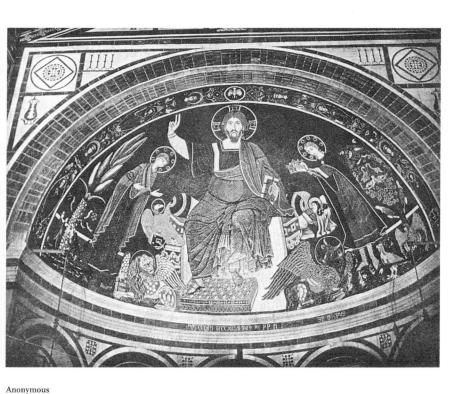

Anonymous
Untitled, 1905
Half-tone reproduction
8.9 x 12 cm

← Anonymous
Untitled, 1905
Letterpress
19.5 x 9 cm

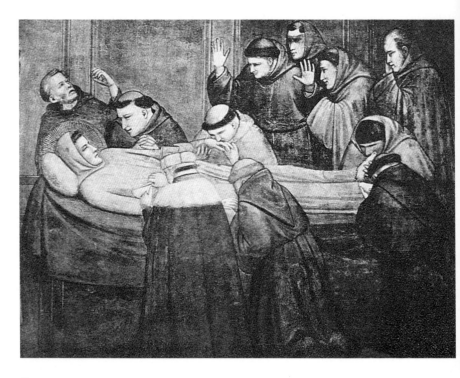

Giotto
Untitled (Death of St. Francis), 1905
Half-tone reproduction
9 x 12 cm

Sandro Botticelli →
Untitled (Spring: detail), 1905
Half-tone reproduction
15.2 x 11,9 cm

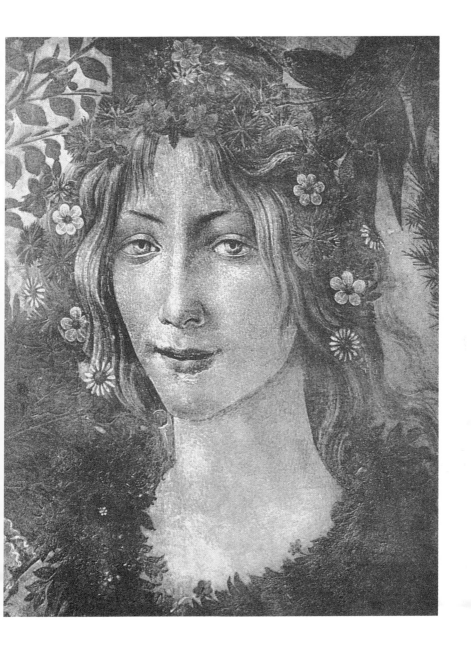

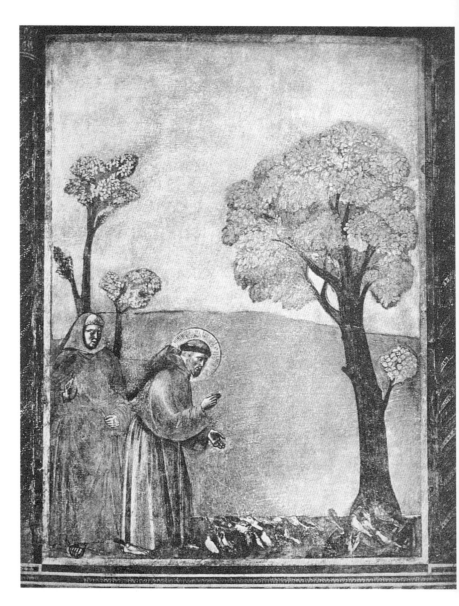

Giotto
Untitled (St. Francis Preaches to the Birds), 1905
Half-tone reproduction
14.9 x 12.1

Diego Velázquez
Untitled (Don Philip), 1905
Half-tone reproduction
15.2 x 11.9 cm

F. Benedict Herzog
Marcella, 1905
Photogravure
20.3 x 17.3 cm

F. Benedict Herzog
Angela, 1905
Photogravure
20.8 x 17 cm

F. Benedict Herzog
The Tale of Isolde , 1905
Photogravure
18.8 x 18.1 cm

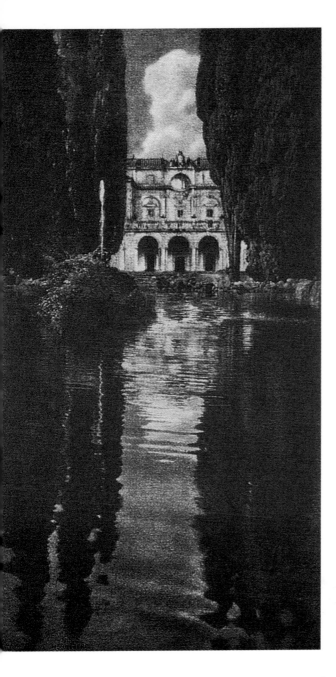

Hugo Henneberg
Villa Falconieri, 1906
Photogravure
23.8 x 12.8 cm

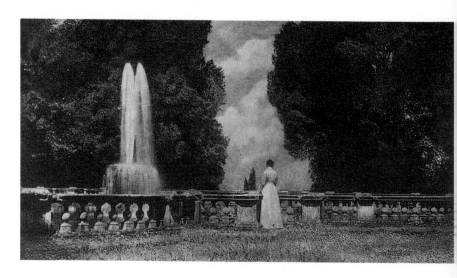

Hugo Henneberg
Villa Torlonia, 1906
Photogravure
12.9 x 24 cm

Hugo Henneberg →
Pomeranian Motif, 1906
Photogravure
24.5 x 17.2 cm

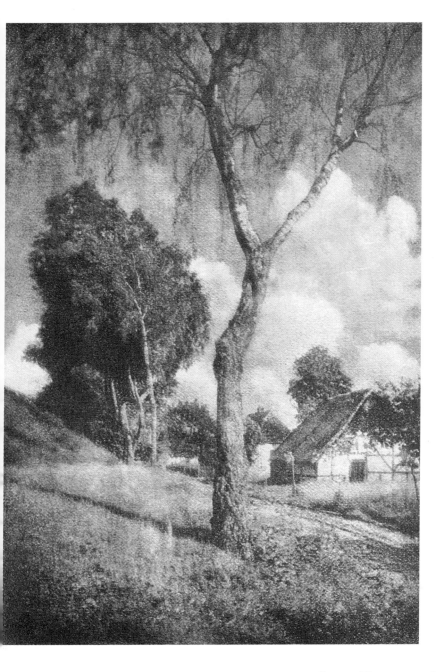

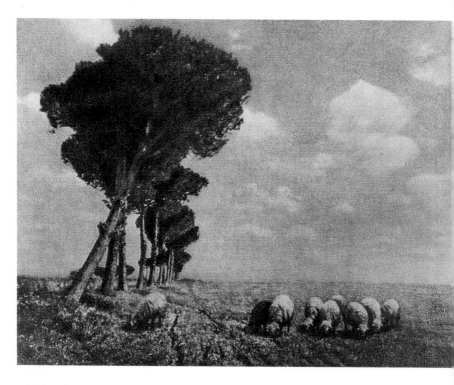

Heinrich Kuehn
Roman Campagna, 1906
Photogravure
17.5 x 22.8 cm

Heinrich Kuehn →
Girl with Mirror, 1906
Photogravure
19.5 x 14.4 cm

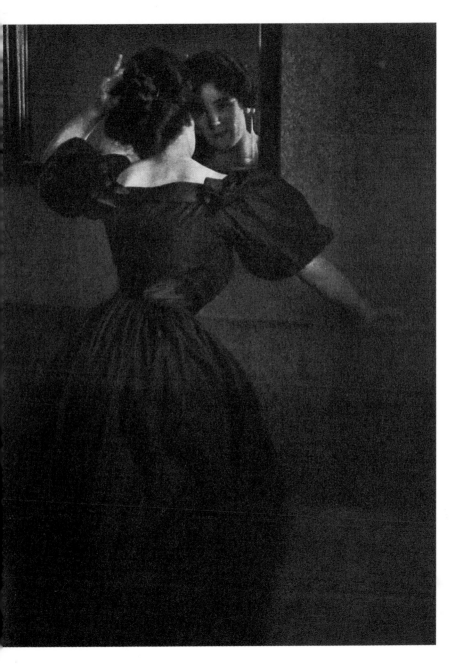

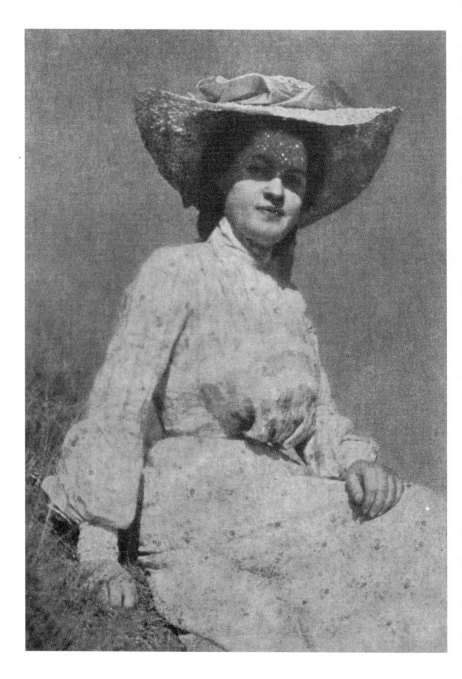

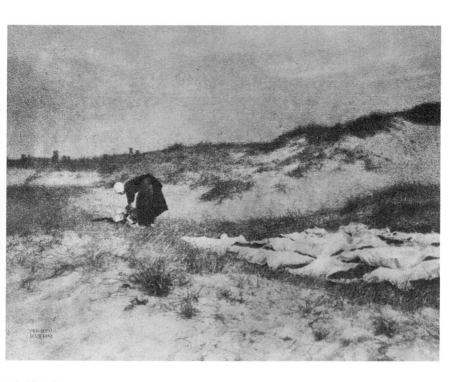

Heinrich Kuehn
Washerwoman on the Dunes, 1906
Photogravure
16.8 x 22.8 cm

← Heinrich Kuehn
A Study in Sunlight, 1906
Photogravure
19.8 x 14 cm

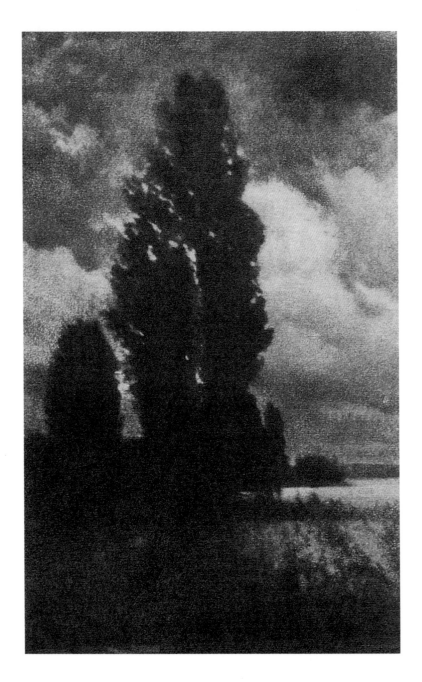

Hans Watzek
Mountain Landscape, 1906
Photogravure
14.3 x 20 cm

← Hans Watzek
Poplars and Clouds, 1906
Photogravure
21.1 x 13.4 cm

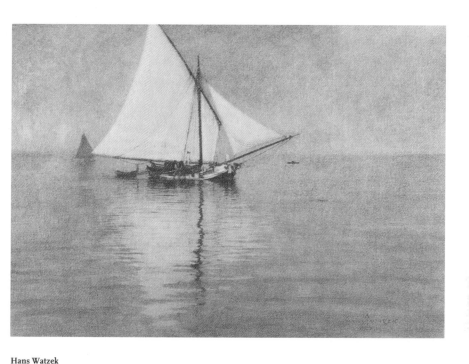

Hans Watzek
The White Sail, 1906
Photogravure
16 x 22.9 cm

← **Hans Watzek**
A Village Corner, 1906
Photogravure
19.4 x 14.9 cm

Hans Watzek
Sheep, 1906
Photogravure
16.8 x 21.9 cm

Eduard J. Steichen →
George Fredrick Watts, 1906
Photogravure
21.3 x 16.5 cm

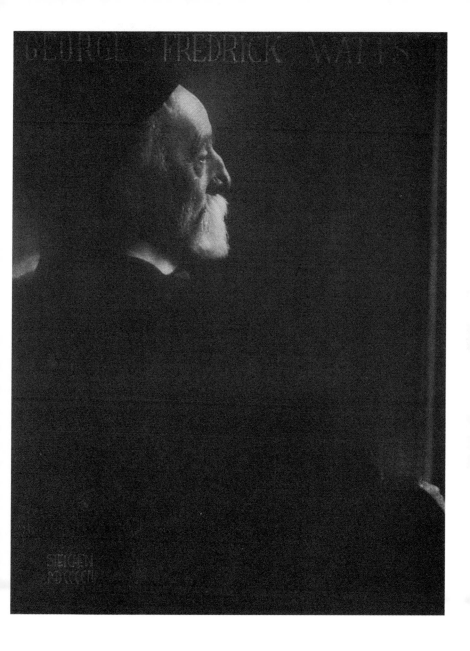

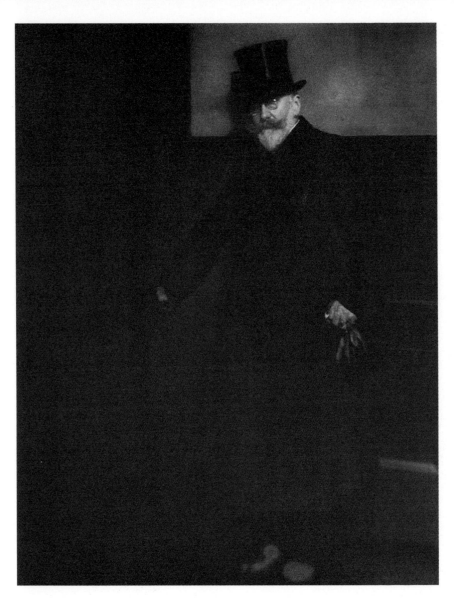

Eduard J. Steichen
William M. Chase, 1906
Photogravure
20.8 x 16.2 cm

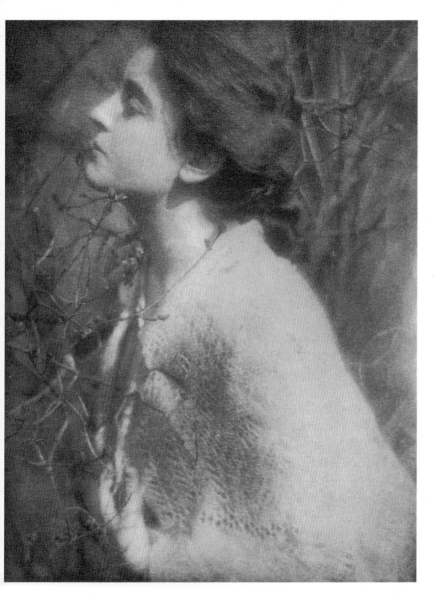

Eduard J. Steichen
Lilac Buds: Mrs. S., 1906
Photogravure
20.5 x 15.8 cm

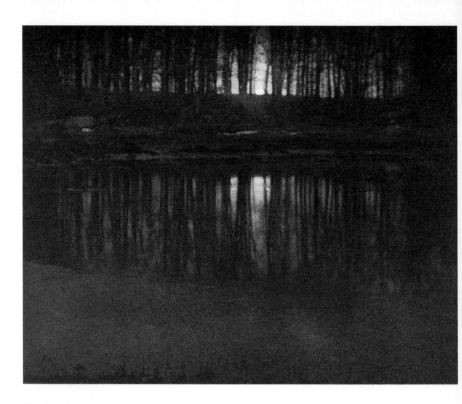

Eduard J. Steichen
Moonlight: The Pond, 1906
Photogravure
16.2 x 20.3 cm

Eduard J. Steichen →
The Little Round Mirror, 1906
Photogravure
21.3 x 14.1 cm

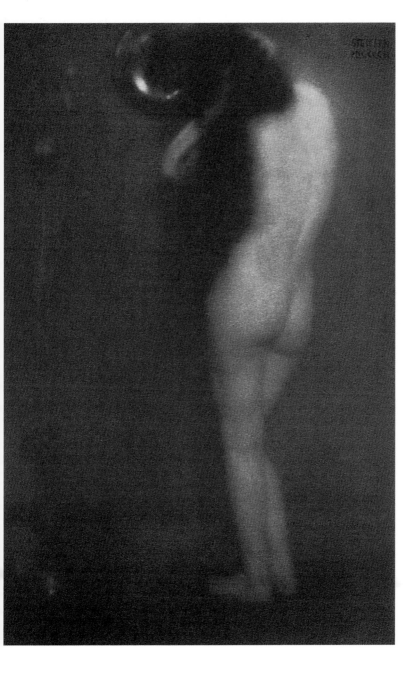

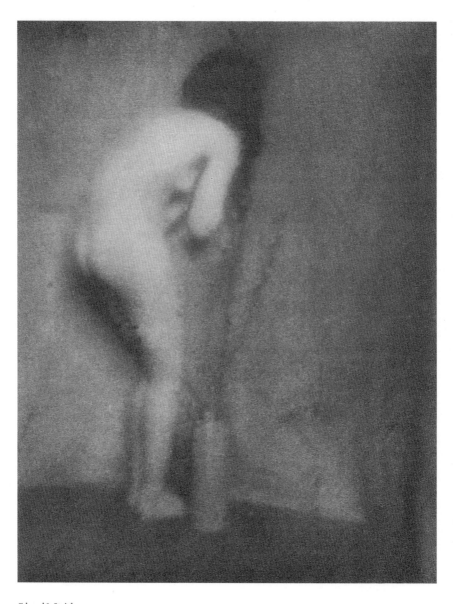

Eduard J. Steichen
The Little Model, 1906
Photogravure
20.9 x 16.1 cm

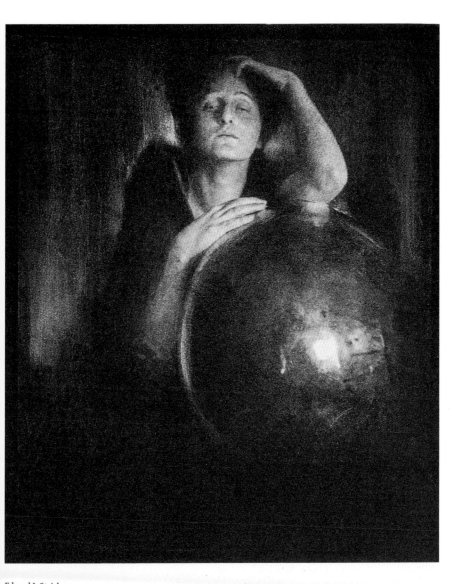

Eduard J. Steichen
The Brass Bowl, 1906
Half-tone reproduction
19.3 x 16.4 cm

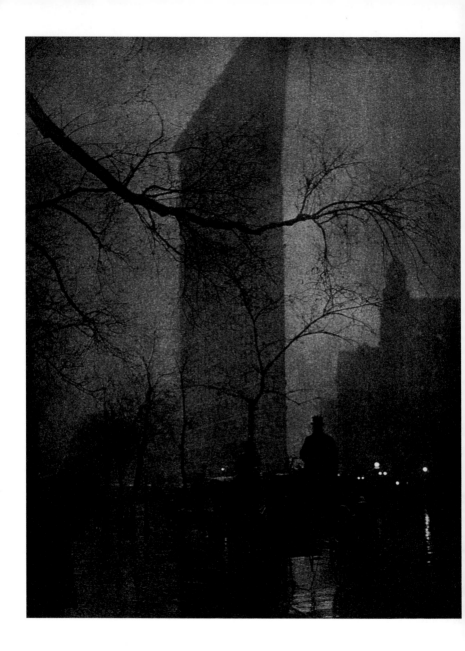

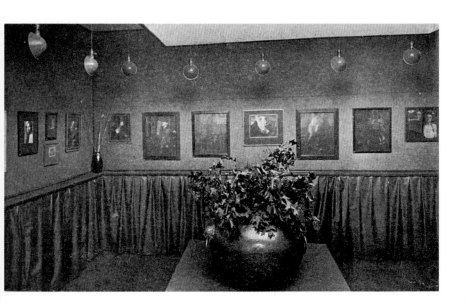

Alfred Stieglitz
The Little Galleries of the Photo-Secession, 1906
Half-tone reproduction
7.4 x 12.4 cm

← Eduard J. Steichen
The Flatiron–Evening, 1906
Three-colour half-tone reproduction
20.6 x 16 cm

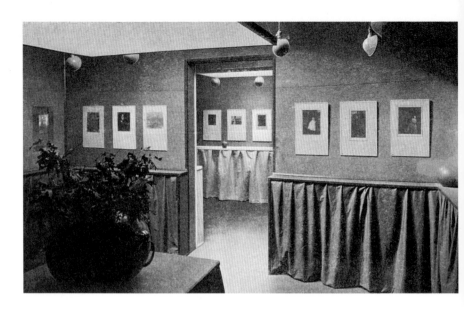

Alfred Stieglitz
The Little Galleries of the Photo-Secession, 1906
Half-tone reproduction
7.5 x 12.4 cm

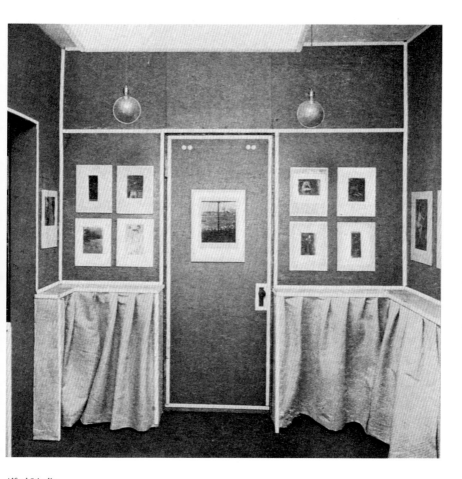

Alfred Stieglitz
The Little Galleries of the Photo-Secession, 1906
Half-tone reproduction
8 x 8.4 cm

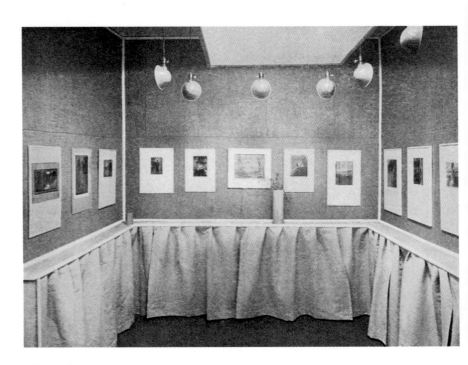

Alfred Stieglitz
The Little Galleries of the Photo-Secession, 1906
Half-tone reproduction
7.5 x 10.6 cm

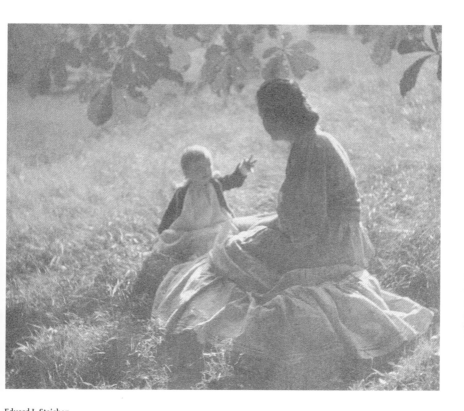

Eduard J. Steichen
Mother and Child – Sunlight, 1906
Photogravure
12.9 x 15.7 cm

Eduard J. Steichen →
Cover Design, 1906
Coloured half-tone reproduction
20.3 x 13.4 cm

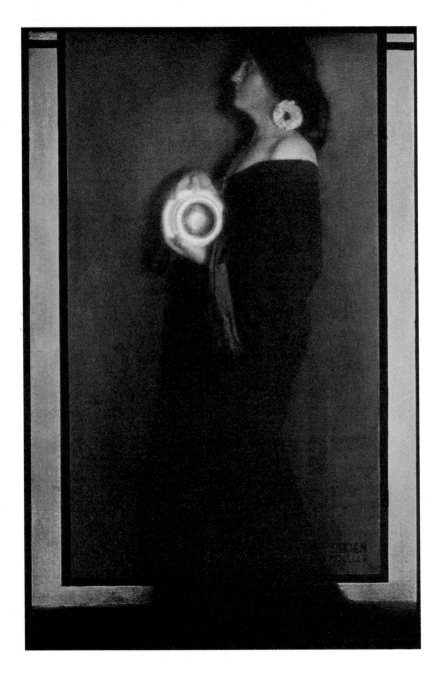

OUR ILLUSTRATIONS.

IT is not many years ago that the work and name of Steichen acted upon the average photographic public as a red rag does upon a bull. How things have changed—even Mr. Steichen's work—but his has been no step backward. The inference is plain that the photographic public has been in a measure educated. The non-photographic public, at first but slightly interested, has begun to appreciate that photography holds within itself some possibilities, though individuals still differ as to their extent. This interest is growing, and reacting upon photographers tends toward a more comprehensive understanding and appreciation, resulting in such a decided improvement in the standards of all, even in the standards of the Philistine, that we feel confident that many who found no pleasure in the earlier published work of Mr. Steichen will now thank us in giving them a second opportunity of viewing the work of this maturing young painter and photographer.

The plates in this number, together with those published in the Special Supplement, constitute a landmark in the achievements of the camera and in their relation all that has thus far been accomplished in photography give promise that either Mr. Steichen himself or some one at present unknown will in the future accomplish such achievements that even the most doubting Thomas will be convinced. Perhaps what we believe in to-day, the world will acknowledge to-morrow. The photogravures were all made from the original negatives and under Mr. Steichen's personal direction. We flatter ourselves that some of the gravure plates are even above our own average of reproduction and give a fair idea of Mr. Steichen's spirit, although it is impossible to reproduce the full quality of his originals, some of which are in gum, some in platinum, some in bromide and some in a combination of these processes. It should be a matter of interest to all photographers that "Mother and Child—Sunlight," the chief prize-winning print in the recent International Kodak Competition, in which 28,000 prints were submitted, was made with a 4 x 5 Kodak camera and lens on a roll-film, developed in machine and printed on velox paper. This ought to be sufficient answer to the many charges that Mr. Steichen's acknowledged superior skill is dependent upon faking negatives and prints or both. The prize-winning cover design in the Goerz Catalogue-cover Competition, in which the famous designer M. Alphonse Mucha was one of the three judges, proves that photography lends itself to this branch of art. The Goerz people deserve great credit for encouraging the use of the camera in this hitherto undeveloped field.

Mr. Steichen's three-color work which we had hoped to include is as yet not ready for publication, owing to the fact that the engravers have not been able to satisfy us in this regard. It will be published in a later issue of Camera Work.

"PHOTO-SECESSION"

291 FIFTH AVENUE
BETWEEN THIRTIETH AND THIRTY-FIRST STREETS

✠ ✠ CALENDAR OF EXHIBITIONS ✠ ✠

✠ ✠ FEBRUARY FIFTH TO FEBRUARY NINETEENTH ✠ ✠
PHOTOGRAPHS FROM THE PORTFOLIOS OF
GERTRUDE KÄSEBIER NEW YORK
CLARENCE H. WHITE NEWARK, OHIO

FEBRUARY TWENTY-FIRST TO MARCH FOURTEENTH
BRITISH EXHIBITION NO. I
PHOTOGRAPHS BY J. CRAIG ANNAN GLASGOW
ARCHITECTURAL PHOTOGRAPHS BY FREDERICK H. EVANS, LONDON
AND A COLLECTION OF PHOTOGRAPHIC PORTRAITS MADE SIXTY
YEARS AGO BY D. O. HILL, R.S.A., OF GLASGOW
MR. HILL WAS THE ACTUAL PIONEER OF MODERN PICTORIAL PHOTOGRAPHY

✠ ✠ MARCH SIXTEENTH TO MARCH THIRTY-FIRST ✠ ✠
PHOTOGRAPHS BY EDUARD J. STEICHEN NEW YORK
THE EXHIBITION WILL INCLUDE THE PHOTOGRAPHER'S EXPERIMENTS IN COLOR-PHO-
TOGRAPHY

✠ ✠ ✠ ✠ ✠ APRIL THIRD TO APRIL TENTH ✠ ✠ ✠ ✠ ✠
"SALON DES REFUSÉS"
A COLLECTION OF PAINTINGS, BY AMERICAN PAINTERS, THAT
HAVE BEEN REFUSED AT THE SOCIETY OF AMERICAN ARTISTS,
NATIONAL ACADEMY, CARNEGIE INSTITUTE, AND PENNSYLVANIA
ACADEMY OF FINE ARTS EXHIBITION

✠ ✠ ✠ APRIL TWELFTH TO APRIL THIRTIETH ✠ ✠ ✠
MULTIPLE GUM-PRINTS BY GERMAN & AUSTRIAN PHOTOGRAPHERS
HANS WATZEK (DECEASED) VIENNA
HUGO HENNEBERG VIENNA
HEINRICH KÜHN INNSBRUCK
THEODORE AND OSCAR HOFMEISTER HAMBURG

✠ ✠ ✠ ✠ MAY SECOND TO END OF SEASON ✠ ✠ ✠ ✠
GENERAL EXHIBITION OF WORK BY MEMBERS OF THE PHOTO-
SECESSION

THESE EXHIBITIONS ARE OPEN TO THE PUBLIC DAILY,
SUNDAY EXCEPTED, FROM TEN A. M. TO SIX P. M.
A VISITING-CARD ADMITS ✠ ✠ ✠ ✠ ✠ ✠ ✠ ✠ ✠ ✠ ✠ ✠ ✠

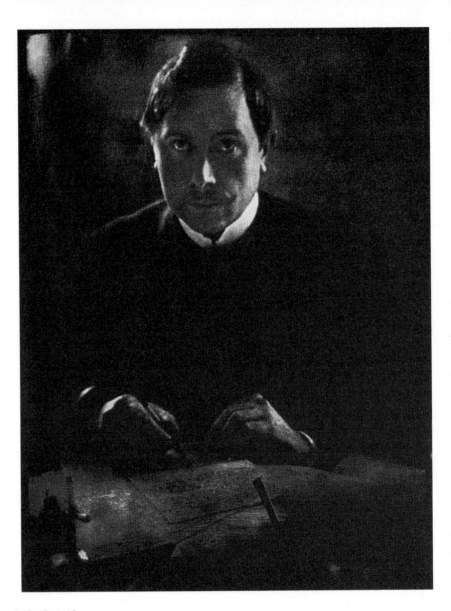

Eduard J. Steichen
Maeterlinck, 1906
Half-tone reproduction
20.8 x 15.1 cm

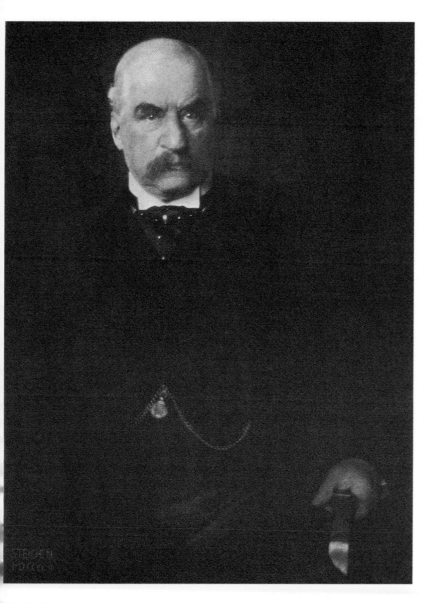

Eduard J. Steichen
J. Pierpont Morgan, Esq., 1906
Photogravure
20.5 x 15.6 cm

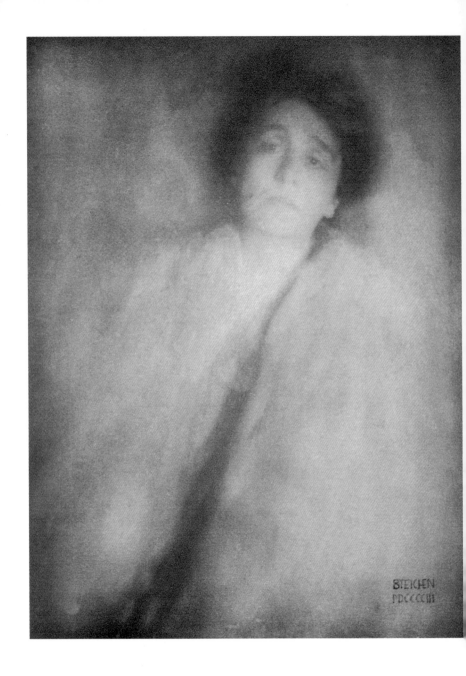

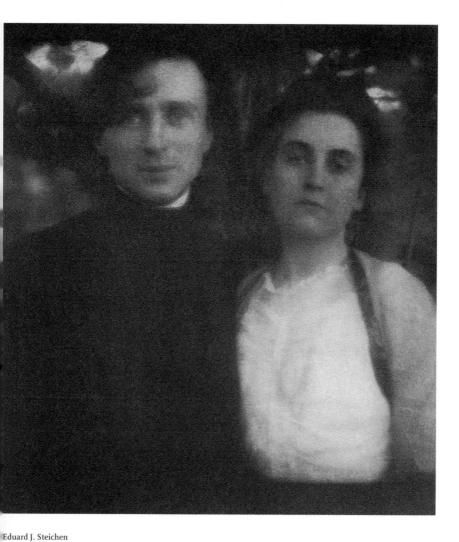

Eduard J. Steichen
Portraits – Evening, 1906
Photogravure
18.7 x 17 cm

← Eduard J. Steichen
Duse, 1906
Photogravure
21.6 x 16.5 cm

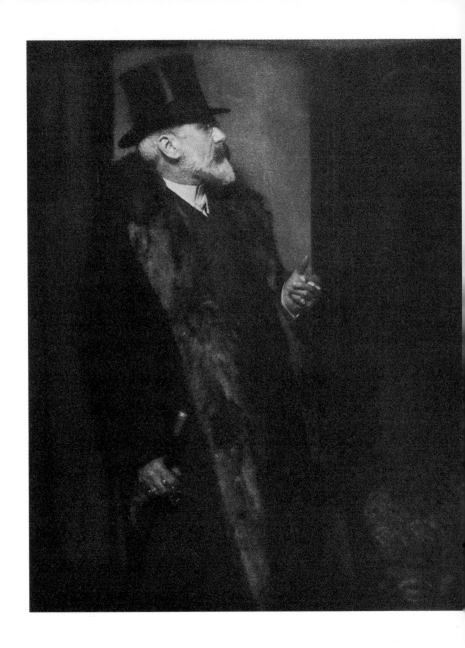

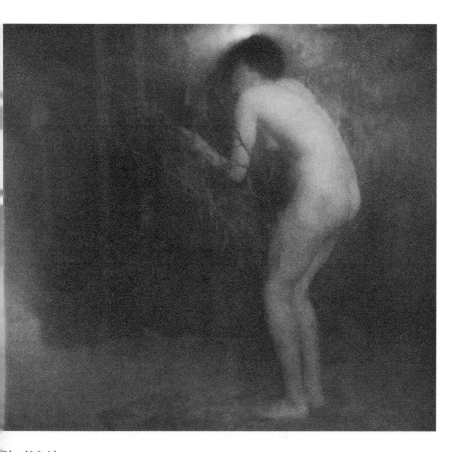

Eduard J. Steichen
La Cigale, 1906
Photogravure
16 x 17.9 cm

← Eduard J. Steichen
Wm. M. Chase, 1906
Photogravure
20.7 x 16.5 cm

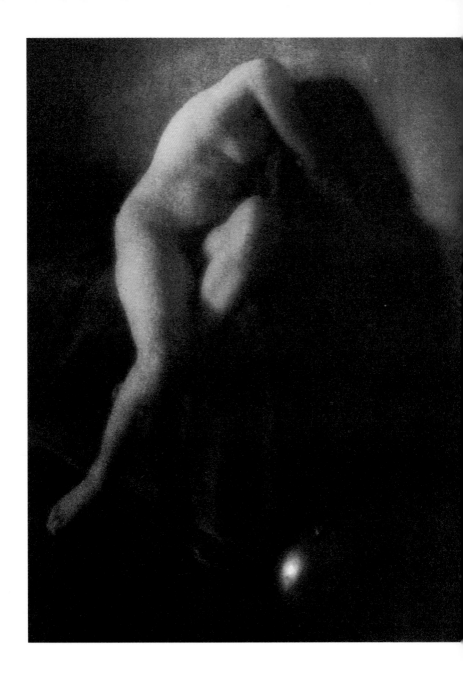

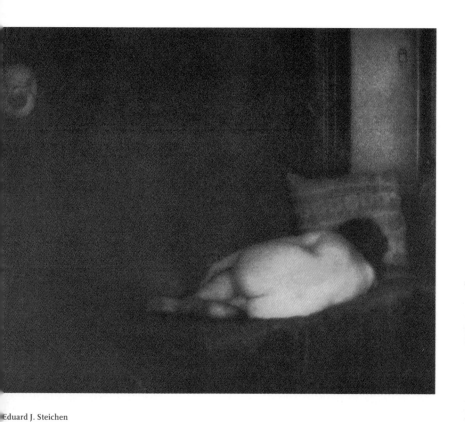

Eduard J. Steichen
The Model and the Mask, 1906
Photogravure
16.7 x 20.7 cm

→ Eduard J. Steichen
In Memoriam, 1906
Photogravure
20.7 x 15.8 cm

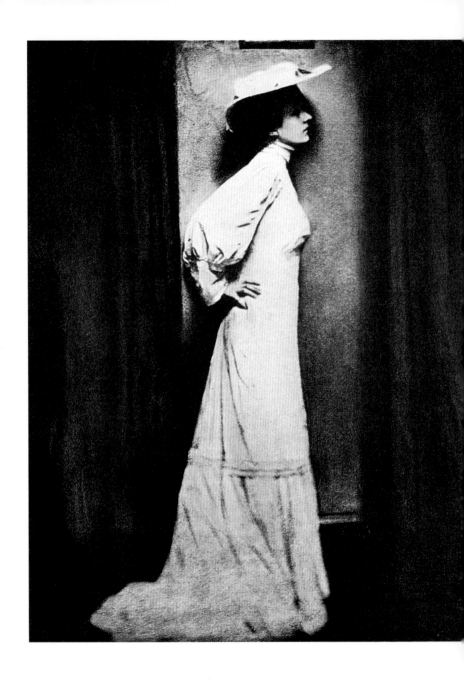

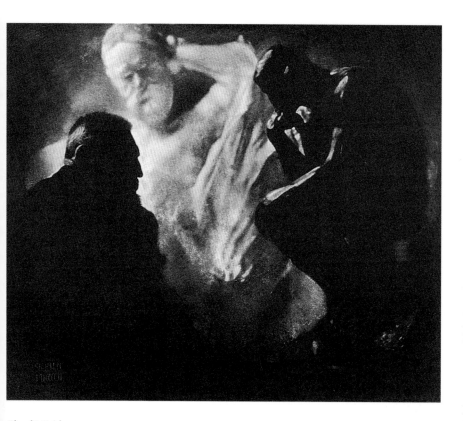

Eduard J. Steichen
Rodin–Le Penseur, 1906
Photogravure
15.4 x 18.5 cm

← Eduard J. Steichen
The White Lady, 1906
Half-tone reproduction
20.7 x 15.7 cm

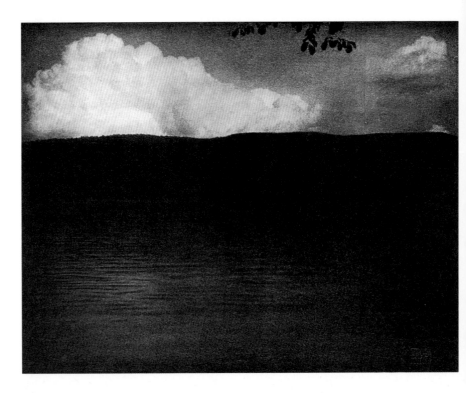

Eduard J. Steichen
The Big White Cloud, 1906
Half-tone reproduction
15.2 x 20 cm

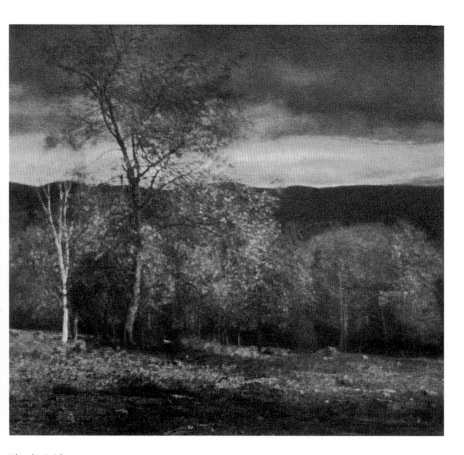

Eduard J. Steichen
Landscape in Two Colors, 1906
Two-colour half-tone reproduction
16.1 x 17.7 cm

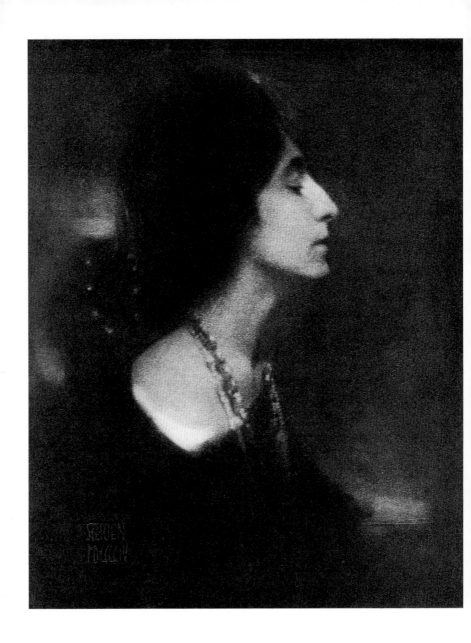

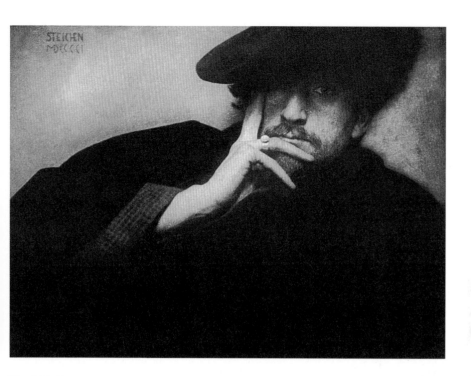

Eduard J. Steichen
Solitude, 1906
Photogravure
12.1 x 16.6 cm

← **Eduard J. Steichen**
Profile, 1906
Half-tone reproduction
20.1 x 16.2 cm

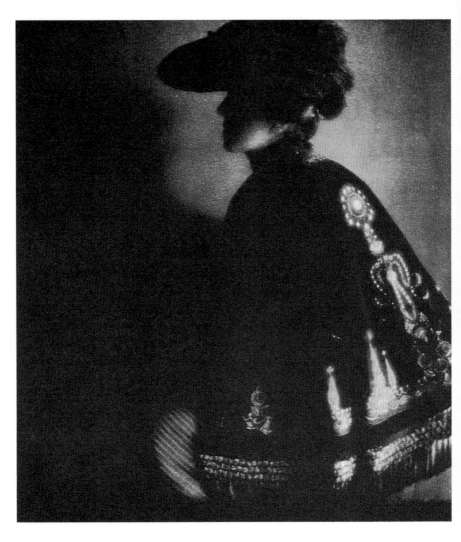

Eduard J. Steichen
Poster Lady, 1906
Photogravure
17.7 x 16 cm

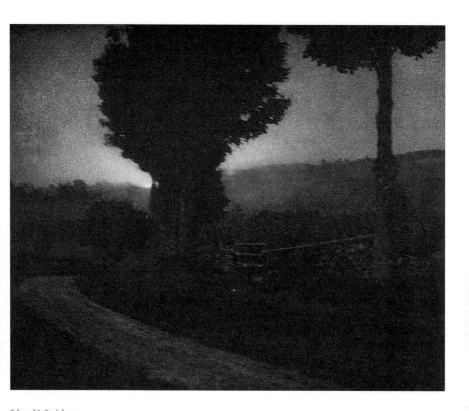

Eduard J. Steichen
Road into the Valley – Moonrise, 1906
Hand-toned photogravure
16.4 x 20.5 cm

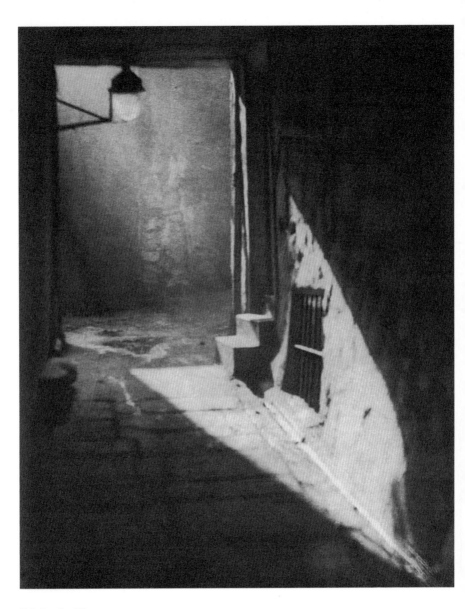

Alvin Langdon Coburn
Wier's Close – Edinburgh, 1906
Photogravure
20.3 x 16.2 cm

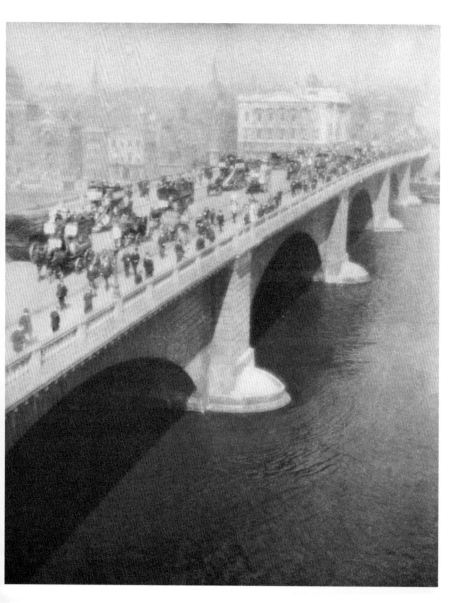

Alvin Langdon Coburn
The Bridge – Sunlight, 1906
Photogravure
19.7 x 15.8

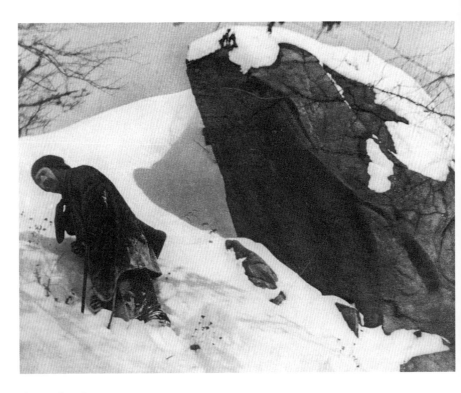

Alvin Langdon Coburn
After the Blizzard, 1906
Photogravure
16.3 x 21.1 cm

Alvin Langdon Coburn
Decorative Study, 1906
Photogravure
20.1 x 16.3 cm

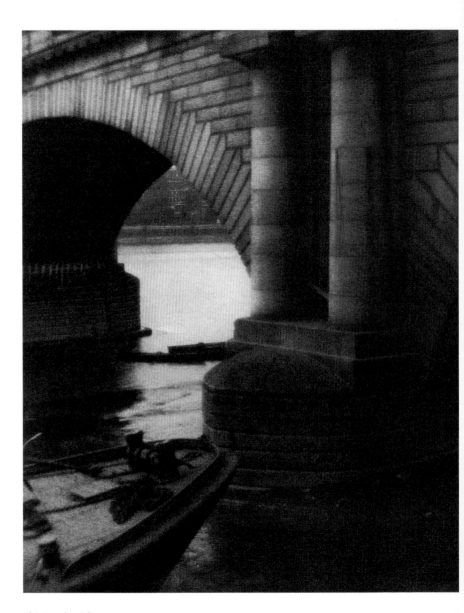

Alvin Langdon Coburn
The Bridge – London, 1906
Photogravure
20.3 x 16.2 cm

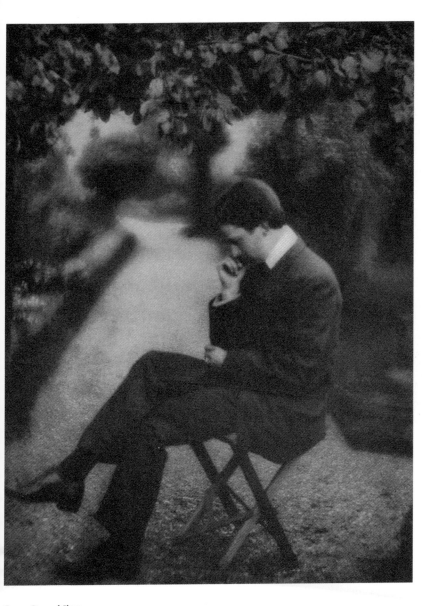

George Bernard Shaw
Portrait of Alvin Langdon Coburn, 1906
Photogravure
21 x 16.1 cm

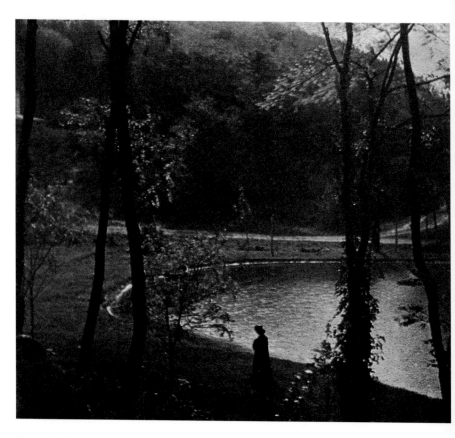

Eduard J. Steichen
Experiment in Three-color Photography, 1906
Three-colour half-tone reproduction
10.7 x 12.3 cm

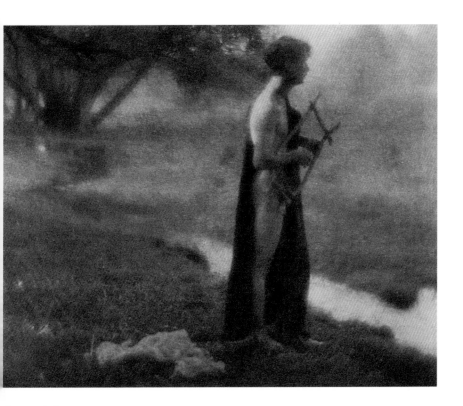

George H. Seeley
No Title, 1906
Photogravure
11.9 x 15.2 cm

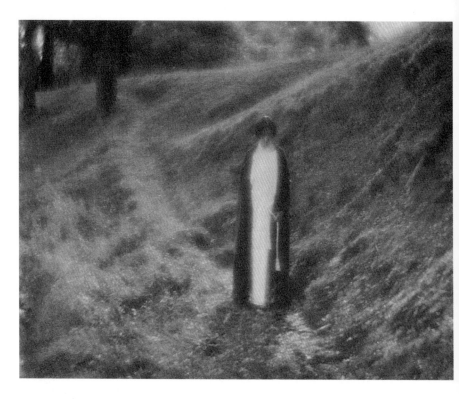

George H. Seeley
No Title, 1906
Photogravure
15.2 x 19.3 cm

BERNARD SHAW'S APPRECIATION OF COBURN.

During the months of February and March of the present year, an exhibition of Mr. Alvin Langdon Coburn's photographs took place in the rooms of the Royal Photographic Society of Great Britain, London. The exhibition aroused unusual interest, not only through the actual merit of the work shown by this Photo-Secessionist, but through the exceptionally enthusiastic Appreciation from the pen of Bernard Shaw prefacing the catalogue. The Appreciation has made copy for virtually every photographic magazine in the English language, and has also appeared as an original contribution in one of our prominent New York popular monthlies. We nevertheless feel impelled to reprint it, not only as a matter of record — Coburn being one of the leading spirits in the class of photography we are so deeply interested in — but because it is especially opportune in this number. — EDITOR.

MR. ALVIN LANGDON COBURN is one of the most accomplished and sensitive artist-photographers now living. This seems impossible at his age — twenty-three; but as he began at eight, he has fifteen years' technical experience behind him. Hence, no doubt, his remarkable command of the one really difficult technical process in photography — printing. Technically, good negatives are more often the result of the survival of the fittest than of special creation: the photographer is like the cod which produces a million eggs in order that one may reach maturity. The ingenuities of development which are so firmly believed in by old hands who still use slow "ordinary" plates and develop them in light enough to fog a modern fast color-sensitive plate in half a second, do not seem to produce any better results than the newer timing system which is becoming compulsory now that plates are panchromatic and dark-rooms must be really dark. The latitude of modern plates and films, especially those with fast emulsions superimposed on slow ones, may account partly for the way in which workers like Mr. Evans get bright windows and dark corners on the same plate without overexposure in the one or underexposure in the other. And as to choosing the picture, that is not a manipulative accomplishment at all. It can be done by a person with the right gift at the first snapshot as well as at the last contribution to The Salon by a veteran. But printing remains the test of the genuine expert. Very few photographers excel in more than one process. Among our best men the elder use platinotype almost exclusively for exhibition work. People who can not see the artistic qualities of Mr. Evans' work say that he is "simply" an extraordinarily skilful platinotype printer, and that anybody's negatives would make artistic pictures if he printed them. The people who say this have never tried (I have); but there is no doubt about the excellence of the printing. Mr. Horsley Hinton not only excels in straightforward platinotype printing, but practices dark dexterities of combination printing, putting the Jungfrau into your back garden without effort, and being able, in fact, to do anything with his methods except explain them intelligibly to his envious disciples. The younger men are gummists, and are reviled as "splodgers" by the generation which can not work the gum process.

But Mr. Coburn uses and adapts both processes with an instinctive skill and range of effect which makes even expert photographers, after a few wrong guesses, prefer to ascertain how his prints are made by the humble and obvious method of asking him. The device of imposing a gum-print on a platinotype—a device which has puzzled many critics, and which was originally proposed as a means of subduing contrast (for which, I am told, it is of no use)—was seized on by Mr. Coburn as a means of getting a golden-brown tone, quite foreign to pure or chemically-toned platinotype, whilst preserving the feathery delicacy of the platinotype image. Lately, having condescended to oil-painting as a subsidiary study, he has produced some photographic portraits of remarkable force, solidity, and richness of color by multiple printing in gum. Yet it is not safe to count on his processes being complicated. Some of his finest prints are simple bromide enlargements, though they do not look in the least like anybody else's enlargements. In short, Mr. Coburn gets what he wants one way or another. If he sees a certain quality in a photogravure which conveys what he wants, he naively sets to work to make a photogravure exactly as a schoolboy with a Kodak might set to work with a shilling packet of P. O. P. He improvises variations on the three-color process with casual pigments and a single negative taken on an ordinary plate. If he were examined by the City and Guilds Institute, and based his answers on his own practice, he would probably be removed from the classroom to a lunatic asylum. It is his results that place him *hors concours*.

But, after all, the decisive quality in a photographer is the faculty of seeing certain things and being tempted by them. Any man who makes photography the business of his life can acquire technique enough to do anything he really wants to do ; where there's a will there's a way. It is Mr. Coburn's vision and susceptibility that make him interesting, and make his fingers clever. Look at his portrait of Mr. Gilbert Chesterton, for example ! " Call that technique? Why, the head is not even on the plate. The delineation is so blunt that the lens must have been the bottom knocked out of a tumbler, and the exposure was too long for a vigorous image." All this is quite true ; but just look at Mr. Chesterton himself ! He is our Quinbus Flestrin, the young Man Mountain, a large, abounding, gigantically cherubic person who is not only large in body and mind beyond all decency, but seems to be growing larger as you look at him—" swellin' wisibly," as Tony Weller puts it. Mr. Coburn has represented him as swelling off the plate in the very act of being photographed, and blurring his own outlines in the process. Also, he has caught the Chestertonian resemblance to Balzac, and unconsciously handled his subject as Rodin handled Balzac. You may call the placing of the head on the plate wrong, the focusing wrong, the exposure wrong, if you like, but Chesterton is right, and a right impression of Chesterton is what Mr. Coburn was driving at. If you consider that result merely a lucky blunder, look at the portrait of Mr. Bernard Partridge ! There is no lack of vigor in that image ; it is deliberately weighted by comparative underexposure (or its equivalent in

underdevelopment), and the result is a powerfully characteristic likeness. Look again at the profile portrait of myself *en penseur*, a mere strip of my head. Here the exposure is precisely right, and the definition exquisite without the least hardness. These three portraits were all taken with the same lens in the same camera, under similar circumstances. But there is no reduction of three different subjects to a common technical denominator, as there would have been if Franz Hals had painted them. It is the technique that has been adapted to the subject. With the same batch of films, the same lens, the same camera, the same developer, Mr. Coburn can handle you as Bellini handled everybody; as Hals handled everybody; as Gainsborough handled everybody; or as Holbein handled everybody, according to his vision of you. He is free of that clumsy tool—the human hand—which will always go its own single way and no other. And he takes full advantage of his freedom instead of contenting himself, like most photographers, with a formula that becomes almost as tiresome and mechanical as manual work with a brush or crayon.

In landscape he shows the same power. He is not seduced by the picturesque, which is pretty cheap in photography and very tempting. He drives at the poetic, and invariably seizes something that plunges you into a mood, whether it is a mass of cloud brooding over a river, or a great lump of a warehouse in a dirty street. There is nothing morbid in his choices. The mood chosen is often quite a holiday one; only not exactly a Bank Holiday: rather the mood that comes in the day's work of a man who is really a free worker and not a commercial slave. But anyhow, his impulse is always to convey a mood and not to impart local information, or to supply pretty views and striking sunsets. This is done without any impoverishment or artification. You are never worried with that infuriating academicism which already barnacles photography so thickly—selections of planes of sharpness, conventions of compositions, suppression of detail, and so on. Mr. Coburn goes straight over all that to his mark, and does not make difficulties until he meets them, being, like most joyous souls, in no hurry to bid the devil good morning. And so, good luck to him, and to all artists of his stamp. G. BERNARD SHAW.

Size of Poster, 13½ x 19½ inches.

I N answer to numerous requests from artists and art-
lovers, the C. P. Goerz Optical Works have decided
to publish a limited issue of two hundred and
fifty reproductions from Mr. Steichen's Prize-winning
Catalogue-cover Design. They are in the form of a poster,
and are reproduced in facsimile, as to size and color,
directly from the original. They are printed in two colors
and gold on extra heavy paper, and are ready for framing.

They will be mailed, carefully packed and registered,
on receipt of check or money-order, at the following prices:

Copies (unsigned) . $1.25
Copies (signed by artist,
edition limited to 50), 5.00

Send orders, accompanied by remittance, to

C. P. GOERZ OPTICAL WORKS

52 Union Square, New York City

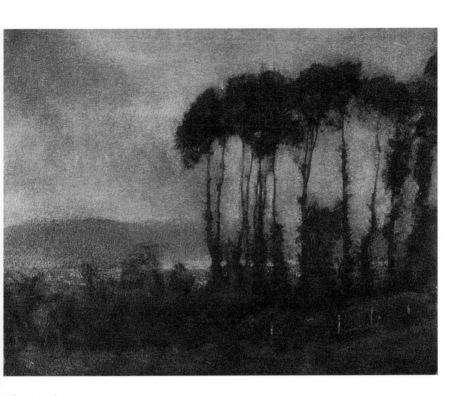

Robert Demachy
Toucques Valley, 1906
Photogravure
15.6 x 20.5 cm

Robert Demachy
A Model, 1906
Photogravure
17.4 x 15 cm

Robert Demachy →
Portrait – Mlle. D., 1906
Half-tone reproduction
20.7 x 15.2 cm

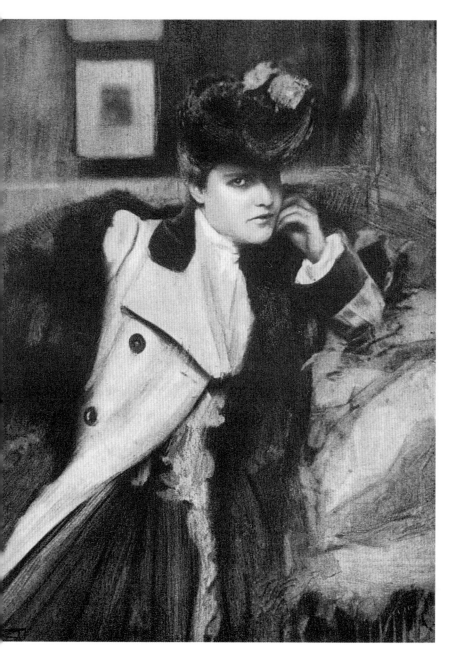

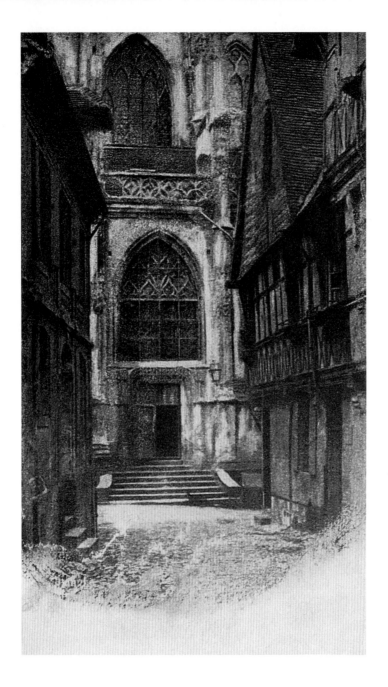

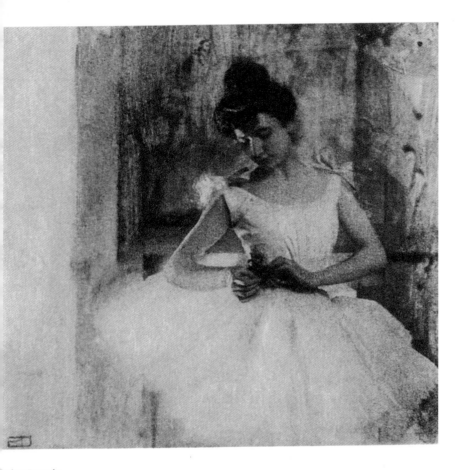

Robert Demachy
Behind the Scenes, 1906
Photogravure
13.8 x 15.1 cm

← Robert Demachy
Street in Lisieux, 1906
Half-tone reproduction
21.3 x 12.3 cm

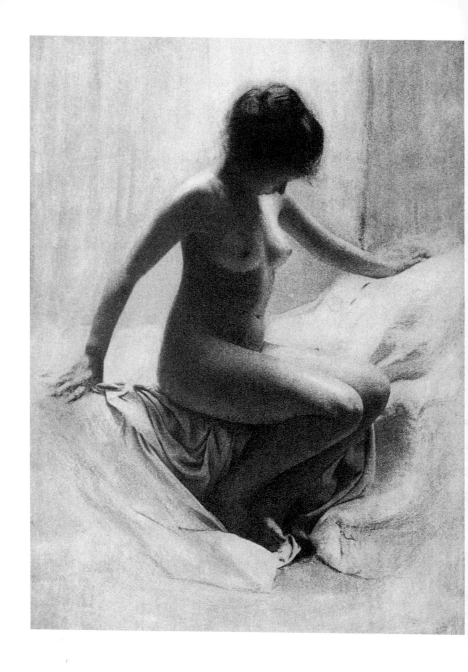

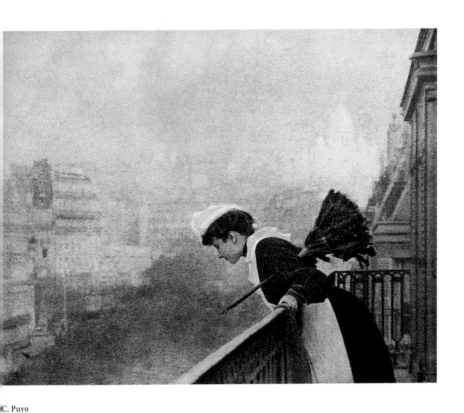

C. Puyo
Montmartre, 1906
Half-tone reproduction
16.1 x 20.9 cm

← Robert Demachy
Study, 1906
Half-tone reproduction
19.9 x 15.2 cm

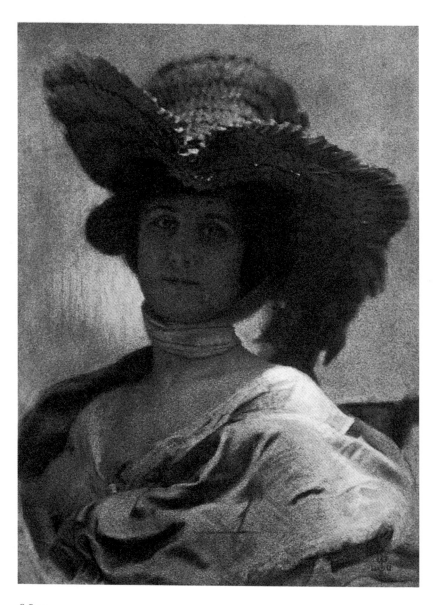

C. Puyo
The Straw Hat, 1906
Colour half-tone reproduction
21.3 x 15.9 cm

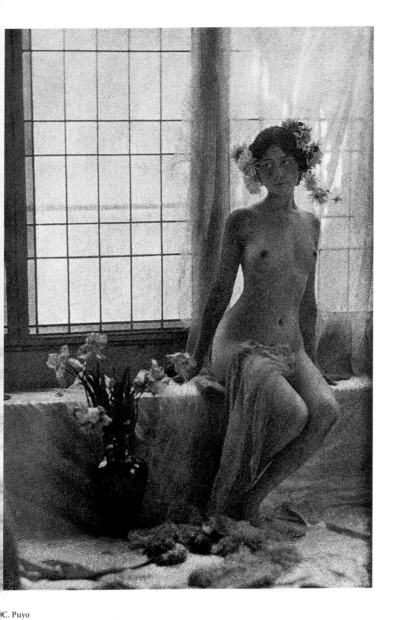

C. Puyo
Nude – Against the Light, 1906
Half-tone reproduction
21.3 x 14.7 cm

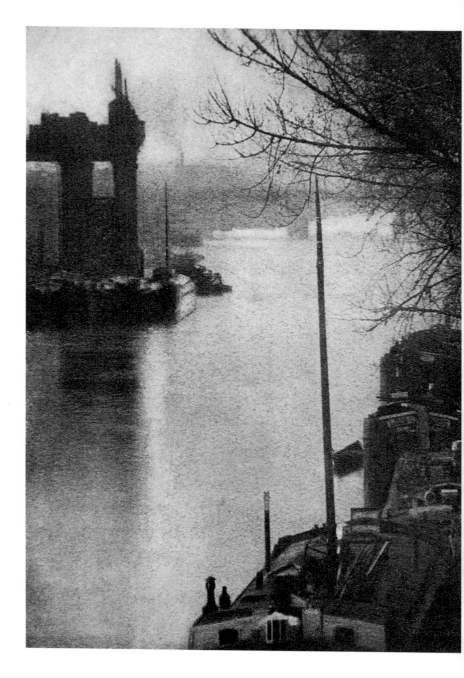

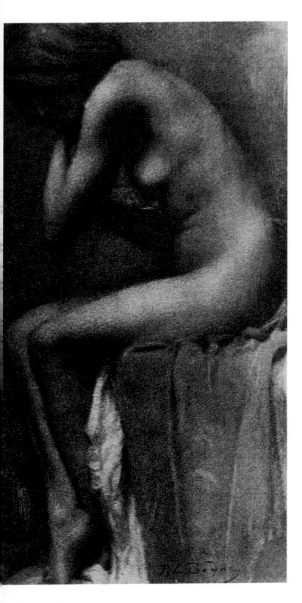

René Le Bègue
Study, 1906
Photogravure
21.6 x 11.5 cm

← Robert Demachy
The Seine at Clichy, 1906
Half-tone reproduction
20.4 x 15.1 cm

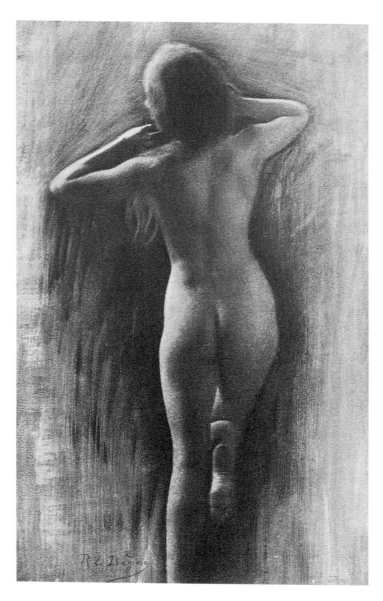

René Le Bègue
Study, 1906
Colour half-tone reproduction
19 x 11.7 cm

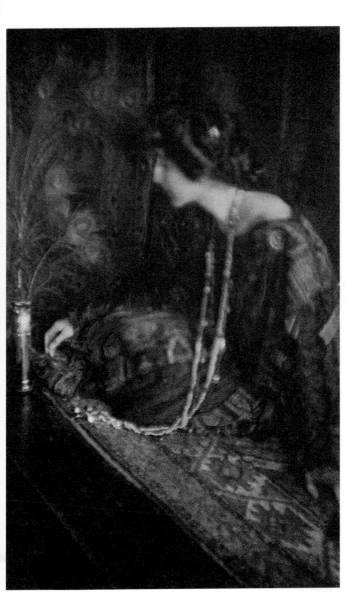

Joseph T. Keiley
Lenore, 1907
Photogravure
22.5 x 14. 8 cm

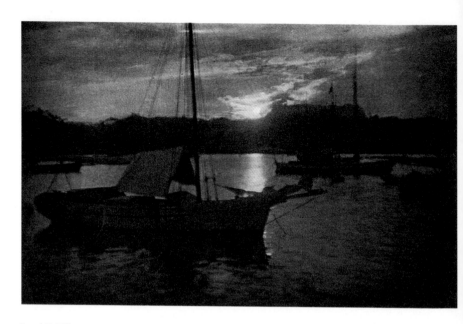

Joseph T. Keiley
The Last Hour, 1907
Photogravure
12.1 x 19. 2 cm

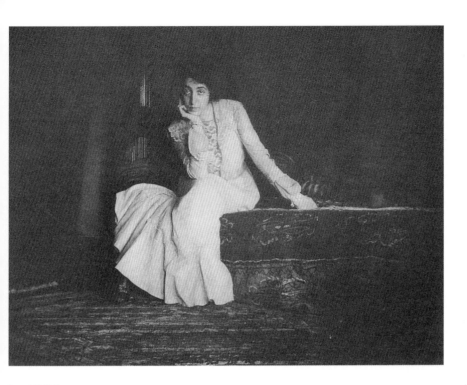

Joseph T. Keiley
Portrait – Miss De C., 1907
Photogravure
12 x 16 cm

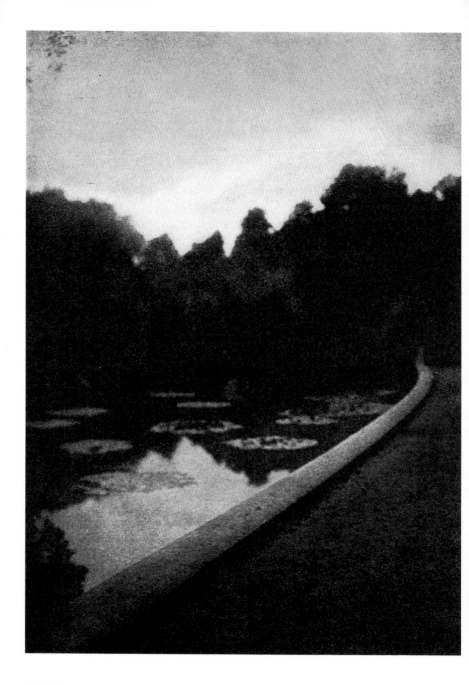

Joseph T. Keiley
Spring, 1907
Photogravure
11.4 x 18.6 cm

← Joseph T. Keiley
A Garden of Dreams, 1907
Half-tone reproduction
19.1 x 13.9 cm

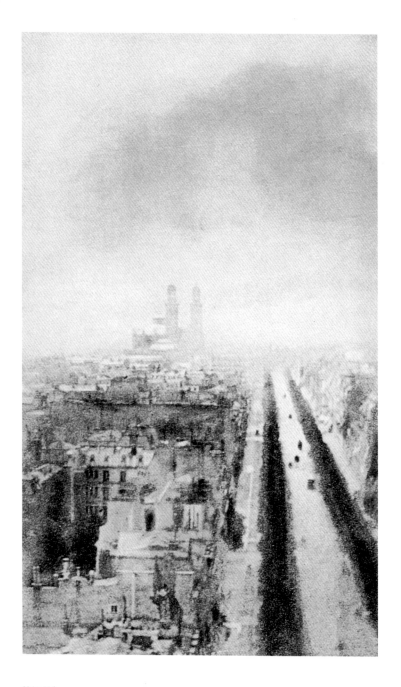

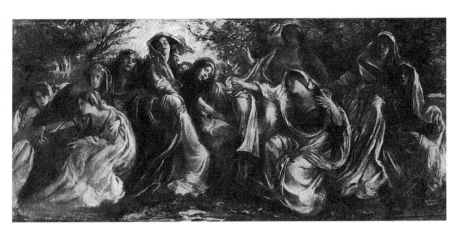

F. Benedict Herzog
The Banks of Lethe, 1907
Photogravure
12.2 x 26.6 cm

← Joseph T. Keiley
A Bit of Paris, 1907
Half-tone reproduction
20 x 12.1 cm

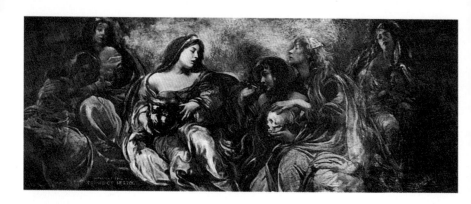

F. Benedict Herzog
Twixt the Cup and the Lip, 1907
Photogravure
10.3 x 26.5 cm

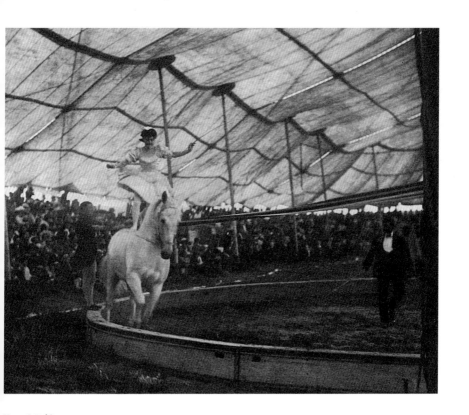

Harry C. Rubincam
In the Circus, 1907
Photogravure
15.5 x 19.3 cm

A. Radclyffe Dugmore
Fish, 1907
Photogravure
14.2 x 19.2 cm

J. Montgomery Flagg →
Progress in Photo-Portraiture.
Portrait of Mr. Wotsname taken
several years ago, 1907
Colour half-tone reproduction
15.1 x 9.5 cm

J. Montgomery Flagg
Progress in Photo-Portraiture.
Portrait of the same gentleman taken
to-day, 1907
Colour half-tone reproduction
17.8 x 15.5 cm

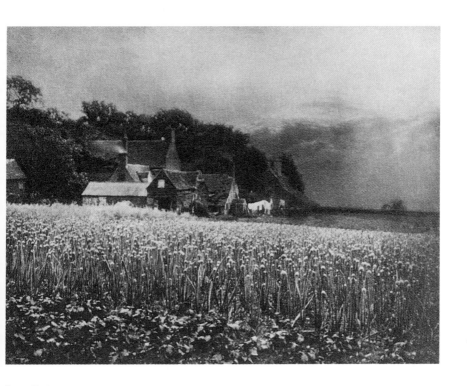

George Davison
The Onion Field– 1890, 1907
Photogravure
15.5 x 20.6 cm

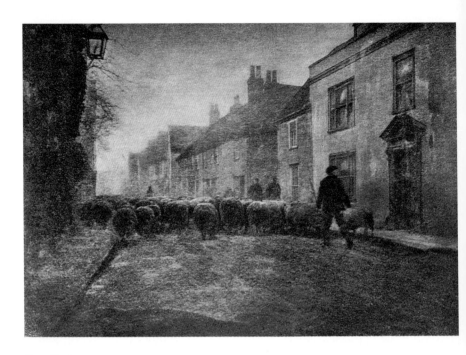

George Davison
In a Village under the South Downs, 1907
Photogravure
11 x 16.7 cm

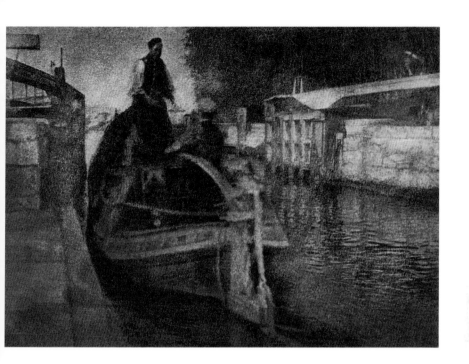

George Davison
A Thames Locker, 1907
Photogravure
11.8 x 16.7 cm

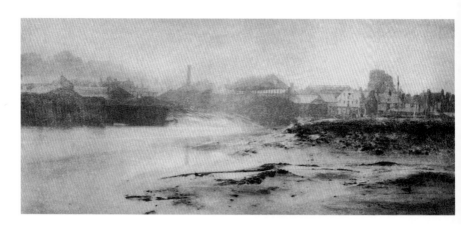

George Davison
Wyvenhoe on the Colne in Essex, 1907
Photogravure
7.2 x 16.7 cm

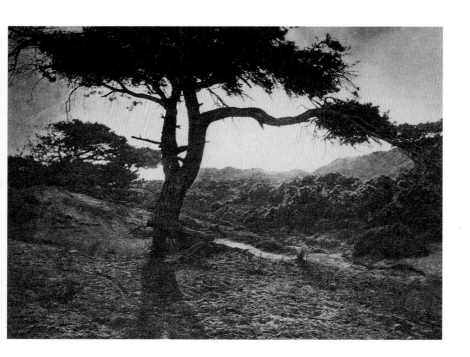

George Davison
The Long Arm, 1907
Photogravure
11.5 x 16.3 cm

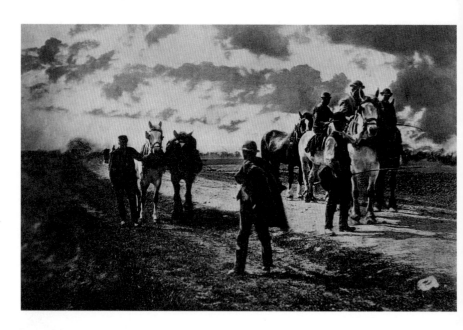

George Davison
Berkshire Teams and Teamsters, 1907
Photogravure
10.8 x 16.8 cm

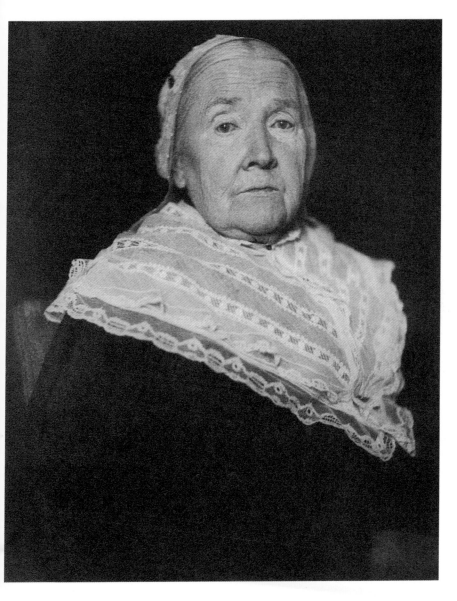

Sarah C. Sears
Mrs. Julia Ward Howe, 1907
Photogravure
20.7 x 16.9 cm

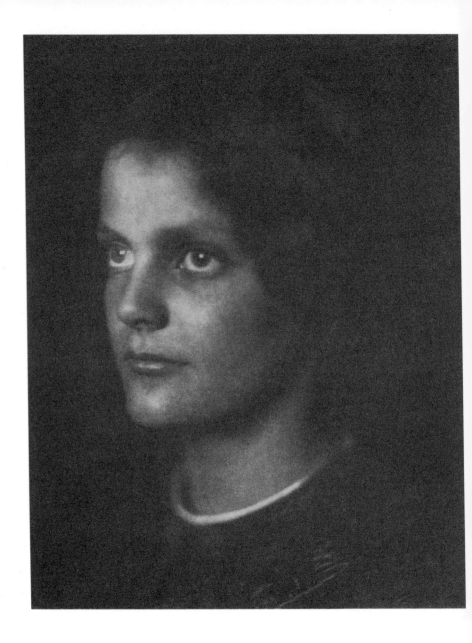

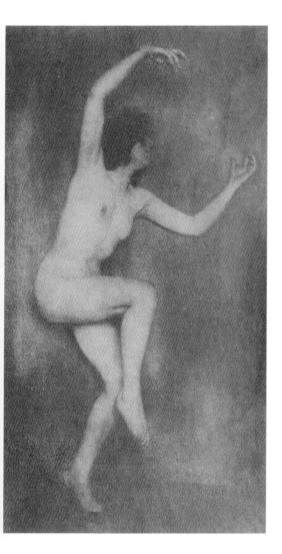

William B. Dyer
The Spider, 1907
Photogravure
21.8 x 12 cm

← Sarah C. Sears
Mary, 1907
Photogravure
20.7 x 16.5 cm

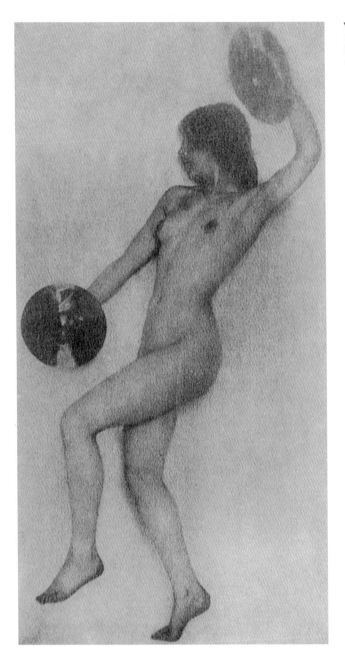

William B. Dyer
L' Allegro, 1907
Photogravure
21.6 x 11.4 cm

PICTORIAL PHOTOGRAPHY.*

HOSE who think that pictorial photography is a product of the last quarter of a century would do well to study the work of David Octavius Hill,† a Scottish painter, who turned to photography in 1842, originally to help him in his painting. He soon became fascinated with his new method. Some of his portraits are not surpassed by anything that has been done since, although Hill had no other process than calotype at his command. A volume of his work is in the possession of the Royal Photographic Society, and his negatives are still in existence, so that it is possible that one day they may be published. After Hill, the history of pictorial photography in England shows a long gap. The wet collodion process was being perfected, and the extraordinary detail and delicacy of the pictures obtained with it, took photographers away on a totally different track. Mid-Victorian tendencies were shown as strongly in photography as anywhere, and able workers lost themselves in morasses of false sentiment, and swamps of elaborate theatrical unrealities. Rejlander, a Swede, who came to England after an adventurous career on the Continent, studied as a sculptor and painter, but, turning photographer, endeavored to get a living by professional work, and at the same time to practise photography as an art. Rejlander and, later, H. P. Robinson carried combination printing as far as it was possible to do, one of the former's most notable pictures having more than twenty figures, separately arranged and photographed. It is easy to sneer at such things now—we have traveled far since "the Railway Station" and "the Derby Day"—but in their time, and amongst their generation, these men did much to keep up the recognition of photography as an art, whatever may now be thought of the lines on which they worked.

Contemporaneously with them lived a lady, Mrs. Julia Margaret Cameron, who exercised a considerable influence upon those who came within her circle, and was fortunate enough to include in this category many of the well-known men of the time—amongst others, Herschel and Tennyson. Mrs. Cameron realized what few could then appreciate, the difficulty of dealing with the critically sharp definition of the portrait lens, and it was to meet her requirements that instruments were made with an adjustment by which the required degree of spherical aberration could be introduced at will. Her portrait work is characterized by a breadth and force seen in that of no one else since the time of Hill, and it is only by one or two modern workers, of whom Steichen may be noted in particular, that the succession is maintained.

Mrs. Cameron died in 1879, just as the dry plate was being perfected, and during the next few years there is little to note in pictorial photography, except that the modern amateur movement was gradually gathering force. By 1885 it was in full swing; photography had once more become a craze,

*Reprinted with the author's special permission from R. Child Bayley's "The Complete Photographer."
† See CAMERA WORK No. XI.—EDITOR.

and interest was manifested in it by thousands. The Camera Club was founded, and in its early days was a social center for pictorial workers, although these were only a small minority of its members.

Photography was now to feel the effects of the sweeping change in art which characterized the last quarter of the nineteenth century. In 1888, Dr. P. H. Emerson published "Naturalistic Photography," a work which has been compared to a bombshell dropped into the midst of a tea-party. Manifestations of the change, as far as pictures were concerned, were shown at the exhibition of the Royal Photographic Society in 1890. Davison's "Onion Field" took the photographic world by storm. Photography had taken little count of the trend of art, and when Emerson and Davison drew attention to it with a jerk, old-fashioned toilers at composite photography found the ground moving from under their feet, and their palace of art, a respectable stucco-fronted mansion, collapsing over their heads. The earthquake passed away, but its effects remain to this day. Impressionism was to have its place in photography as in the other graphic arts; and the conventionalities and unreality of thirty years were left behind in three. "Naturalism" was the text preached from by Davison, Emerson, and others, and their influence was immediately seen in exhibitions, both in subject and in treatment. Davison had gone to the Essex marshes for some of his best-known pictures, and a weekly exodus toward Canvey Island and the Blackwater followed, which must have had its effect upon the dividends of the Great Eastern Railway. It followed that going down into Essex, photographers must need discover Constable's country, and the discovery was not without its result on English photographic landscape. The "Mud Flat School," as it was termed, broadened in its views until its name ceased to be appropriate.

The characteristic of present-day photographic work in this country is its atmosphere, its appreciation of the beauty of cloud-form, and the reliance often placed upon the sky to provide the real subject of the picture. These, of course, have always been essential features of British landscape art, and in this photography is at one with painting. But mediocrity seems to be the note to-day, and the center of interest, as far as pictorial photography is concerned, has shifted across the Atlantic. No one seeing our exhibitions year by year can fail to observe that, while the number of workers of some note has increased, there has been no increase in the interest of the pictures shown.

Some have explained it as a leveling up, others call it stagnation. Certain it is that the leaders of ten or fifteen years ago have been caught up by those who followed them; but it is not so easy to determine whether this is due to the progress of the one or the lack of movement of the other. The great increase in numbers has been brought about by the extraordinary simplicity and ease of modern methods, which have attracted thousands to photography who would never have thought of it otherwise. Here and there amongst the number have been some who realized that the amusement of an idle hour might be made much more, and that in the camera they might have a means of expression, which lack of inclination or lack of training had prevented them from finding in the pencil.

The "Linked Ring"—an association of pictorial photographers, mostly British—although taking its origin in a personal squabble in the Royal Photographic Society, was inevitable in some form or another; and, in spite of well-meant, but not far-seeing, efforts to combine the Society and the Ring, will no doubt continue to have a separate existence. The outward manifestation of the Linked Ring is its annual exhibition—"The Photographic Salon"—held for many years in the Dudley Gallery, Piccadilly, but latterly transferred to the Water-color Society's Gallery in Pall Mall East. The Royal Photographic Society's Exhibition is held in the New Gallery, Regent Street. The two shows are to a certain extent rivals, and are open simultaneously. The older body, however, has to cater for more than pictorial photographers only, and its pictorial section is only a section, though the most important one, of the entire exhibition. Signs are not wanting that the Linked Ring in its present form has outlived its utility, but that there is a field for such a body, if it choose to occupy it, no one can doubt. There is much to be done both in Britain and on the Continent to secure the inclusion of pictorial photography in the category of art; and in this, as might have been expected, the New World has taken the lead.

In the United States the last few years have witnessed a considerable change in the attitude of the art world generally, but of the painter more especially, toward photography. Much of this has been due to the publication there, by Mr. Stieglitz, of a series of quarterly volumes, besides which nothing else can be placed. First as *Camera Notes*, the official organ of the New York Camera Club, and then as CAMERA WORK, an independent publication altogether, this series, by familiarizing the art world with the work of photographers, by means of the most careful facsimiles in photogravure, and by its persistent teaching, has had its effect. The loosely formed union of photographers calling itself the "Photo-Secession," as indicating its independence and general attitude, controlled and directed by the same individual, has tended to the same end. Apart altogether from the particular pictorial work which the members of the "Photo-Secession," have achieved, we must put the fact that it has come to be regarded by the Painters' Societies and by other bodies of artists as one of themselves; the Secessionists have had art galleries placed at their disposal in different cities, and have obtained a recognition for their art, which it has certainly not received elsewhere. To no one man can this be exclusively attributed, but the lion's share of the labor has undoubtedly fallen on Alfred Stieglitz, as organizer, editor, and author, and it is to him that we turn to know how such a result has been achieved. He has been good enough to send us a note, which he entitles, "Some of the Reasons." It is perhaps best printed here exactly as he sends it.

"SOME OF THE REASONS.

"All movements that have exercised any influence on the moral and artistic advancement of mankind have been actuated by abiding faith and hope in the hearts of the leaders. The mass is always quick to enthusiasm,

but, like the Banderlog, just as quick to lose faith and to worship strange gods. Each revolution of thought has been founded by the fanatic, bigoted, and single-minded belief in its principles, which through thick and thin held sway in the minds of the very few.

"This principle has held true in the revolution which has convulsed the American photographic world for the past years. And to-day, when the photographic world has acknowledged, and the art world is in the act of acknowledging, the achievements of American photography, it is interesting to analyze the causes which have led up to these results. In photography, as in every other department of human endeavor, individual ambitions are the prime causes which lead to sporadically-successful exploits; but it requires something more than isolated achievements to accomplish the aims of a radical movement. In their clear insight and recognition of this principle lay the power of the leaders of American photography. While ready to acknowledge the successes of the individual, they nevertheless insisted upon a certain subordination of the claims and ambitions of the one, in the interests of the cause which they believed in, fearing lest such limited and circumscribed views of the functions of photography, as would necessarily be held by the isolated worker, would result in making photography narrow and provincial—stifling the universal spirit which is essential to the life of every art. It was because of their adherence to this rule of partial suppression of the individual that the leaders were subjected to the reproach and misunderstanding of those who would serve only their personal ambitions, and of those who failed to understand, because they lacked the knowledge, or were constitutionally disabled from appreciating, the motives of these leaders.

"It may be that the world's approval of the bull-dog tenacity of those who do not know when they are beaten was an element in the beginning of the success which followed the strict adherence to their rule. A certain respect was ultimately gained among those who began to feel that there must be some kernel of truth in a faith for which men were willing to sacrifice so much, and a reaction from the blind rage of the mob began to set in. Undazzled by growing successes, the American pictorialists, as a body—of course, there were always some stragglers—continued to tread the steep and narrow path which led toward the heights of their ideals, and to-day, while they have reached above the clouds, they distinctly realize that the pinnacle is still far above them.

"Of course, we in America fully acknowledge that in other countries there are enthusiastic workers who have done very much toward enhancing the dignity of pictorial photography, and even bodies of workers who have striven toward a goal; but it is borne in upon us that their spirit of loyalty and enthusiasm has been directed toward organizations, rather than toward broad and universal ideals. True to the American spirit, of which it has been said that even its transcendentalism and Puritanism have been tempered by practical considerations, there has been an incidental material side to all this, which the American worker fully realizes. Though the individual

American photographer was subordinated to the success of the cause, yet, in its success, the individual was enabled to achieve, and did achieve, a far greater distinction than could ever have been his portion if he had been compelled to rely upon his unaided effort; and thus, while individual effort, ability, and talent have made possible the results of the American School, yet the recognition which is being accorded to photography, as a new and additional means of art expression, could not have been accomplished by the work of any one, no matter how inspired. As an example of this, there can be cited the accomplishments of one American, a painter-photographer, whose work has succeeded in clinching the conviction, photographic and pictorial, that the claims of photography were entitled to serious consideration. Yet had the movement not prepared the way for an appreciation and active encouragement of his talents, they would have excited but sporadic and passing interest as the clever manifestations of a painter.

"The ultimate results no wise man will attempt to prophesy, but the future can in a measure be anticipated by an analysis of the present and the past; and, taking the accomplishments of the past few years into consideration, it would be folly to limit the possibilities. But even if its future strides be not as great as those just taken, yet there is already apparent in America one result which is fraught with great promise. Through the medium of carefully-selected and restricted exhibitions there is being placed before such members of the younger generation, as are endowed with artistic feelings and desires, the ripest past and present achievements of photography, and the art student of to-day, who will be the painter of to-morrow, is learning, before prejudices and cant have narrowed his artistic soul, that photography not only may be, but actually is, one medium of individual expression.

ALFRED STIEGLITZ."

Turning from the United States to the Continent, we find the condition of things resembling more that which prevails in Britain. Denmark, Belgium, Holland, Germany, and Austria have their workers, but each labors in his own way, and beyond the ordinary clubs and societies, there is no distinctive organization of pictorial photographers. The Camera Club of Vienna has produced two or three of the front rank, but they have not sufficient followers to be regarded as a school, although the work of Henneberg and the Hofmeisters is perhaps more distinctive and characteristic than that of any other.* In France, MM. Demachy and Puyo are leaders who have a following, though not a large one.

M. Demachy himself, writing to us recently, said that he did not believe that the state of pictorial photography in France was different enough from what it is in England to allow of any striking comparison between the two countries. The only difference was in numbers, the proportion of really talented photographers being about the same on both sides of the Channel.

* The Austrian photographers, Watzek, Kühn and Henneberg were the founders of the German-Austrian school of pictorial photographers, and their work has had a far-reaching influence throughout the two empires. The two Hofmeisters were the pioneers in Germany, although followers of the Viennese. See CAMERA WORK No. XIII. Compared to the extent of the American school the German-Austrian is insignificant, yet the foremost work of both countries may be considered artistically on a par.— EDITOR.

"There exists," says M. Demachy, "a much thicker layer in England than in France between the quite upper strata and the lowest. It seems to me that amongst French pictorialists those who have failed to attract the enthusiastic attention they expected at the National or foreign salons have dropped photography altogether; it has been a case of everything or nothing for them. This would explain the absence in our country of the good and honest work—not very original, perhaps, because it is founded on correct composition more than on personal interpretation—that comes after the work of the English leaders, and fills up in your exhibitions the gap that we notice in ours. This peculiar state of affairs is more than elsewhere felt in the arduous recruiting of illustrations for first-class photographic magazines. These are extremely rare in France; I may even say that, outside of a portfolio publication or two, there is only one good illustrated periodical of the sort in the whole country."

British landscape work comes in for praise at the hands of M. Demachy, who points out that, after the best workers have been put on one side, there still remain many landscapes which show undeniable qualities of composition, and, in their authors, positive appreciation of Nature and its different moods. "But I must say," he goes on to observe, "that, in that class of work, the level of the studies or pictures dealing with figures is very much lower than in landscape—as bad as with French workers of the same order. For it is evident that amongst photographers there are many who are capable of recognizing and making use of good composition—ready-made—in Nature, and yet who can not mold stuffs, folds, and human limbs into a correspondingly harmonious *ensemble*.

"Now, I do not exactly know what is the degree of temperature of the English pictorialist's enthusiasm in his own work and process. I think it must be higher than Frenchmen's, if I take into account the superior amount of work brought out in England, and the greater number of able workers. Here we do not 'take ourselves seriously,' and are heavily handicapped by this fact alone. Look at the beautiful enthusiasm of American workers—violently attacked by half the photographic community, and raised to the skies by the other half—that is quite invigorating! Here we politely compliment our leaders once a year on their interesting work, in just about the same tone as we would take to thank them for the delightful evening we have passed in their company, and we say the same thing, or nearly so, to the man whose work we do not like in the least—because we feel that, after all, there is no use in getting ourselves excited—*à quoi bon?* This is certainly not productive of emulation. Then there is the influence of artistic Paris—the constant comparison between our small work and the work in the numberless private and public exhibitions in oils, pastels, water-color and what not—by first-rate artists, whose names will perhaps never be known out of their own set. There is the *camaraderie* with the leaders of both the Salons de Peinture, their frank avowal of discontent at their own superb work, and of their inefficient striving after other and more complete expression. All this may turn a self-proud photographer into a more

modest man, and it does, generally; it will also make him more careful in his productions and more severe for his faults, but it will not make him work furiously with the idea of glory ahead. Now, I really believe, if the active body of the Secessionists was brought forcibly to Paris and left there for a year, that after six months they wouldn't 'do a thing.' And it would be a pity, for I admire their work immensely, and I was the first one over here to fight for their cause.

"Yet pictorial photography is not at its last gasp. It is quite alive, and we are trying to keep it so. MM. de Pulligny and Puyo are working at pictorial lenses, Puyo and I at a book on pictorial processes, Fresson has been perfecting a pictorial printing-paper, and a number of men are working over photographs in the hope that they will turn out pictorial too. In truth, we have been getting some very promising work from the provinces lately, from Brittany especially, and the prospect is not of an alarming character.

"But there is no getting out of it, pictorial photographers are, and always will be, called photographers, and the name covers such an amount of anti-artistic iniquity that it will be hard, in France, at least, to get rid of the associations that cling to that name, and suggest eternally young ladies with beautiful smooth faces and clean-cut eyes, smiling at you from the polished surface of a beveled-edged portrait carte.

"You will probably find a certain lack of optimism in my private views on pictorial photography in France. Well, it would have been easy enough to stir up a frothy mixture of jingoism and gum, and serve it hot; but you know that we Frenchmen have a knack of painting ourselves blacker than we are, for fear of subsequent detection, perhaps, or with the hope that we will be judged more leniently when the time comes. R. DEMACHY."

THE STRAIGHT AND THE MODIFIED PRINT.*

HERE is still a misunderstanding on the subject of the straight print, as opposed to the modified print. Some champions of pure photography, as it is called, will even deny that a modified print is a photograph at all. For my part, I believe that if the X deposit forming an image is built up by the action of light, under the shadow of another image, transparent, and also due to light action, the result must be a photograph, whatever modifications the photographer has thought proper to introduce amongst the relative proportions of the deposit.

What we call in French "l'intervention" consists in purposely adding to or substracting from certain parts of the photographic deposit. In the case of addition, the extra thickness will be identical in substance to the primitive deposit (glycerine-developed platinotype and Rawlins' process). This practice of intervention, forbidden by pure photographers when applied to the positive print, is recommended by the same school when applied to the negative, and is then called intensification or reduction, general or local. Its final effect is similar to that of the positive intervention, viz., modification in the general or local thickness of the positive deposit. The whole question lies in this diminutive nutshell.

Straight result or modified result—one has to choose. It stands to reason that a genuine straight photograph must owe every subsequent transformation to the first action of light on the film of the negative. This negative must neither be intensified nor reduced—no paint must be dabbed on to its back—no pencil-strokes on its face, no shading to part of its surface during exposure must be allowed. The same strict rules will be applied to the development, if any, of the positive print. For if we admit that the faking that photographers have indulged in for the last fifty years is legitimate, but that similar faking, under other names and by more effective methods, is not, we are acting like overgrown children.

I maintain that if I have the right, as a photographer, to lower the density of part of my negative with Farmer's reducer, I have the equal right not to use the reducer, and to darken the corresponding part of my positive print by piling on pigment with the Rawlins stenciling-brush; that if I have the right, as a photographer, to dab color on a definite portion of my negative, in order to add to its density, and thus create a white spot on my positive print, I have an equal right to leave my negative alone, and to wipe off the colored gum deposit on my print on the corresponding spot, and for the same purpose. Words will not stand against facts, and these facts, I believe, are in logical sequence.

The limit? Well, there is no limit except extreme black on one side and extreme white on the other. For nobody, except a few professional photographers, and those of no very high order, has ever attempted to paint

* Reprinted from the *Amateur Photographer*, London.

in a dark portion of his print, or to add Chinese white to his high lights — the result is too obvious and too ugly. When we read of a print "entirely due to hand-work," we simply do not believe that a jury of sane men would admit an oil or water-color painting amongst photographs (for that is what the expression means), and we pass on.

You will say that the practice of intervention is dangerous? Not more so than the use of straight photography for pictorial aims. This may sound paradoxical; but I believe it is just as useless for a man to attempt art through purely mechanical means as it would be foolish for an astronomer to choose gum-bichromate for printing the chart of the Milky Way.

Do not say that Nature being beautiful, and photography being able to reproduce its beauty, therefore photography is Art. This is unsound. Nature is often beautiful, of course, but never *artistic* "per se," for there can be no art without the intervention of the artist in the *making* of the picture. Nature is but a theme for the artist to play upon. Straight photography registers the theme, that is all — and, between ourselves, it registers it indifferently. ROBERT DEMACHY.

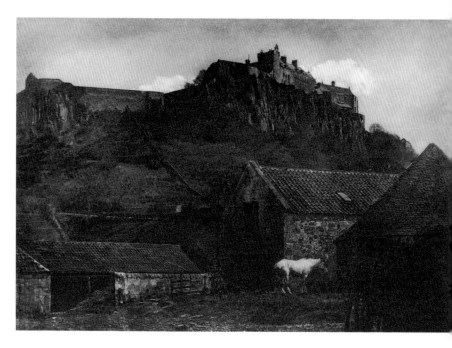

J. Craig Annan
Stirling Castle, 1907
Photogravure
15 x 21.7 cm

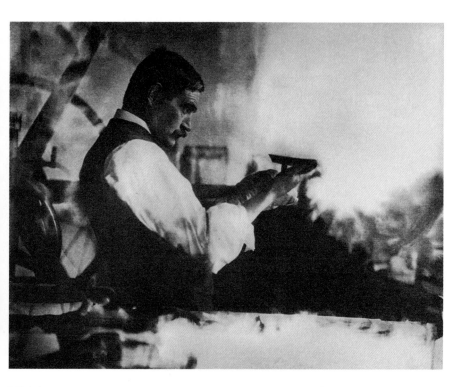

J. Craig Annan
The Etching Printer – William Strang, Esq., A. R. A., 1907
Photogravure
15.1 x 19.8 cm

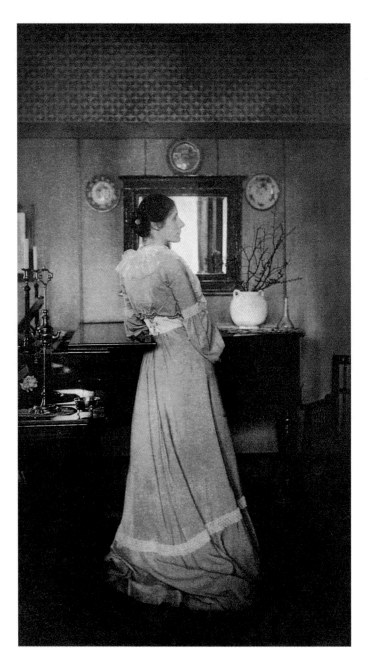

J. Craig Annan
Portrait of Mrs. C., 1907
Photogravure
21.5 x 12.2 cm

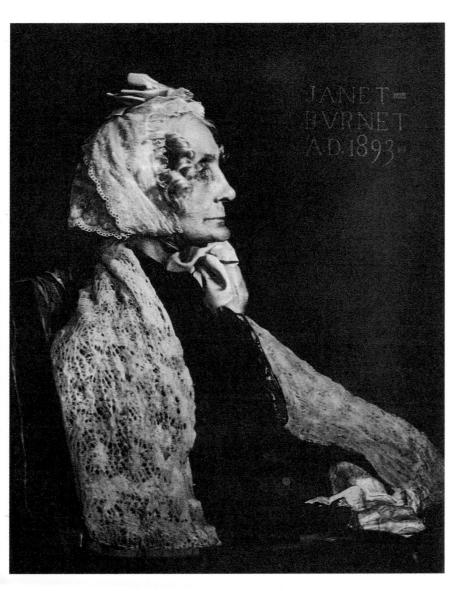

J. Craig Annan
Janet Burnet, 1907
Photogravure
20.4 x 16.8 cm

J. Craig Annan
Ploughing Team, 1907
Photogravure
9.2 x 23.7 cm

Eduard J. Steichen
Pastoral – Moonlight, 1907
Hand-toned photogravure
15.6 x 19.9 cm

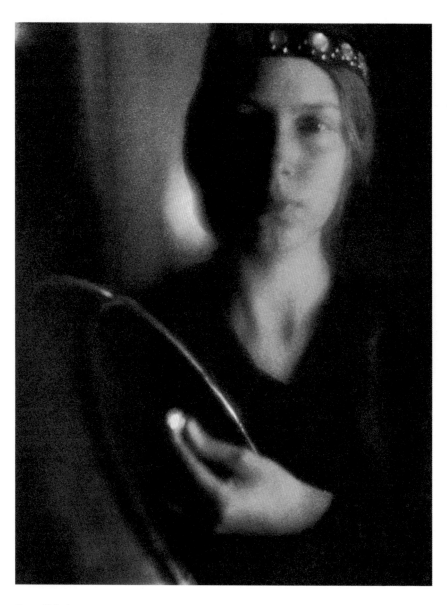

George H. Seeley
The Firefly, 1907
Photogravure
20.2 x 15.7 cm

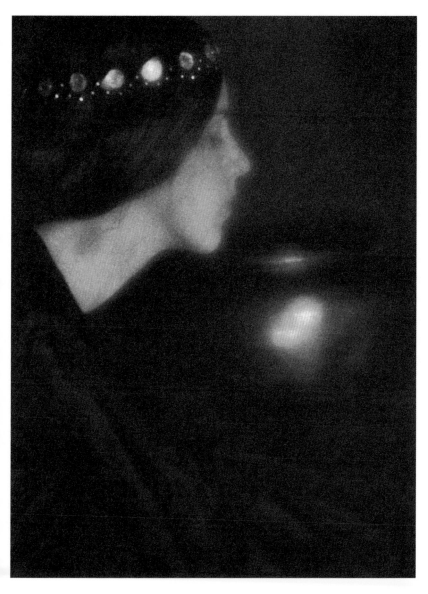

George H. Seeley
Black Bowl, 1907
Photogravure
20.5 x 15.5 cm

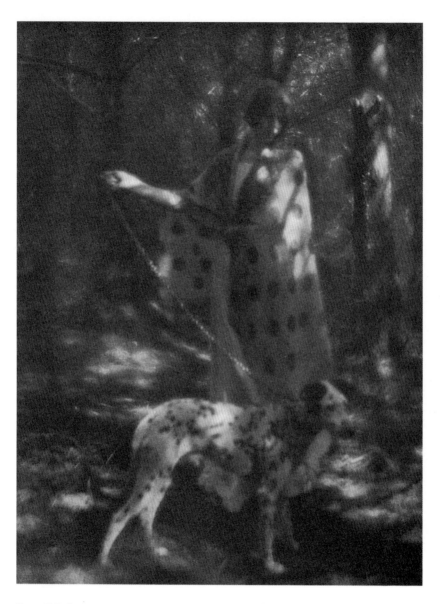

George H. Seeley
Blotches of Sunlight and Spots of Ink, 1907
Photogravure
20.8 x 15.7 cm

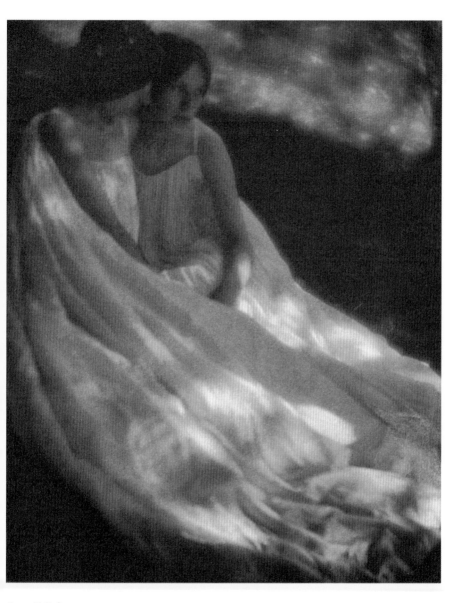

George H. Seeley
The Burning of Rome, 1907
Photogravure
19.7 x 15.8 cm

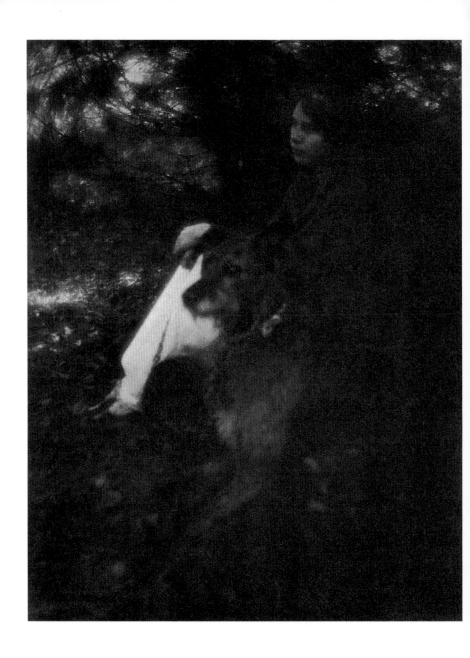

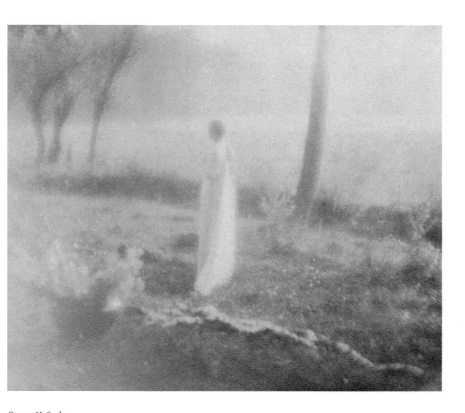

George H. Seeley
The White Landscape, 1907
Photogravure
15.7 x 19.3 cm

← George H. Seeley
Girl with Dog, 1907
Photogravure
19.8 x 15.5 cm

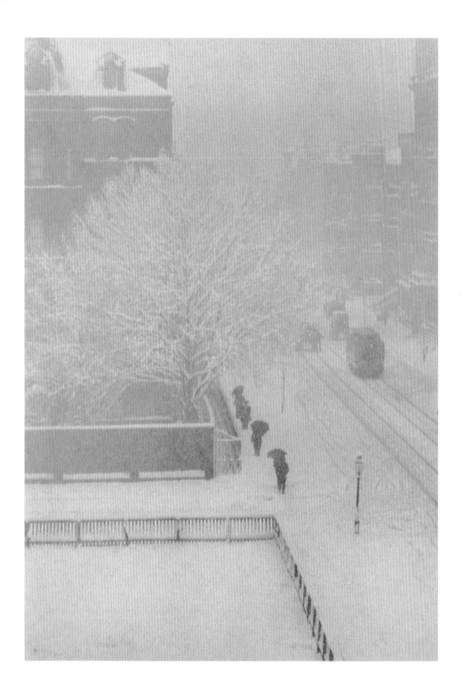

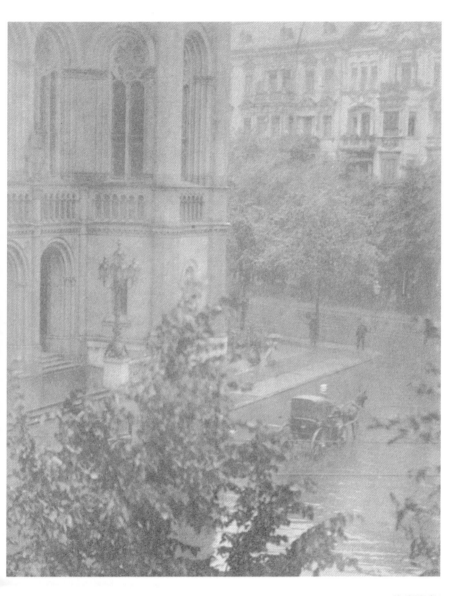

← Alfred Stieglitz
Snapshot – From my Window, New York, 1907
Photogravure
18.5 x 12.9 cm

Alfred Stieglitz
Snapshot – From my Window, Berlin, 1907
Photogravure
21 x 17.2 cm

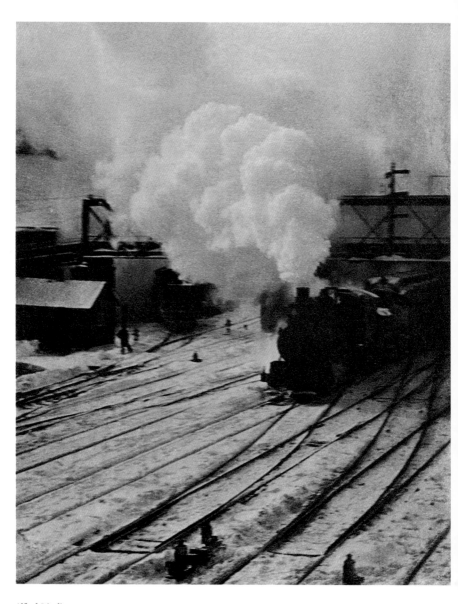

Alfred Stieglitz
Snapshot – In the New York Central Yards, 1907
Photogravure
21 x 17.2 cm

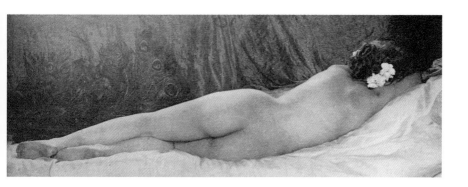

W. W. Renwick
Nude, 1907
Photogravure
7.4 x 15.9 cm

THE NEW COLOR PHOTOG-
RAPHY.—A BIT OF HISTORY.

COLOR photography is an accomplished fact. The seemingly everlasting question whether color would ever be within the reach of the photographer has been definitely answered. This answer the Lumières, of France, have supplied. For fourteen years, it is related, they have been seeking it. Thanks to their science, perseverance, and patience, practical application and unlimited means, these men have finally achieved what many of us had looked upon practically as unachievable. Prof. Lippmann, of the Sorbonne at Paris, had a few years ago actually obtained scientifically correct color photographs, but his methods were so difficult and uncertain as to make each success very costly. In consequence his invention is only of scientific value. But the Autochrome Plate, as the plate invented and made by the Lumières has been named, permits every photographer to obtain color photographs with an ordinary camera and with the greatest ease and quickness. The Lumières evolved their plate from the theories of others, but the practical solution is entirely theirs. They have given the world a process which in history will rank with the startling and wonderful inventions of those two other Frenchmen, Daguerre and Nièpce. We venture to predict that in all likelihood what the Daguerreotype has been to modern monochrome photography, the Autochromotype will be to the future color photography. We believe the capitalist, who has for obvious reasons fought shy of color "fanatics," will now, in view of the beautiful and readily obtained practical results with the Autochrome plate, untie his purse-strings and support the color experimenters whose numbers are already legion. The latter will thus receive a fair opportunity to work out their innumerable theories and countless patents. Who can predict what may yet be in store for us from these sources? In the meantime we rejoice in what we have. It will be hard to beat.

The Autochrome Plate photographs color automatically. A transparent support (glass) is covered with an adhesive matter which receives a coating of potato-starch grains dyed blue-violet, green, and red-orange. After isolating this with a waterproof varnish (zapon, we believe) it is coated with a panchromatic (collodion) emulsion. The exposure is made in the usual way, but with the glass side of the plate facing the lens, so that the light passes through the colored grains and only then reaches the emulsion. The lens is fitted with a special yellow filter made by the Lumières for the plate. The ·plate is developed and then, without fixing, is treated in broad daylight with an acid permanganate reducer, rinsed and re-developed. The result is a positive print in natural colors. If the exposure has been correct—and correct exposure is *the* essential for ultimate success—the results are uncommonly realistic. Thus far only one picture can result from each exposure. It is a transparency which can only be seen properly by transmitted white light or, if small enough to put into the lantern, on the screen. The Lumières, as well as others, are now at

work trying to make possible the multiplication of the original, but so far the experimental stage has not been passed. No print on paper will ever present the colors as brilliantly as those seen on the transparencies. This is due to the difference of reflected and transmitted light. The solution of the problem is but a matter of time.

It was in the beginning of June that the plates in small quantities were put on the market in Paris; a few plates had been sent to Germany to be tested by scientific experts. Elsewhere none were to be had. Fortunately for ourselves, Steichen and I were in Paris when Lumière was to demonstrate his process for the first time. The following letter sent by me to the Editor of *Photography* (London) speaks for itself: It is reprinted with the Editor's comments:

"THE COLOR PROBLEM FOR PRACTICAL WORK SOLVED.

The characteristically outspoken letter from Mr. Stieglitz, which we print below, will be read with interest by those who have seen some of the amusing deprecatory statements as to the real meaning of the Autochrome advance.

Sir,—Your enthusiasm about the Lumière Autochrome plates and the results to be obtained with them is well founded. I have read every word *Photography* has published on the subject. Nothing you have written is an exaggeration. No matter what you or anyone else may write on the subject and in praise of the results, the pictures themselves are so startlingly true that they surpass anyone's keenest expectations.

I fear that those of your contemporaries who are decrying and belittling what they have not seen, and seem to know nothing about, will in the near future, have to do some crawling. For upwards of twenty years I have been closely identified with color photography. I paid much good coin before I came to the conclusion that color, so far as practical purposes were concerned, would ever remain the *perpetual motion* problem of photography.

Over eighteen months ago I was informed from inside sources that Lumière's had actually solved the problem; that in a short time everyone could make color pictures as readily as he could snap films. I smiled incredulously, although the name Lumière gave that smile an awkwardness, Lumière and success and science thus far always having been intimately identified. Good fortune willed it that early this June I was in Paris when the first results were to be shown at the Photo-Club. Steichen and I were to go there together. Steichen went; illness kept me at home. Anxiously I awaited Steichen's report. His "pretty good only" satisfied my vanity of knowing it all.

Steichen nevertheless bought some plates that morning, as he wished to see what results he could obtain. Don't we all know that in photography the manufacturer rarely gets all there is in his own invention? Steichen arrived breathlessly at my hotel to show me his first two pictures. Although comparative failures, they convinced me at a glance that the color problem for practical work had been solved, and that even the most fastidious must be satisfied. These experiments were hastily followed up by others, and in less than a week Steichen had a series of pictures which outdid anything

that Lumière had had to show. I wrote to you about that time, and told you what I had seen and thought, and you remember what you replied. His trip to London, his looking you up and showing you his work, how it took you literally off your feet, how a glance (like with myself) was sufficient to show you that the day had come, your enthusiasm, your own experiments, etc., etc.—all that is history, and is for the most part recorded in your weekly. While in London Steichen did Shaw and Lady Hamilton in color; also a group of four on Davison's house-boat. The pictures are artistically far in advance of anything he had to show you.

The possibilities of the process seem to be unlimited. Steichen's pictures are with me here in Munich; he himself is now in Venice working. It is a positive pleasure to watch the faces of the doubting Thomases—the painters and art critics especially—as they listen interestedly about what the process can do. You feel their cynical smile. Then, showing them the transparencies, one and all faces look positively paralysed, stunned. A color kinematographic record of them would be priceless in many respects. Then enthusiasm, delighted, unbounded, breaks loose, like yours and mine and everyone's who sees decent results. All are amazed at the remarkably truthful color rendering; the wonderful luminosity of the shadows, that bugbear of the photographer in monochrome; the endless range of grays; the richness of the deep colors. In short, soon the world will be color-mad, and Lumière will be responsible.

It is perhaps fortunate that temporarily the plates are out of the market. The difference between the results that will be obtained between the artistic fine feeling and the everyday blind will even be greater in color than in monochrome. Heaven have pity on us. But the good will eventually outweigh the evil, as in all things. I for one have learned above all that no problem seems to be beyond the reach of science.

Yours truly,

Tutzing, Munich, July 31st, 1907. Alfred Stieglitz."

When Steichen visited Mr. Bayley, the editor of *Photography*, he gave him a box of plates to try and judge for himself what could be done with them. It is needless to say that Bayley took the cue. *Photography* came out at once with a blare of trumpets about the wonderful invention. The Steichen interview was printed in full. As no plates could be had in Great Britain until very recently—even France had virtually none in July and part of August owing to some trouble in the factory at Lyons—and as the editors had no opportunity of seeing any pictures, Bayley and his enthusiasm were laughed at with·derision. It was then that my letter was written. As a result some of the English Dailies which devote space regularly to photography had become keenly interested in Color Photography, although none had seen any actual results. In the United States also, most of the editors having followed the English press, were having great sport with the claims made about the pictures which they had not seen. Then followed, therefore, a second letter to Bayley. It is more suggestive than comprehensive:

"MR. STIEGLITZ ON THE PERSONAL FACTOR IN AUTOCHROME.

The following extract from a letter to hand from Mr. Stieglitz, which we have had his permission to publish, was written under the impression that the writer in the *Daily Telegraph* referred to had sufficient knowledge of the process and its results to give his opinion weight. We are informed that when the paragraph in question was penned he had seen no representative work on the Autochrome plates whatever. But the value of Mr. Stieglitz's views does not depend on the triviality or otherwise of the occasion that called them forth.

Why does a writer in the *Daily Telegraph* of August 23 rush into print and jump at erroneous conclusions not only about the Autochrome process, but about myself? I have overlooked nothing in considering the Lumière method of producing color photographs, I can assure him.

No one realizes more fully than I do what has been accomplished so far in color photography, what really beautiful results have occasionally been achieved in press color printing, and also in the other color processes thus far invented—Ives' Chromoscope, Lippmann, etc.* It is even my good luck now to be in Munich, where color printing is probably carried to the most perfect degree of the day, and where Dr. Albert—undoubtedly one of the greatest of all color experimenters as far as theory and practical achievement are concerned—has his laboratory and his plant. I have seen him; seen his newest experiments and latest results, and these, I can assure my readers, are in their way as remarkable as Lumières are in theirs. His methods are mostly still unpublished, and the world knows but little of what he has in store for it. A revolution as far as the production of color plates for letter-press printing is concerned is close at hand, thanks to Albert's genius.

Albert is a rare man in more ways than one; his is a scientific mind combined with a goodly portion of natural artistic feeling. Upon my showing him Steichen's color transparencies he granted at a glance—the glance of a student and expert—that in color photography he had seen nothing quite so true and beautifully rendered as Shaw's hands and wrists. Probably nothing in painting has been rendered more subtly, more lovingly, than has been by the camera in this instance.

We all realize that the Lumière process is far from perfection. It has its limitations, like every other process, but these limitations are by no means as narrow as we were originally led to believe.

We know that for the present at least the rendering of a pure white † seems impossible. Yet, artistically considered, this is not necessarily a fault. The photographer who is an artist and who has a conception of color will know how to make use of it. Steichen's newer experiments, as well as those now being made by Frank Eugene and myself, have proven to our satisfaction that the Lumière method has quite some elasticity, and promises much that will be joyous and delightful to even the most sensitive eye.

Certain results I have in my mind's eye may eventually lead to endless controversy similar to that waged not so very long ago about sharpness and diffusion, and to that now being waged about "straight" and "crooked"

* Etc. includes Joly, Sanger Shepherd, Brasseur, Pinatypie, Miethe, McDonough and others.
† Read scientifically pure white.—EDITOR.

photography. But why consider that of importance? I wish to repeat that the Lumière process is only seemingly nothing more than a mechanical one. It is generally supposed that every photographer will be able to get fine artistic pictures in color merely by following the Lumière instructions, but I fear that suppositions are based upon mere illusions. Given a Steichen and a Jones to photograph the same thing at the same time, the results will, like those in black and white, in the one case reflect Steichen, and in the other case probably the camera and lens—in short, the misused process. Why this should be so in a *mechanical* process—*mechanical* and *automatic* are not synonymous—is one of those phenomena not yet explained, but still understood by some.

The Lumière process, imperfect as some may consider it, has actually brought color photography in our homes for the first time, and in a beautifully ingenious, quick, and direct way. It is not the ideal solution of color photography by any means, but it is a beautiful one, and, with all its shortcomings, when properly used will give satisfaction even to the most fastidious. Those who have seen the Steichen pictures are all of one opinion. Lumière's own examples which I have thus far seen, as well as those samples shown me at the various dealers in Munich, would never have aroused me to enthusiasm nor led me to try the process myself. That in itself tells a story."

My own opinion about the plates is reflected in the two letters, and little need be added to them. Eugene and I continued our experiments in Tutzing, but owing to circumstances over which we had no control, they were only of a comparatively short duration and made under great difficulties. We satisfied ourselves, nevertheless, that the scope of the plates was nearly as remarkable as the invention itself. The tests—permanency, and for keeping qualities, were all considered in the experiments. The varnishing question, an important one, is still unsettled in my mind. In short, the process received a thorough practical test in my hands, and my enthusiasm grew greater with every experiment, although the trials and tribulations were many, and the failures not few. On getting to Paris, on my way back to New York, I found that Steichen had not been idle; he had far surpassed his early efforts. He had been experimenting chiefly to get quality and tone, and had obtained some beautiful pictures. In fact he had evolved a method of his own for treating the plates.* Hand-work of any kind will show on the plates—that is one of the blessings of the process—and faking is out

* A special supplement to CAMERA WORK is in the course of preparation. It is to deal with this new color photography. Steichen is preparing the text. The celebrated firm of Bruckmann, in Munich, early in July received the order to reproduce four of Steichen's early efforts for the book. They are the pictures of Lady Hamilton, Mrs. Alfred Stieglitz, G. Bernard Shaw, and the portrait group made on Mr. George Davison's house-boat. The date of publication will be announced later.—EDITOR.

of the question. Steichen's methods are solely chemical ones, as must be everyone else's. This for the benefit of the many ready to jump at erroneous conclusions. On September 18th, I sailed from Europe with a series of pictures made by Steichen, Eugene, and myself. On the 24th I landed, and on the 26th the Press received the following notice :

"NEW YORK, September 26, 1907.

To the Press:

GENTLEMEN : — Color photography is an accomplished fact. That this is actually true will be demonstrated at an exhibition, reserved exclusively for the Press, in the Photo-Secession Galleries, 291 Fifth Avenue, on Friday and Saturday, September 27 and 28, between the hours of 10 and 12 A. M., and 2 and 4 P. M.

Mr. Alfred Stieglitz, having just returned from Europe, has brought with him a selection of color photographs made by Eduard J. Steichen, Frank Eugene and himself.

They will demonstrate some of the possibilities of the remarkable Lumière Autochrome Process, only recently perfected and placed upon the French market. These pictures are the first of the kind to be shown in America. You are invited to attend the exhibition.

Yours truly,

ALFRED STIEGLITZ,
Director of the Photo-Secession."

On the days designated the Secession rooms were crowded with the best talent from the Press. One and all were amazed and delighted with what was shown them. A few had seen pictures done in Lyons by the Lumières themselves, and were not favorably impressed with them. Our early verdict was unanimously upheld. Thus, color photography and its wonders were set loose upon America. As I write, no plates are in the American market. The agents expect them daily. The practical uses to which the process can be put are really unlimited; the purely pictorial will eventually be but a side issue. Nevertheless, the effect of these pictorial color photographs when up to the Secession standards will be revolutionary, and not alone in photographic circles. Here then is another dream come true. And on the Kaiser Wilhelm II I experienced the marvelous sensation within the space of an hour of marconigraphing from mid-ocean; of listening to the Welte-Mignon piano which reproduces automatically and perfectly the playing of any pianist (I actually heard D'Albert, Paderewski, Essipoff, and others of equal note while they were thousands of miles from the piano) ; and of looking at those unbelievable color photographs! How easily we learn to live on former visions!

ALFRED STIEGLITZ.

Why Grope in the Dark

WHEN IT'S DAYLIGHT ALL THE WAY WITH THE

KODAK TANK

"It has been proved, by logic, by experiment, and by rule of thumb, time after time, that tank development does all that hand and eye nursing can do, yet there are thousands who refuse to believe what is known as a fact, and who still stick to the old, red light, hot stuffy room and variable formula methods."—*C. H. Claudy in "The Camera."*

The Experience is in the Tank

Eastman Kodak Company
ROCHESTER, N. Y. *The Kodak City*

Alvin Langdon Coburn
El Toros, 1908
Photogravure
11.9 x 23.9 cm

Alvin Langdon Coburn
Road to Algeciras, 1908
Photogravure
19.8 x 17.7 cm

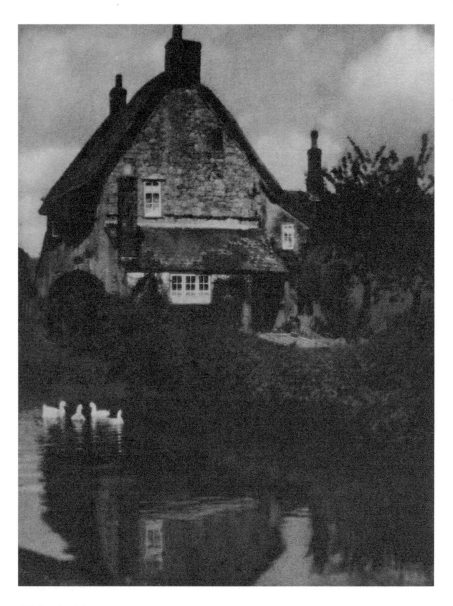

Alvin Langdon Coburn
The Duck Pond, 1908
Photogravure
18.9 x 14.5 cm

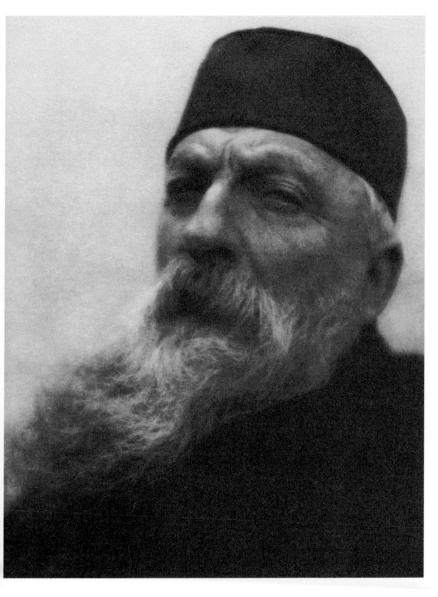

Alvin Langdon Coburn
Rodin, 1908
Photogravure
20.2 x 15.9 cm

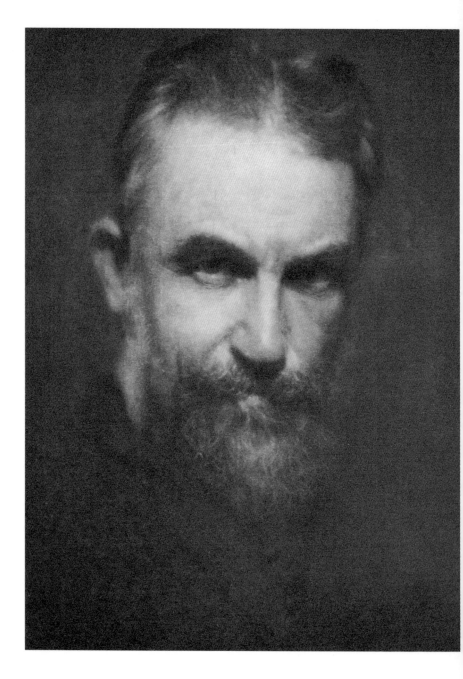

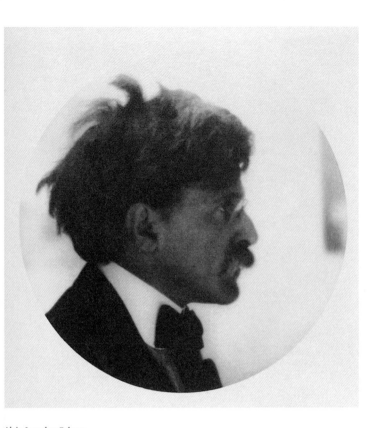

Alvin Langdon Coburn
Alfred Stieglitz, Esq., 1908
Photogravure
15.7 cm diameter

← Alvin Langdon Coburn
Bernard Shaw, 1908
Photogravure
21.1 x 16.4 cm

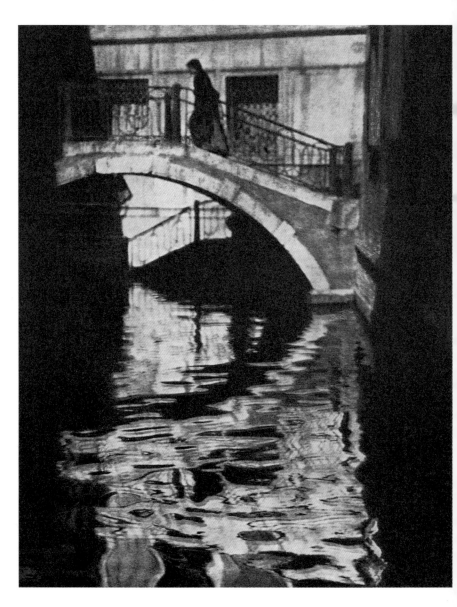

Alvin Langdon Coburn
The Bridge, Venice, 1908
Half-tone reproduction
20.8 x 16.5 cm

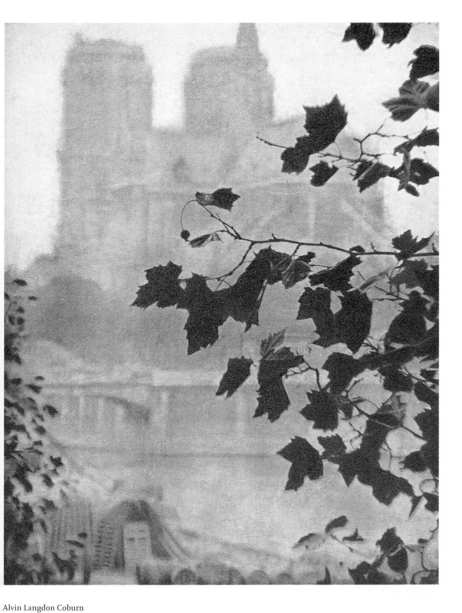

Alvin Langdon Coburn
Notre Dame, 1908
Duotone reproduction
20.4 x 16.3 cm

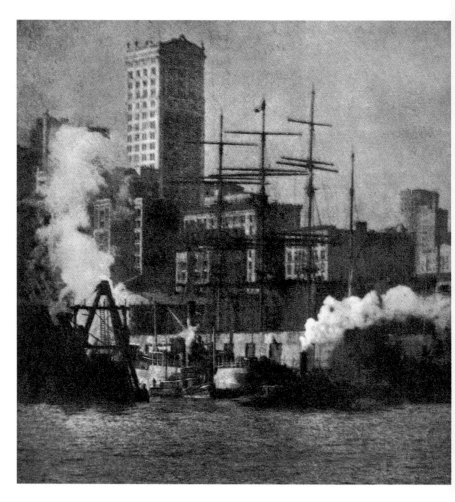

Alvin Langdon Coburn
New York, 1908
Half-tone reproduction
16.7 x 16.4 cm

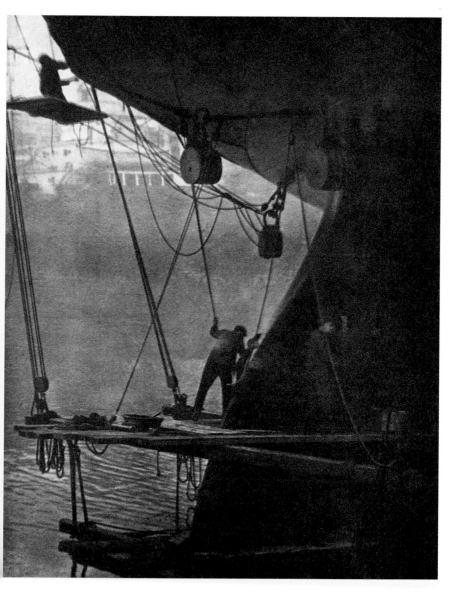

Alvin Langdon Coburn
The Rudder, 1908
Half-tone reproduction
20.7 x 16.4 cm

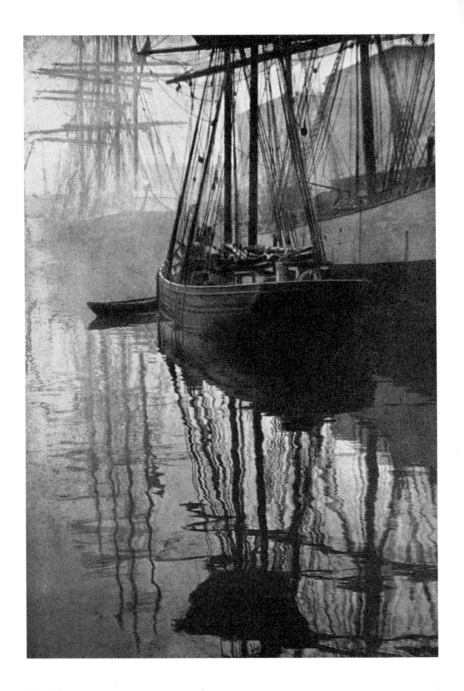

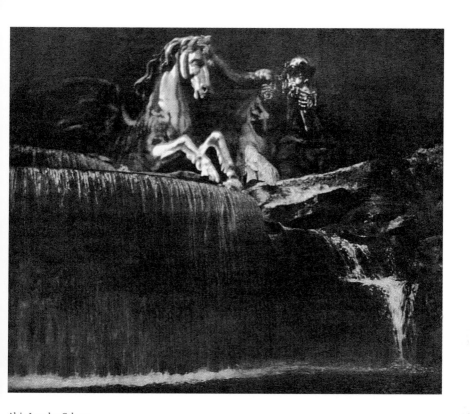

Alvin Langdon Coburn
The Fountain at Trevi, 1908
Half-tone reproduction
16.4 x 20.3 cm

← Alvin Langdon Coburn
Spider-webs, 1908
Half-tone reproduction
23.7.x 16.4 cm

A BIT OF COBURN—OUR PICTURES.

THIS number of CAMERA WORK is devoted to the work of Mr. Alvin Langdon Coburn, of Boston and London. Some of Mr. Coburn's pictures are already well known to our readers, six of them having appeared in Number VI, and six others in Number XV. The twelve of his more recent productions; shown in this number, prove that Coburn has kept his early promise, and has justified those who from the very first had faith in his artistic potentiality.

Coburn has been a favored child throughout his career. Of independent means, he launched into photography at the age of eight. Gradually, and to the practical exclusion of everything else, he devoted all of his time to its study. Originally guided by his distant relative, Holland Day, he, at one time or another, at home or abroad—the Coburns, mother and son, were ever great travelers—came under the influence of Käsebier, Steichen, Demachy, and other leading photographers. Instinctively benefiting from these associations he readily absorbed what impressed itself upon his artistic self. Through untiring work, and urged on by his wonderfully ambitious and self-sacrificing mother, his climb up the ladder was certain and quick. Arriving, three years ago, in London, for a prolonged stay there, his sudden jump into fame through the friendship of Bernard Shaw is well known. Shaw's summing up of Coburn can be found in CAMERA WORK, Number XV. No other photographer has been so extensively exploited nor so generally eulogized. He enjoys it all; is amused at the conflicting opinions about him and his work, and, like all strong individualities, is conscious that he knows best what he wants and what he is driving at. Being talked about is his only recreation. At present he is full of color photography. He was not greatly attracted to the autochrome process when he saw Steichen's color pictures in London early in the summer. Later, however, in September, he waxed enthusiastic after having seen, at the Steichen studio in Paris, the collection which was intended for the Photo-Secession Exhibition. Initiated by Steichen into the process, Coburn was enabled, within ten minutes in the dark-room, to reap the benefit of a whole summer's experimenting. Filled with the possibilities he returned to London loaded with plates. He writes that, for the present, black and white has lost its fascination, and that he is reveling in autumn landscapes, in portraits of Shaw and of actresses with gorgeous costumes and jewels. He informs us that many of the pictures he has obtained are great. Thus Coburn masters the field of photography and stands beyond cavil among the very few first-class photographers of the age. His pictures in this number of CAMERA WORK prove that conclusively. The gravure plates were made in London, under Coburn's personal supervision, by the firm of Waddington. In fact, Coburn did part of the work himself. The edition was printed in New York by the Manhattan Photogravure Company. The process blocks were made by the Photochrome Engraving Company, New York, from the original gum-platinotypes which were recently shown in Coburn's one-man exhibition at the Photo-Secession Galleries. As reproductions these are exceptionally good, interpreting fully the spirit of Coburn's quality and methods.

Eduard J. Steichen
On the House-boat – "The Log Cabin", 1908
Four-colour half-tone reproduction
14.7 x 19.6 cm

← Eduard J. Steichen
G. Bernard Shaw, 1908
Four-colour half-tone reproduction
19.6 x 14.5 cm

Eduard J. Steichen →
Portrait - Lady H., 1908
Four-colour half-tone reproduction
19.8 x 14.6 cm

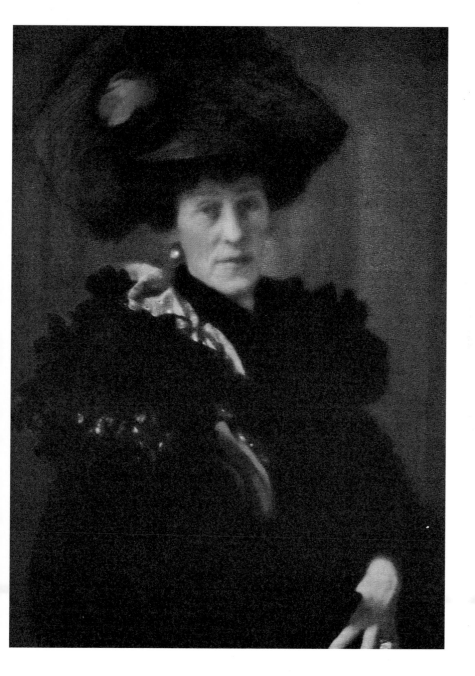

NEW TENDENCIES IN ART.

I N January last there was held in the National Arts Club an exhibition of Contemporary Art that promises to become historic. Its historic significance lies in the little fact that here, for the time being, the public had an opportunity of seeing a collection of paintings and sculpture, of prints and photographs, that in a measure reflected the art movement of our time.

The exhibition was composed almost entirely of work by the leading artistic rebels of America who have disparagingly or in ignorant admiration been dubbed "Impressionists." In the proper sense of the word that is just what they are—Impressionists. But perhaps it may be well to define and limit the meaning of the word, lest these men be confused with the host of sloppy, aping daubers who use it as a convenient cloak to hide their incompetency. Impressionism is but an expression of the eternal yearning of man to reach the truth. The history of the word in its application to art dates back to the salon of 1866, when Eduard Manet exhibited a landscape, the title being "Impression." Manet and Pissaro, who likewise used the system of divided tones to obtain the effect of real life, were promptly labelled "Impressionists" by the Parisians. The term was one of derision, but it has remained to justify itself. To-day it is a reproach only to those by whom it was invented. Nevertheless there are "Impressionists" and "Impressionists." Manet was an "Impressionist," and so was Whistler, but not owing to any similarity of method, for Whistler's art was the antithesis of that of Manet, or Monet; but because all these men were in revolt against the academic system of painting and returned to nature, striving to give a momentary Impression. This is a little distinction not generally understood, and many a canvas is classed with the "Impressionists" owing to the method of placing colors, either in juxtaposition or in an apparent carelessness. Impressionism has so penetrated into our thought, our culture and our ethical expression that the very academies are willy-nilly and subconsciously affected by it—hence the more than ordinary importance of this exhibition at the National Arts Club, which was, in the main, an exhibition of Impressions.

This little exhibition, which attracted thousands of people to it in the three weeks that it was open, suggests some reflections. Here, for the first time in our art history, an attempt was made to show to the American public in a collective manner the work of a number of men who have been more or less discussed in the columns of our daily press as rebels of one kind or another, as men of genius, or decried as charlatans. And here, too, for the first time in America, pictorial photography was shown on a level with paintings and etchings. That they held their own and "made good," so to speak, was amply proven by the unusual interest these prints aroused, despite the fact that many mistook them for mezzotints at first glance, only to discover to their amazement and mortification that these were *merely photographs* they had been admiring.

These examples of the work of the Photo-Secessionists furnished a continual surprise to all who visited the exhibition, and not a few remarked the superiority in quality of the portraits by Steichen and White to many of the canvases shown, which led one art critic into the error of calling them reproductions of paintings, evidently on the presumption that nothing like Steichen's striking portrait of Maeterlinck or White's fine, sympathetic portrait of Mrs. White, could possibly be done with a camera ; while Coburn's print, called " The Bridge—Venice," was mistaken for an etching and a mezzotint. One thing was demonstrated beyond dispute—that the work of these men reflected their personality with no less certainty than did the paintings of Luks, Henri or Dabo, and in certain instances with a more potent charm—one of the finest bits of Impressionism in the whole exhibition was Joseph T. Keiley's " A Bit of Paris," and the "Snapshot—Berlin," by Alfred Stieglitz.

Next to the photographs by the Photo-Secessionists, the paintings by Luks, Dabo, and Steichen, attracted the most attention. Luks, the very mention of whose name is panicky to art-officialdom, was represented by eight canvases—practically his best work. Luks is of the race of Manet, a simple, unphilosophical nature, who is never bothered by any kind of artistic abstractions, who paints the life about him with a naturalness and an abandon unpreoccupied by precedents or traditions. Luks is neither moral nor immoral, neither literary nor religious. Luks paints as Velasquez painted, because the subject is a painter's subject. Luks is one of the glories of American art, and probably our greatest figure painter.

Robert Henri, son of Manet and Whistler, a link between the formalists and the methodists and the free expression of Luks, was represented by several canvases. His immediate adherents—Glackens, Sloan, Shinn, Lawson, whose artistic antecedents are the same as Henri's—were also well represented here, together with others of the same general tendency, all related and harking back to Manet.

Eduard Steichen, one of our most interesting and able painters, was represented by several canvases which reflected a refined sense of color combined with a poetic temperament. His painting of Beethoven, hanging between his subtle landscapes, was one of the most impressive canvases in the whole exhibition.

Of peculiar and historic interest, because of his constant rejection by all our official art bodies, was the six landscapes shown by Leon Dabo, who is to-day the most discussed and best hated painter in America. He, like Steichen, has been compared with Whistler and accused of aping that master's manner, a contention based on a superficial knowledge of the work of both of these painters. Dabo is, above all, a painter of light effects ; he sacrifices form for light and atmosphere; Whistler sacrifices form for tone, which is quite a different matter.

On the whole, this exhibition was one of the most interesting and vital that has been held in this country, and marks the beginning of a new movement in our art life. J. NILSEN LAURVIK.

THE RODIN DRAWINGS AT THE PHOTO - SECESSION GALLERIES.

N art matters the month of January was a very live one in New York; several important exhibitions took place simultaneously, but none attracted more or probably as much attention as that of the Rodin drawings at the Little Galleries of the Photo-Secession. During the three weeks these were shown, connoisseurs, art-lovers of every type, and students from far and near flocked to the garret of 291. It was an unusual assemblage—even for that place—that gathered there to pay homage to one of the greatest artists of all time. It may be said to the credit of New York—provincial as it undoubtedly is in art matters generally—that in this instance a truer and more spontaneous appreciation could nowhere have been given to these remarkable drawings. For the benefit of the readers of CAMERA WORK who did not have the pleasure of seeing the exhibition we reprint the text of the Catalogue in full:

In this exhibition an opportunity is, for the first time, given the American public to study drawings by Rodin. The fifty-eight now shown were selected for this purpose by Rodin and Mr. Steichen. To aid in their fuller understanding we reprint from Arthur Symons' " Studies in Seven Arts " the following extract from his sympathetic essay on Rodin:

" In the drawings, which constitute in themselves so interesting a development of his art, there is little of the delicacy of beauty. They are notes for the clay, 'instantanés,' and they note only movement, expression. They are done in two minutes, by a mere gallop of the hand over paper, with the eyes fixed on some unconscious pose of the model. And here, it would seem (if indeed accident did not enter so largely into the matter) that a point in sentiment has been reached in which the perverse idealism of Baudelaire has disappeared, and a simpler kind of cynicism takes its place. In these astonishing drawings from the nude we see woman carried to a further point of simplicity than even in Degas: woman the animal; woman, in a strange sense, the idol. Not even the Japanese have simplified drawing to this illuminating scrawl of four lines, enclosing the whole mystery of the flesh. Each drawing indicates, as if in the rough block of stone, a single violent movement. Here a woman faces you, her legs thrown above her head; here she faces you with her legs thrust out before her, the soles of her feet seen close and gigantic. She squats like a toad, she stretches herself like a cat, she stands rigid, she lies abandoned. Every movement of her body, violently agitated by the remembrance, or the expectation, or the act of desire, is seen at an expressive moment. She turns upon herself in a hundred attitudes, turning always upon the central pivot of the sex, which emphasizes itself with a fantastic and frightful monotony. The face is but just indicated, a face of wood, like a savage idol; and the body has rarely any of that elegance, seductiveness, and shivering delicacy of life which we find in the marble. It is a machine in movement, a monstrous, devastating machine, working mechanically, and possessed by the one rage of the animal.

Often two bodies interlace each other, flesh crushing upon flesh in all the exasperation of a futile possession ; and the energy of the embrace is indicated in the great hand that lies like a weight upon the shoulders. It is hideous, overpowering, and it has the beauty of all supreme energy.

"And these drawings, with their violent simplicity of appeal, have the distinction of all abstract thought or form. Even in Degas there is a certain luxury, a possible low appeal, in those heavy and creased bodies bending in tubs and streaming a sponge over huddled shoulders. But here luxury becomes geometrical; its axioms are demonstrated algebraically. It is the unknown X which sprawls, in this spawning entanglement of animal life, over the damped paper, between these pencil outlines, each done at a stroke, like a hard, sure stroke of the chisel.

"For, it must be remembered, these are the drawings of a sculptor, notes for a sculpture, and thus indicating form as the sculptor sees it, with more brevity, in simpler outline, than the painter. They speak another language than the drawings of the painter, searching, as they do, for the points that catch the light along a line, for the curves that indicate contour tangibly. In looking at the drawings of a painter, one sees color; here, in these shorthand notes of a sculptor, one's fingers seem actually to touch marble."

As a further record we also reprint what some of the chief art-critics of the daily press had to say. These are the opinion-formers of the large majority of the American public. In no other city does this rule apply so generally as it does in New York, and for that reason the art-critic really holds a more responsible position there than is usually realized. Is he always conscious of it?

J. N. Laurvik in the *Times :*

The exhibitions of drawings by Rodin at the Little Galleries of the Photo-Secession, 291 Fifth Avenue, is of unusual artistic and human interest. It is also a challenge to the prurient prudery of our puritanism. As one looks at these amazing records of unabashed observations of an artist, who is also a man, one marvels that this little gallery has not long since been raided by the blind folly that guards our morals.

In these swift, sure, stenographic notes a mastery of expressive drawing is revealed—a sculptor's mastery—which is seldom beautiful, according to accepted standards of beauty, but that never fails to be interesting and imbued with vital meaning. They have a separate, individual beauty of their own—the beauty of all expressive, characteristic things. Here are set down with an all-embracing scrawl the most curious contortions and unlikely postures of the human body. The soft undulations of the female form are recorded with a few hastening lines that speak eloquently of life. It is the quintessence of brevity, the essence of art expression that has here been flashed upon a piece of paper, illuminating unsuspected corners of the genus Man—the procreating machine.

There is a force elemental and appalling in these simple outlines, that has never before been presented in art. Life has been surprised and stands shivering, breathless and all absorbed in its passionate, flesh-crushing embrace. In these mad, glad yearnings of man, the female form is like an undulating, writhing, sinuous reptile that will not be denied its prey. It squats, toad-like, on all fours, it sprawls on the ground like the snake on its belly, face forward, arms outstretched with frog-like digits ; it reveals the rippling, wave-like line of its profile as, with arms overhead, it fixes its hair, and, crouching on hands and knees, it exposes the flat base of the feet and the beautiful, broad expanse of the back as seen from above.

Some of these are colored with primitive Egyptian blues and reds and yellows, spread on the paper in delicate washes and puzzling blotches, as incomprehensibly childlike at times as the scrawl that envelops the color. A few facetious ones have likened these drawings to Gillett Burgess's "goups," and perhaps the analogy is not so far-fetched, but surely more significant than these ready wits imagined. It is this unbiased quality, the very essence of good humor which becomes satire the moment it becomes biased, that gives to these drawings their great and abiding value. They express the child's wonder at the great facts of life as seen by a man who has lived and become acquainted with its spirit. It is this good humor and this wonder that keep them from being both vulgar and immoral. Nothing that concerns man is alien to him, and all natural acts are to him clean and beautiful.

In his work there is a modesty that defies prudishness and a manly outspokenness that confounds the licentious rantings of libertinism. In this he has something in common with Whitman and every other man who has not looked askance at life.

It is a hopeful sign of the changing order of things when work such as this can be shown here in New York. No one interested in the development of the modern spirit in art should miss the opportunity of seeing these drawings.

Put a

DARK ROOM

In Your Suit Case

Eastman Kodak Company
ROCHESTER, N. Y., *The Kodak City*

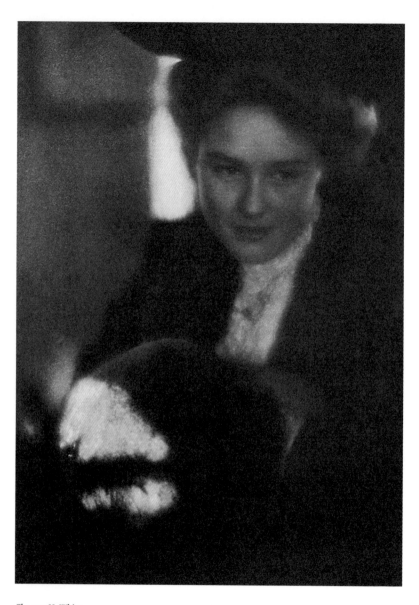

Clarence H. White
Portrait – Miss Mary Everett, 1908
Photogravure
22 x 15.7 cm

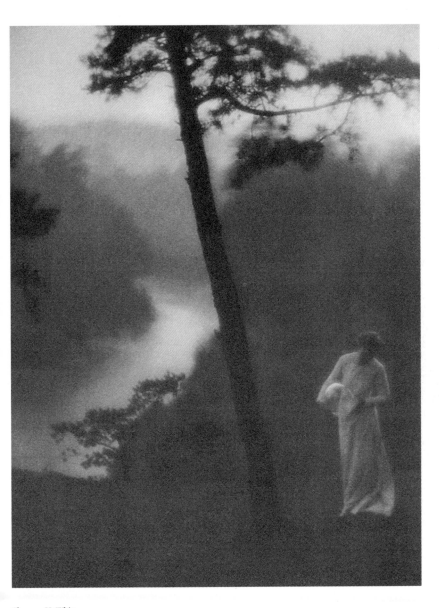

Clarence H. White
Morning, 1908
Photogravure
20.2 x 15.5 cm

Clarence H. White
The Arbor, 1908
Photogravure
20.6 x 15.3 cm

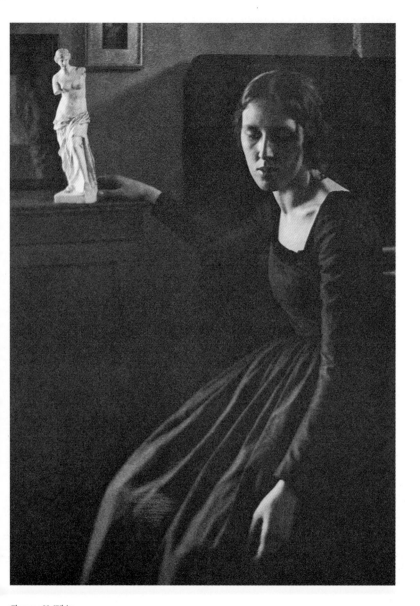

Clarence H. White
Lady in Black with Statuette, 1908
Photogravure
19.3 x 13.6 cm

Clarence H. White
Landscape – Winter, 1908
Photogravure
15.3 x 18.9 cm

← Clarence H. White
Boys Going to School, 1908
Photogravure
20.5 x 15.6 cm

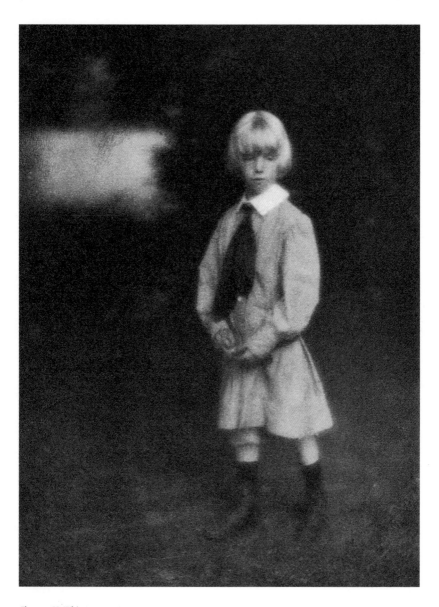

Clarence H. White
Portrait – Master Tom, 1908
Photogravure
21 x 15.7 cm

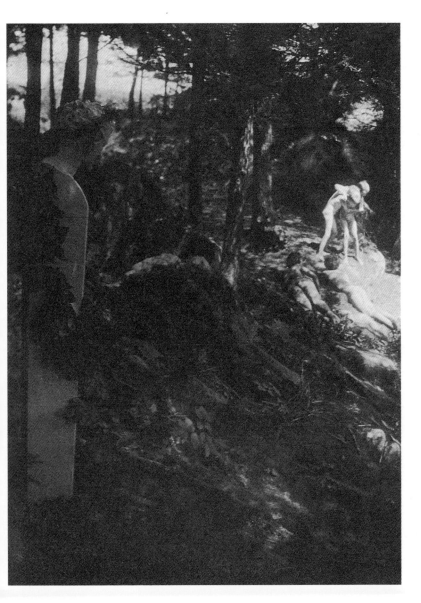

Clarence H. White
Boys Wrestling, 1908
Photogravure
21.4 x 15.5 cm

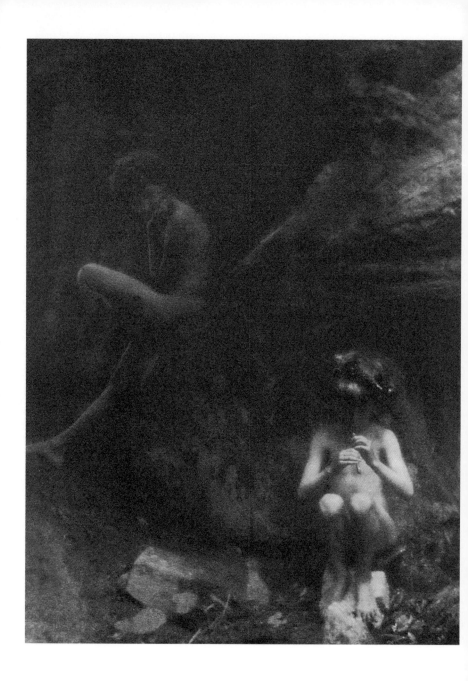

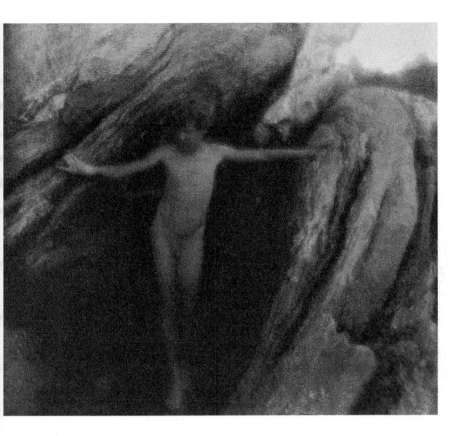

Clarence H. White
Nude, 1908
Photogravure
15.7 x 18 cm

← Clarence H. White
The Pipes of Pan, 1908
Photogravure
19.7 x 14.8 cm

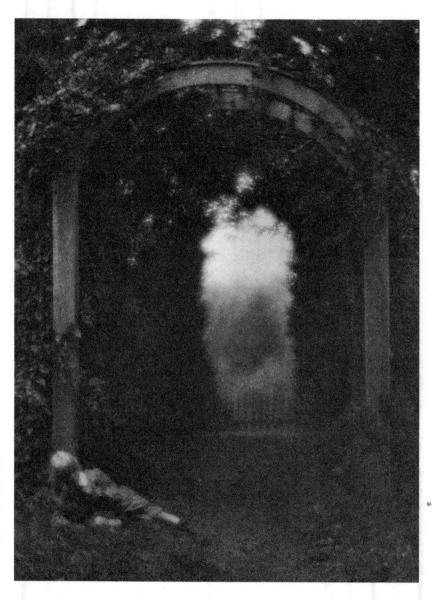

Clarence H. White
Entrance to the Garden, 1908
Photogravure
20.4 x 15.3 cm

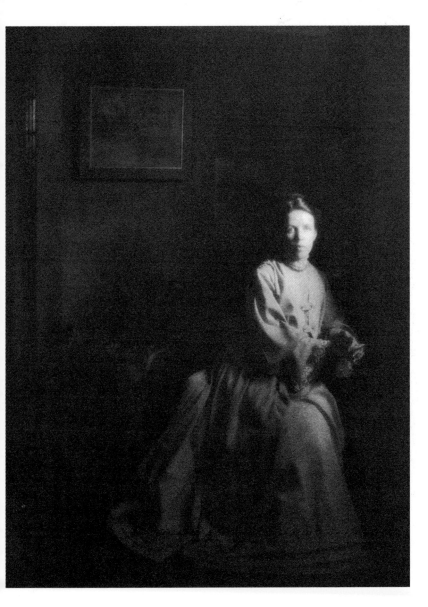

Clarence H. White
Portrait – Mrs. Clarence H. White, 1908
Photogravure
20.6 x 15.7 cm

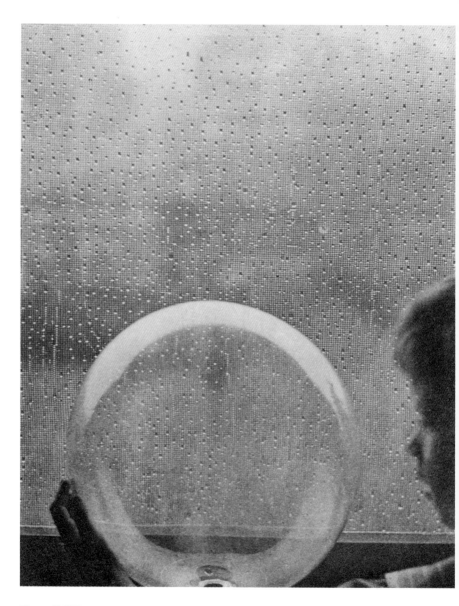

Clarence H. White
Drops of Rain, 1908
Photogravure
19.4 x 15.4 cm

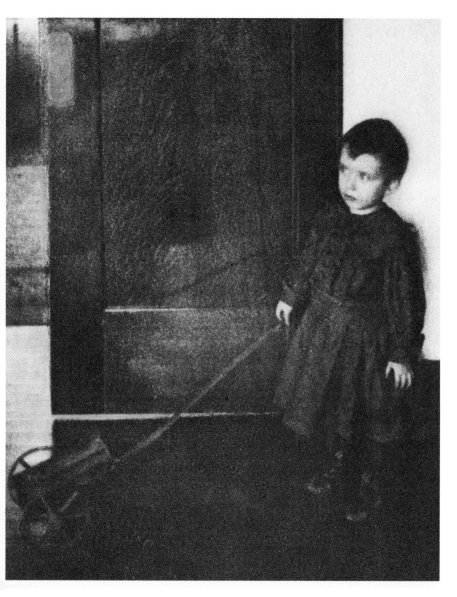

Clarence H. White
Boy with Wagon, 1908
Photogravure
19.8 x 15.8 cm

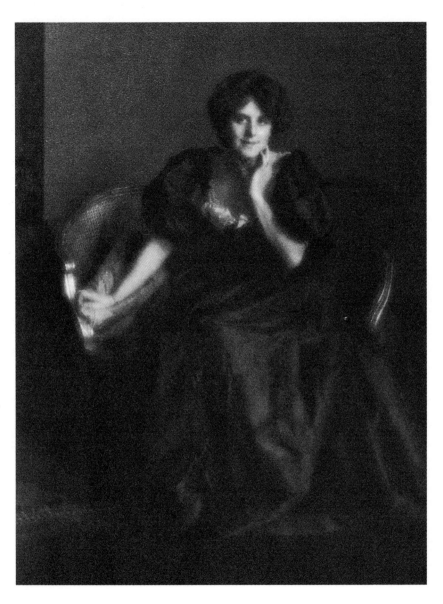

Clarence H. White
Portrait – Mrs. Harrington Mann, 1908
Photogravure
20 x 15.3 cm

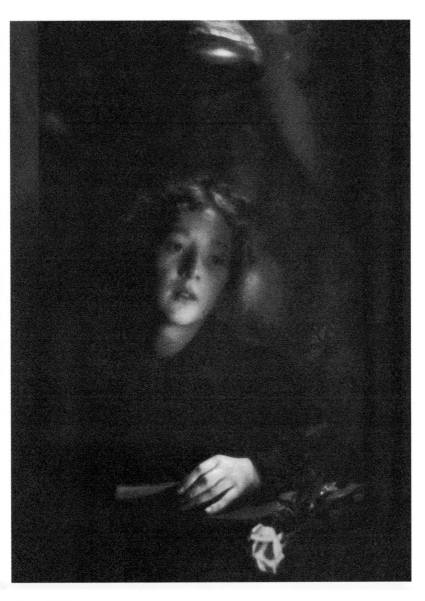

Clarence H. White
Girl with Rose, 1908
Photogravure
19.6 x 14.6 cm

PAINTING AND PHOTOGRAPHY.

MR. GEORGE BERNARD SHAW wrote an article a few years ago, in which he conclusively demonstrated the unmechanicalness of photography, and expressed opinions that brought forth prompt and profuse apologies to the public from photographers and the photographic press. He was most generally assailed for a statement that if Velasquez were living to-day he would be a photographer instead of a painter; and by way of adding another photographer's apology for this statement, I will have to go Mr. Shaw one better on the same point and insist that Velasquez could hardly become more of a photographer to-day than he already was in his own time, except that he would surely use the camera to-day.

It is strange that we should so carefully cherish the fallacy that photography began with Daguerre's discovery; as far as the shareholders of the Eastman Kodak Co. are concerned, there is no doubt about this being true, but from the standpoint of pictorial art, photography dates back to earlier days. When art began and when art flourished, as it did in Egypt, in Persia, in China, in Japan, and in Greece, photography—the art of representation—was undeveloped and unknown. The elements of beauty as expressed in form, design and color were the whole of art, and the artists knew art and created great works of art. Without pretending in any way to go into the reasons, the causes, or a careful chronology of its evolution, we find that art to-day reaches its greatest heights in the painting of pictures and in these actually represents nature. The making of beautiful objects and things of ornament, and even of utility, have practically been banished from the realm of art to the more active and more lucrative scope of commerce; and that perfect expression of an artist's conceit, the easel painting, has become a very high grade of wall-paper, enclosed in a frame of gold, hung regardless of its uses, intentions or environment, to be worshipped as the great form of art.

With but few notable exceptions the gradual tendencies of painting since about the time of Giotto have been towards a more complete and a more perfect physical representation of nature. Since that time, light and shade, and chiaroscuro, have become important elements in painting; then atmosphere and the rendering of light; and finally the art of representation reached such a climax in its development that we went beyond the surface representation of things and even analyzed light and color in painting. We have dubbed the minute detail painting of a Meissonier as photographic, because it gave what we understood photography generally gave us—but the analytical art of Monet and Sisley is a much greater step into the domain of photography, for the Monet is simply a greater representation and a truer one than the Meissonier—just as a White is a greater and more realistic photograph than an H. P. Robinson.

When looking at a Japanese picture, a print by Kionaga, or at the Sphinx, at the painting on a Greek vase, a gorgeous Chinese garment, a

Persian bowl or rug, we do not think of them as representing nature or compare them to anything existing in nature. The Chinese dragon does not appeal to us as the representation of a real animal. We are impressed in all of these things and we are moved by their imaginative power and by their beautiful creation of form, design, and color. Photography is not present.

An eminently able student of the arts spending several months in the Prado, at Madrid, found himself unconsciously comparing the paintings of Velasquez with the real people that were about the gallery, and he came to the frank conclusion that wonderful as were the paintings, and skilled and beautiful their execution, the human beings were in themselves still finer.

Whistler was obviously of such an attitude, but only from a distant and reservedly exquisite Beau Brummel standpoint; the dainty butterfly fluttering among the flowers, sipping a little here and there, and combining it all by his great genius. In his writings and in the titles of his pictures he was more radical than in the pictures themselves, and in these he makes it clear that his resentment was not merely directed at the more vulgar forms of literary painting, like " Breaking Home Ties " and " The Doctor," but that he does not approve of pictures and men much more closely allied to himself. Although there was no decisive spirit of revolution in the make-up of Whistler, the entitling a picture, a "harmony in blue and gold," and his subsequent defence of the title, proclaim at least a disapproval of existing conditions in art. But beyond this the picture itself is neither an innovation nor a renaissance; nothing more than a complete and personal expression of great genius, for the picture is but the actual representation of nature in an abstract form with a tentative attempt to eliminate such foreign elements as light and shade and chiaroscuro, and these not frankly or radically, but by the subterfuge of flattening the effect of light, and by producing a harmony of color which by its title is proclaimed a harmony of contrast, but which is actually one of very low-toned color analogy. For Whistler was not a great colorist to the point of color appealing to him for color's sake. The resonance and harmony of pure rich color was foreign to him, even to the point of his resenting it. Just as this refined estheticism kept him from ever producing anything blatantly ugly in color, so this same faculty limited him and his palette to a narrow and tone-degraded gamut of color which was influenced by the generations of established photographic instinct for representation. It is in his very last work, unfortunately not well known or much appreciated, that he sounded a more definite challenge to photographic painting, even though he sounded this challenge through a tiny golden flute. This work is all a delicate patchwork of color and design, that combines the qualities of form in the Tanagra figurine, and the arabesque and color of the Persian potteries.

Photography and photographers have had the imitation of other mediums clapped on their heads at almost every step in their development and in their seeking to make pliable a medium which seems on the surface entirely mechanical; and although this reproach was eminently justifiable in many instances of flagrant imitation of the technique of inferior media—the writer

himself pleads guilty—they basically and in a broad general way have been reproached for being true to themselves and their medium when painters have all the while been making photographs. What now does remain is the complete demonstration of the superiority of the lens and of light in the hands of an artist, over the brush and palette for the making of photographs. I am personally willing to avoid the discussion of the subject and calmly watch developments, feeling confident that even the most conservative critic will soon discover the superiority, at least in portraiture, of photography *per se* over the big majority of so-called portrait paintings; and that in another direction a Winslow Homer, himself, may live to see a perfected cinematograph, that has been operated by another Winslow Homer, exhibit representations of the Maine coast in color, with the possible accompaniment of a phonograph, that will have all the great qualities of his canvases and obviously more. It will have the heave and swell of the sea, the bigness of space, and the wetness of things — the hardness of rock and dashing of the spray—and the truthful color-renderings. It is bound to have these if they existed in nature, and even these very qualities can be photographically exaggerated, just as Homer himself might do them in paint. One thing will be missing, the brilliant virtuoso performance of his brushwork—the so-called technique. Camera photography can never compete with this. In picturing nature this technique is the only element of personal equation which the camera cannot, or rather will not, do better for the artist than paint photography, and the state of things in the art of representation has come to a strange period in its evolution when the manipulation of the brush and the paint is its greatest reason for existence. Let it not be imagined that all this is but a cocksure bandying of a great genius, for one considers Homer such, even if one does not consider him a great artist—for a great artist would never permit nature to fascinate him beyond his art and cause him to paint the ugliest imaginable arrangements of color on a canvas, simply because they existed in the "motif" before him. The great painter would find in this motif that which would inspire him to paint a picture that must first and foremost be beautiful in form and in color regardless of its physical representation of nature, otherwise it is only a photograph, and photography can never be a great art in the same sense that painting can ; it can never create anything, nor design. It is basically dependent on beauty as it exists in nature, and not as the genius of the artist creates it. It is an art entirely apart and for itself. Its successful developments, technically and artistically, of to-day, are the definite proof of the fallacy of most modern painting; and yet the greatest photograph of a living woman that can ever be made will be much less beautiful than the Mona Lisa, just as nature is less beautiful than art, and as the greatest Velasquez sinks into insignificance beside the gods of granite of ancient Egypt.

<div align="right">EDUARD J. STEICHEN.</div>

CLARENCE H. WHITE.

MONG Clarence H. White's prints are several woodland scenes. Rocks and trees are interspersed, and a *Hermes* looks down smiling on some boys wrestling in play, whose straight young bodies are dappled with sun and shadow. They are pictures that suggest the idea, old even in Greek times, of a young world, fresh as the buds that in the past three days have gathered on the poplar which I see from my city window, a spray of delicate purity against the shabby bricks beyond it. It is an exquisite reminder that the world, the real world of nature and the spirit, is still young; and it is in this young world that the artist in White, it seems to me, lives and has its being.

Then I recall another of his prints. A woman's figure, moving away from us along a garden pathway. She is abroad in the fragrance of the early morning sunshine, that is as yet too cool to disperse the film of mist which clings to the trees and grass and even envelopes her form. Then another picture in which, as the twilight slips away, a woman and a child stand, motionless as shades, gazing down over a vista of descending grass-land, ending in a mystery of trees. And yet another. It is but a slope of foreground, and a stretch of water separated from the sky by the thread-line of the opposite shore. In the distribution, however, and relation of the masses, the selection of lines, and the tonality of color-values, it is a composition that recalls the choiceness of a Japanese print.

Remembering these pictures, I seem to find in them a clue to the charm that White's work possesses. There is, firstly, a peculiar refinement of feeling in the conception of the subject and choice of details to embroider it, and an unfailing resourcefulness in the arrangement of the composition. Secondly, a reverence of feeling, due to a consciousness of the mystery of beauty. Thirdly, the source of expression in all his pictures is a susceptibility to the effects of light. And fourthly, informing expression, feeling and composition, is a spirit that maturity of experience has not divested of its essential youthfulness. And all these qualities are in him the product of instinct.

Psychologically considered, he represents a curiously interesting example of an artist being born, not made. His early environment—a small western town, and his particular occupation of a clerkship in a store offered neither encouragement nor impediment to his artistic development. Nor had he any opportunities of private study, except such as *Camera Notes* suggested to him. He bought a camera and, for the most part, was forced to go his own way. It lead him in directions opposed to the current traditions of photography. Thus he leveled his camera directly toward the light. It was the mistake of ignorance, as any photographer would have told him. Yet it proved to be the opening up of new possibilities. He had followed an instinct that was truer than tradition. That instinct was toward light; to make light, rather than light and shadow, the basis of his study. In doing so, he was not aware that he was setting photography in line with

the most progressive motives of modern painting; still less did he reason out, that, as the photographic process is the product of light, it is through light that its highest potentiality must be sought. He simply followed an instinct.

He did the same in selecting subjects for his early experiments. He was ignorant of the principles of composition, as expounded in the schools; but he felt that such and such an arrangement was more pleasing than another and accordingly adopted it. And this very ignorance of tradition gave an elasticity and freedom to his habit of looking at his subject, that encouraged inventiveness. How he should arrange his subject was suggested to him by the subject itself; and it is so still. Thus, if you look over a number of his prints, their compositions do not stale by repetition; each has its own note of freshness, and all are distinguished by an exceeding tactfulness and reserve. They have the charm of novelty without bizarrerie: and a most expressively close relation to the character of the subject.

A similarly keen and subtle instinct for the propriety of balance has taught him the secrets of tonality. A false note hurt his instinctive sense of fitness and must be avoided. Thus, without any knowledge of the jargon of "values," he found his own way to the principles involved in it. So too, he discovered for himself the meaning and the need of "quality" in the various values of color in the print. It probably grew out of his instinct for light, since quality is merely a convenient term to express that the colors, whether they contain more or less of light, suggest the vibration of light and thus unite with one another in completing the rhythm of the whole picture.

But, informing all this growth in technique, was what one may call an instinctive reverence. It colors the way in which he sets about a portrait. There is never a suggestion of exploiting the sitter, to secure a technical achievement or to pursue a personal notion of his own. It is to the personality of the subject that he looks for suggestion, sets the key of his motive, and attunes, for the time being, his technique. This fine reverence, however, becomes impregnated with personal feeling when his model is nature, or when he combines a figure with surroundings to express some idea of his own. Then he sheds around his subject an atmosphere of spiritual significance that is poignantly alluring. Whether pitched to a lightsome strain or to a minor key, it is arrestingly pure and plaintive; sometimes suggestive of the youthful intensity of the Italian Primitives, at other times burdened with a modern seriousness. Yet, even so, not encumbered with age and worldliness. Always, as I said at first, it suggests the fragrance and the freshness that one associates with the springtime of the spirit.

It is this rare combination of a natural instinct for beauty, refined and trained by an impulse from within, and of an imagination, pure and serious, that gives to all White's work not only a pronounced individuality, but also a peculiarly rarified charm. They are the emanations of a beautiful spirit.

CHARLES H. CAFFIN.

EXHIBITION OF PRINTS BY GEORGE H. SEELEY.

HE value of the Photo-Secession, both in its general upholding of the higher purposes of photography and in its particular ability to help the individual, has never been better illustrated than in the recent exhibition of prints by George H. Seeley. Incidentally it is very much to the latter's advantage that his work should be granted for nearly three weeks an exclusive showing, where it was seen by the exceptionally intelligent clientele that the Secession has attracted to its galleries. Yet this would be of small account, if the work itself did not merit the indorsement which is implied in this privilege. That Mr. Seeley's does is very largely due to the spirit which animates the Secession. It is keenly awake to any signs of promise; helps alike with criticism and encouragement, and, when the results warrant it, affords the inestimable benefit of a well-organized exhibition.

As some of us go, Mr. Seeley is still a young man; though he is no stripling, and, for aught I know, may have been experimenting with photography for a very considerable time, before I became aware of his existence. This was some two years ago, when a few of his prints appeared in a members' exhibition. In any ordinary exhibition they would have been swamped in the general mass of material, uncongenial to themselves; or, if observed, would probably have been voted cranky. For Mr. Seeley has a vision of the world peculiarly his own, and, at that time, did not possess the technical ability to express it. So much so, that one might feel a doubt as to whether he were even sure of his own motive. In every respect the work seemed uncertain and immature.

One of the prints represented a girl in flowing drapery, and a dog, standing under trees, through which the sunlight filtered, dappling their bodies with spots. It was a spotted girl and a spotted dog in a spotty landscape; for, like the novice in *plein air* painting, Mr. Seeley had not succeeded in rendering the luminosity of the light. Another print, however, from the same negative appeared in the recent exhibition. But, though similarly printed in platinotype, it was entirely different.

By this time the artist had acquired control over his medium. The figures and their surroundings were in harmonious relation; the spottiness had been merged in a coherent composition of light and shadow, and the callow feeling that pervaded the original print had been replaced by one of assurance and authority.

Nor was this the result merely of an accidental success in printing. For fifty other prints, though they differed in quality, were at one in suggesting that at least Mr. Seeley felt certain of his own intentions and was reasonably sure of the resources of his technique. The exhibition, in fact, showed an amazing advance both in technical and mental grasp. The credit for this is, of course, primarily due to himself; yet, I am sure he would be the first to acknowledge his indebtedness to the Photo-Secession; which at a critical point in his career neither ignored him nor plastered him

with faint praise; but, entering sympathetically into his point of view, helped him with judicious criticism.

I greatly enjoyed the exhibition. It struck so individual a note and, what is more, maintained it. And the note represented a fine quality of imagination. Nor am I thinking only of the sentiment of the subjects; but still more of the technical treatment. Vollon's fruit and vegetable subjects, for example, display more of the truly artistic imagination than many a so-called "ideal" picture. It is not *what* the artist imagines, but *how* he imagines it, that determines the quality of his artistic imagination. Mr. Seeley's work would indicate that he realizes this.

Yet the character and quality of his work undoubtedly have their origin in sentiment. His life has been spent in the beautiful village of Stockbridge, Massachusetts, and I, who as a boy, have felt the spell of the hills and woods, can fancy somewhat the nature of the influence he has absorbed. If one can reduce so vaguely wonderful an impression to the inconvenient precision of words, I should say it is one of spaciousness and silence. Hill tops are aloof from the stir of human things, and the eye and the spirit, skipping immediate distances, seek the distance far removed, where *Ultima Thule* hovers. Nor do the sounds of the woodland creatures disturb the silence of the woods, where despite innumerable interruptions the vision still persists in traveling on. These vast silences of nature may be a trifle eerie at times, not seldom awesome, but for the most part spiritually companionable, inviting converse with the abstract and universal. Such impulse, artistically interpreted, makes for symbolism. Form and the color of things, the weavings of light and shade, and vistas of distance, become seen as symbols of spiritual expression. It is in some such vein as this, if I mistake not, that Mr. Seeley views the world and seeks subjects for his pictures.

Naturally, the impression conveyed is most poignantly convincing in the prints that are technically superior. And these are the ones, it seems to me, which have not been subjected to enlargement. No doubt the gallery that contained the enlargements made a brave showing. But mere size is a method of attracting attention that is aroused quickly but soon wears off. We saw an instance of this in the large (although not "enlarged") portrait-heads by Mr. Coburn in the members' exhibition of the Photo-Secession last November. Technically, it is true, these enlargements of Mr. Seeley's are superior to the Coburn portraits, which were produced, if I mistake not, under very rapid and rather commercial conditions. But they are not good enough to justify themselves. There are large spaces of flesh and drapery, which are insufficient in interest, whether of texture, tone, or color. Sometimes the alteration of scale, as in the case of *The Pine God*, even impairs the unity of the composition. Occasionally, however, as in *Youth with Globe*, I must admit that the enlargement is a fair success.

Still, to find this artist at his best, one turns to the unenlarged examples; to such an entirely satisfying print, for instance, as *The Pines — Sunset*. Here the feeling and its technical expression reach a very high

mark indeed. One is able to enter with unalloyed pleasure into the motive of the picture, and to enjoy in every part the means by which it has been wrought out. To enlarge such a print, would be to reduce the esthetic meaning of its passages of dark and light, to dislocate the harmony of its tonal relations, and to increase, possibly, its effect of imposingness, but at the expense throughout of quality. CHARLES H. CAFFIN.

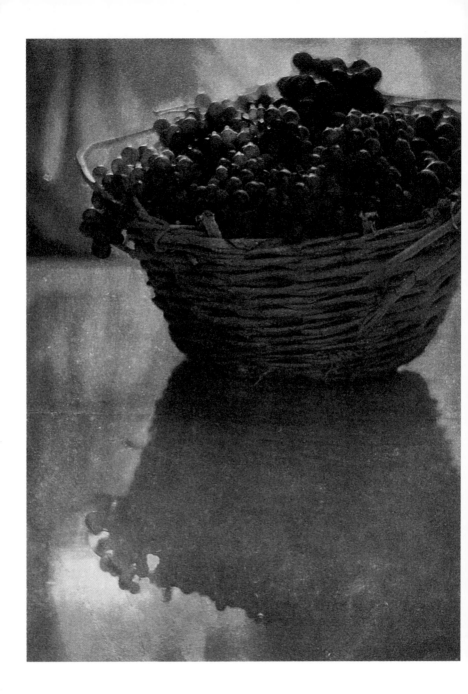

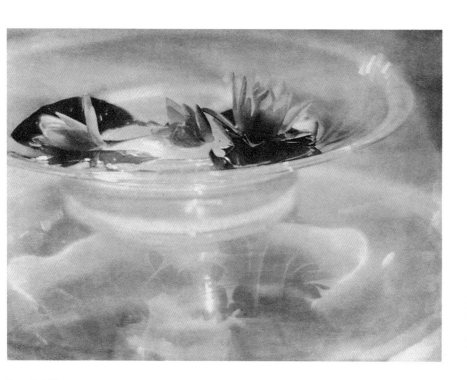

Baron A. de Meyer
Still Life, 1908
Photogravure
16.4 x 22.4 cm

← Baron A. de Meyer
Still Life, 1908
Photogravure
21.3 x 15.4 cm

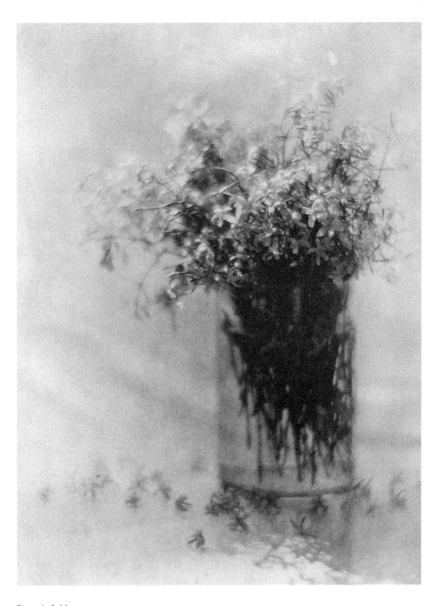

Baron A. de Meyer
Still Life, 1908
Photogravure
22 x 16.5 cm

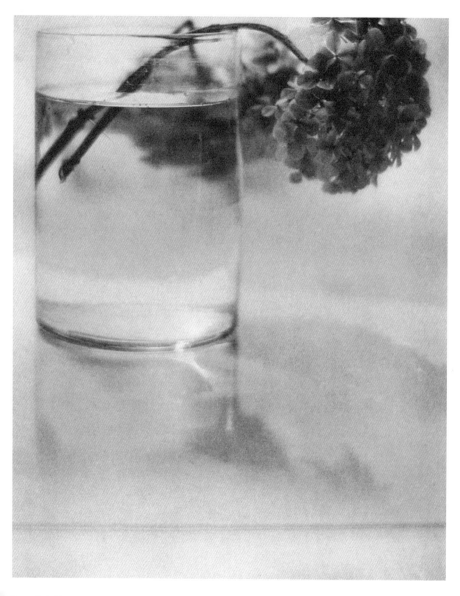

Baron A. de Meyer
Still Life, 1908
Photogravure
19.2 x 15.5 cm

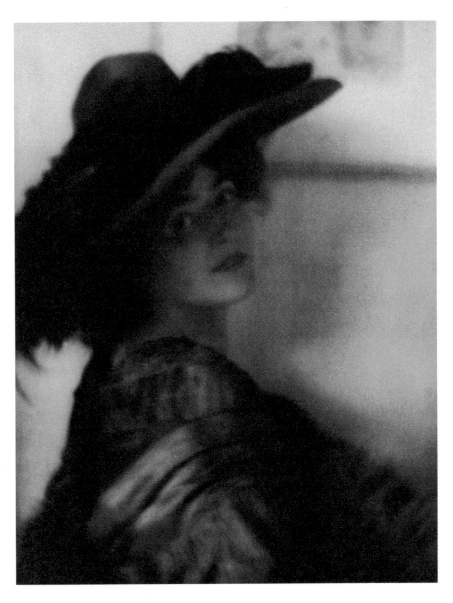

Baron A. de Meyer
Mrs. Brown Potter, 1908
Photogravure
20.8 x 16.1 cm

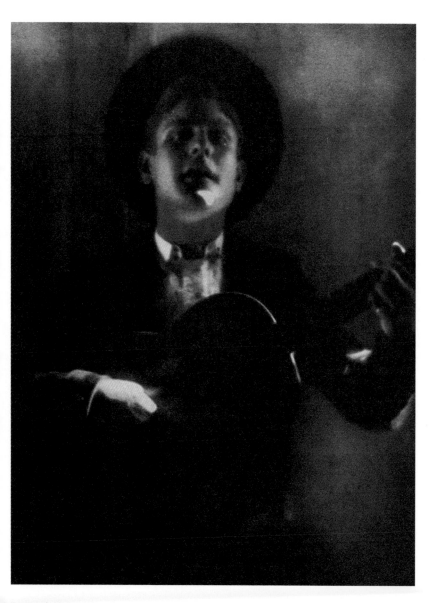

Baron A. de Meyer
Guitar Player of Seville, 1908
Photogravure
20.7 x 15.6 cm

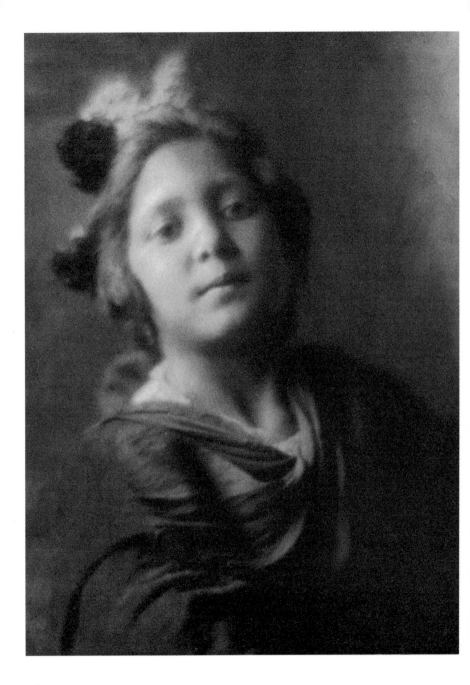

William E. Wilmerding
Over the House-Tops – New York, 1908
Photogravure
15.3 x 19.2 cm

← Baron A. de Meyer
Study of a Gitana, 1908
Photogravure
20.6 x 15 cm

Guido Rey
The Letter, 1908
Photogravure
20.2 x 15.3 cm

Guido Rey
A Flemish Interior, 1908
Photogravure
21.3 x 15.5 cm

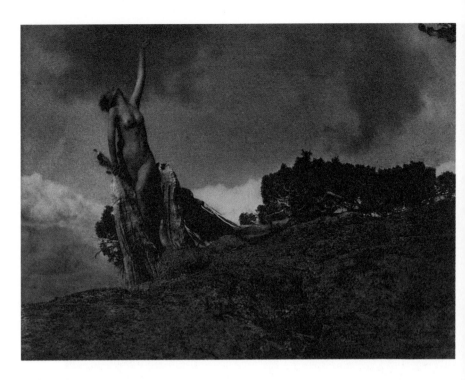

Annie W. Brigman
Soul of the Blasted Pine, 1909
Photogravure
15.4 x 20.9 cm

Annie W. Brigman →
The Dying Cedar, 1909
Photogravure
23.2 x 13.7 cm

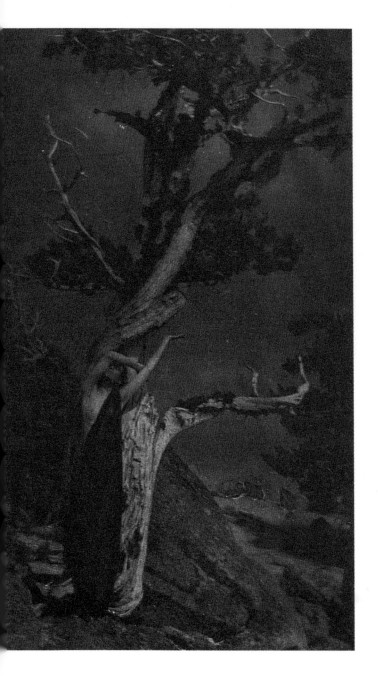

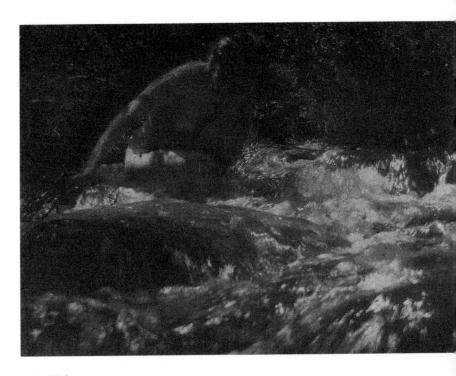

Annie W. Brigman
The Brook, 1909
Photogravure
15.7 x 21.3 cm

Annie W. Brigman →
The Source, 1909
Photogravure
23.5 x 13.8 cm

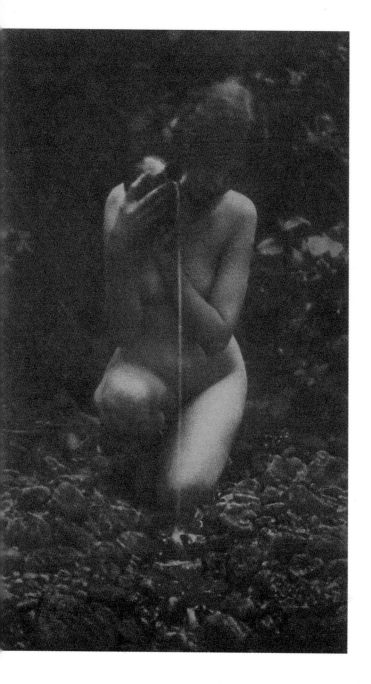

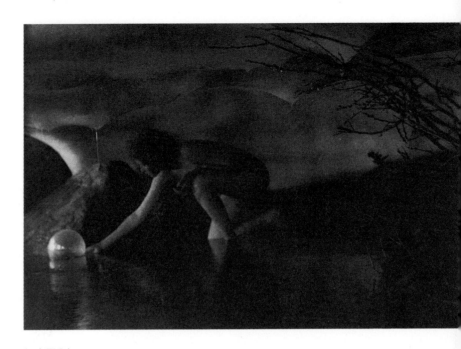

Annie W. Brigman
The Bubble, 1909
Photogravure
16.1 x 23.5 cm

Ema Spencer →
Girl with Parasol, 1909
Photogravure
20.7 x 15.7 cm

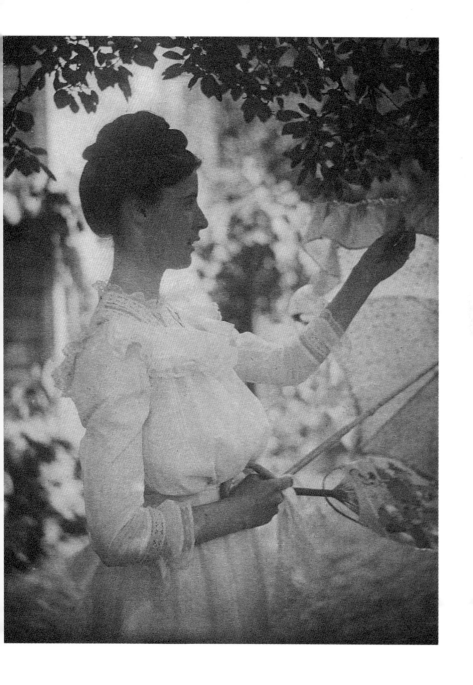

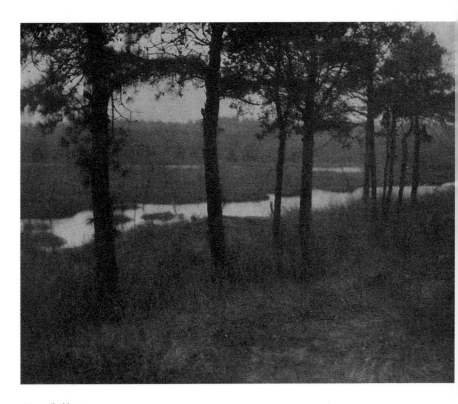

C. Yarnall Abbott
Sentinels, 1909
Photogravure
12.4 x 15.6 cm

Frank Eugene →
Mr. Alfred Stieglitz, 1909
Photogravure
16.4 x 11.2 cm

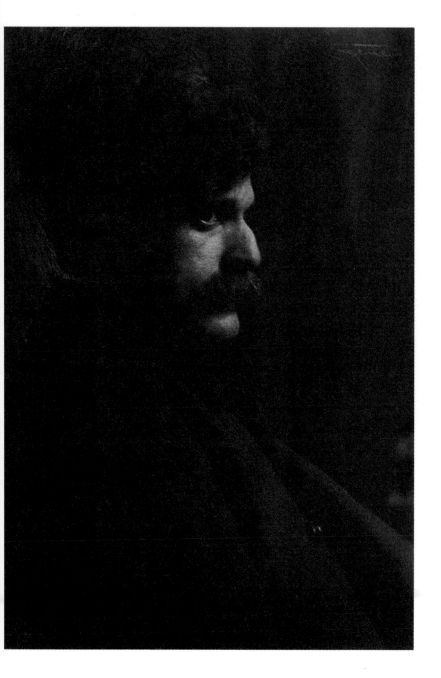

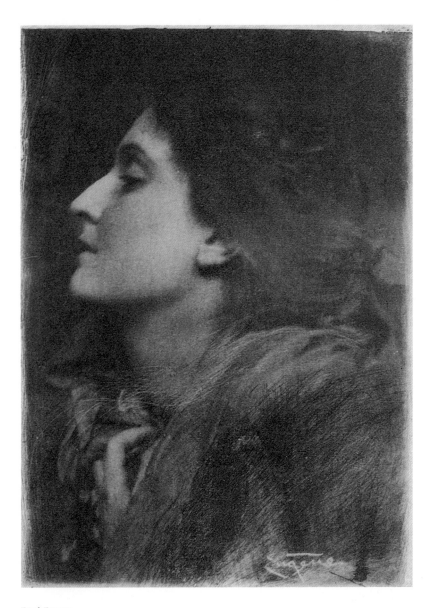

Frank Eugene
Lady of Charlotte, 1909
Photogravure
11.4 x 8.2 cm

HENRI MATISSE AND ISADORA DUNCAN

MONG the sculptors, painters and critics, quoted in the latest issue of CAMERA WORK, there were only two men who dissented from the proposition that photography may be a form of artistic expression, and one of these was Henri Matisse. He regards photography as a source of documents, valuable to the artist for their richness of suggestion; a means to an end, not an end in itself. Therefore the photographer should not tamper with the record. Let the objectivity of the latter be completely preserved.

This opinion is interesting in its self-revelation of Matisse, whose own motive is to get away from objectivity and to make his pictures interpret an abstract idea. While he has a small but ardent following in Paris, to the great majority of artists and critics his work is *bêtise*. Some one dubbed him and his group *Les Fauves;* and the name has stuck; and certainly from the ordinary standpoint of appreciation and criticism "The Wild Men" have justified it. To the academic painter their pictures are an inconceivable outrage; to the impressionist, as offensive as those of the original impressionists were to the conservatives of their own day.

To the student, however, who keeps aloof from the clatter of cliques and tries to understand each man in the light of the man's own intentions, some questions arise: Is Matisse a charlatan? If not, is he, though not trying to deceive others, a victim of self-deception? On the other hand, is it possible that a later generation may endorse at least his motive, just as today we endorse the motive, if not all the productions, of impressionism?

What is his motive? As he himself explains it, it is the effort to interpret the feeling which the sight of an object stirs in him. This has a familiar sound. Yes, there is nothing novel in the general motive of Matisse. The novelty begins to appear in its application. He too is an impressionist, but with a difference. It is not the ocular but the mental impression that he is intent on rendering, which again has a ring not unfamiliar. But his difference consists in the big gap which appears between the ocular and the mental impression. For example, I saw a picture of a woman. The original I was told, had a band of orange and scarlet ribbon around her throat and waist; otherwise she was dressed from head to foot in black. So much for the ocular impression. This, however, when it had filtered through his mental vision, emerged as a brilliant color scheme of rose, purple, peacock-green and blue, with a prevalence throughout of greenish suggestion. Why not, you reply? He was not bound to represent the woman as you or I might have seen her. How much better, if the contrast of yellow, red and black suggested to his imagination a sumptuous and subtle color harmony, that he should create it.

Yes, as an abstract proposition, such a course seems admirable. But you examine the picture in detail, the features of the face have been drawn in with lines of the brush, very crudely as it seems, almost like a child's handling of the brush. Then you turn to another picture, this time of a nude. The

features again are portrayed in this rudimentary way, and the chin slopes into the neck with a suggestion of imbecility. But the drawing of the limbs and torso are worse yet; one leg, for example, is palpably bigger than the other; and, while some of the lines have a fine sweep of movement, passages occur that seem to you like the fumbling of a person who cannot draw. The grotesqueness of the whole thing shocks you. It is impressionism run mad! But a visit to Matisse does not endorse this hasty surmise. When I entered the big building—a disused convent—in which he works, the first sight I encountered was that symbol of domestic conformity, a baby carriage, and the next the father himself, a stocky simple person, in appearance a sane and healthy bourgeois. No suggestion of the decadent esthete; still less of the poseur or charlatan. He shows me a series of drawings from the nude. In the first, he explains that he has drawn "what exists"; and the drawing shows the knowledge and skill, characteristic of French academic art. Then others follow in which he has sought for further and further "simplification," until finally the figure, as he expressed it, was *organisé*. To the academician it may appear spoilt, brutalised or enfeebled, at any rate ridiculous. But for Matisse's own purpose it has been "organized," brought into conformity with his controlling purpose. And the latter, he explains, is to sacrifice everything to unity; so that you may be able to see the composition as a whole without any interruption.

He sees me looking at some wooden figures carved by African natives. These with some fragments of Egyptian sculpture are almost the only objects, besides pictures, in his studio. As he passes his hand over the wooden figures, he utters one word, "Simplification." Meanwhile, it does not escape me that the incised lines and the treatment of the planes in these figures, bear a close analogy to his own method of drawing and modeling; and I note that his figures have a feeling of quiet self-contained bulk, corresponding to the old African carver's expression in wood.

Then, as he talks about the importance of form, and especially the need of preserving and relying on its plasticity, he leads me to another room, where in the big emptiness of the surroundings he is modeling a figure in clay. It is a woman, seated cross-legged, and it has the proud, poignant aloofness of Chinese hieratic sculpture, and something also of the plastic stability, yet nervous calm, of an Egyptian statue.

In fact it is toward Oriental art that Matisse leans in his study of how to simplify. His simplification is not for the purpose of rendering more vividly the actuality of form; it is to secure a unity of expression in the interpretation of an abstract idea. And he is seeking for the source of the motive and the means of achieving it in primitive art, even in what in our sophistication we too hastily reject as the era of the child-man in art.

A few days ago I saw Miss Isadora Duncan in her dance interpretive of Beethoven's Seventh Symphony, which Wagner described as "An Apotheosis of the Dance." It appears that some of the musical pundits of the

press were shocked. It was a desecration of such music to associate with it so "primitive" an art as dancing; too much, I suppose, like opening a cathedral window and letting nature's freshness blow through the aisles and vaulting. It ruffles the hair of the worshippers, and disturbs the serene detachment of their reveries.

From their own standpoint, quite possibly, the pundits are right. Like so many musical folks, they have trained their ears at the expense of their eye-sight, and accustomed their brains to respond exclusively to aural impressions. Why should they sympathize with an effort to reach the imagination simultaneously through the avenues of sight and sound? So they belittled the dancer and her art.

If you have seen her dance, I wonder whether you do not agree with me that it was one of the loveliest expressions of beauty one has ever experienced. In contrast with the vastness of the Metropolitan Opera House and the bigness of the stage her figure appeared small, and distance lent it additional aloofness. The personality of the woman was lost in the impersonality of her art. The figure became a symbol of the abstract conception of rhythm and melody. The spirit of rhythm and melody by some miracle seemed to have been made visible.

A presence, distilled from the corporeality of things, it floated in, bringing with it the perfume of flowers, the breath of zephyrs, and the ripple of brooks; the sway of pine trees on hill sides, and the quiver of reeds beside woodland pools; the skimming of swallows in the clear blue, and the poise of the humming bird in a garden of lilies; the gliding of fish, and dart of fire-fly, and the footfall of deer on dewy grass; the smile of sunlight on merry beds of flowers and the soft tread of shadows over nameless graves; the purity of dawn, tremble of twilight, and the sob of moonlit waves. These and a thousand other hints of the rhythm which nature weaves about the lives and deaths of men seemed to permeate the stage. The movement of beauty that artists of all ages have dreamed of as penetrating the universe through all eternity, in a few moments of intense consciousness, seemed to be realized before one's eyes. It was a revelation of beauty so exquisite, that it brought happy, cleansing tears. Brava, Isadora!

But why should I think of her while writing about Matisse? Simply, I believe, because the musical critic thought her performance primitive and therefore beneath his notice. It *was* primitive; old as the world, and it was for that reason that I loved it. And yet toward Matisse's motive, notwithstanding that it also is an expression of primitive elemental feeling, I find myself like the musical pundit. At least, not quite; I can appreciate the motive, but not understand the interpretation of it. That may be my fault or Matisse's. I may still be too sophisticated to appreciate; too wedded to the need of scholarly drawing and the preconceived ideas of beauty; too much at the mercy of our habit of expecting to find in pictures accurate representation of the ocular impressions; not yet able to detach the spiritual

idea of abstract beauty sufficiently from the accidents of concrete appearance.

On the other hand, it may be that Matisse has too completely cut himself off from our traditions, and has not yet bridged over the wide space with methods reasonably persuasive. For the present, maybe, he is but blazing a path, that as yet he does not himself know how to coördinate with the rhythm and melody of nature.

Meanwhile, I found that after I had been with his pictures some time, they exerted a spell upon my imagination. So much so, that after I had left them I could not immediately look at " ordinary " pictures. For the time, at least, the latter seemed banal in the comparative obviousness of their suggestion.

<div align="right">Charles H. Caffin.</div>

THE HOME OF THE GOLDEN DISK

HEN, on April 30th, 1908, "The Little Galleries" turned over their original rooms, at 291 Fifth Avenue, to a tailoring establishment, a chapter was closed in the history of the Photo-Secession. For three years, under the directorship of one man, who gave his entire time to this educational work, exhibitions have been held in these rooms, which have attracted the New York public, compelled the attention of dealers, critics and art institutions, and obtained that recognition for photography as an art, for which the champions of the new movement have been striving.

Perhaps, the first time you went up the narrow elevator which took inquirers to the top floor and entered the room to your right, the director, the leading spirit, would be found in conversation with some friends or visitors. The minute you gazed into the rooms so fittingly designed, you seemed to breathe a different atmosphere. The quiet, neutral tone of the walls and of the woodwork; the softly diffused light; the happy spacing and proportions of the rooms and their furnishings; the color note of autumn foliage in the big brass bowl in the centre of the farther room; all combined to give you from the outset a feeling of harmony, balance and repose. You insensibly relaxed. You fell into a receptive mood.

Before you could phrase your inquiry as to whether you were in the right place or were addressing the proper person, you would be greeted by a slight nod of the head, and a, "You want to see the photographs? They are inside. Walk right in." Entering the rooms to your left, you found yourself confronting a set of pictures which immediately arrested your attention. You looked to the catalogue for the name of the artist; the name was unknown to you; the titles did not help you. Giving up the catalogue, you returned to some one picture which had attracted your attention more particularly; then to a second, then to a third,—and you wondered at it all. Surely these were only photographs, obtained by a mechanical process incapable of recording anything but facts, and yet they appealed to your emotions. There was atmosphere, there was feeling in them, an unexplainable something recognizable in every one,—the stamp of individuality.

Startled out of your reverie by a, "Well, what do you think of them?" you turned around and met a pair of dark eyes behind glasses, looking at you from under a mass of bushy black hair. If your answer showed any response whatever to the artist's appeal, then you had a treat before you. Conversation warmed up; you branched out into other fields, painting, etching, sculpture, music; you heard of personal experiences with casual visitors, and with friends, some encouraging, some discouraging. For half an hour, or an hour, or two hours you forgot all about New York, the rush of the subway and the struggle after the almighty dollar; and when you got back into the street, into the turmoil of everyday life, you felt that you had discovered an oasis, seemingly thousands of miles from the scorching struggle for life, where at your pleasure you could stop and refresh yourself in the peaceful

enjoyment of the beauty of life; a quiet nook in a city of conflict, where you breathed an atmosphere of mutual helpfulness and understanding.

You began to wonder also how much or how little truth there was in the rumors you had heard, that the Photo-Secession was merely an organization working in a narrow circle for the benefit of a few individuals of the photographic world. The Secessionist spirit loomed far bigger before you. The label of Photo-Secession seemed almost a misrepresentation, apparently narrowing its interest to photography,—while your talk with its director had left you under the impression that its scope spread far beyond this first field of its activity. Its fight had been first and foremost for recognition of photography among the arts, but now that this object had been attained, could it not legitimately bring to the fore new and interesting work in other arts, provided the men it championed worked in a medium which allowed personal expression?

Etching, drawing, painting, sculpture, music, seem to be its legitimate province. We are dealing, not with a society, not with an organization, as much as with a movement. The Secession is not so much a school or a following as an attitude towards life; and its motto seems to be :—" Give every man who claims to have a message for the world a chance of being heard."

Under our social system each generation is living forty years behind its time. Our laws are written by men past their sixties, and reflect the ideas which they formed when they were in their twenties. The artists now in vogue are either dead or old men. Ibsen writes :—"The younger generation is knocking at the door," and the older generation is trying to keep it closed before them. The Photo-Secession, through the " Little Galleries," has tried to help the modern tendencies to come to the front, to show the public what was being done, and not what had been done; to make people look, not to the past, but to the present and to the future; and now that the original " Little Galleries " are closed, having accomplished their purpose, the Photo-Secession is still living, and stronger than ever through the interest it has awakened widespread among the public.

It has its new gallery right across the hall from its old quarters, and under the same enthusiastic and devoted directorship, it will pursue its work without any fixed programme, for, depending on work which is yet undiscovered or possibly not even produced, it knows not what its evolution may be. It will give those of strong individual artistic personality a chance to make their appeal to the public, even though it may not feel in unison with them. It will be sufficient that the work be of the kind that makes one interested in discovering the message of the artist.

If it has led one step further towards our interest in the thoughts of our fellow-men, and towards the happiness which is to be found in love and understanding, its efforts will not have been in vain, and such a result will be sufficient reward for the man who has given so much of his time, energy and financial support, in the accomplishment of this self-appointed task.

<div style="text-align: right">Paul B. Haviland.</div>

PERSONALITY IN PHOTOGRAPHY—
WITH A WORD ON COLOR

HE unwise, those who refuse to learn from the study of exhibited work, and who are unable to learn by practical experience, say that though photography may have its art aspects and value, yet it can never hope to attain to a very high place, as its sense of personality, its obedience to individuality, is so limited. Give half a dozen men the same camera, lenses and plates, and send them to the same place to do the same thing, and all the results will be alike, or so nearly alike as to reveal the real mechanicalness of photography. Yet, curiously enough, this is just one of the most difficult things a photographer can be set to do, to exactly repeat himself, or another. He may use the identical apparatus, know the subject perfectly, and yet be totally unable to bring away an exact replica.

Years ago I had the honor of having some architectural studies reproduced in this magazine, and to one of them I gave the title "Height and Light in Bourges Cathedral." Since then I have been able to repeat the subject in a larger size (4 x 5), but it came with a totally different effect of lighting; and this year I was able to repeat it once more, still larger, in 8 x 10 size; and as I was fully content with the light effect in my 4 x 5, I tried hard to get that rendering again. But the increase in size of apparatus and focus of lens made the position of camera so different as to prevent an exact repeating of the composition, the narrowness of the aisle was such as to compel the camera's distance from the subject to give a different composition.

The light also proved baffling; the two previous efforts had been made, as was this, in full summer, with a continuous blaze of sun; but the direction of the sun's rays from the different month, or week, or day, made a repetition of the previous light effect quite impossible, though it was studied and watched for at all hours. One version is not inferior to another, but it was interesting to find how impossible it was to repeat the former effect even by the same worker.

Critics, of the vague sort referred to, also deny the sense of creation to photography, limiting it, even at its best, to the achieving of a mere record. But set two men to record, say, a Rodin sculpture, or a cathedral grotesque; the mechanically minded man will only see and produce a lifeless result, a mere empty record; the artist, the trained observer, will study his subject till he sees the one point of view at which the vital essence of the sculpture is revealed in its fullest degree; one will be a dull, dead, uninteresting copy, the other as welcome and stimulating in its way as the original is in its, with its fullest characteristic or vitality made manifest.

That the recording factor is an instrument, a machine, if you will, no more compels mechanicalness than a piano makes a Beethoven sonata mechanical because it is only audible through its agency; it is neither the piano or the camera that really matters, it is what is done by them.

It is here also that the wonderful new color methods will prove so exhilarating and successful or so disastrously disappointing. So few are artists in color; the love of the reticent, refined, and pure in color is so rare among us. And the fact that photographers have been, necessarily, training themselves in black-and-white and all its subtleties, and therefore neglecting the study of color, may compel most of them to very dreadful failures; and failure in this color direction will be more painful than failure in black-and-white. The sense of values in color is a rare one, even among painters, with whom it is a daily professional study; it is but rarely we can say, so-and-so is a great colorist.

The photographer who aims at this color work must study his methods afresh from the beginning, it is a new education he needs on quite different lines.

The rules for exposure will need readjusting and formulating; it is one thing to expose for color with a view to an all-round successful translation into monochrome, and quite another thing to render in color the pure color values of nature. I forsee endless difficulties and failures, but the failures will only make the successes the more entrancing; though, alas! to those who are imperfect in their color sense and training, the sense of failure will not be apparent; what they get will be so novel and exciting as to make it difficult to regard it with cold criticality. But to the lover of pure color the difficulties will be only so many incitements towards the achievement of perfection.

And if we can hope to go as far with it as photography already has gone in black-and-white, what a " feast of fat thing " may be looked for!

<div align="right">Frederick H. Evans.</div>

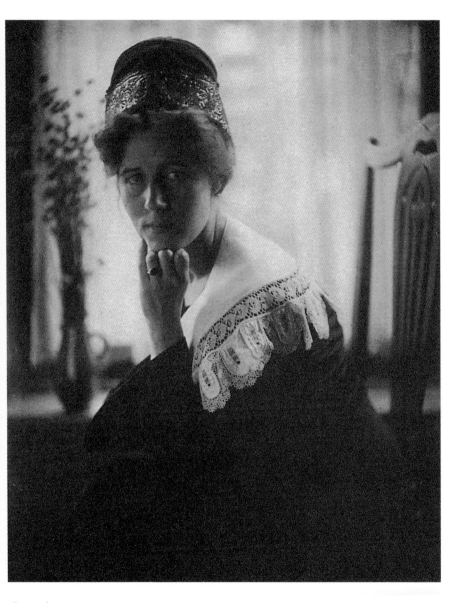

Alice Boughton
Danish Girl, 1909
Photogravure
20 x 16 cm

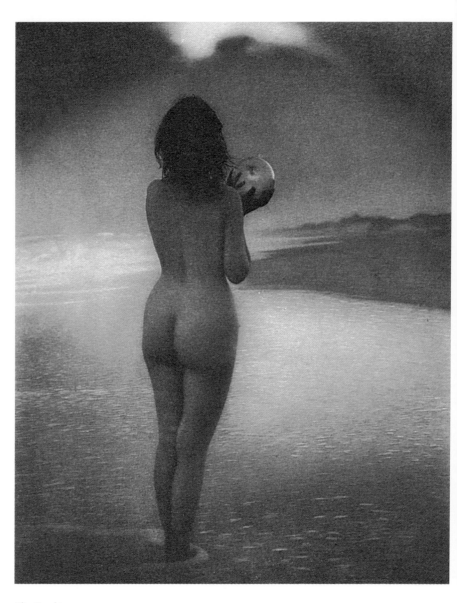

Alice Boughton
Dawn, 1909
Photogravure
19.5 x 15.5 cm

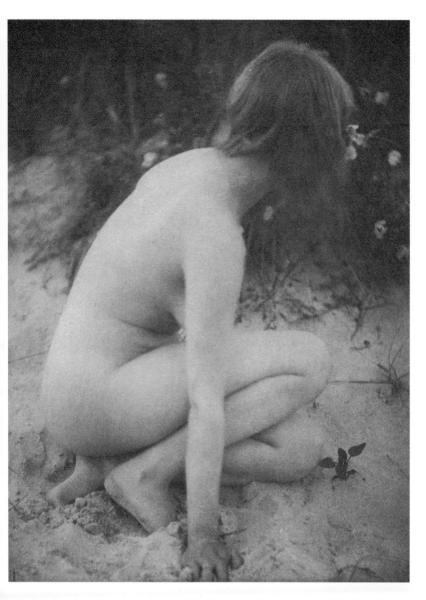

Alice Boughton
Sand and Wild Roses, 1909
Photogravure
21 x 15.7 cm

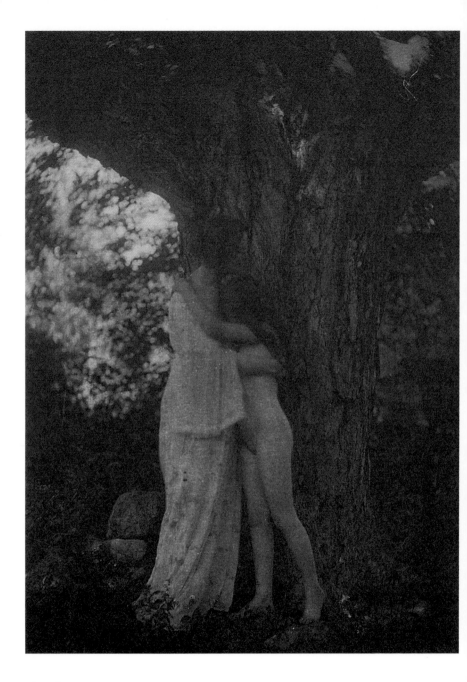

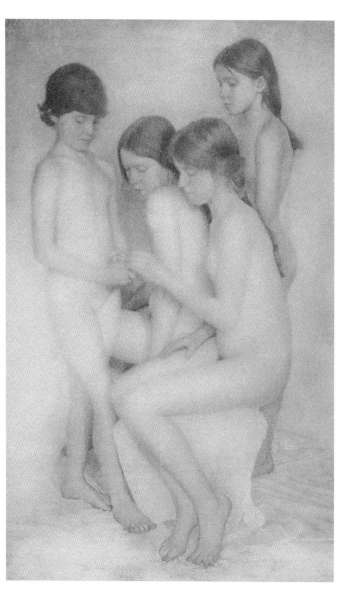

Alice Boughton
Nude, 1909
Photogravure
21.9 x 13.3 cm

← Alice Boughton
Nature, 1909
Photogravure
22 x 16 cm

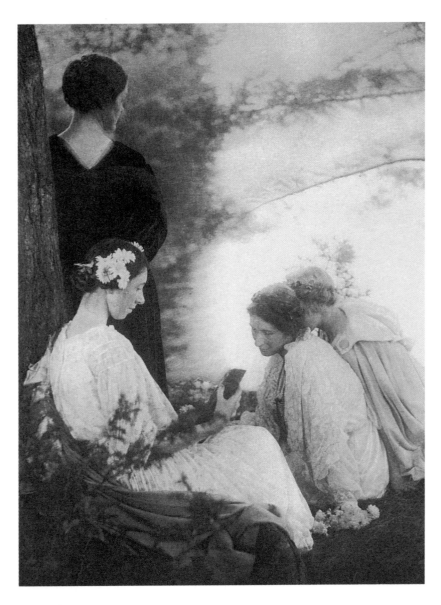

Alice Boughton
The Seasons, 1909
Photogravure
20.8 x 15.6 cm

J. Craig Annan
Ex Libris, 1909
Photogravure
19.6 x 14 cm

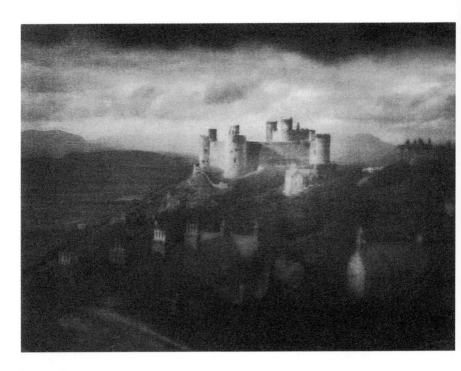

George Davison
Harlech Castle, 1909
Photogravure
15.5 x 21.1 cm

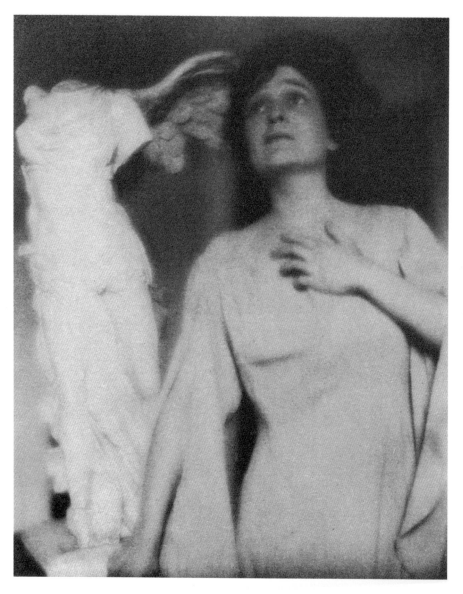

Herbert G. French
Winged Victory, 1909
Photogravure
19.6 x 16 cm

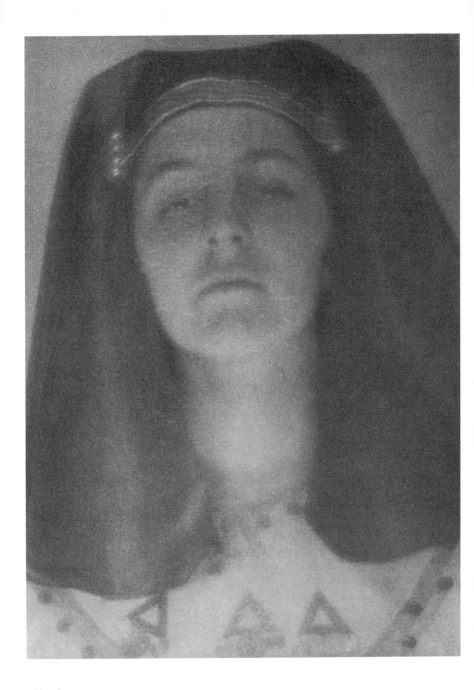

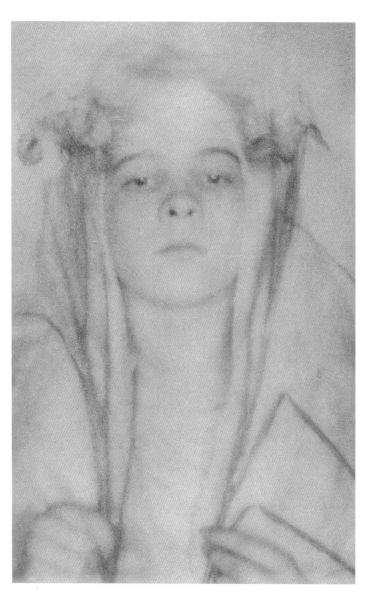

Herbert G. French
Iris, 1909
Photogravure
23.5 x 15 cm

← Herbert G. French
Egyptian Princess, 1909
Photogravure
21.5 x 16 cm

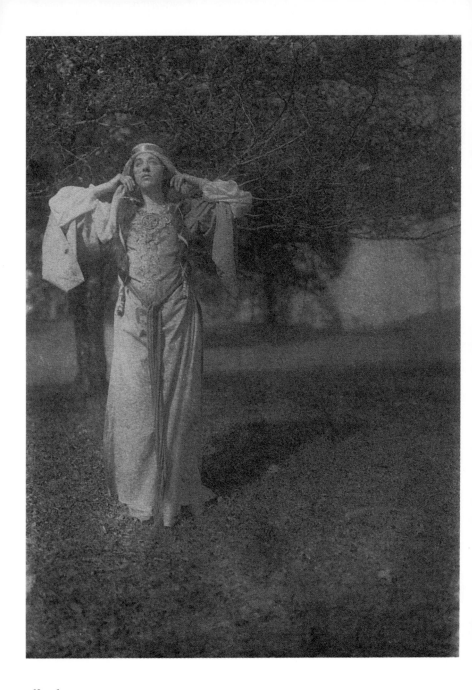

Herbert G. French
Illustration, No. 22, 1909
Photogravure
17.2 x 9.7 cm

← Herbert G. French
Illustration, No. 18, 1909
Photogravure
21.2 x 15.2 cm

Clarence H. White and Alfred Stieglitz
Experiment 27, 1909
Photogravure
20.5 x 15.9 cm

Clarence H. White and Alfred Stieglitz
Experiment 28, 1909
Photogravure
20.5 x 15.8 cm

Clarence H. White and Alfred Stieglitz
Miss Mabel C., 1909
Photogravure
22.6 x 15.8 cm

Clarence H. White and Alfred Stieglitz
Torso, 1909
Photogravure
21.3 x 16.1 cm

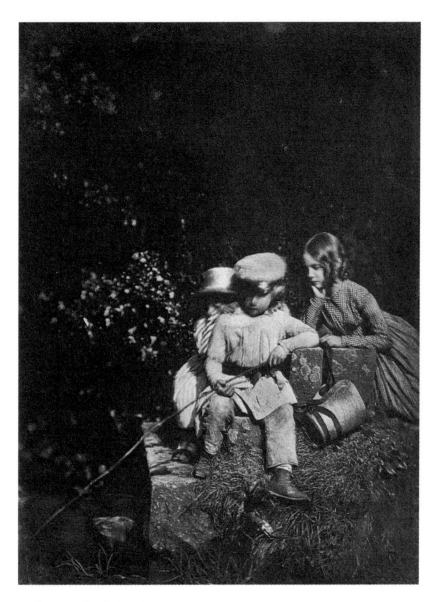

David Octavius Hill (and Robert Adamson)
The Minnow Pool, 1909
Photogravure
21 x 15.8 cm

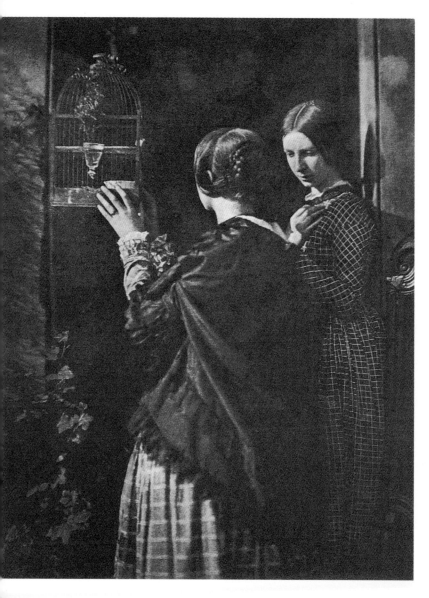

David Octavius Hill (and Robert Adamson)
The Bird-Cage, 1909
Photogravure
20.7 x 15.9 cm

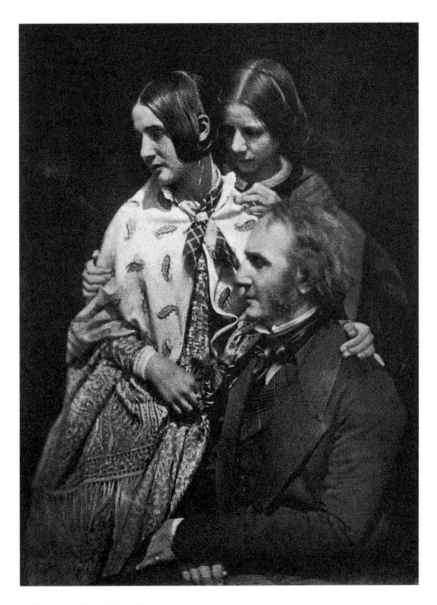

David Octavius Hill (and Robert Adamson)
Portraits – A Group, 1909
Photogravure
21.2 x 15.8 cm

David Octavius Hill (and Robert Adamson)
Portrait – The Gown and the Casket, 1909
Photogravure
20.6 x 14.5 cm

David Octavius Hill (and Robert Adamson)
Newhaven Fisheries, 1909
Photogravure
13.9 x 19.3 cm

← David Octavius Hill (and Robert Adamson)
Mrs. Rigby, 1909
Photogravure
21.1 x 14.9 cm

George Davison
Houses near Aix-les-Bains, 1909
Photogravure
15.2 x 19.4 cm

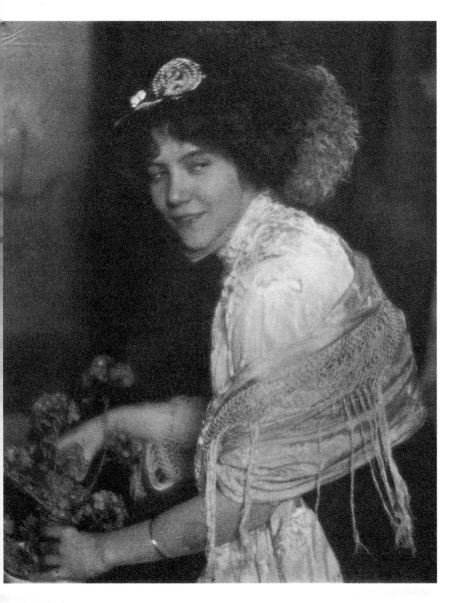

Paul B. Haviland
Portrait – Miss G. G., 1909
Photogravure
19.4 x 15.9 cm

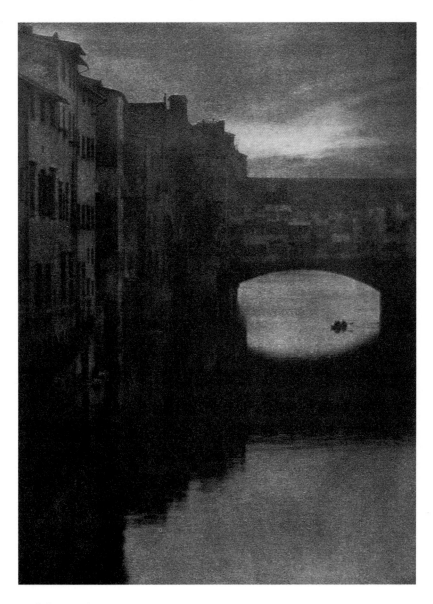

Marshall R. Kernochan
Ponte Vecchio – Florence, 1909
Photogravure
21.6 x 16 cm

Alvin Langdon Coburn
On the Embankment, 1909
Photogravure
21.5 x 15.7 cm

PRINTS BY EDUARD J. STEICHEN —
OF RODIN'S "BALZAC"

IT happened one night between moonrise and sunrise, on the hill at Meudon near to Rodin's studio. The spot, if you know it, may already have seemed to you to be haunted. As you explore the paths that wind amid shrubbery beneath the trees and open out occasionally into a little sanctum, enclosed with greenery, you come upon relics of the life of the past. Here it may be a fragment, chiseled by some early sculptor of Florence; there, the torso of a Venus, modeled by some Athenian whose zest of life had been stimulated by the pungency and penetration of Menander's comedies. Even by daylight a certain intoxication hangs about the spot; while in the silence of the night, it seems pervaded with the spiritual presence of the past.

Perhaps you have been in Rodin's studio, and the passion and the power congealed into an unearthly repose in the work of the living sculptor, have fired your imagination until it is the so-called unreal that seems to you the most real. You step into the garden, and its very obscurity makes the things of spirit seem more clear; its silence renders audible the footfall of incorporeal presences: the shadow seems to be the substance. Is it only fancy? I doubt it. Let us but believe that all matter is permeated with spirit, and there need be no surprise, if spirit sometimes disengages itself from its temporary local shell and walks unhampered. Nor that our own, in rare moments of enlightenment, may meet it. Something of this sort happened that night on the hill at Meudon.

As a prelude to the story, let me remind you of what the world has been trying to forget. It has to do with Balzac and Rodin and with French Officialdom. You recall that the curtain had been rung down on the final act of

La Comédie Humaine fifty years before the occupants of the Academic fauteuils woke up to applaud. Half a century had elapsed since the great protagonist of realism passed for the last time behind the scenes. Surely it might be safe for official France to recognise his greatness; and in what safer way than by the non-committal expedient of a statue? But by whom? Let logic decide. Certainly it were fitting that the most dominant personality in modern literature should be commemorated by the most original and commanding of modern sculptors. Without doubt, Rodin was the man.

Ye gods and little fishes! But here was matter for another act in the inexhaustible repertory of *La Comédie Humaine!* Officialdom coquetting with the man whom it had studiously ignored; standardised convention seeking to consort with the contradiction of all that Officialdom stands for! Truly, the French are a nation of comedians! Or did Officialdom suppose that, because it was paying the piper, it could call the tune? Anyhow, we know the sequel.

What was expected to be an innocuously refined drama, as unobtrusively appropriate to the Foyer of the Théatre Français as to some square or garden, where it need not incommode the nurserymaids, turned out to be, as the world viewed it, a burlesque. Was the jest intentional on the sculptor's part? Did he mean to scandalise Officialdom, even at the expense of his own reputation? to doff the seriousness of the artist and don the motley of the clown, to fool the public? This was, on the whole, the public's notion: a comfortable one, since it is a nuisance anyhow to have to take an artist seriously, and accordingly to find that he does not take himself so is reassuring. Yes, Rodin was clearly fooling. And if on this occasion, why not on others? The fellow, in fact, was what most sane people had long ago suspected—an arrant charlatan; and his admirers, a flock of gullible and cackling geese. Ah! how their necks ached with straining to discover the merits of this Balzac! Of course they rubbed their silly heads together, and raised a clatter of adulation, but it was more suppressed than usual, intermittent and quavering. They were, in fact, a considerably discomfited flock.

Meanwhile, the statue had been rejected with much gnashing of Official tusks and Academic anathema, while the Crowd stood by and jeered. Perhaps it was the sculptor's proudest moment. Who knows? At any rate, nothing abashed, he set it up in the boutique that he had erected outside the gates of the International Exposition, and invited the cognoscenti of all the earth to come and see this New Thing. They came and went, bewildered. Then Rodin removed this offense to his big studio on the hill at Meudon, and gradually the excitement died down. The Balzac passed to the limbo of things rejected and, for a time, forgotten.

Behold, however, a marvel! One night, between moonrise and sunrise, while the world slept, silently and upon a sudden, the Spirit stirred in its plaster shell. With the expansion of its breath It was free of its material incumbrances, and stood forth in the moonlight on the studio floor, pure spirit. Then, with a sound as of the night air among the rushes by a pool, it passed out into the night; faintly stirring in its passage the leaves of a Japanese picture-book,

wherein were curious revelations of *La Comédie Humaine* as interpreted by the Oriental mind.

The Spirit is outside in the moonlight and the night. For a moment, in the exultation of its disembodied liberty, It halts beside the trees; the branches forming an interlace of blackness around the illumined head. For the moonlight is full upon the proud head: lambent on its lion's mane of hair, on the smooth high forehead, the arched nostrils and curling upper lip. Only the eyes are plunged in the depths of introspective mystery. Robed in shadow also is the form; rearing up like the swell of a wave, luminous upon the arch of its breast.

But the Spirit has moved and is now upon the summit of the hill, fronting the spiritual immensity of the sky. Paris and the world beyond are once again at its feet. Slumbering below is the breed of mortals, whom so often It had waked to a consiousness of life. But the Spirit's thought is not of them; not of the gnats on the stream of mortality; not of the fire-flies, tangled in fashion's maze; nor of the common fly that basks now on the beauty of a girl's cheek and now battens on the carrion thrust into the street. These are but ephemera; and the Spirit has passed beyond the concerns of a day, be it a day of fifty years as its own had been. Those hot days of the flesh are past; past too the cold clear consciousness of the intellect, the throes of creative insight and the throb of triumph at success achieved. These were but the accidents of fleeting moments; and the Spirit has passed into the permanence of Eternity, into the immensity of the Universal Force. It is toward the symbol of the Universal and the Eternal immensity, the moon-illumined sky, that the Spirit's gaze is turned.

As the moon pursues her path through space, the presence of the Spirit changes. Now It looms a darkened mass against the ocean of light, motionless on the edge of its ebb and tide; one foot advanced, like that of a strong swimmer about to plunge into the deep. Now the mass glows faintly phosphorescent, as the pale light of dawn comes slowly up to mingle with the moonlight. Midway the Spirit stands at the meeting place, where the half light that envelopes the darkness of our night feels the first embrace of the larger, fuller light that comes with the day of the Hereafter.

While the world below still slumbers, turning fitfully in its dreams and reaching out a hand to feel sure that what it loves is near, the Spirit, wrapt in the shadow of its own imperturbable calm, which is the calm of the Universe, stands fronting the coming of the larger light. One foot advanced, the head flung back, the shoulders squared, It stands, as an eagle on a mountain peak about to unfurl its wings for a leap into the liberty of boundless light.

Dawn has glinted on the studio roof. Broad day follows and the sculptor resumes his work. He looks a moment at the Balzac. "Will they ever," he murmurs, "understand my meaning?" And he laughs a little as one who can afford to wait.

<div style="text-align: right">Charles H. Caffin.</div>

LONDON

By
ALVIN LANGDON COBURN

With an Introduction by
HILAIRE BELLOC

Folio Boards. $6.00 net.

¶ This collection of photographs of London has been in preparation by Mr. Coburn for the past five years but technically they represent the latest development · of his art.

Mr. Coburn is a master of photographic printing. The photogravure plates in this volume are made by Mr. Coburn himself and printed by him. The pictures are marvels of impressionism. Mr. Coburn, like Whistler, looks at London imaginatively, and he has compelled his camera to give what he has seen in the London he photographed. It is London seen by the imagination of Mr. Coburn. That is the astonishing achievement here realized. If photography is to be an art, this book is certainly the art's finest expression.

Brentano's : Fifth Ave. & 27th St. : New York

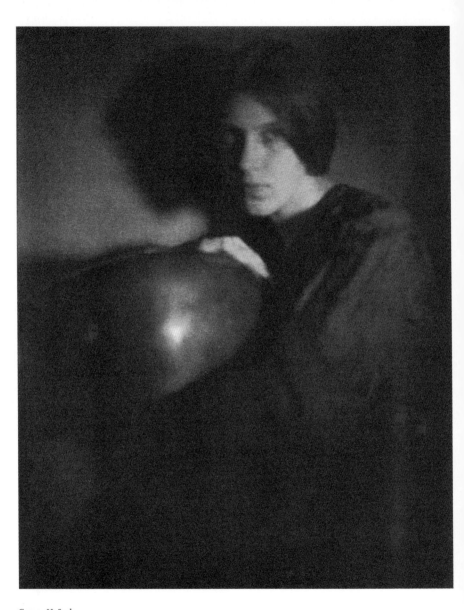

George H. Seeley
Girl with Bowl, 1910
Photogravure
20.1 x 16.1 cm

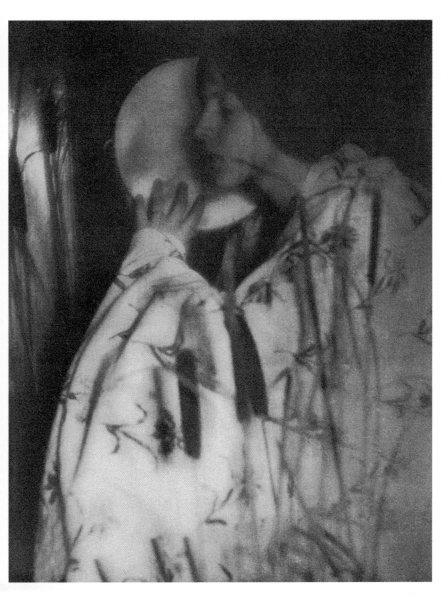

George H. Seeley
Autumn, 1910
Photogravure
20.4 x 16 cm

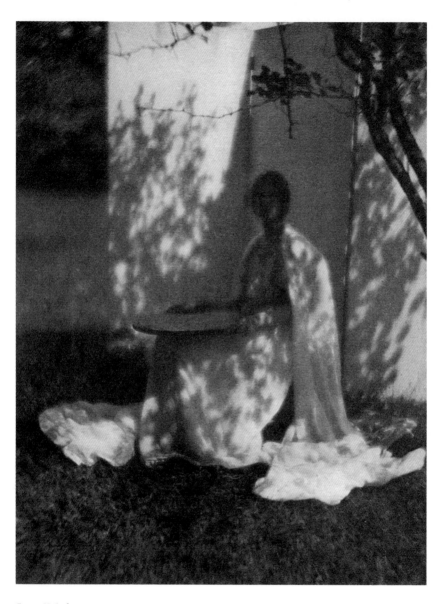

George H. Seeley
The White Screen, 1910
Photogravure
20.8 x 15.9 cm

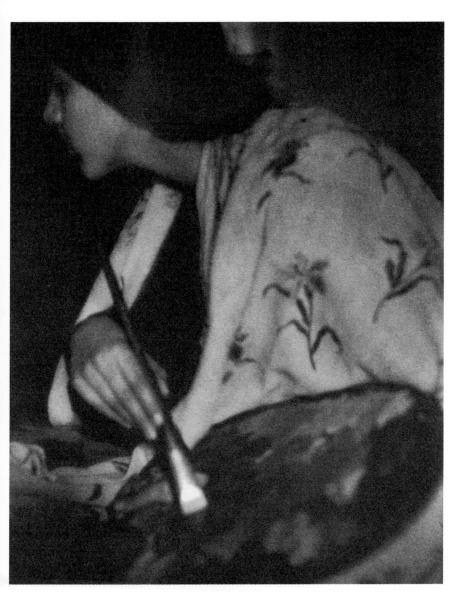

George H. Seeley
The Artist, 1910
Photogravure
20.1 x 15.8 cm

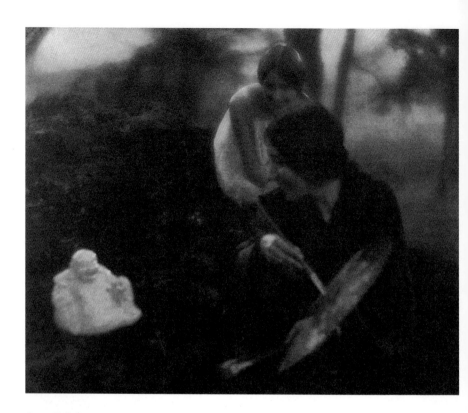

George H. Seeley
Conspiracy, 1910
Photogravure
15.6 x 19.4 cm

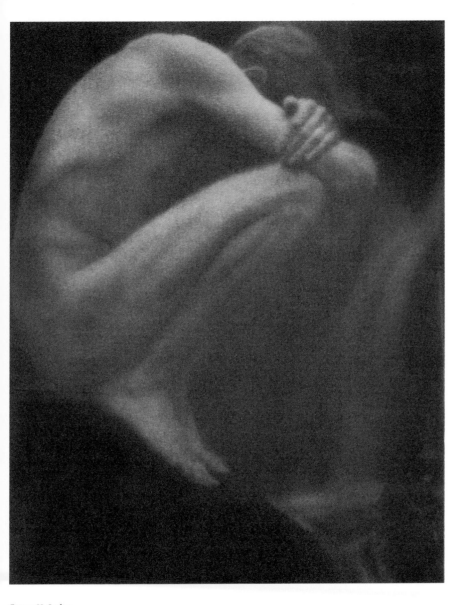

George H. Seeley
Nude – The Pool, 1910
Photogravure
20.1 x 16.1 cm

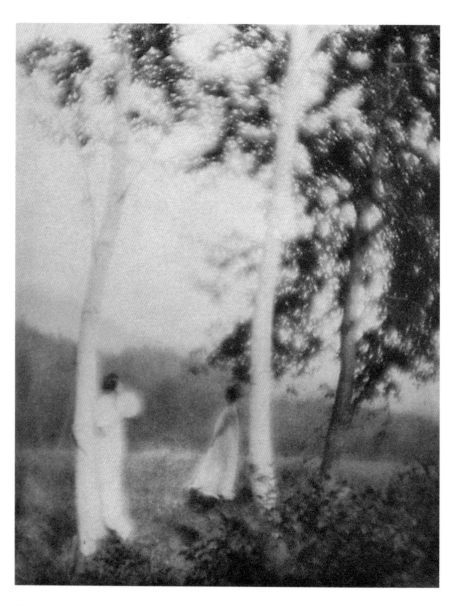

George H. Seeley
White Trees, 1910
Photogravure
19.9 x 15.6 cm

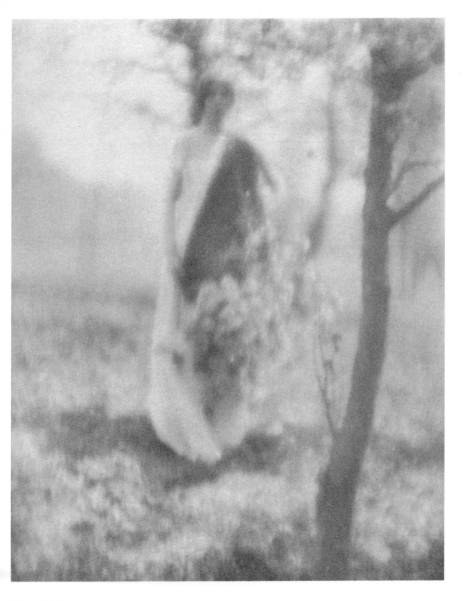

George H. Seeley
Spring, 1910
Photogravure
19.7 x 15.7 cm

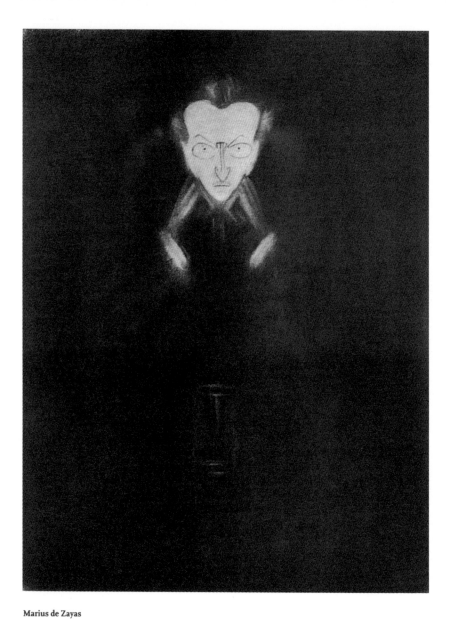

Marius de Zayas
Benjamin de Casseres, 1910
Photogravure
20.3 x 16 cm

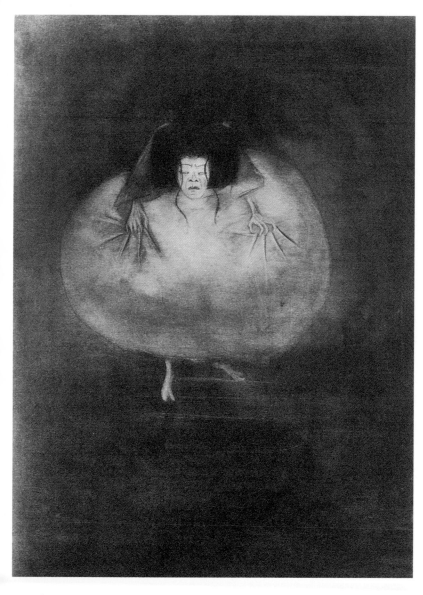

Marius de Zayas
Madame Hanako, 1910
Photogravure
21.1 x 16 cm

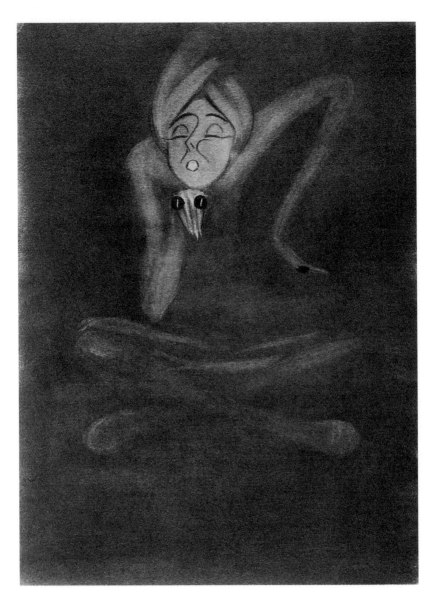

Marius de Zayas
Ruth St. Denis, 1910
Photogravure
21.8 x 16.3 cm

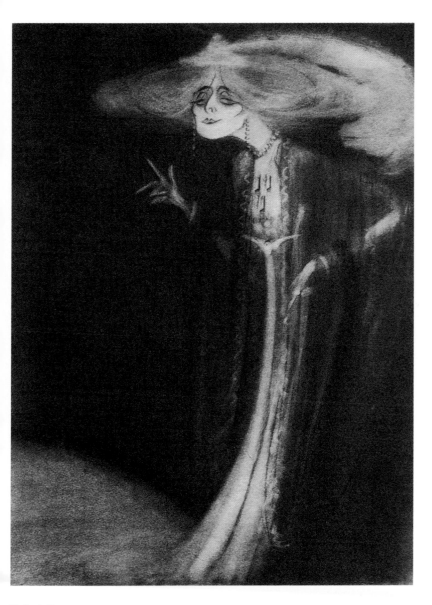

Marius de Zayas
Mrs. Brown Potter, 1910
Photogravure
20.4 x 15.8 cm

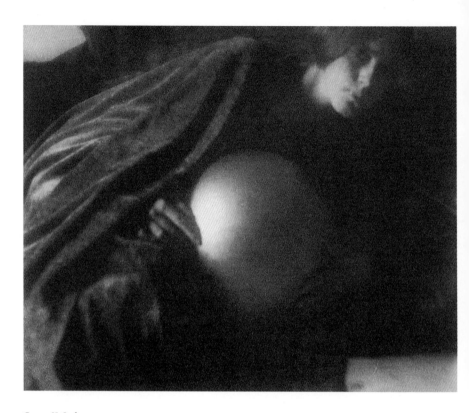

George H. Seeley
No. 347, 1910
Photogravure
14.2 x 17.7 cm

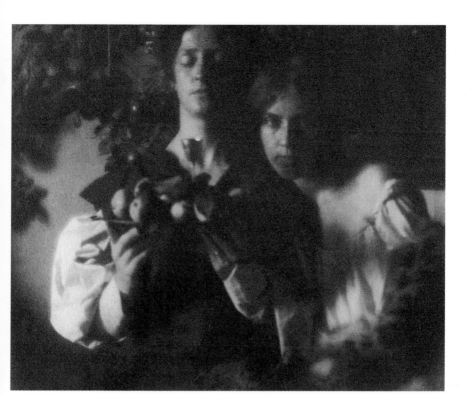

George H. Seeley
No. 356, 1910
Photogravure
14.3 x 17.7 cm

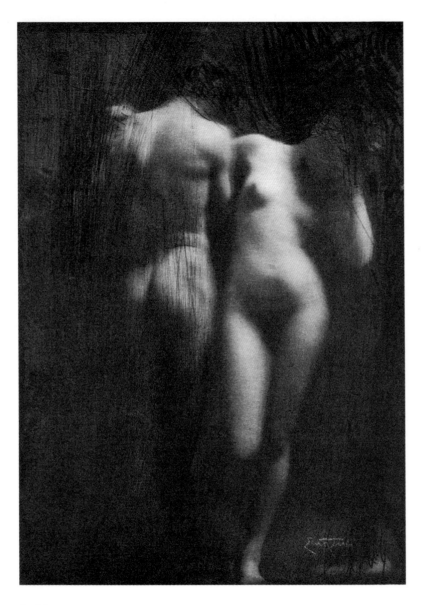

Frank Eugene
Adam and Eve , 1910
Photogravure
17.7 x 12.7 cm

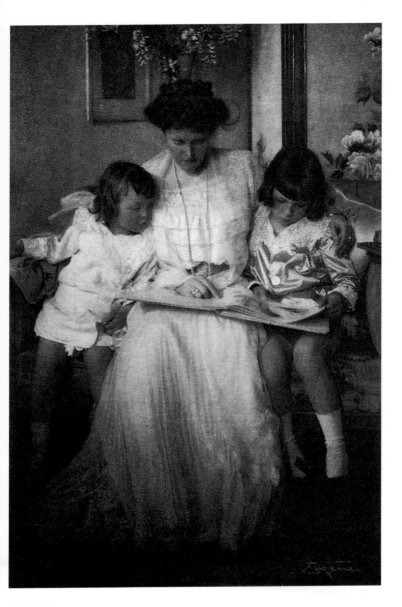

Frank Eugene
Princess Rupprecht and Her Children, 1910
Photogravure
17.6 x 12 cm

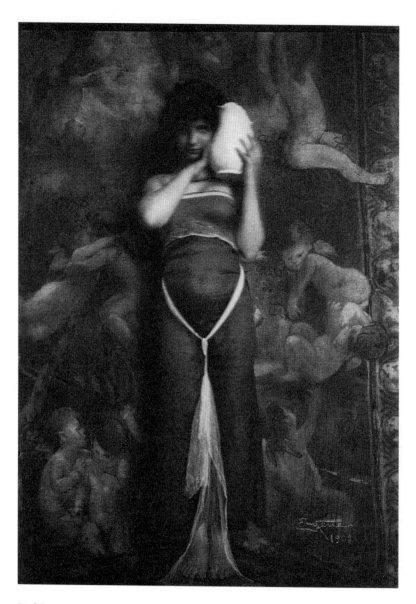

Frank Eugene
Rebecca, 1910
Photogravure
17 x 12.2 cm

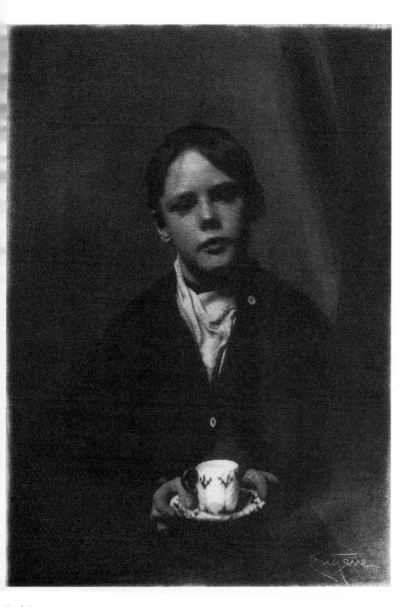

Frank Eugene
Master Frank Jefferson, 1910
Photogravure
17.2 x 12.6 cm

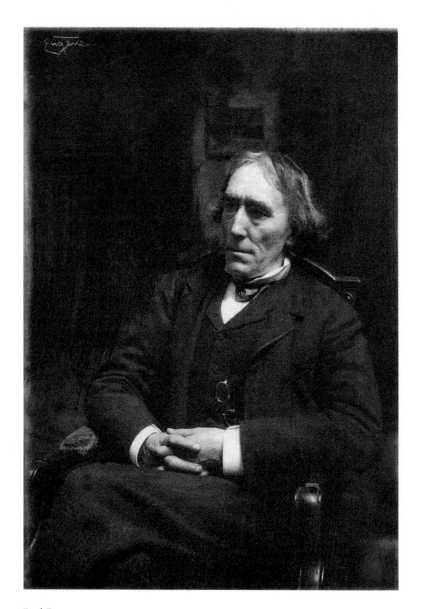

Frank Eugene
Sir Henry Irving, 1910
Photogravure
17.5 x 12.5 cm

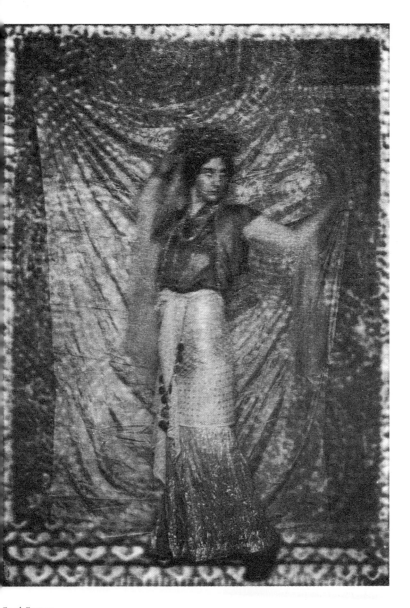

Frank Eugene
Mosaic, 1910
Photogravure
18.8 x 13.9 cm

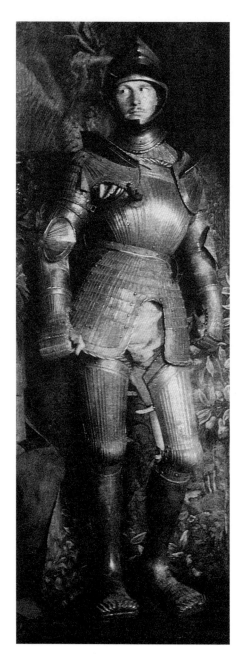

Frank Eugene
Man In Armor, 1910
Photogravure
17.2 x 6.3 cm

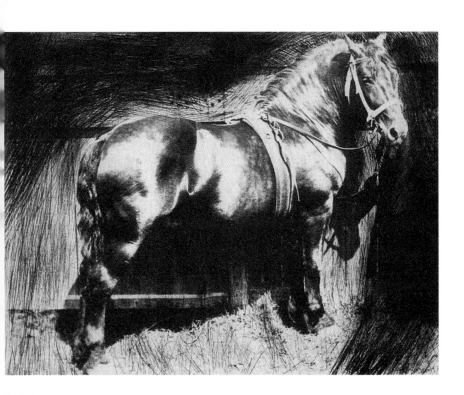

Frank Eugene
Horse, 1910
Photogravure
8.8 x 11.6 cm

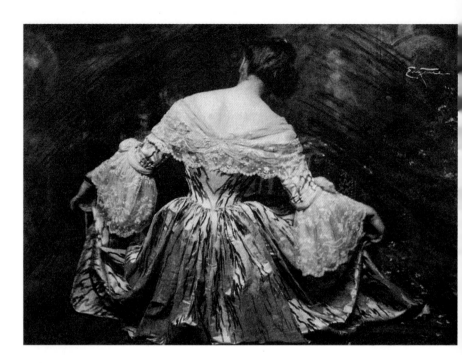

Frank Eugene
Minuet, 1910
Photogravure
12.3 x 17.6 cm

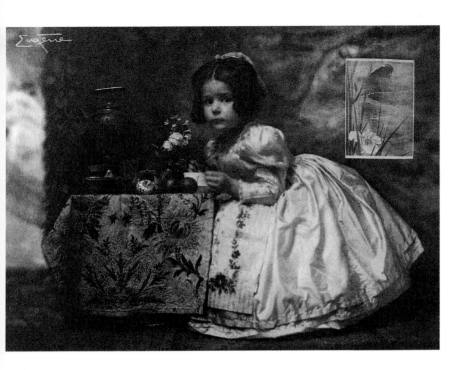

Frank Eugene
Brigitta, 1910
Photogravure
11.9 x 16.9 cm

QUALITY IN PRINTS

THE field of recognized media of personal expression in art has been enlarged in recent years with the advent of pictorial photography. As had been the case with etchers, when they had to fight for recognition of their craft among the fine arts, and by the name of painter-etchers had to distinguish themselves from those of their confrères who used the medium simply as a process of reproduction, before they were allowed to exhibit their work side by side with the painters, so did the photographers of the new school have to contend with the prejudice which attached to a tool heretofore imperfectly understood and the possibilities of which had only been dimly apprehended.

But the fight is won and it is not our purpose to discuss the merits of the case. The pictorial possibilities of photography having been recognized, patrons appeared, anxious to secure some of the best examples of the art. Here a new surprise awaited those who examined prints critically before purchasing—the rarity of good prints. Many were the prints which showed artistic feeling and knowledge, where linear composition, grouping, spotting and chiroscuro were faultless, and yet the prints did not fully satisfy. They did not produce the sensuous pleasure due to that subtle and evasive combination of merits named "quality." Two prints from the same negative may produce an entirely different impression on us. One may please us, the other leave us indifferent, and the only explanation we can give is that one has "quality," while the other lacks it.

Quality in prints is rare because it is due to two elements, one born of knowledge, the other of chance. No man who does not possess an absolute command over the technique of the process will produce a print capable of giving us the delicate pleasure created by a fine thought perfectly expressed. No man, no matter how great a master of his craft he may be, is ever certain of exactly duplicating a print, no more than Whistler could have printed two pulls from the same plate where minor differences did not exist, and where out of an edition of twenty-five prints, or whatever number the plate would yield, one print could not be pronounced superior to all the others. It is no more true of photographs than it is of etchings that one print is as good as another. You have only to look through the portfolios of any of the leading photographers to become convinced of the fact. You will be surprised to see how wide the differences may be.

The making of the negative is of course the first step, and you must first get in your negative what you want it to yield in your print. But the negative is only a means to an end and, to be frank, the easiest part of the process. Good negatives are abundant, good prints are scarce. The final result is dependent on a multiplicity of factors, such as the texture of the paper, the nature of the coating, its age, the composition and temperature of the developing bath, length of exposure, quality of the printing light, the condition of the atmosphere, local manipulations,—many of these factors being beyond the control of the photographer.

But while some of the elements which make the print a success or a failure escape human control, the majority of the conditions which shape the final results are sufficiently within the photographer's grasp to enable him to attain under favorable circumstances whatever he wishes to express, or at least to approach it without feeling handicapped by his medium any more than a worker in oil or water-color. For every worker must figure with the possibilities of his tools, and it is necessary for him to study the points of superiority and the limitations of his medium.

So much of the result depends on the photographer's control that if he goes back to one of his old negatives after his freshness of vision is gone, or his natural evolution has modified his point of view, he will not be able to duplicate his former work. Choice photographic prints follow the universal law that things of beauty are scarce, for they are rarer in fact than fine etchings or even paintings. Painters have often painted several replicas of their successful canvases. Böcklin has painted seven of "The Isle of Death." Chardin has frequently painted six or seven replicas of the same subject, and there are others amongst the famous painters who did likewise. In etchings the usual "edition" comprises twenty-five to fifty pulls from the same plate. Many photographs, such as Steichen's gum prints of "Lenbach," "Le Penseur," "The Little Round Mirror," "In Memoriam," are unique prints, and this worker has decided not to print more than six prints from any of his negatives. The instances are few where this number has been exceeded by any worker, and they are numerous where no more than two or three prints from a negative are, or ever shall be, in existence. In Eugene's case most of his beautiful Japan paper proofs exist but in one example.

On the day when art lovers and collectors understand that fine photographic prints are as scarce as pulls from Whistler's rarest plates and a source of as keen an artistic enjoyment, a few more collectors will be added to the ranks of those who guard these rare examples jealously. Competition will become keener for the possession of unusual prints as they appear in the market, and the auction rooms shall witness royal battles where the best prints of some of the foremost pictorialists shall be disputed with as much fire as the choicest Meryons, Whistlers or Seymour Hadens.

PAUL B. HAVILAND.

OUR ILLUSTRATIONS

OUR illustrations include ten examples of prints by Frank Eugene, of New York and Munich, which will be supplemented in the next issue by about fourteen others. Taken together, they will present a very fair resumé of the photographic work of this artist whose career involves some particulars of exceptional interest. For, while Eugene is one of the pioneers of pictorial photography, having been working in the medium for some twenty-five years, he has kept aloof from the personalities and politics in which most other photographers have at one time or another found themselves entangled. Except for occasional visits to America, he has for many years resided in Munich. In that chief center of German art he studied and won recognition as a painter, meanwhile turning to photography as a recreation. Although fascinated by its possibilities, he did not at first practise it with a view to developing its technical resources, but rather in a spirit of independent experiment. Thus, at first, he attained elimination of detail by the arbitrary short-cut of etching the negative. Meanwhile, he was the first to use platinumized Japanese tissue for printing, and some of his prints in this genre are among the most beautiful that have been produced in photography. Then came an occasion which changed the course of his artistic career. He was invited by some of the artists of Munich to give an exhibition of his photographs in the Künstler-Verein. The impression which it created was so favorable that the Bavarian State Institution of Photography and the Reproductive Processes established a Chair of Pictorial Photography and prevailed upon Eugene to occupy it. From that time onward painting has become his secondary interest. Munich, while still regarding him as one of her artists, now recognizes him as professionally a photographer. A few of his prints have appeared from time to time in CAMERA WORK; but an extended survey has been impossible hitherto, through Eugene's unwillingness to take the risk of sending his negatives to America. Last summer, however, the editor being in Munich, he was able to overcome the objection, through the coöperation of his old friend, Mr. Goetz. This gentleman, an American, one of the originators of the three-color process in this country, is now at the head of the famous house of F. Bruckmann Verlag, of Munich, which, in addition to its comprehensive half-tone and color works, has an extensive photogravure plant. Mr. Goetz arranged to reproduce Eugene's prints under the latter's own supervision. The results are forthcoming in the present number, to be succeeded, as we have said, by fourteen more in the following issue. Thus, for the first time, the photographic work of this American artist can be adequately studied in reproduction. The Eugene pictures and the quality of the Bruckmann gravures speak for themselves.

Camera Work

**THE MAGAZINE WITH-
OUT AN "IF"—FEARLESS—
INDEPENDENT—WITH-
OUT FAVOR** □ □ □

BY MARIUS DE ZAYAS

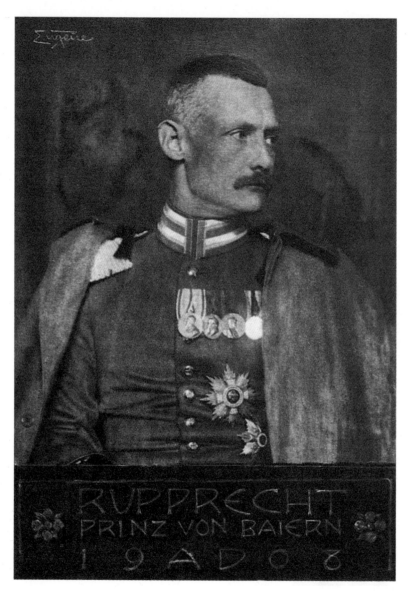

Frank Eugene
H. R. H. Rupprecht, Prince of Bavaria, 1910
Photogravure
23.4 x 16.5 cm

Frank Eugene
Fritz v. Uhde, 1910
Photogravure
17.7 x 12.5 cm

Frank Eugene
Prof. Adolf Hengeler, 1910
Photogravure
16.9 x 12.3 cm

Frank Eugene
Prof . Franz v. Stuck, 1910
Photogravure
17.1 x 12 cm

Frank Eugene
Willi Geiger, 1910
Photogravure
17.6 x 12.7 cm

Frank Eugene
Prof. Adolf v. Seitz, 1910
Photogravure
16.7 x 12.1 cm

Frank Eugene
Dr. Georg Hirth, 1910
Photogravure
17.1 x 12.1 cm

Frank Eugene
Dr. Emanuel Lasker and his Brother, 1910
Photogravure
17.6 x 12.5 cm

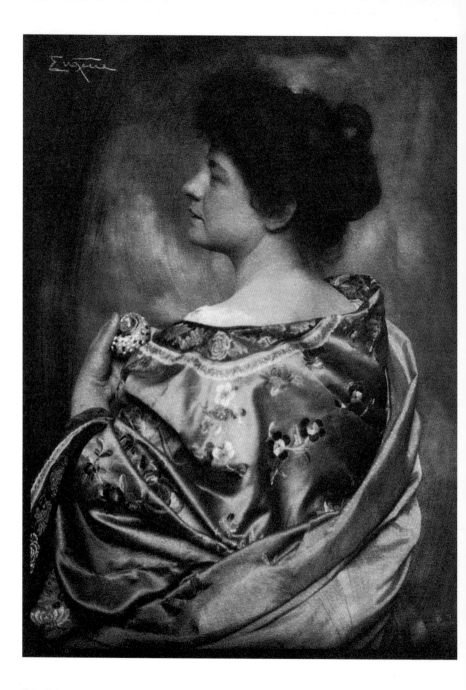

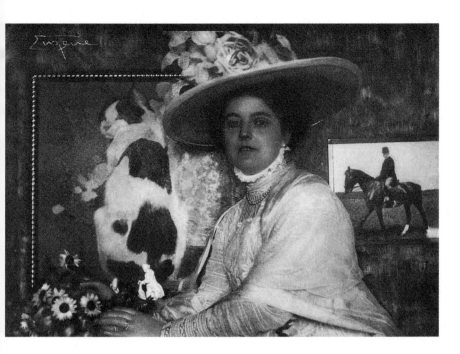

Frank Eugene
Frau Ludwig von Hohlwein, 1910
Photogravure
12.3 x 17.6 cm

← **Frank Eugene**
Kimono – Frl. v. S., 1910
Photogravure
17.4 x 12.5 cm

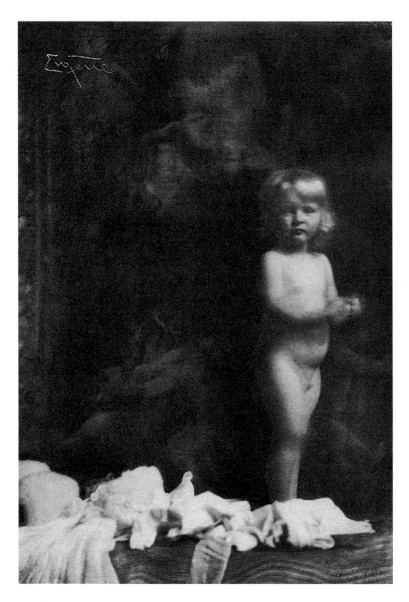

Frank Eugene
Nude – A Child, 1910
Photogravure
17.1 x 12 cm

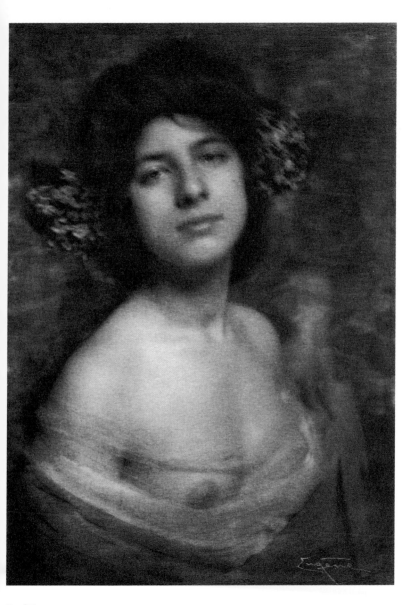

Frank Eugene
"Hortensia", 1910
Photogravure
17.5 x 12.5 cm

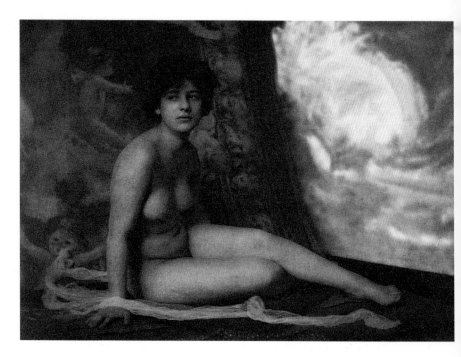

Frank Eugene
Nude – A Study, 1910
Photogravure
12 x 16.9 cm

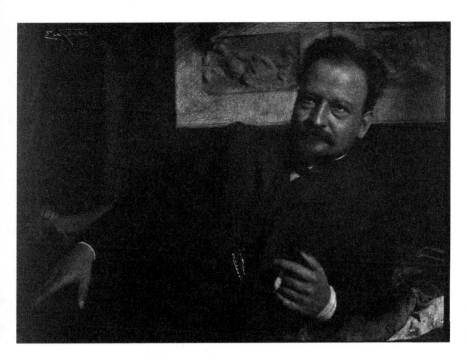

Frank Eugene
Direktor F. Goetz, 1910
Photogravure
12.6 x 17.6 cm

THE FOURTH DIMENSION FROM
A PLASTIC POINT OF VIEW

IN plastic art, I believe, there is a fourth dimension which may be described as the consciousness of a great and overwhelming sense of space-magnitude in all directions at one time, and is brought into existence through the three known measurements. It is not a physical entity or a mathematical hypothesis, nor an optical illusion. It is real, and can be perceived and felt. It exists outside and in the presence of objects, and is the space that envelops a tree, a tower, a mountain, or any solid; or the intervals between objects or volumes of matter if receptively beheld. It is somewhat similar to color and depth in musical sounds. It arouses imagination and stirs emotion. It is the immensity of all things. It is the ideal measurement, and is therefore as great as the ideal, perceptive or imaginative faculties of the creator, architect, sculptor, or painter.

Two objects may be of like measurements, yet not appear to be of the same size, not because of some optical illusion, but because of a greater or lesser perception of this so-called fourth dimension, the dimension of infinity. Archaic and the best of Assyrian, Egyptian, or Greek sculpture, as well as paintings by El Greco and Cézanne and other masters, are splendid examples of plastic art possessing this rare quality. A Tanagra, Egyptian, or Congo statuette often gives the impression of a colossal statue, while a poor, mediocre piece of sculpture appears to be of the size of a pin-head, for it is devoid of this boundless sense of space or grandeur. The same is true of painting and other flat-space arts. A form at its extremity still continues reaching out into space if it is imbued with intensity or energy. The ideal dimension is dependent for its existence upon the three material dimensions, and is created entirely through plastic means, colored and constructed matter in space and light. Life and its visions can only be realized and made possible through matter.

The ideal is thus embodied in, and revealed through the real. Matter is the beginning of existence; and life or being creates or causes the ideal. Cézanne's or Giotto's achievements are most real and plastic and therefore are they so rare and distinguished. The ideal or visionary is impossible without form; even angels come down to earth. By walking upon earth and looking up at the heavens, and in no other way, can there be an equilibrium. The greatest dream or vision is that which is *regiven* plastically through observation of things in nature. "Pour les progrès à réaliser il n'y a que la nature, et l'œil s'éduque à son contact." Space is empty, from a plastic point of view.

The stronger or more forceful the form the more intense is the dream or vision. Only real dreams are built upon. Even thought is matter. It is all the matter of things, real things or earth or matter. Dreams realized through plastic means are the pyramids and temples, the Acropolis and the Palatine structures; cathedrals and decorations; tunnels, bridges, and towers; these are all of matter in space—both in one and inseparable. MAX WEBER.

PHOTO-SECESSION NOTES

RODIN EXHIBITION

AN exhibition of drawings by Rodin was on view in the exhibition rooms of the Little Galleries from March thirty-first to April eighteenth. Following two years after the Photo-Secession had first introduced drawings by Auguste Rodin to the New York public, this second exhibition of sketches, selected with great care from the best contained in the master's portfolios, enabled those who witnessed both shows to form a more comprehensive estimate of the range of this great artist's versatile talent.

Some of his early drawings, shown side by side with his later work, were interesting chiefly as historical documents and as illustrative of the change brought by years in the master's attitude, and in his command over his medium. Drawn mostly on a much smaller scale than his more recent sketches, they are more complicated, less direct and less imbued with emotion. In the sketches produced during the last ten or fifteen years, we feel that the artist has attained such thorough control over his medium that he is no longer conscious of it and that his whole power is concentrated on the attitude to be recorded without any waste of energy over the means of recording it. The lines, few in number, drawn with apparent carelessness and wonderful ease, encompassing a movement with a single uninterrupted stroke seem almost as if born of instinct rather than knowledge. And yet an examination of his early sketches convinces us that only by a constant use of his medium and a constant attention to the elimination of unnecessary details could the artist have attained the power of expressing himself so completely with such economy in the use of lines, the limit of successful artistic simplification.

The range of human emotions seems to have been covered by this versatile artist. It is emphasized in those sketches in which he has used a washed-in color which assumes an almost symbolic significance quite distinct from representation of local color. The force of his "Hell" with its abysmal blue tint broken by flamelike spots of red, or the bestiality of his Nero, the Roman emperor, whose square sensual head is crowned with foliage, while the lower part of the figure is enveloped in an orgy of color suggestive of spilt wine and blood, could hardly be surpassed. What a contrast when we pass to the charming figure of his "Salome" with that strange note of red on the flower in her hair which gives vibration to the light of blue of the drapery. His almost Greek love for the tender attitudes of women is well exemplified in his drawing of two semi-nude figures called "The Embrace" in which the cool green tint of the draperies sings in juxtaposition to the tender flesh tint of the girlish bodies. Three sketches for a series entitled "The Sun" occupied the centre of the main wall in the exhibition room. They are remarkable not only by the loftiness expressed in each figure but also from the point of view of composition, Rodin having managed to fill the space of his sheet of paper in a manner so thoroughly satisfactory in spite of the minimum amount of material used.

"THE YOUNGER AMERICAN PAINTERS"
AND THE PRESS

IN the Photo-Secession Notes in the last number of CAMERA WORK, when reference was made to the exhibition of the work of "The Younger American Painters," it was announced that some of the press notices of the exhibition would be reprinted in this issue for the sake of record. They follow:

James Huneker in the "New York Sun":

We picked out Max Weber from the rest of the revolutionists in the Little Gallery of the Secession, 291 Fifth Avenue. Mr. Weber caught our eye (collided with it would be more truthful) with his dainty exposure of three ladies in search of the mad naked summer night. That their legs are like casks, their hips massive as moons, their faces vitriolic in expression is beside the fact. The chief thing that interested us was to note the influence of Matisse. We know that Cézanne reduced all forms to the sphere, the cone and the cylinder, and this study viewed as such reveals plenty of cleverness and research. In the meantime the "picture" has vanished. Like the old saying at the hospital, "The operation was successful but the patient died." The entire new movement, its æsthetic, is based on the avoidance of the picturesque, of the "picture," of the lyric interpretation of nature. Courbet called himself a realist. Was he? No more than Zola. He was at heart a blustering romantic, accepted many studio conventions, and consider his horrible rusty blacks! Manet went far, but Hals and Velasquez hooked him in the end. The break with the past must be radical, one in which the present practice of form and color will be superseded by an absolutely (in a relative sense, toujours, mes enfants!) truthful rendering of nature. Monet, with his colored shadows, is as old-fashioned as Turner or Whistler! This Max Weber in his still life has some good color, and his treatment of volumes of tone a la Cézanne must be praised. Steichen is represented by several portraits, classic in comparison with the efforts of his associates. One, that of a woman sitting and gazing at the spectator, is intensely felt. In technique it is strong.

As for shadows, they are antique studio baggage. These young Peter Schlemils of paint have shed their shadows. A garden scene with tea table by Alfred Maurer is another vivid piece. It is vital paint this, and if it is not in the misty poetic key of Le Sidaner (who is fond of just such stunts with contrasted lights, lamplight against moonlight), it is very individual all the same. Marsden Hartley makes you catch your breath, yet a mountainside of his has a touch of the grandiose and no doubt looked that way to the young artist. Sincerity is the keynote, even the interpretation of the ugly, or what is called ugly, for it's all a matter of degree. Monet, now a rosewater idealist in landscape, was declared hideous thirty years ago. The fact is the opticians and aurists tell us that the capacity for optical and aural "accommodation" of the human eye and ear is very great. Therefore do not be surprised if some of these chaps, Brinley, Carles, Arthur Dove, Fellows, Hartley, John Marin, Alfred Maurer, Steichen and Weber loom up as pontiffs of the Futurists. We confess we went up to the Academy in a chastened mood and sought the compositions of Gilbert Gaul, Henry (not "Oh!" Henry, but E. L.) and dear old J. G. Brown as anodynes.

The Matisse controversy proceeds apace in Paris. Some German admirers sent the artist a gold crown. This moved Charles Morice—himself once a leader of les Jeunes—to make sarcastic comment in the columns of the Paris *Journal.* He finds Matisse on the wrong track, a victim to his fanatical admirers, to his native bad taste, to his research of the bizarre, the morbid, the horrible (sounds like a cast iron indictment of Richard Gambrinus Strauss) and also to a misapprehension of Cézanne. We would not mention this banal accusation if it had not been made by Morice, the same Morice who defended Paul Gauguin. He concludes by declaring that every epoch has its Bonnat and its Matisse. Yes, and its Max Nordau. There is no evading the logic of Mr. Mather, who, after a study of the Matisse drawings, summed up thus: "They are in the high tradition of fine draughtsmanship of the figure. If on sufficient acquaintance they still seem merely eccentric to any one, let him rest assured that the lack of centrality is not with them but

with himself." Pregnant sentences! And Mr. Mather did not fear to mention the august names of Pollaiolo and Hokusai in connection with Matisse. But we mustn't forget that the followers of Matisse, like the followers of Manet and Whistler, should be regarded with a suspicious eye.

B. P. Stephenson in the "New York Evening Post":

One of the surprises in the present exhibition at the Photo-Secession galleries, No. 291 Fifth Avenue, is that the paintings by Eduard Steichen look almost old-fashioned in the company where they find themselves. Besides Steichen the exhibitors are Arthur Beechwood Carles, Marsden Hartley, John Marin, Alfred Maurer, Max Weber, Arthur Dove, and D. Putnam Brinley. But Brinley does not really belong to this group of younger American painters, who are creating so much discussion by their individuality, eccentricity, or whatever you choose to call it, as is quite evident from an exhibition of his own to be described further on. These Steichen pictures were not among those shown recently at the Montross gallery, whose owner feared they might frighten away his customers, but were gladly accepted for the Photo-Secession galleries by Alfred Stieglitz, because, as he will tell you, the Photo-Secessionists have no customers to frighten. We have already spoken of these men, not knowing exactly what they are struggling to reach, and as they do not know themselves, it would be absurd for an outsider to attempt to point it out, but that they are honestly experimenting we have no doubt, and it is only as experiments that these pictures must be judged. They certainly are not masterpieces, and the men who painted them do not pretend they are. They even fight among themselves as to what the point is which they hope to reach.

Hartley sees greatness in a weird picture of two figures by Max Weber, one of the recent recruits, which looks to the present writer like a very crude painting from an Assyrian tomb, but Weber can see nothing in Hartley's three waterfalls, painted at different times of the day, nor even in a mountainside, which the writer is just beginning to understand. A well-known critic, himself a painter, refuses to publish a word about the exhibition, which he considers "an insult to the public." An hour later a critic of international repute enters the galleries and declares the exhibition to be one of the most important ever held in this country, for it is the first time that the American public has had an opportunity of seeing these works of men who express themselves in color, the whole structure of whose paintings is color. One artist exclaims, "Were the great old masters, then, all wrong?" Another, "It is not my style, but why should men be tied down to distances and middle distances because of Claude and Turner? Why not allow them to be individual?" Well, whether they be on the right or wrong tack, they are adding to the gayety of nations.

But to return to Steichen. There is one picture of his at the Photo-Secession of a woman leaning over the back of a coral colored chair, dark-haired and dark-eyed, and rich purples about her, a screen behind of many colors. It is all color broadly swept on, and the color gradually acts as magic on you, casts a spell, so that at last you begin to wonder how the most academized mind can find fault with its draughtsmanship. And so with Maurer. A few years ago he won a Carnegie prize, or something of that sort, for a figure painting, and was hailed as "the coming man." Some one called him "the modern Velasquez"; others told him the mantle of Whistler would fall upon him, and he believed what he heard. So he painted like Velasquez and he painted like Whistler, and no one bought his pictures, for men who wanted a Velasquez bought either a Velasquez or a Mazos, and those who needed a Whistler bought Whistlers; and there was no art dealer willing to push the young painter's pictures. And he went to the Salon d'Automne in Paris, saw Matisse and his followers, and scoffed; and presently he went again and, returning to his studio, he saw there was no color in his pictures, and, more than that, no individuality. So he determined to express himself. Now he is painting landscapes, and there are a spring scene of his at the Photo-Secession and a tea table on a lawn, which, if you will only take the trouble to look at them for a while and without prejudice, will tell you that Maurer has discovered an indiviual expression. Some day he will return to figure painting. It will be interesting to see how he will express himself then. Arthur Dove used to illustrate, but he went to Europe and was attacked by the epidemic rather badly, too, judging from his picture of fruit, but as yet he has not expressed individuality. But Lawrence Fellows has in his purely decorative pieces, mostly figures, in which he has not tried to follow nature, used color in a broad and simple fashion, and of all this group of painters, with the exception of Steichen, perhaps, appears to have got nearer his goal.

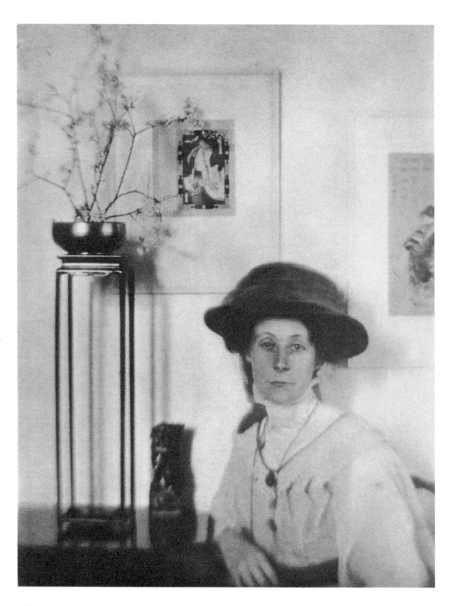

J. Craig Annan
East & West, 1910
Photogravure
20.5 x 15.7 cm

J. Craig Annan
Man Sketching, 1910
Photogravure
20.7 x 15.9 cm

J. Craig Annan
Harlech Castle, 1910
Photogravure
15.1 x 21.4 cm

J. Craig Annan
Bolney Backwater, 1910
Photogravure
14.6 x 23.4 cm

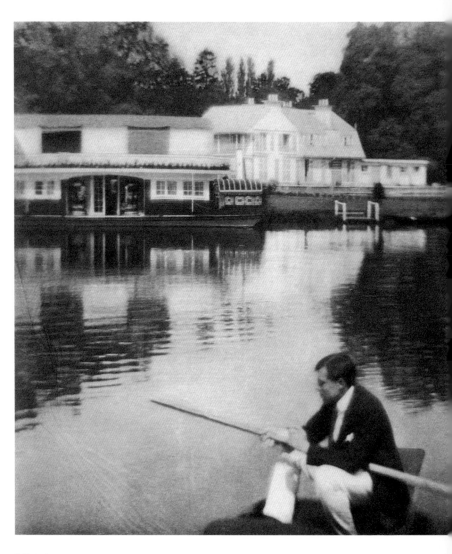

J. Craig Annan
The White House, 1910
Photogravure
19.4 x 17.6 cm

Henri Matisse →
Photogravure of Drawing, 191o
Photogravure
22.9 x 17.3 cm

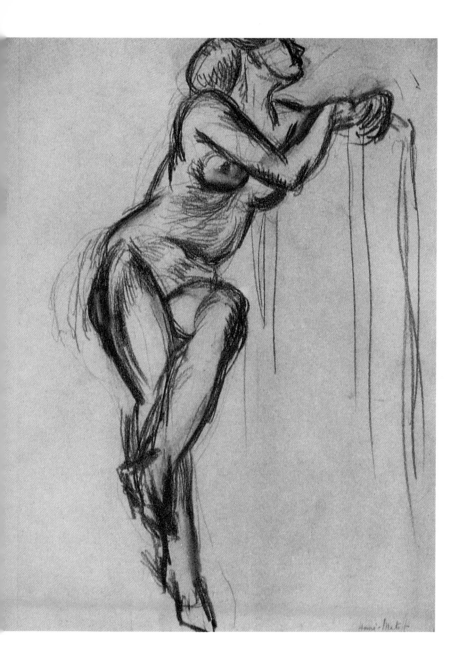

Henri Matisse
Photogravure of Drawing, 1910
Photogravure
17.7 x 22.9 cm

Gordon Craig ➜
Ninth Movement, 1910
Photogravure
19.7 x 15.6 cm

Clarence H. White
Alvin Langdon Coburn and His Mother, 1910
Photogravure
21.1 x 15.8 cm

Heinrich Kuehn
Portrait – Meine Mutter, 1911
Photogravure
9.8 x 14.7 cm

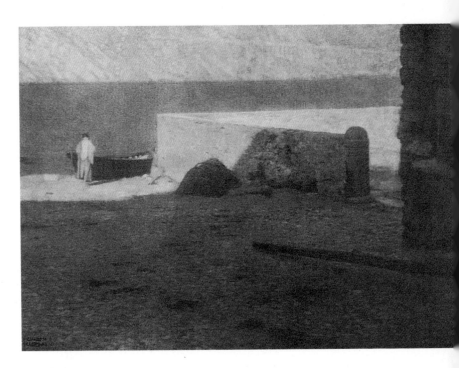

Heinrich Kuehn
On the Shore, 1911
Photogravure
15.3 x 21.4 cm

Heinrich Kuehn →
Windblown, 191
Photogravur
19.3 x 13.7 cr

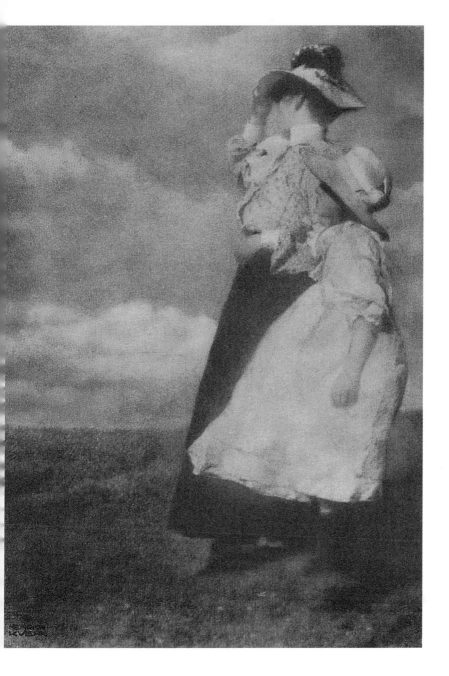

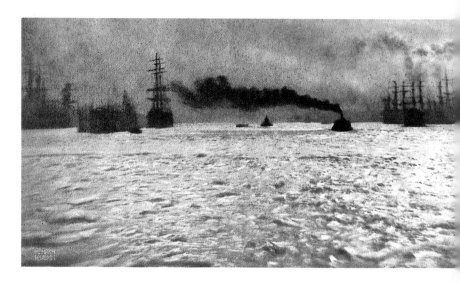

Heinrich Kuehn
Harbour of Hamburg, 1911
Photogravure
12 x 21.7 cm

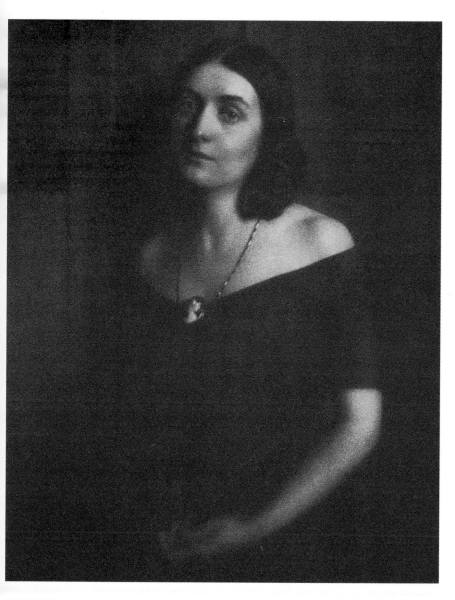

Heinrich Kuehn
Portrait, 1911
Photogravure
17.7 x 14.3 cm

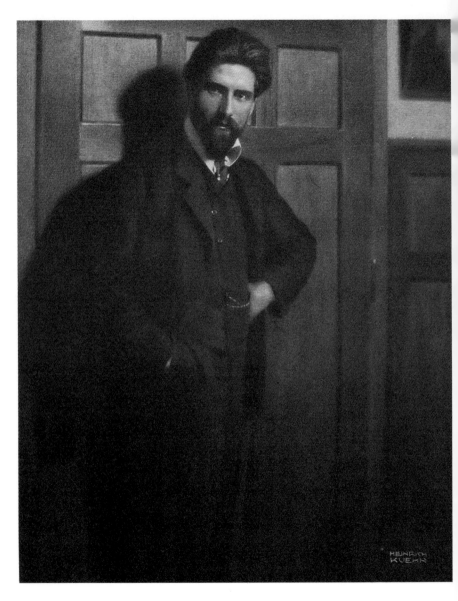

Heinrich Kuehn
Portrait, 1911
Photogravure
17.7 x 14.1 cm

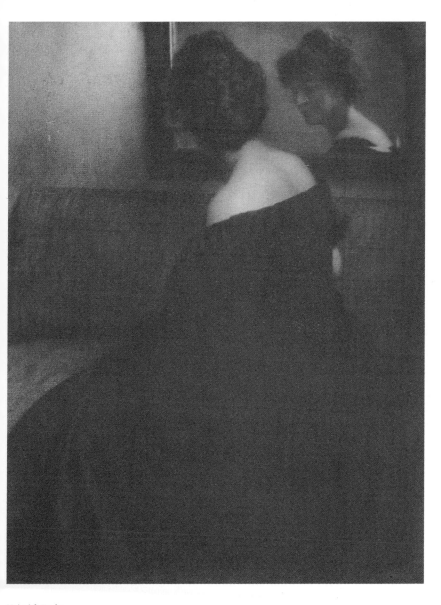

Heinrich Kuehn
Portrait – The Mirror, 1911
Photogravure
18.3 x 14.2 cm

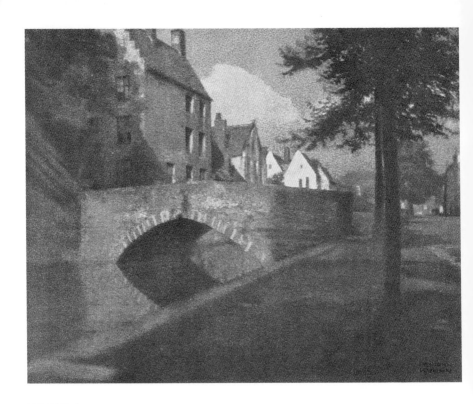

Heinrich Kuehn
Landscape, 1911
Mezzotint Photogravure
12.1 x 15.6 cm

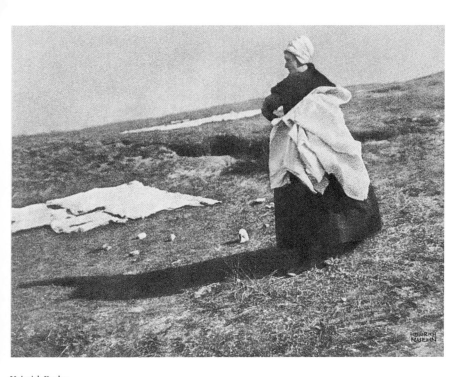

Heinrich Kuehn
On the Dunes, 1911
Mezzotint Photogravure
11.5 x 15.7 cm

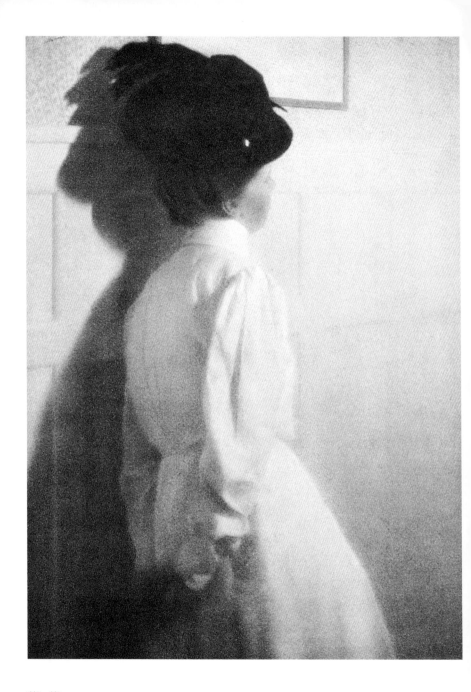

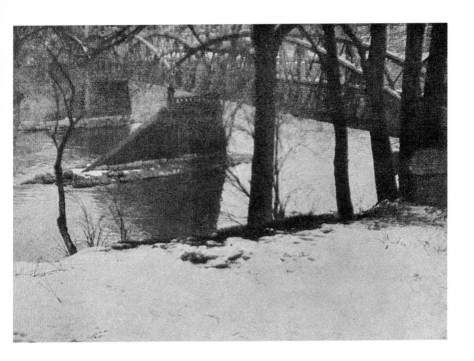

Heinrich Kuehn
Winter Landscape, 1911
Mezzotint Photogravure
11.7 x 16.4 cm

← Heinrich Kuehn
Study, 1911
Mezzotint Photogravure
18.7 x 13.8

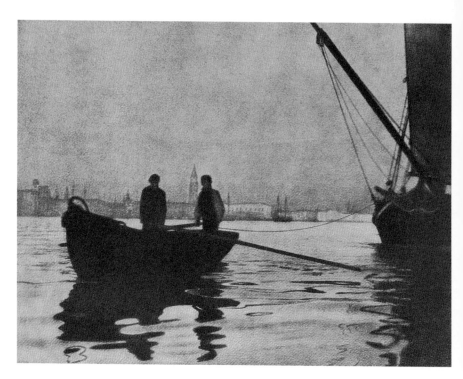

Heinrich Kuehn
Venice, 1911
Duplex half-tone reproduction
14.7 x 19.5 m

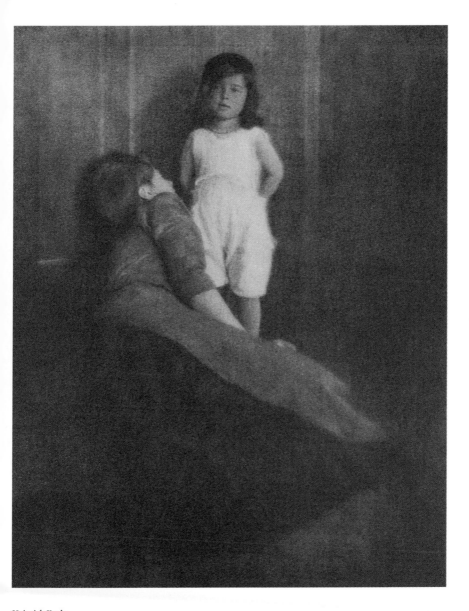

Heinrich Kuehn
Lotte and Her Nurse, 1911
Duplex half-tone reproduction
18.2 x 14.6 cm

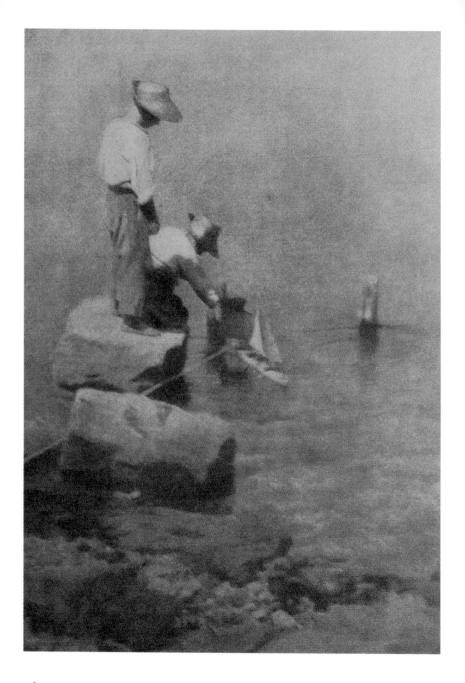

Heinrich Kuehn
Landscape, 1911
Duplex half-tone reproduction
14.6 x 19.3 cm

← Heinrich Kuehn
Sailing Boats, 1911
Duplex half-tone reproduction
20.3 x 14.3 cm

WHAT REMAINS

THE photographic exhibition at the Albright Art Gallery is a thing of the past. There are many rooms in that white marble mansion and they will be devoted as heretofore to the display of art in all its varied aspects. But its hospitable doors may never swing open again for a similar array of photographic prints. It was not an ordinary exhibition, this November show at Buffalo. It was a conquest, the realization of an ideal. Its triumph will rarely be repeated and even if repeated will assume a different aspect. It is not my intention to dwell upon any official reports of this successful venture. It is not a question of favorable comments or the number of visitors that availed themselves of the intellectual treat. They fail to tell the story. May it suffice to say that the general consensus of opinions agreed that pictorial photography had never been presented to the public in so effective, comprehensive and beautiful a manner. I endorse this estimate with absolute sincerity. I have seen numerous exhibitions, photographic and otherwise, but I do not remember any which excelled this one in clarity and precision of presentation. This is now a matter of history and its harmony of lines, the charm of its individual exhibits, and the artistic excitement which was evident in assembling them, is merely a memory.

After hearing a symphony the score remains. After seeing a play the text remains. An exhibition, as soon as it is dispersed, leaves nothing but the general impression and a few cherished recollections, that we may realize again only according to their original sensitiveness and strength.

What is it that remains of the exhibition? Of what significance is photography artistically in these days of eclectic art expressions? This, I maintain, is what interests the true lover of photography most of all. Questions like these have nothing to do with the style of presentation, of mounting, hanging and the exquisite proportions of the exhibition halls. It is the print itself, stripped of all embellishment, and the eye, brain and hand behind it which must tell the story.

I believe the old cry "art for art" has become meaningless. That some pictorialists have fashioned for themselves a personal mode of expression is an established fact. The victory over the photographic bureaucracy has been won long ago. It needs no further argument. We have learnt that a photographic print can be a thing of beauty aside from reference to any subject it portrays. The high average of excellence throughout the exhibit was astounding as it was exquisite.

Now, as heretofore, the pictorial army is divided in two camps, the Demachy-Eugene-Steichen camp who favor painter-like subjects and treatment, and the Stieglitz-White-Craig-Annan class who flock around the standard of true *photographic themes and texture*. The camp of the former, true evidently, becomes more and more deserted, the old flag hangs limp and the fires burn low—only the dense and indifferent public, which is always behind the time, begins to patronize what was popular ten years ago. But in the rank and file the old feuds are forgotten. The artist who rose at dawn and measured

swords with his critics has acquiesced. Each man went his way, made his own audience, and challenged it for his own specific purposes.

The contention has become a much subtler one. What we would like to fathom is what photography can do better than any other monochrome medium, not what it may do eventually, but what it has done. This is strictly a matter of technical consideration, as the æsthetic satisfaction derived from an art is in exact proportion to the public's knowledge of that art's technique. We know more about photography, and consequently are more deeply interested in the intricacies of the process. Photographic draftsmanship commands three technical preferences which are always evident when photography is at its best.

1. The image is actually drawn by light, and no other black and white medium can compete with this conveyance of the actual flow and shimmer of light, as it flits from object to object to the deepest shadows, still capable of preserving a degree of delicacy in the most solid black. Prints like White's "Portrait of Mrs. White," Laura Armer's "Mother and Child" and Käsebier's "The Manger," to mention but a few, brought this out distinctly. As soon as the light is manipulated it loses its greatest charm, and often becomes dull and chalky.

2. Line is invariably suggested by the gradation of tonal planes. Precise, or blurred, it is drawn entirely by the differentiation of values. This absence of actual line is possible also in other mediums but achieved only with great difficulty, while it is natural to photography and consequently one of its powerful characteristics. All prints excepting those of the extreme tonalists express this quality.

And 3. As it is impossible to emphasize line except by juxtaposition of values, that tone (a subtle variation of hues within one tint) is one of the most favorable formulæ of photographic picture-making (viz.: Craig-Annan and De Meyer still-lifes). Tone in this sense has never been produced with equal perfection except by American wood engraving.

In subject matter the studio print and landscape photography have advanced but few new themes if any have been brought out. They are borrowed largely from the other arts. It is the men who have preferred the city streets, the impressionism of life and the unconventional aspects of nature to costuming and posing, who have occasionally enriched our wealth of pictorial impressions. In many instances they have discovered and subdued new and unusual motifs and improvised upon the laws of composition with the skill of true virtuosos. I refer in particular to Stieglitz's skyscrapers and dock scenes, and some of Coburn's interpretations of city views.

One can hardly say that photographic picture-making up to this day has revealed much of spiritual gravity. It is mobile and complete, but not splendidly audacious conceptionally. Only in rare instances does it reflect actual mentality, as in the work of Steichen and the Viennese. Perhaps this is a limitation of the pictorial print of portfolio size. Its masterpieces may be defined as perfect beauty of visional appreciation joined to perfect beauty of technical expression. Elaborate figure compositions belong rather to the domain of snapshot photography. It is the single image, the attitude of a

figure, the tonal fragment, a glass among shadows, a fleeting expression or some atmospheric condition, which adds something to our consciousness of beauty. These reflections in a way are the result of my visit to the Albright Art Gallery. No doubt, any student of photography bent upon analysis of its æsthetic significance, has arrived at similar conclusions, but it was never brought out more clearly, more convincingly than at Buffalo. The photographer had a chance to realize the possibilities and limitations of his medium.

But there was something else which could not be seen, but only felt, which emanated as it were from the walls, and which pervaded the entire exhibit. It is difficult to express it in words. An ensemble so exceptional, aside of all actualities, teaches a lesson of deeper significance. It was combined in the spirit which provoked it. I sit at my desk and wonder how such a refined sensation of visional joy mingled with an appreciation of the mind so deep and true, as I experienced walking through these large peaceful galleries, could have ever been conjured up in this diffident commerce-sodden community. It can only be the result, I mused, of the natural exaltation of a mind free from prejudices (except it were directed against insincerity), solely as the pursuit of some lofty ideal. And I must confess that I have never met a group of men who have taken their vocation more seriously and disinterestedly than these pictorialists. Art today in many instances is so mechanical and imitative, so time-pleasing and coin-of-fact that one greets these workers with exceptional feelings of sympathy and appreciation. Not that they are necessarily visionary and fanatic. No, they are practical enough, for it demands a peculiar temperament to be a successful pictorialist. There enters into his make-up a certain amount of patience and scientific calculation which is foreign to the average artist's nature. But they possess the vital spark. Their art expression is germinal, not mimetic. They have put themselves at the service of a new medium, and they endeavor to conquer it. No matter how eclectic they may be, they at least freshly comprehend, reassimilate, readopt accepted principles of beauty to a new virile condition. And thanks to these finer artistic faculties and sensibilities, to their subjective process of taste and ideality the success of the exhibition was due. These workers realize that their art instincts must blossom forth into wholesome consciousness as natural expansion before their medium of expression can take its proper and its fullest meaning.

And it was this spirit which made the Albright Exhibit of November, 1910, memorable in the annals of photography and art.

Like the delicious odor in some mirrored cabinet that lingers indefinitely for years, this spirit will not fade. It will be remembered long after individual efforts have lost their immediate usefulness. The few masterpieces will remain, the rest will be forgotten, but the spirit will continue to remain an active force, and produce fresh impressions of light and tone, of form and grace. SADAKICHI HARTMANN.

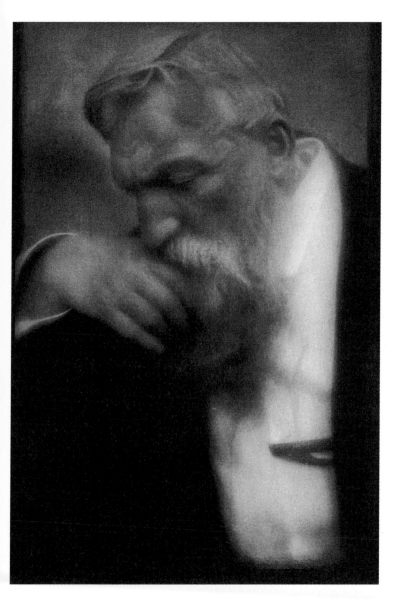

Eduard J. Steichen
M. Auguste Rodin, 1911
Photogravure
24.1 x 16.8 cm

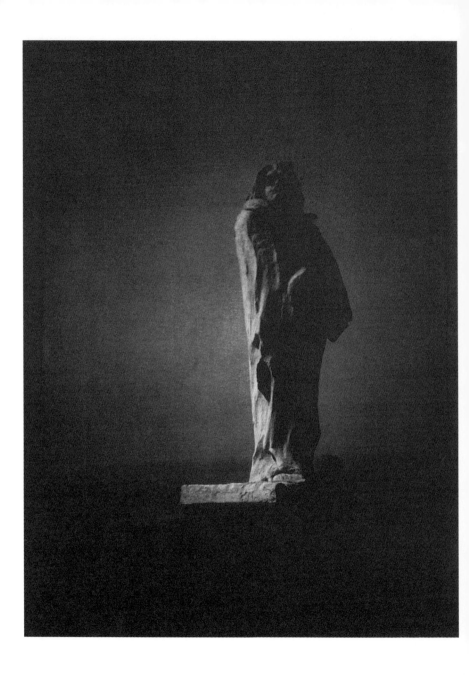

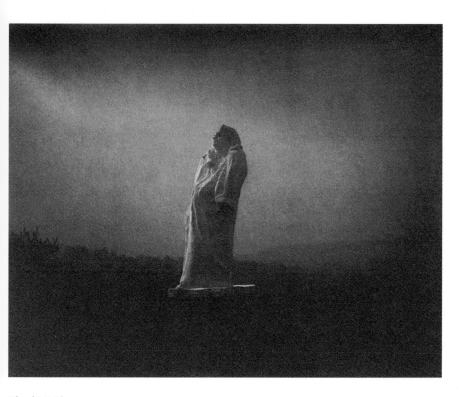

Eduard J. Steichen
Balzac – Towards the Light, Midnight, 1911
Photogravure
15.9 x 20.2 cm

← Eduard J. Steichen
Balzac – The Open Sky, 1911
Photogravure
20.9 x 15.9 cm

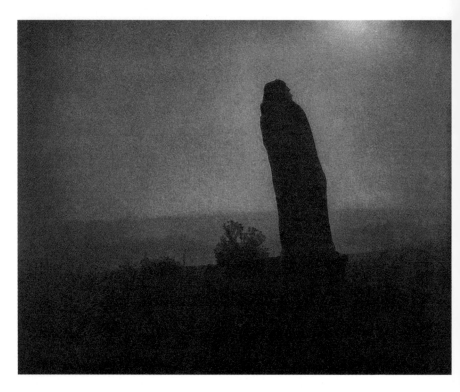

Eduard J. Steichen
Balzac – The Silhouette, 4 a.m., 1911
Photogravure
16.1 x 20.6 cm

Auguste Rodin →
Photogravure of Drawing, 1911
Photogravure
18.6 x 13.7 cm

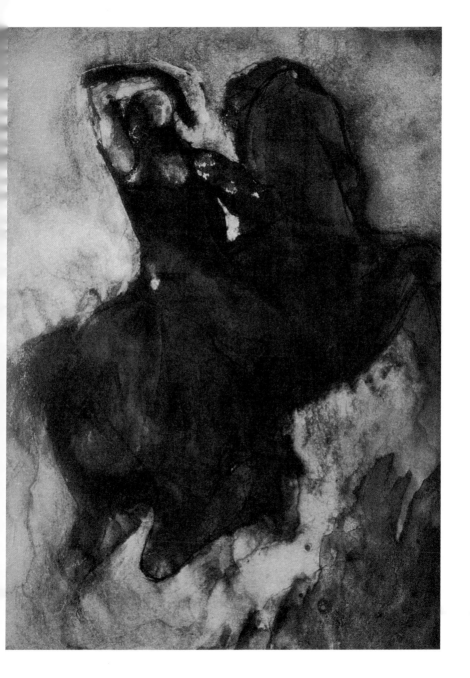

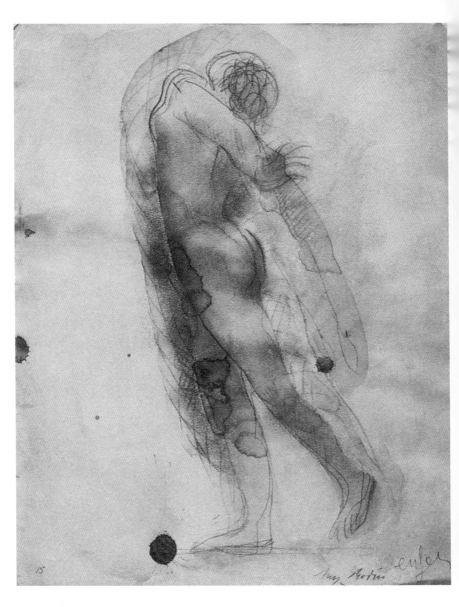

Auguste Rodin
Photogravure of Drawing, 1911
Photogravure
19.1 x 15.7 cm

Auguste Rodin
Cambodian Dancer, 1911
Coloured Collotype
24.3 x 18.5 cm

Auguste Rodin
Drawing, 1911
Coloured Collotype
26.4 x 18.5 cm

Auguste Rodin →
Drawing, 1911
Coloured Collotype
26.2 x 18.4 cm

Auguste Rodin
Drawing, 1911
Coloured Collotype
24.3 x 18.4 cm

Auguste Rodin
Drawing (Sun series), 1911
Coloured Collotype
28.9 x 18.7 cm

Auguste Rodin
Drawing (Sun series), 1911
Coloured Collotype
18.5 x 28.9 cm

Auguste Rodin →
Drawing, 1911
Coloured Collotype
25.7 x 17 cm

RODIN'S BALZAC

EVERY ten or twenty years a work of art seems to be destined to become typical of its period, a symbol of temporary accomplishment as well as new aspiration. Chavannes' "Le Pauvre Pecheur" was such a picture which bewildered and filled me with languid curiosity to solve the everlasting riddle of art. Whistler's "Valparaiso Harbor," dethroning the tyranny of Grecian calm and ushering in the era of Japanese virility, impressed me the same way. When I saw Manet's "Déjeuner," Monet's "Rouen Cathedrals," Gauguin's "Tahiti Woman," I felt that old ideals were crumbling to dust, that art was on the barricades and the expression of life passing through new intellectual advancements. It is the moment when the muses pause in their wanderings, take a deep breath, and lift their diaphanous robes to cross over a boundary line into a new domain of the fairyland of art. Matisse may mean the same to a younger generation. I have not seen enough of his work, or rather not the one work of his that would sound the deeps of my esthetical sensations.

Rodin's "Balzac" in its passionate austerity is perhaps the highest expression of this quest and transition of art convictions in modern times. It possesses that sombre magnetism that instantly arouses all fibres of my heart. In none of his other works burn the internal fires with intenser flame. I do not know or care what other people think or say about this statue. That I have to solve for myself.

Form is recognized by the muscular sweep of the eye in combining adjacent points. A Greek statue affords beautiful lines under every aspect.

Each viewpoint affords a special pleasure. Today the knowledge of the human form is so limited and perverted that even painters copying from the nude cannot produce a perfect type, but represent beauty with all the deficiencies of form of the various models they employ.

So what is the use of attempting it over and over again! Art should be as *individual* as *public*. Most artists forget this obligation to humanity. The quicker an impression is called forth the more ardent and convincing it generally is. People know too little about beauty of line to appreciate a series of curves and undulations. Their knowledge is fragmentary as beauty itself. But they still appreciate a rock of curious shape, a tree, a beautiful fleeting form. It is there that modern sculpture begins. The theory that symmetry alone can yield us pleasant feelings has long been discarded. Greek art starts from unity and reaches diversity, Japanese art starts from diversity and soars to unity. It all depends on coherence of construction.

Thus, Rodin sacrificed everything to one broad immediate effect, to brevity and concentration. The "Balzac" can be viewed and enjoyed from as many different viewpoints as the stereotype statue, but the pleasures granted will resemble each other. It is always the total effect that impresses itself upon our observation. There is little opportunity for detail scrutiny; it is always the general effect of a bulky shape, the silhouette of a human form struggling in a chaos of matter.

The treatment of the surface is painter-like. It is like a chiaroscural composition in high relief. It is the vibratory technique of impressionism applied to sculpture. The surface in itself is interesting only by contrast, it produces the subtleties of monochrome, and these produce tone in actual form, as a statue is after all but an expression of plane figure. If you should chip off a piece here or there, there would still be a chance of making a masterpiece of form.

Rodin's "Balzac" deals rather with the beauty of elemental geometrical lines and forms than the symmetry of the intricate human shape. The feelings are esthetic but do not belong to the domain of sculpture proper, as we have understood it for ages past, but to a more instinctive appreciation of form that still finds a lyrical echo in every human breast. It makes an appeal to our most primitive mode of perception and thereby creates vague emotional feelings, suggestive of mystery and mysticism.

It is supposed to be a symbolical representation of the poet, of Balzac's genius. I would rather say of the genius of any great poet. Surely Whitman or Carlyle could be represented in a similar way.

There is but little of the actual man left. Balzac in his dressing-gown changed into a huge stone image. The wonderful part of it is that every suggestion and representation of fact, save an exquisite vision of the face, has been eliminated. Nothing remains but the intangible expressed by the most tangible of material. The boundary lines are shifting, because they are unusual. Not that they lack grace, but because they are austere, of vertical tendency, lines of peculiar structure and masculine sweep as we have not seen except in Assyrian and Chinese sculpture. It gives the impression—if seen in the open—of being

enveloped in vapor. This is the attempt to lend atmosphere to an art from which every aerial suggestion has been excluded heretofore. In observing angular rough-hewn planes readjustment of our visual organs is constantly required. Similarity of shape and hue tire us by the uniformity of focus which they demand. To appreciate this statue involves greater expenditure of muscular energy. This is its one deficiency.

But arts that are dead are deprived of creative exfoliation. Classic sculpture and painting are dead. And no fairy wand can breathe into them the same old life that pulsated through them centuries ago. We need new expressions reflecting our modern life and boldly have to sound new wells of beauty.

In our age Music is the grand source of instant inspiration—no wonder that the other arts try to exercise many of the same sensuous, emotional and intellectual gratifications. Color turns musical when painting becomes decorative or when the illusion of form is neglected and a more precise division of space emphasized. Form, on the other hand, becomes musical when special stress is laid on surface treatment or the juxtaposition of light and shade, and the broader and more diffused juxtaposition is, the finer the musical exhalation is apt to become. In the "Balzac" form is felt rather than seen It is orchestration by the *blending of planes*—and by the vibration of light on these planes to produce a vague atmospheric effect.

This must be the end, some critics exclaim! No, on the contrary, it is dawn! Here all begins, germinates, grows anew, flowers and streams forth This unrealized dream with nothing corporeal in it, is sculpture for the mind It represents the activity of the soul, the conscience of the man in search for the beautiful. There is revolt in it, the cry of the solitary man, his attack on error, vice, infamy, his contempt and defiance of existing incongruities. It is not the simple beauty of a being like the Venus of Knidos or Myron's "Discus Thrower," but the passionate beauty of a complex soul-state, permeating civilization with light—which is told by the sculptor with sovereign power of hand, terrific force and consummate skill.

It is not the glorification of classic form, but of an abstract idea, of a feeling of awe and wonder akin to that we feel in the presence of a great mind, face to face with the desert, the mountains, night or the sea. It produces instantaneously a tangled mass of sensations; this is the first impression, vague and vacillating but intense, and thereupon slowly, with the help of our intellect, do we arrive at a clear and distinct pleasure. We repeat the same process of soul activity which the statue represents; an ideal struggling through matter, some endless wrong or injustice, some deep flamboyant grace, some bold prophecy or triumphant conquest, struggling to the surface, to light and space.

S. H.

PABLO PICASSO*

L ET me say at the beginning that I do not believe in art criticism, and the more especially when it is concerned with painting.

I grant that everyone has the right to express their opinion in art matters, to applaud, or disapprove, according to their own personal way of seeing and feeling; but I hold that they should do so without assuming any authority, and without pretending to possess the absolute truth, or even a relative one; and also that they should not base their judgments on established rules, upon the pretense that they are consecrated by use, and by the criterion of high authority.

Between a civil or a penal judge and a critic there is a great difference. The judge judges according to the law, but does not make the law. He has to submit himself to the letter and the spirit of the law, though it might conflict with his personal opinions, because that law is an absolute rule of conduct, dictated by society, to which all have to submit. But art is free, it has never had, it has not, and will never have a legislature, in spite of the Academies; and every artist has the right to interpret nature as he pleases, or as he can, leaving to the public the liberty to applaud or condemn theoretically.

Every critic is a priest of a dogma, of a system; and condemns implacably what he finds to be out of his faith, a faith not reasoned but imposed. He never stops to consider the personality of the artist whose work he is judging, to investigate what his tendencies are, what his purpose is, or what efforts he made to attain his object, and to what point he has realized his program.

I have devoted my life to the study of art, principally painting and sculpture. I believe I have seen all that is worth seeing, and I have never dared pass sentence on a work declaring it good, even if signed by the most renowned artist; nor declare it bad, though it bears the name of a person totally unknown. At the most, I dare say that it pleases or displeases me, and to express the personal motives of my impressions.

Scholastic criticism has never profited anyone; on the contrary, it has always restrained the spirit of a creator; it has always discouraged, humiliated, and killed those who have had the weakness to take it into consideration.

Each epoch has had its artists, and must have its art, as each also has its men of science and its science; and any one who intends to oppose a dike to the flood-tide of human genius is perverse or a fool.

This love for the dogma, the tendency of the academy to enchain, to suffocate and to vilify, has greatly damaged the countries in which it has prevailed. This has been the cause of delay in the progress of art in Spain; and on account of this system we see the Spanish artists, those of persona inspiration and haughty spirit, perish there, or emigrate to Paris, looking for a better atmosphere. For, though it is true that there is in Paris also an academic sect that suffocates, one which proclaims that outside of itself there is no salvation, nevertheless art has succeeded in conquering an independence which permits all sorts of attempts at new expression.

Art has not died in Spain, or not at least among Spaniards. What is

* Printed in pamphlet form for the Picasso Exhibition, Photo-Secession Gallery, April, 1911.

beginning to die is the old tradition, or rather the intransigent traditionalism. And the best proof of it is the notable number of Spanish painters living in Paris, who prosper there, gaining enviable fame, and who at the end will figure among the French glories, instead of adding illustrious names to the already extensive Spanish catalogue.

I intend to make these artists known to the American world, describing the work of each one of them, not as I see, feel, and understand it, but as each one of them has conceived it.

I want to tell at present of Pablo Picasso, from Malaga, who finds himself in the first rank among the innovators, a man who knows what he wants, and wants what he knows, who has broken with all school prejudices, has opened for himself a wide path, and has already acquired that notoriety which is the first step towards glory.

I do not know if he is known in Spain, and if he is, whether they appreciate his efforts and study his works. What I know is that he is a Parisian personality, which constitutes a glorious achievement.

I have studied Picasso, both the artist and his work, which was not difficult, for he is a sincere and spontaneous man, who makes no mystery of his ideals nor the method he employs to realize them.

Picasso tries to produce with his work an impression, not with the subject but the manner in which he expresses it. He receives a direct impression from external nature, he analyzes, develops, and translates it, and afterwards executes it in his own particular style, with the intention that the picture should be the pictorial equivalent of the emotion produced by nature. In presenting his work he wants the spectator to look for the emotion or idea generated from the spectacle and not the spectacle itself.

From this to the psychology of form there is but one step, and the artist has given it resolutely and deliberately. Instead of the physical manifestation he seeks in form the psychic one, and on account of his peculiar temperament, his physical manifestations inspire him with geometrical sensations.

When he paints he does not limit himself to taking from an object only those planes which the eye perceives, but deals with all those which, according to him, constitute the individuality of form; and with his peculiar fantasy he develops and transforms them. And this suggests to him new impressions, which he manifests with new forms, because from the idea of the representation of a being, a new being is born, perhaps different from the first one, and this becomes the represented being.

Each one of his paintings is the coefficient of the impressions that form has performed in his spirit, and in these paintings the public must see the realization of an artistic ideal, and must judge them by the abstract sensation they produce, without trying to look for the factors that entered into the composition of the final result. As it is not his purpose to perpetuate on the canvas an aspect of external nature, by which to produce an artistic impression, but to represent with the brush the impression he has directly received from nature, synthesized by his fantasy, he does not put on the canvas the remembrance of a past sensation, but describes a present sensation.

Picasso has a different conception of perspective from that in use by the traditionalists. According to his way of thinking and painting, form must be represented in its intrinsic value, and not in relation to other objects. He does not think it right to paint a child in size far larger than that of a man, just because the child is in the foreground and one wants to indicate that the man is some distance away from it. The painting of distance, to which the academic school subordinates everything, seems to him an element which might be of great importance in a topographical plan or in a geographical map, but false and useless in a work of art.

In his paintings perspective does not exist: in them there are nothing but harmonies suggested by form, and registers which succeed themselves, to compose a general harmony which fills the rectangle that constitutes the picture.

Following the same philosophical system in dealing with light, as the one he follows in regard to form, to him color does not exist, but only the effects of light. This produces in matter certain vibrations, which produce in the individual certain impressions. From this it results, that Picasso's painting presents to us the evolution by which light and form have operated in developing themselves in his brain to produce the idea, and his composition is nothing but the synthetic expression of his emotions.

Those who have studied Egyptian art without Greco-Roman prejudices, know that the sons of the Nile and the desert sought in their works the realization of an ideal conceived by meditation before the mysterious river and by ecstasy before the imposing solitude, and that is why they transformed matter into form and gave to substance the reflection of that which exists only in essence. Something of this sort happens in Picasso's work, which is the artistic representation of a psychology of form in which he tries to represent in essence what seems to exist only in substance.

And, likewise, just as when we contemplate part of a Gothic cathedral we feel an abstract sensation, produced by an ensemble of geometrical figures, whose significance we do not perceive and whose real form we do not understand immediately, so the paintings of Picasso have the tendency to produce a similar effect, they compel the spectator to forget the beings and objects which are the base of the picture, and whose representation is the highest state to which his fantasy has been able to carry them through a geometrical evolution.

According to his judgment, all the races as represented in their artistic exponents, have tried to represent form through a fantastic aspect, modifying it to adapt it to the idea they wanted to express.

And at the bottom, all of them have pursued the same artistic ideal, with a tendency similar to his own technique.

<div style="text-align:right">MARIUS DE ZAYAS.</div>

ART AS A COMMODITY

A T the risk of being branded as a Philistine, I feel it necessary to express my views on the relations of artist and patron in the buying and selling of works of art.

Nobody will question the right of the artist in producing a picture to use any materials he may desire irrespective of permanency. No more can anyone presume to take away from him the privilege of valuing his work artistically above the most prized possessions of any museum. As long as he is working for his own satisfaction there is no limit to his rights.

But very few are the translators of visions of beauty who do not seek for recognition of their merits and who do not expect this recognition to take the form of an exchange of their cherished productions for the despised shekels of the bourgeois.

Hard as it may be for them to admit the truth of the following statement, it is a fact that when this exchange takes place the artist becomes a merchant. His status as an artist stops with the production of the picture. When he seeks to dispose of it, we must look upon him as a dealer, and in the transaction both parties have certain rights and certain obligations towards one another.

The first obligation both parties assume is the exchange of fair equivalents. Artists, as a rule, are inclined to think of people with money as a favored class who simply happen to have been standing in a propitious spot during a "local shower" of gold, and that all they had to do was to stretch out their hands to gather in the precious metal. They forget too easily that in the majority of cases money is the reward of thought, labor, worries, privations and hardships, that the man who is tendering them the precious medium of exchange may in order to do so be depriving himself of many comforts.

The artist takes the point of view that he is a benefit to the community and that the community owes him a living. To a certain extent he is right. A community is certainly the richer intellectually by the work of its artists, and benefits by the contemplations of beautiful expression. Too many so-called patrons of the arts believe in patronizing "the arts but not the artists." On the other hand, we cannot deny the man who possesses money to dispose of it as he sees fit and to appreciate on his own basis the value to himself of the work he intends to acquire. This value, in terms of money, is based on many elements the least of which is probably its intrinsic artistic value. This is a regrettable state of affairs, but we might as well try to suppress the law of attraction of planets among themselves as to correct certain economic laws. The prime factor in all questions of value is the law of supply and demand, and the artist who complains that his beautiful paintings bring him less cash than those of a less talented brother painter is reasoning in very much the same way as the farmer who complains that his beautiful apples from a bountiful crop are worth less on the market than the poorer specimens of a lean year twelve months previous.

The amount of pleasure the possessor will get from the work purchased as compared with other possible enjoyments to be obtained from the purchasing

power of the money is another important basis of calculation. It would be unfair, however, to base monetary valuations on this element alone, as the most appreciative people would have to pay the penalty of their appreciation by paying a higher price than less courageous or less enthusiastic friends. It is the duty of the artist not to reduce the level of his prices once established, nor on the other hand to charge some people more than he would others.

Last but not least comes the question of permanency, a question to which artists have often given but too little thought. What fair-minded man will claim that the purchaser who acquires a work of art on the assumption that he becomes the possessor of a "thing of beauty" which will be "a joy forever," is treated honorably when in exchange for a tender of fixed and undisputed value he receives an article which in a short period of time will have lost, through deterioration, much of its exchange value, as well as its power to give esthetic pleasure?

In short, the artist should not take the cash valuation of his work as the measure of its artistic appreciation. He should accept, sadly perhaps, but courageously, the interference of unavoidable economic laws, and remember that while he is entitled on the part of the people he deals with to a fair remuneration for his efforts, he owes it to them to tender them a fair equivalent for their money.

<div align="right">Paul B. Haviland.</div>

OUR ILLUSTRATIONS

The first four plates of this number of CAMERA WORK, devoted to Rodin, are reproductions from the original negatives of Eduard J. Steichen's later portrait of Rodin and of three of the eight "Balzac-Moonlight" series. Good as the gravures are, they unavoidably lack some of the power and naturally also fail to give the print quality of the large original gum prints, which were first publicly exhibited at the Photo-Secession Gallery, in April, 1909.

The nine other plates in the number are reproductions of Rodin drawings, the originals of which were exhibited in the two Rodin exhibitions held at the Photo-Secession Galleries. They include two gravure reproductions; a process which does not lend itself particularly well to this kind of work. But we have used it in the case of two drawings for the purpose of comparison with the process employed in reproducing the seven others. The latter were reproduced, reduced to two-thirds the original size, by a combination method in which collotype plays an important role. The spirit and character of the originals have been preserved with extraordinary fidelity. They were made by the firm of F. Bruckmann Verlag, Munich, under the direction of Mr. Goetz, whom it is pleasant to remember as an American, one compelled, in pursuit of his artistic ideals, to expatriate himself.

Incidentally, we might add that none of these plates has heretofore been published, except No. I, Steichen's Rodin, and No. I of Rodin's drawings; the other eleven are now first issued.

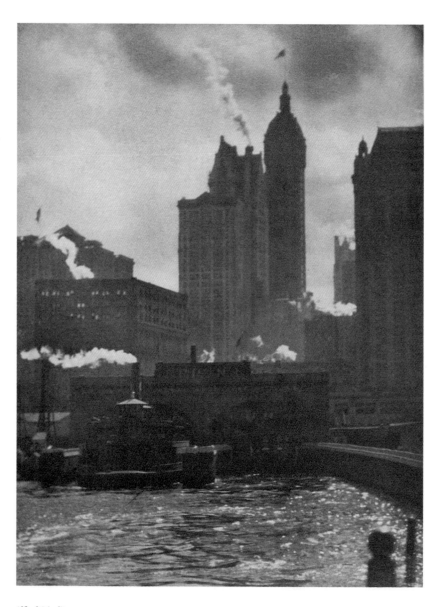

Alfred Stieglitz
The City of Ambition (1910), 1911
Photogravure
22.2 x 16.8 cm

Alfred Stieglitz
The City Across the River (1910), 1911
Photogravure
19.9 x 16 cm

Alfred Stieglitz
The Ferry Boat (1910), 1911
Photogravure
20.9 x 16.3 cm

Alfred Stieglitz
The Mauretania (1910), 1911
Photogravure
20.9 x 16.3 cm

Alfred Stieglitz
Lower Manhattan (1910), 1911
Photogravure
16 x 19.7 cm

Alfred Stieglitz →
Old and New New York (1910), 1911
Photogravure
20.2 x 15.8 cm

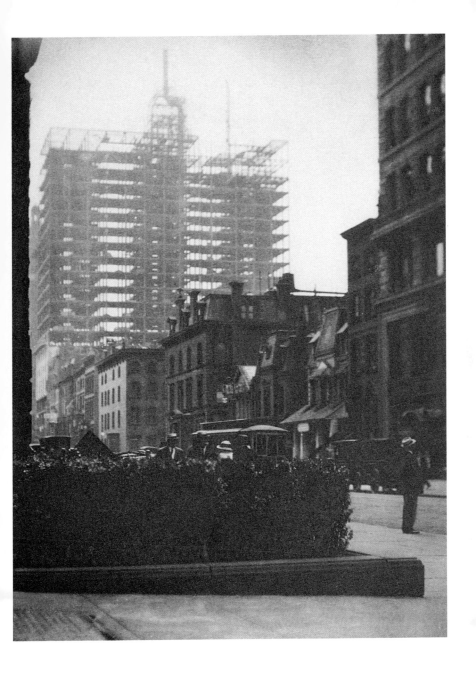

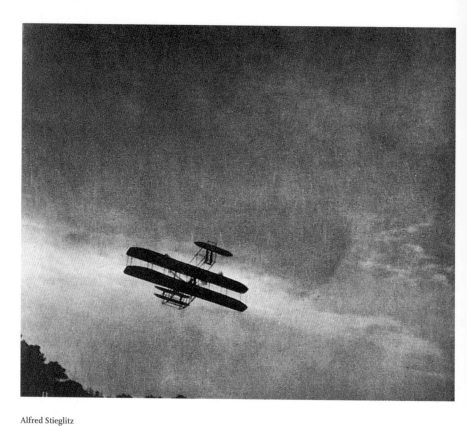

Alfred Stieglitz
The Aeroplane (1910), 1911
Photogravure
14.4 x 17.5 cm

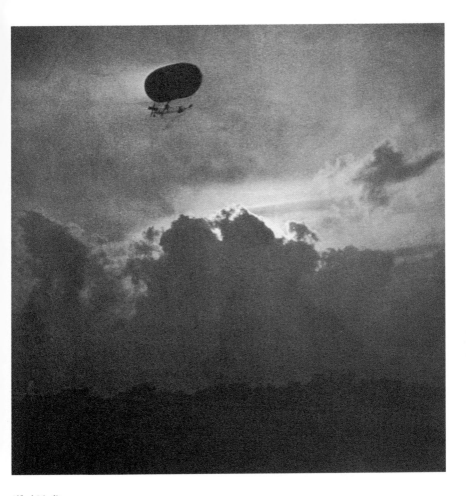

Alfred Stieglitz
A Dirigible (1910), 1911
Photogravure
17.7 x 18 cm

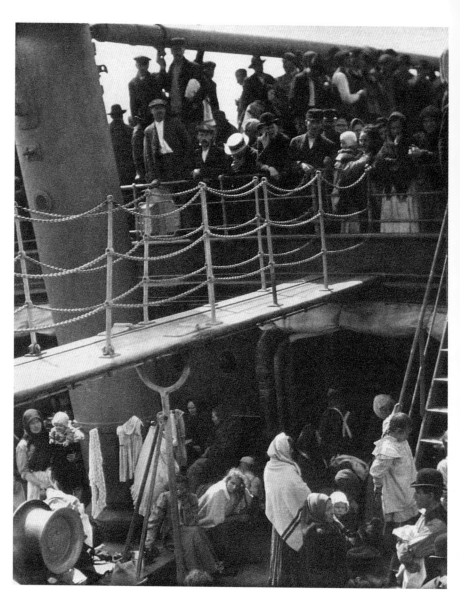

Alfred Stieglitz
The Steerage (1907), 1911
Photogravure
19.7 x 15.8 cm

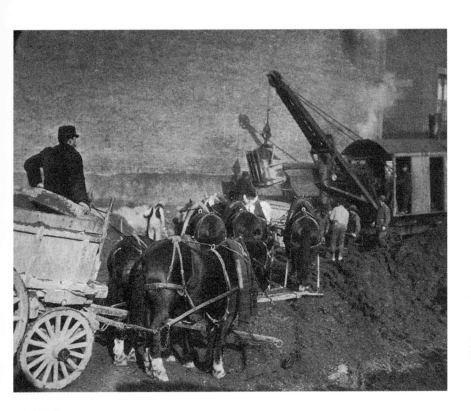

Alfred Stieglitz
Excavating – New York (1911), 1911
Photogravure
12.7 x 15.7 cm

Alfred Stieglitz
The Swimming Lesson (1906), 1911
Photogravure
14.8 x 23 cm

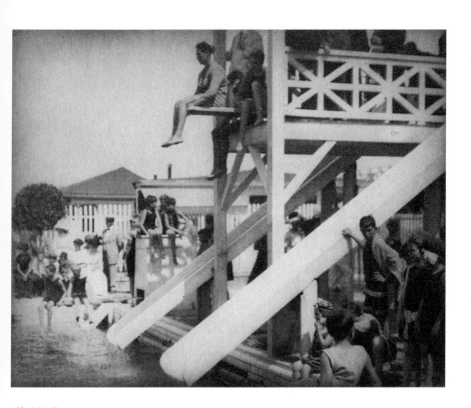

Alfred Stieglitz
The Pool – Deal (1910), 1911
Photogravure
12.6 x 15.9 cm

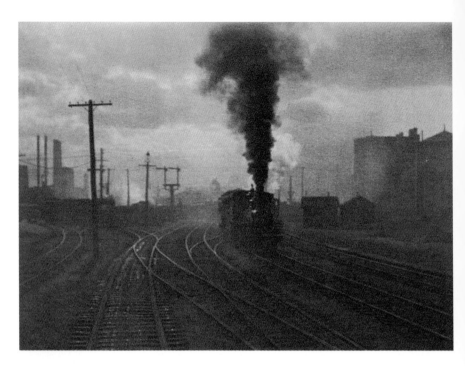

Alfred Stieglitz
The Hand of Man (1902), 1911
Photogravure
15.9 x 21.4 cm

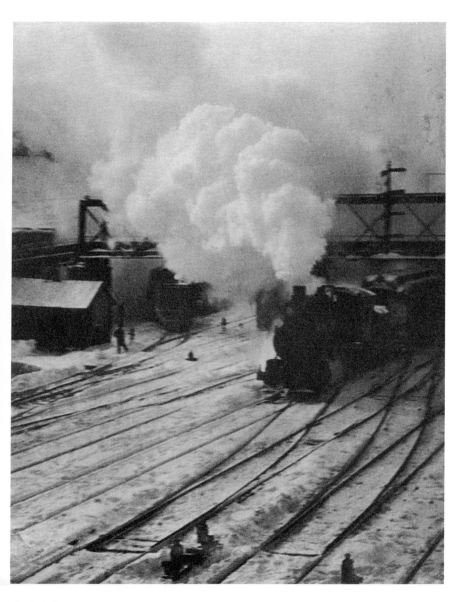

Alfred Stieglitz
In the New York Central Yards (1903), 1911
Photogravure
19.4 x 15.9 cm

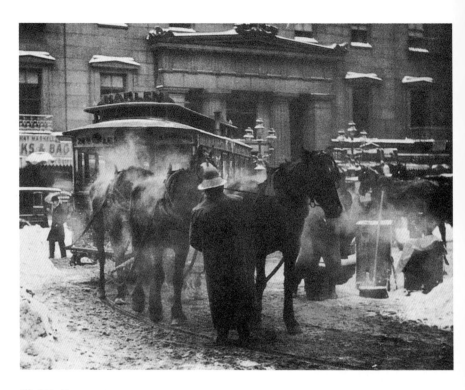

Alfred Stieglitz
The Terminal (1892), 1911
Photogravure
12.1 x 15.9 cm

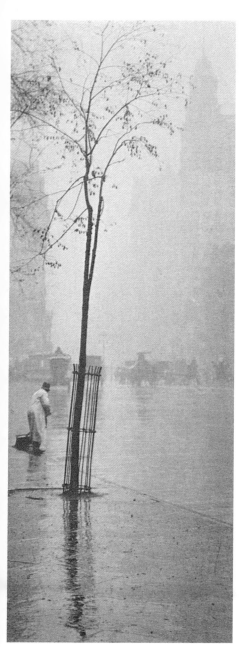

Alfred Stieglitz
Spring Showers, New York (1900), 1911
Photogravure
23 x 9.2 cm

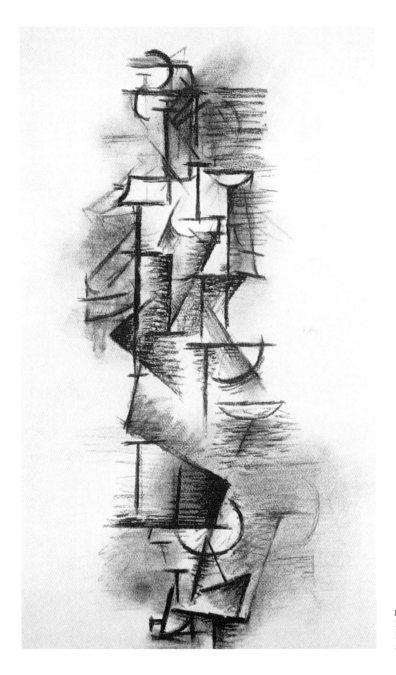

Pablo Picasso
Drawing, 1911
Half-tone reprodu[
27.9 x 17.3 cm

THE RELATION OF TIME TO ART

AFTER living constantly for two years in the quiet and seclusion of a London suburb, and then suddenly being plunged into the rush and turmoil of New York, where time and space are of more value than in any other part of our world, this consideration of the relation of time to art has been forced upon me.

As photography has, up to the present time, been my sole means of expression, I can best understand and attempt to explain my meaning by consideration of the part time plays in the art of the camera.

Photography is the most modern of the arts, its development and practical usefulness extends back only into the memory of living men; in fact, it is more suited to the art requirements of this age of scientific achievement than any other. It is, however, only by comparing it with the older art of painting that we will get the full value of our argument plainly before us; and in doing so we shall find that the essential difference is not so much a mechanical one of brushes and pigments as compared with a lens and dry plates, but rather a mental one of a slow, gradual, usual building up, as compared with an instantaneous, concentrated mental impulse, followed by a longer period of fruition. Photography born of this age of steel seems to have naturally adapted itself to the necessarily unusual requirements of an art that must live in skyscrapers, and it is because she has become so much at home in these gigantic structures that the Americans undoubtedly are the recognized leaders in the world movement of pictorial photography.

Just imagine any one trying to paint at the corner of Thirty-fourth street, where Broadway and Sixth avenue cross! The camera has recorded an impression in the flashing fragment of a second. But what about the training, you will say, that has made this seizing of the momentary vision possible? It is, let me tell you, no easy thing to acquire, and necessitates years of practice and something of the instinctive quality that makes a good marksman. Just think of the combination of knowledge and sureness of vision that was required to make possible Stieglitz's "Winter on Fifth Avenue." If you call it a "glorified snapshot" you must remember that life has much of this same quality. We are comets across the sky of eternity.

It has been said of me, to come to the personal aspect of this problem, that I work too quickly, and that I attempt to photograph all New York in a week. Now to me New York is a vision that rises out of the sea as I come up the harbor on my Atlantic liner, and which glimmers for a while in the sun for the first of my stay amidst its pinnacles; but which vanishes, but for fragmentary glimpses, as I become one of the grey creatures that crawl about like ants, at the bottom of its gloomy caverns. My apparently unseemly hurry has for its object my burning desire to record, translate, create, if you like, these visions of mine before they fade. I can do only the creative part of photography, the making of the negative, with the fire of enthusiasm burning at the white heat; but the final stage, the print, requires quiet contemplation, time, in fact, for its fullest expression. That is why my best work is from American negatives printed in England.

Think for a moment of the limitations of photography. You are confined to what a friend of mine sums up in the high-sounding words, "contemporary actuality," and now I find that my vision of New York has gradually taken upon itself a still narrower range, for it is only at twilight that the city reveals itself to me in the fulness of its beauty, when the arc lights on the Avenue click into being. Many an evening I have watched them and studied carefully just which ones appeared first and why. They begin somewhere about Twenty-sixth street, where it is darkest, and then gradually the great white globes glow one by one, up past the Waldorf and the new Library, like the stringing of pearls, until they burst out into a diamond pendant at the group of hotels at Fifty-ninth street.

Probably there is a man at a switchboard somewhere, but the effect is like destiny, and regularly each night, like the stars, we have this lighting up of the Avenue.

<div align="right">ALVIN LANGDON COBURN.</div>

OUR ILLUSTRATIONS

The Plates in this number of CAMERA WORK are, with one exception, devoted to the work of Mr. Alfred Stieglitz. There are sixteen in all, and they represent a series of "Snapshots" most of which were made in and about New York. The number appearing after each title refers to the date when the original negative was made. The photogravures were produced directly from the original negatives. The Manhattan Photogravure Company who are responsible for the editions deserve a word of special praise for the sympathy with which they have done their work.

The other Plate in this issue of CAMERA WORK is a reproduction of one of Picasso's drawings, the original of which was exhibited in the Picasso exhibition held in the Photo-Secession Galleries during last April. At some future time it is planned to devote at least part of a number of the magazine to the work of this most interesting artist whose exhibition at the Secession Galleries is referred to in "Photo-Secession Notes". The excerpt from Plato reprinted elsewhere in this number has seemed to us interesting in connection with the latest phase of Picasso's evolution.

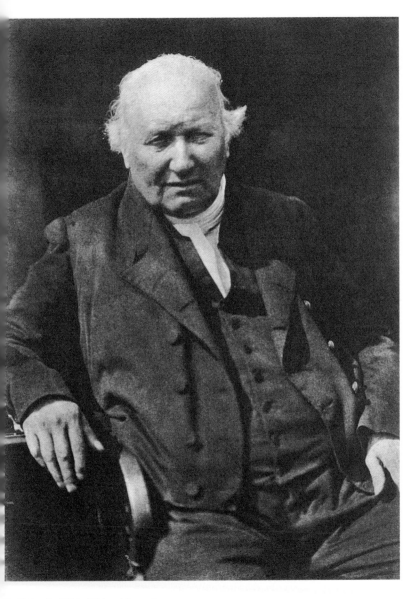

David Octavius Hill (and Robert Adamson)
Principal Haldane, 1912
Photogravure
21.5 x 15.8 cm

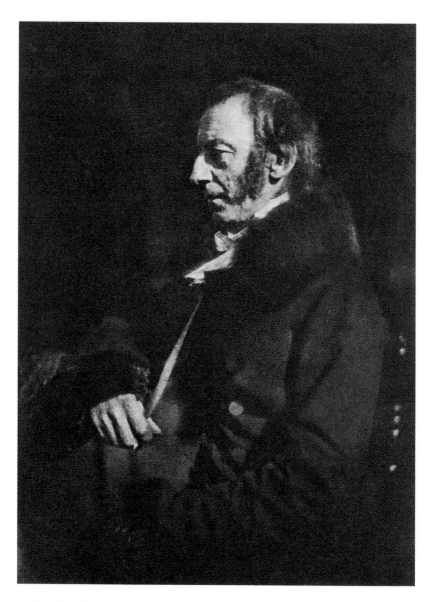

David Octavius Hill (and Robert Adamson)
The Marquis of Northampton, 1912
Photogravure
19.9 x 14.9 cm

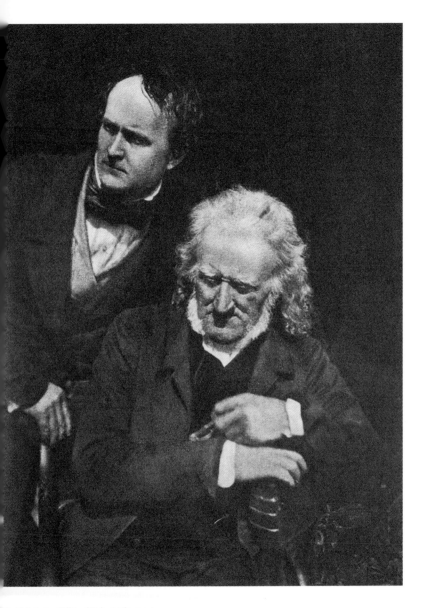

David Octavius Hill (and Robert Adamson)
Handyside Ritchie and Wm. Henning, 1912
Photogravure
21.3 x 15.8 cm

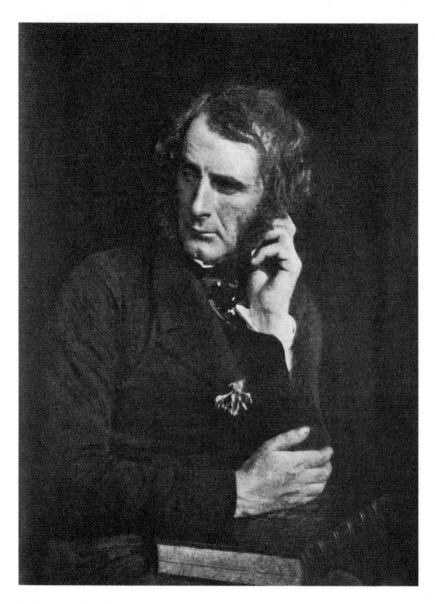

David Octavius Hill (and Robert Adamson)
Sir Francis Grant, P. R. A., 1912
Photogravure
20 x 14.7 cm

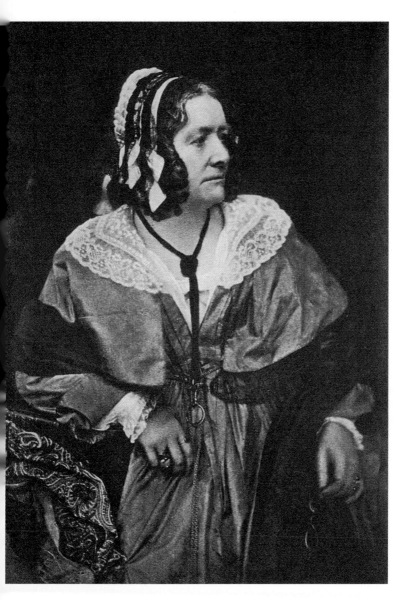

David Octavius Hill (and Robert Adamson)
Mrs. Anna Brownell Jameson, 1912
Photogravure
20.2 x 14.6 cm

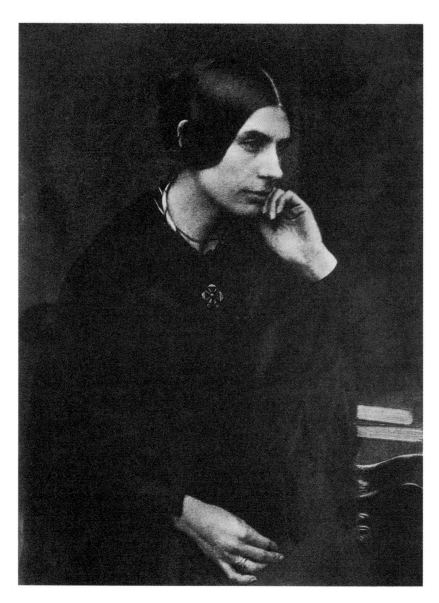

David Octavius Hill (and Robert Adamson)
Lady in Black, 1912
Photogravure
20.9 x 15.7 cm

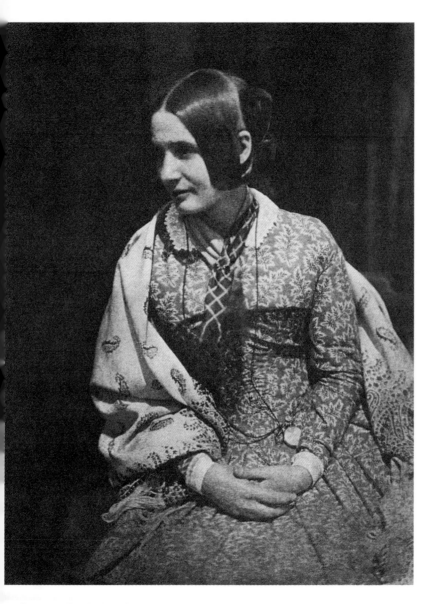

David Octavius Hill (and Robert Adamson)
Lady in Flowered Dress, 1912
Photogravure
20.5 x 15.7 cm

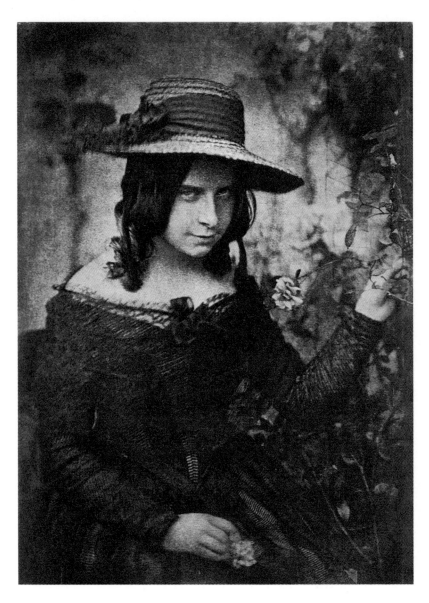

David Octavius Hill (and Robert Adamson)
Girl in Straw Hat, 1912
Photogravure
21.5 x 15.8 cm

David Octavius Hill (and Robert Adamson)
Mr. Rintoul, Editor "Spectator", 1912
Photogravure
20.2 x 14.9 cm

EXHIBITION OF PRINTS BY
BARON AD. DE MEYER

THE exhibition of photographs by Baron Ad. de Meyer, recently held in the Gallery of the Photo-Secession, created its air of distinction. This is to say, that the prints were out of the ordinary, since the little room has acquired for itself an atmosphere which is quite foreign to routine impressions. For the visitors who frequent it, whether they sympathize or not with the work shown, at least have the habit of expecting to see something that differs from the staple art-ware of other exhibitions. They look for a *choc* and, even if what they receive is a shock in the plain ordinary English sense, are disposed to tolerate the outrage, because it stimulates thought and speculation. They have the satisfaction of being piqued to rebellion if not appreciation. They are at least stirred to think, which itself may be something out of the ordinary.

To those who do not sympathize with, because they cannot understand, the motive which inspires Mr. Stieglitz in his work at the Little Galleries, this will sound like sensationalism. And, indeed, it is unfortunately impossible for a man to blaze a trail which is out of the ordinary without running the risk of incurring this charge. For example it is alien to usual experience that a man should promote exhibitions without any idea of gain or even of pleasing the public. That his motive should be, on the one hand, to give the public a chance of seeing what he thinks it ought to be pleased to see and will be able to see nowhere else in New York—at least until the example set at the Little Gallery has been followed, as in the case of Rodin's and Matisse's drawings, by the Metropolitan Museum—seems like an amiable form of lunacy. That he should be on the lookout for evidence of honest individuality in young unknown painters and strive to encourage it by exhibitions which display the weakness as well as the strength of the beginner—what can this be but sensationalism?

No one more than Mr. Stieglitz recognizes that there is a danger of this sort of thing degenerating into sensationalism, or is more afraid of it. Accordingly, he tries to balance one exhibition with another; off-setting, for example, the startling radicalism of a Picasso with the stable conservatism of an Octavius Hill; the experimental work of some young painter with the assured achievement of another photographer, such as De Meyer. Nor does the delicious irony of this escape one. For years, Mr. Stieglitz has taken the advanced position that photography is entitled to be considered a medium of pictorial art, and has been ridiculed by the critics of painting. Now that the latter are foaming in impotent bewilderment at the vagaries of modern painting he offers as an antidote the sanity of the photographic process. After claiming for photography an equality of opportunity with painting, he turns about and with devilishly remorseless logic shows the critics, who have grown disposed to accept this view of photography, that they are again wrong. As long as painting was satisfied, as it has been for half a century, to represent the appearances of things, photography could emulate it. Now, however, that it

is seeking to render a vision of things not as they are palpable to the eye but as they impress the imagination, Mr. Stieglitz proves, what he has known all along, that photography is powerless to continue its rivalry with painting. He has, in fact, called the bluff on the recent pretensions of painting by showing that it is in its motive essentially photographic.

There was, therefore, a streak of malice aforethought in arranging this exhibition of De Meyer's prints. For the latter are far above the average; represent an honest and exceedingly skilful use of the medium, and display more pictorial imagination than is discernible in the majority of photographs and paintings. They illustrate to an unusual degree the flexibility of the camera's resources; and thereby are all the stronger evidence of the latter's limitations, as compared with those of the draughtsman and painter.

For De Meyer unquestionably has vision. He sees beyond the mere prose of his subject; his imagination realizes how the significance of the facts may be enhanced by pictorial expression. Take, for example, his series of still-life subjects, in which flowers and fruit are arranged in glass vessels, upon a glass tray on the polished surface of a table. One of them, "Water-lilies," was exhibited on this occasion. In its lucid purity of color, the magic of its shimmering light and evanescent half-tones, and the *enveloppe* of silky atmosphere which unites everything into an ensemble of impression, it is a veritable dream of loveliness. The poetry, latent in the material, hovers like fragrant breath over the whole conception.

Or, again, in the series in which the subjects are dainty porcelain figures, what exquisiteness of fancy is revealed! Color, texture, tone and lighting are at the service of an imagination which has felt beyond the daintiness and miniature quality of the material and invested it with a certain intangible piquancy of charm and enhanced it with a suggestion of the abstract dignity of plastic immobility. Within their range of expression, the vision rendered in these prints is delightful and complete.

In a less degree, there is a suggestion of individual vision in the portrait and model studies. Perhaps the best of these are "The Cup" and "The Silver Skirt," since here the fancy of the artist seems to have played most freely in the joy of what could be done with the treatment of lighted textures. Meanwhile, portraits, such as those of "Mrs. Brown Potter" and "Percy Grainger," while far less individualized in treatment, have yet a distinction of superior feeling, such as portraiture, whether in painting or photography, none too often exhibits.

And throughout this scale of expression how is the result achieved? The very simplicity of the means involves its own high commendation. For it is founded upon that none too common quality of honesty: the honest study of the resources of the camera and the platinum method of printing; the honest purpose to rely on these resources directly and exclusively, and the honest purpose to shape the vision to what without trickery or evasion these may be made to accomplish. Baron de Meyer is a man of the world, of wide culture and sympathy with diverse forms of aesthetic expression. All this has tended to broaden and refine his vision; but has never tempted him to distort

the possibilities of the process to the requirements of his vision. On the contrary, with the logic and conscience of a true craftsman he has adjusted the latter to the technical resources. He discovered, for example, what I suppose is known to many photographers, that the very inexactness of a particular uncorrected lens makes it available for rendering certain effects of light and texture; and by bringing his imagination to bear upon these possibilities he has developed results very beautiful in themselves and thoroughly individual to himself.

Thus, by making his vision amenable to the resources of the process he has made the latter serve his imagination. This seems to be distinguished by a sort of Slavic bias; tending toward exquisiteness and subtlety, to an occasional flavor of *diablerie* and a preference for abstract rather than concrete sensations. It is also purely aesthetic. That is to say, while the process and result are reasoned out, the impression itself has not been intellectualized. It is a product of intuition rather than of the intellectual faculty; a point which is worth consideration, since at first appearance De Meyer's work is modern *au point des ongles* and yet, when analyzed, is found not to involve the most modern quality, namely that of intellectualized sensation. It stimulates an exquisite refinement of feeling, but stops short of that higher stimulus to rarified intellectual content.

I venture to predict, for instance, that fifty years hence it will not prove to have such effectiveness, as after a still longer interval the "Hill" prints possess today. Yet, so long as people are interested in the pictorial resources of photography, De Meyer's prints will be likely to preserve an intrinsic value, as examples of sterling honesty and of a rarely refined individuality. They may also continue to be cited as illustrations of the flexibility of the process in its response to the varying vision of the artist and, at the same time, of how that vision is necessarily bounded by the inexorableness of the medium. CHARLES H. CAFFIN.

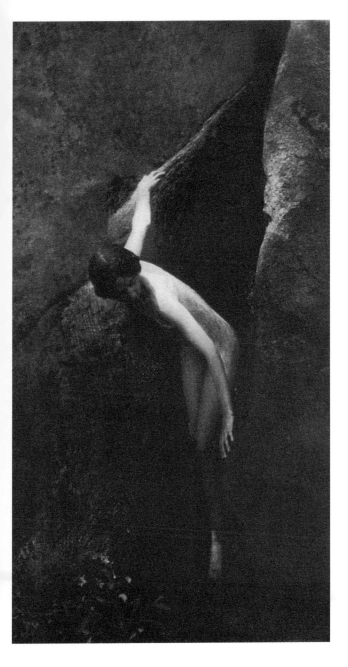

Annie W. Brigman
The Cleft of the Rock, 1912
Photogravure
23.8 x 12.9 cm

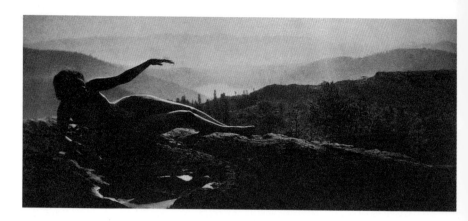

Annie W. Brigman
Dawn, 1912
Photogravure
10.5 x 24.3 cm

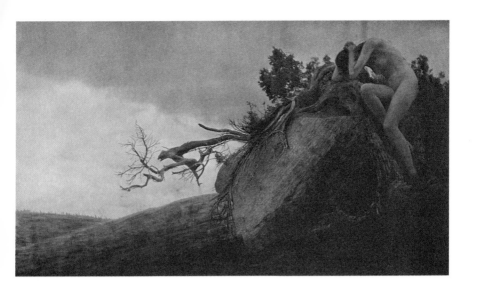

Annie W. Brigman
Finis, 1912
Photogravure
13.5 x 24 cm

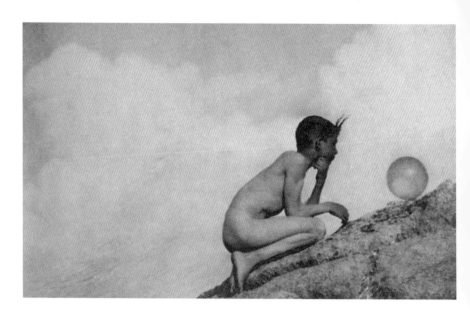

Annie W. Brigman
The Wondrous Globe, 1912
Photogravure
12.1 x 19.9 cm

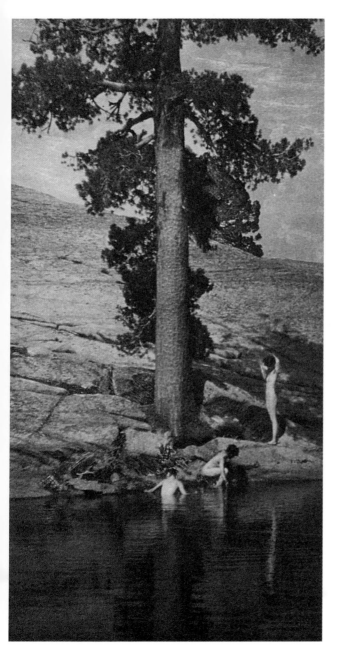

Annie W. Brigman
The Pool, 1912
Photogravure
23.6 x 12.4 cm

Karl F. Struss
Ducks, Lake Como, 1912
Photogravure
19.5 x 15.5 cm

Karl F. Struss
Sunday Morning Chester, Nova Scotia, 1912
Photogravure
19.3 x 15.7 cm

Karl F. Struss
The Outlook, Villa Carlotta, 1912
Photogravure
19.3 x 16 cm

Karl F. Struss
On the East River, New York, 1912
Photogravure
19.9 x 16 cm

Karl F. Struss
Capri, 1912
Photogravure
19.8 x 16 cm

Karl F. Struss
The Landing Place, Villa Carlotta, 1912
Photogravure
15.9 x 21.6 cm

Karl F. Struss
Over the House Tops, Miss‹
Photogravure
23.0 x 12.5 cm

Karl F. Struss
The Cliffs, Sorrento, 1912
Photogravure
15.7 x 20.8 cm

After all illusions have gone the prying Intellect still remains — the stealthy ghoul who creeps to the grave after the interment of the corpse. That is irony. That is the phase the intellectual and æsthetic worlds have reached.

Is all painting, all art, ascending into the heaven of irony, the zenith of scorn and mockery? BENJAMIN DE CASSERES.

THE ESTHETIC SIGNIFICANCE
OF THE MOTION PICTURE

NO other form of popular amusement to-day enjoys as steady and general a patronage as the moving picture shows receive.

The people in the larger cities can hardly imagine what this entertainment means to town and village populations. It is cheap and within the reach of all. And it is in many communities the one regular amusement that is offered. A town of six thousand inhabitants will easily support three to four houses with continuous performances of three reels each. Larger towns of sixty thousand residents, where concerts, lectures and theatrical performances occur more frequently, furnish sufficient patronage for eighteen to twenty of these amusement halls. This shows a decided decrease in the percentage of attendance. In the larger cities where the motion picture is taken less seriously, the percentage is still smaller. It takes the place of the theatre only among the lower strata of society.

But its popularity is undeniable. It contains some element that appeals to the masses, and whenever I see one of these auditoriums packed to standing room only, I become conscious that I am in the presence of something that touches the pulse-beat of time, something that interests a large number of people and in a way reflects their crude esthetic taste. And is it not curious, with the popularity of this kind of pictorialism, regular art exhibits should be deprived of a similar appreciation. Generally no admission is charged and yet the public does not take advantage of these opportunities with any sort of enthusiasm.

The public is as fond as ever of illustrations, stationary art, and cheap reproductions, perhaps more so than formerly, but it does not feel at home in art galleries. The fine arts seem to evade popularity. Works of art are generally so high-priced that they are beyond the means of the middle class. And merely to study them is too much of an intellectual exertion. People understand a Tschaikowsky symphony as little as an Impressionist exhibit, nevertheless ninety-nine out of a hundred will prefer to hear the concert, while one solitary individual will derive a similar pleasure and satisfaction from the paintings, for the simple reason that music is easier to enjoy. One pays a comparatively small admission, sits down and listens, and the music drifts without any personal effort into one's consciousness.

Paintings are seen to the best advantage in daylight, when most people are busy in the more material things. They have to be enjoyed standing and

walking about. One is forced to make one's own selections. Rather a laborious task, even for connoisseurs and critics.

No, there is something wrong in the present distribution of art products. Exhibitions are naught but battlefields for the survival of the fittest, and museums the morgues for pictures that are unsuitable or too unwieldy for private possession. Pictures and books should be owned by the people. Museums and circulating libraries are the products of a trust civilization. They are abnormal. Historical collections and reference libraries, like those of the Louvre and the Vatican, are not included in this statement.

Of course, there are many solitary works of art that can claim a certain popularity. Botticelli's "Spring" shares this distinction with "The Doctor's Visit" by Lucas Fildes. Madame Le Brun's portrait of herself and daughter is popular and so is Gibson's latest drawing. It is largely the problem of quality—of the work, versus quantity—of the appreciation. An explanation is difficult. My contention is that every masterpiece must possess some of the "buckeye" element, or in other words, no matter how elaborate, fascinating and exquisite in finish a painting may be, it must offer some tangible, ordinary interest that the average mind can seize in order to be truly popular. And it is this element which modern painting lacks, and which the motion picture possesses to an almost alarming degree, for it contains all the pictorialism the average person wants, plus motion.

Readers may ask whether I take these pictures seriously and whether I see any trace of art in them. Yes, honestly, I do. I know that most cultivated people feel a trifle ashamed of acknowledging that they occasionally attend moving picture shows. This is due to caste prejudice, as the largest percentage of the attendance belongs to the illiterate class (at least as far as art esthetics are concerned). To my mind there is not the slightest doubt that these performances show much that is vivid, instructive, and picturesque, and also occasionally a fleeting vision of something that is truly artistic.

Judging from the ideal standpoint that a moving picture reel should reveal action in a series of perfect pictures, of course the majority are still very imperfect and unsatisfactory. There is too much bad acting and stage scenery in most of them. And many are absolutely tawdry and foolish, in execution and sentiment. My arguments in favor refer necessarily to the more practical ones.

The French film makers are in every way our superiors. They succeed in making excursions even into purely imaginary realms. I saw a Pathé reel in color representing Poe's "The Masque of the Red Death" which was done in a masterly way. There was more real art in the composition and arrangements of these groups and natural backgrounds than can be found in the majority of paintings of our annual exhibitions. The French command better talent and more picturesque scenery. They know how to handle costume and scenes of dramatic interest. The Americans excel only when they put aside cheap studio interiors, go into the open and handle realistic episodes of modern life.

Of course, it is generally not the story which interests me but the repre-

sentation of mere incidents, a rider galloping along a mountain path, a handsome woman with hair and skirts fluttering in the wind, the rushing water of a stream, the struggle of two desperate men in some twilight atmosphere. These fragmentary bits of life, or merely of scenery, with the animating spirit of motion as main attraction, contain all the elements of pure esthetic pleasure, although we still hesitate to acknowledge it. But the motion picture will steadily gain in recognition, for it has come to stay. No doubt it will undergo many transformations. It will be in color and accompanied by phonographic speech. It may become like the piano-player, a home amusement, and also enter the domain of home portraiture. And the reels will be free of all blemishes that will obscure the image on the screen. All this, however, will not make it more artistic.

More artistic it will become solely by more artistic handling, and there is no reason why some genius like Henry Irving, Gordon Craig, or Steichen should not invade the realm of motion picture making and more fully reveal its esthetic possibilities. As long as dramatic action, story telling or records of events will constitute the principal aim, it will remain imitative of the stage. Only when poetic and pictorial expression become the main object will it develop in esthetic lines. Some literary theme will always be necessary to support the action, but it could be the theme of a painter that is stage-managed by a poet or vice versa.

Imagine Böcklin's Villa at the Sea as a motion picture:—Old Roman architecture, with waving pinions, and the approach of a coming storm. The waves would caress the shore, the leaves would be carried away by the wind, and into this scene of melancholy and solitude would enter a dark draped figure who in a few superb gestures would express the essence of grief. Many paintings of Leighton could be rendered in such a poetic fashion. And also themes of more realistic painters, like Breton, Cottet and Liebermann, would be available. Short episodes in which all the laws of composition, color and chiaroscuro are obeyed, just as in a painting, only with the difference that there would come to our vision, like a series of paintings, one perfect picture after the other, linked together by action.

Would this not be an art equally as beautiful as the painting of to-day— while more intricate, and more in harmony with our present life's philosophy!

SADAKICHI HARTMANN.

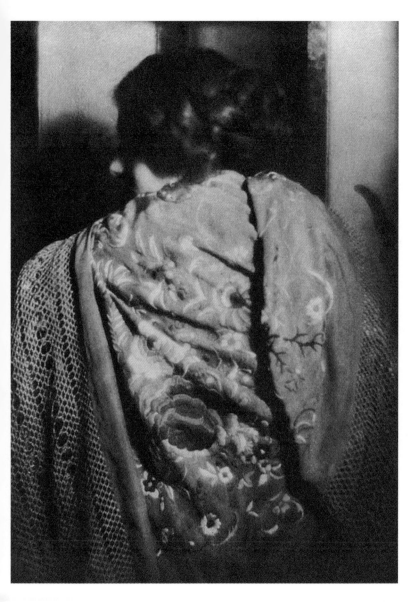

Paul B. Haviland
The Spanish Shawl, 1912
Photogravure
22.2 x 16 cm

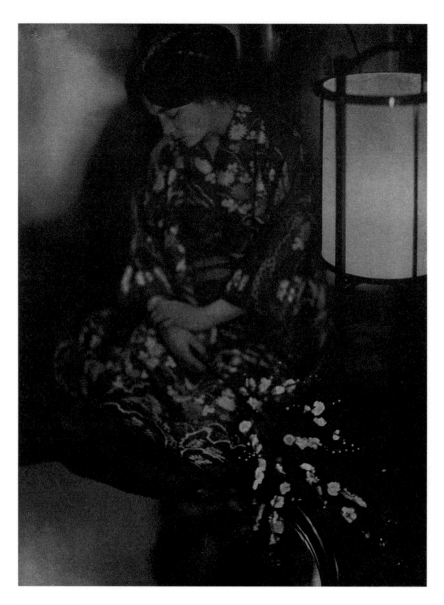

Paul B. Haviland
The Japanese Lantern, 1912
Photogravure
20.6 x 15.8 cm

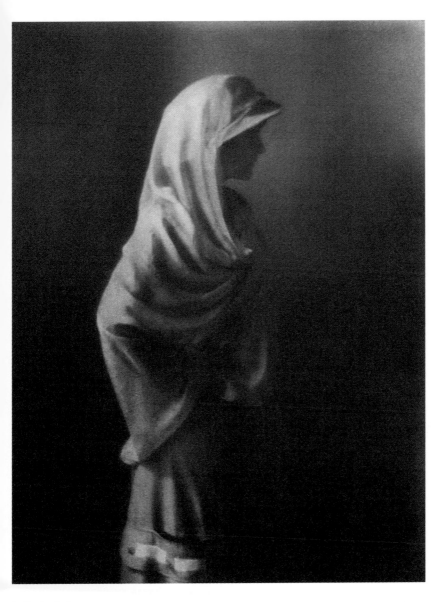

Paul B. Haviland
Miss Doris Keane, 1912
Photogravure
20.6 x 16 cm

Paul B. Haviland
Totote, 1912
Photogravure
21.0 x 16.2 cm

Paul B. Haviland
Mr. Christian Brinton, 1912
Photogravure
20.8 x 16.2 cm

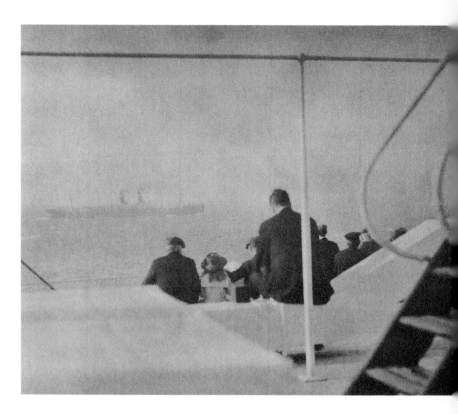

Paul B. Haviland
Passing Steamer, 1912
Photogravure
14.5 x 17.8 cm

ohn Marin
In the Tirol – No. 13, 1912
Three-colour half-tone reproduction
24.5 x 17.4 cm

John Marin
In the Tirol – No. 23, 1912
Three-colour half-tone reproduction
14.3 x 17.3 cm

Manolo
Totote, 1912
Half-tone reproduction
24.4 x 19.6 cm

Manolo
Reproduction of a Drawing, 1912
Mezzotint photogravure
19.8 x 15.7 cm

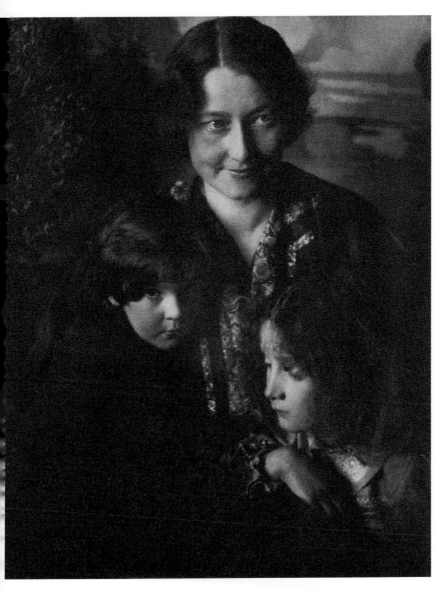

H. Mortimer Lamb
Portrait Group, 1912
Photogravure
20.1 x 15.9 cm

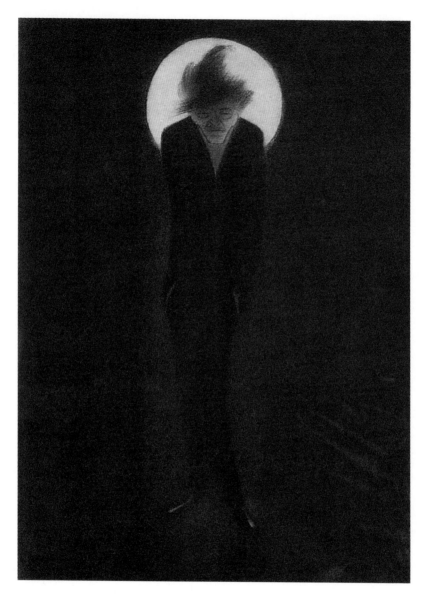

Marius de Zayas
L' Accoucheur d'Idées, 1912
Photogravure
22.2 x 16.1 cm

ONCE MORE MATISSE

(WRITTEN AFTER HAVING SEEN THE LAST EXHIBITION OF WORKS BY MATISSE IN THE PHOTO-SECESSION GALLERY)

WHAT will Matisse mean to the coming generation? Rather a strange question to ask when an artist is still exposed to the critical analysis and jeering doubt of his own generation. Yet in this instance it is tangible. Esthetically, stripped as it were of all notes of novelty, momentary influences and contentions, the essence of his work—not unlike his "Serf"—stands forth, stridulously and strenuously, as an embodiment of Strength. This is the one impression left on the mind. It is the intrinsic note that supersedes the fascination of all his other manifold gifts. This influence will remain.

As an innovator of form he is apt to be of less importance. Whenever a method of treatment becomes familiar, and easy to ply even by a beginner, the time of a new birth of imagination is inevitable. The result is a reaction. The art of our days is as vacillating in its aim and effect as the annual spring sales of millinery. There is no steadiness and solidity in the present trend of art thought. One ideal follows closely upon another. There are a dozen schools running parallel as in a race of thoroughbreds. Besides there are other men engaged in the very same problems. Every artist with original aspirations has forerunners, disciples and soulless imitators. Matisse has actual competitors. He may be made the patriarch of the movement; or this doubtful distinction will be eventually thrust upon somebody else. The centrifugal force of this movement is still elusive and shifting. The process of corrosion to which all intellectual products are subject has not yet set in.

Cézanne, Matisse, Picasso endeavor to give a new understructure to color. Their contribution to color is progressive, evolutionary. It is an expansion of impressionism. Their revolt against academic form and surface records (no matter whether of the classic or realistic school, it is idealization anyhow) is bolder, more far reaching, but it would take an augural mind indeed to prognosticate whether they have found the point of Archimedes in this respect or not. It is very much like discovering the North pole. One has to believe in hearsay.

Form and color are the only means to suggest or reproduce an illusion of the rotundity of objects in space. Form is either an elaboration or simplification of line and plane facts. With Matisse, despite all exaggeration and inconsistency, satire, anatomical and geometrical emphasis, it is simplification. But it is not a new form factor. It is rather a spiral return from a more scientific age to the primitive conceptions of an antique world, where instinct reigned supreme. The childlike attitude is impossible to the eclectic mind. Little round men, who brag incessantly about their discoveries, can not in the appearance of things feel the same innocent delight as a child in the prettiness of a world of new toys.

Matisse is at present the recipient of most rigorous denunciation. Art journalism apparently has concentrated its magnifying glass upon his technical eccentricities, and the public is at loss as to an accurate estimate of the painter's

ability. All this is meaningless to the individual appreciator. It is, alas, not only Matisse they do not understand. Nearly all pioneers of eminence share that fate. Nor is there any harm in opposition. A blank smooth surface can have no blemishes; any corrugation and discoloration can lend it a character of its own.

Matisse is the logical sequence of art events. Modern art is tame and frangible. It rarely vibrates with personal magnetism, solely with color. Painters are too busy with the conquest of technique. A *paysage intime*, or ladies sitting on a piazza represent the pinnacles of visual expoliation. If it attempts more, it generally becomes grossly illustrative. It is all grace of movement, charm of fancy, felicity of expression, the ideals of the *bourgeoisie*. Glance for a moment at the Old Masters, at a Tintoretto, Ribera, Rubens, Goya, just to mention a few. What a contrast! One can persuade oneself that some of their paintings were painted by them with fleeting eyes and foaming mouths. They show the flotsam of the soul; mental upheavals—the miry understrata of the soul.

It is not so much the expression of human passion as the product of passion itself. Matisse comes from the same lineage. Tainted as his art is with affectation, it has all been lived through, and deeply felt. He is a man who has knowledge and who expounds it with a tremendous force. His work glows as if fresh from the crucible. What you or I, or the public thinks of it, what does that matter? Art justifies its own ends. It is of no importance whatsoever whether you or I understand this whim of transforming the face and bust of a plain looking girl into a caricature, and thence into a skeletonized enigma of their most characteristic structural traits. That the public has a right to demand certain things from an artist, as lucidity, ethical dignity, for instance, is a most foolish and sorrowful contention. The artist is his own master. The public patronizes not out of any love for art (with the exception of exceptional connoisseurs perhaps) but merely because it is fond of luxuries, pastime and sport. What right then has it to dictate? All it has a right to expect is that the artist is a producer who possesses the inborn or acquired gift to express a vision of beauty to others. Art is the outcome of a mood of inspiration. Inspiration is sustained by strength. Creation demands vigor and endurance, reliance upon one's own resources and impregnability against interference from outside. The artist who is so valiantly equipped takes no heed of the public, nor even of his fellow artists. He smashes and kicks in the doors of tradition. He exerts the *Faustrecht* of superior mentality. His conviction will neither break nor yield. He looms in rugged outlines and gorgeous color by the sheer magnificence of his self-assurance. Buoyed up by the conviction that he lives to accomplish a great task he works—happy mortal!—because he likes the work. He sets himself a problem and tries to solve it for himself. He struggles and experiments—not necessarily to improve his art—but to develop it, to make it more and more, no matter how tentative and confused it may look to the beholder, the expression of his visual appreciation of beauty, from the angle of which he regards the manifestations of life, the one thing which is of value to him and possibly may be to others. It is what he feels and must say, and what he manages to say. And that is all that an artist can do. SADAKICHI HARTMANN.

EXTRACTS FROM "THE SPIRITUAL IN ART"

* * * * * * * * * * * * *

These are the seekers of the inner spirit in outer things.
After a different fashion, and more nearly related to the purer methods of painting, did Cézanne, the seeker for new laws of form, take on like tasks. Cézanne knew how to put a soul into a tea-cup, or, to speak more correctly, he treated the cup as if it were a living thing. He raised "nature morte" (still-life) to that height where the outer dead things become essentially living. He treated things as he treated human beings, because he was gifted with the power of seeing the inner life of everything. He realizes them as color expressions, picturing them with the painter's inner note and compelling them to shapes which, radiating an abstract ringing harmony, are often drawn up in mathematical forms. What he places before us is not a human being, not an apple, not a tree, but all these things Cézanne requires for the purpose of creating an inner melodious painting, which is called the picture. That, also, is how one of the latest of modern Frenchmen, Henri Matisse, understands his own work. Matisse paints "pictures," and in these he seeks to reproduce the "divine" that is in things. To attain this end he requires no other means than the object (be it a man or anything else) for his starting point, and the painter's peculiar means—Color and Form.
Led by the purely personal quality of the Frenchman, specially and excellently gifted as a colorist, Matisse lays the greatest stress and weight on color. Like Debussy, he is not always able to free himself from conventional ideas of beauty—Impressionism runs in his blood. That is why we find in Matisse's work which is the expression of the larger, inward, living fact and which has been called forth as the necessary product of his point of view, other paintings which are chiefly the product of outward influences, outward stimuli (how often one thinks of Manet in this connection!), and chiefly or finally expressions of the outer world. Here is to be seen how the specially French conception of beauty in art, with its refined, epicurean and pure ringing melodious quality, is carried over clouds to cool and abiding heights.
That other great Parisian, the Spaniard, Pablo Picasso, never served this Beauty. Always moved, and always tempestuously torn by a compulsion for self-expression, Picasso throws himself from one extreme of means to another. If there is a chasm between the methods, Picasso takes a mad leap, and there he is on the other side to the astonishment of the enormous mass of followers. Just when these think they have reached him, the wearying descent and ascent must begin again for them. That is how the latest French movement of Cubists arose. Picasso strives to achieve construction by numerical proportion. In his last work (1911) he arrives by a logical road to an annihilation of the material, not by analysis, but by a kind of taking to pieces of each single part and a constructive laying out of them as a picture. At the same time his work shows in a remarkable way his desire to retain the appearance of the material things. Picasso is afraid of no means. If he disturbed by color in a problem of pure line form he throws color overboard and paints a picture in brown and white. And these problems are the high water mark of his art. Matisse—Color. Picasso—Form. Two great highways to one great goal.

<div style="text-align: right">Kandinsky.
(Translated from the German.)</div>

THE EXHIBITION OF CHILDREN'S DRAWINGS

WHAT is the purpose of exhibiting drawings by children, many loyal frequenters of the Little Galleries may have asked themselves. Is there really any deeper meaning attached to them and do they bear any relation to the works of art that have during the last few years been shown in the gray little chamber at Fifth Avenue?

Most visitors had to admit that these infantile excursions into the realm of form and color were of peculiar interest. The selection was carefully made from a raft of material; but it was not this discrimination which made the exhibition worthy of special consideration. Children's drawings, even the crudest, generally contain some note of interest. The exhibition at this particular place and time was like a commentary on modern art ideas, it recalled some elemental qualities that art has lost and which might do much, if attainable at all, to imbue it with a fresh and exquisite virility. How does a child manage in a few lines, rapidly and easily scrawled down, to represent a man on horseback or indicate a landscape! They may be caricatures, travesties, ludicrous nonsense, if you like, but they are neither shallow nor insincere. And despite being contortions and misstatements of facts they contain any amount of allusions, happy touches, notes of keen and sympathetic observation which even prodigious memory and vast learning could not render more satisfactorily.

With the majority of grown up folks the pursuit of art is an engrossing occupation. It leaves but few opportunities for real pleasure. Children draw without a special purpose. There is no responsibility prompting the performance, and no concession to make. It is purely an amusement, the pleasure of a moment. They reveal themselves without hesitancy. They do not attempt to flatter or idealize. Fond of startling contrast and glaring colors they see things vividly and express them strongly, genuinely, without subterfuge. And the honest humble toil of these little draughtsmen to put the plainness of appearances into calligraphic epigrams is due to the purity and alertness of their vision. Every new object they encounter, every incident of life they witness is an event full of curiosity and wonder. Every new record on their retina amounts to a conquest. Wherever they look, life is a book of revelations, and their faces turn with unwonted expression and eager expectancy. They are romanticists by force of this fervency to receive impressions; adventures in reach of some golden fleece, even if it is only a stick of candy, the thin sheet poster of the coming circus, or an apple purloined from a neighbor's yard.

Not that they are absolutely free. Routine and conventions are also darkening child life, and honesty of selection in regard to their pictorial efforts is not possible even at this early stage. Parental influence, pedantic advice of the drawing teacher, or reminiscences and reflections from illustrations seen in picture books and magazine creep unconsciously into their compositions. Nor are their efforts devoid of the influences of tradition. They represent art in an embryonic state; a Japanese child draws entirely different than an

American one. But they can claim honesty of execution. Children draw when they feel the impulse. The idea is vague as mist on a light summer morning. The motif develops while the children are at work. The directness of the performance triumphs over all technical obstructions. As it does not strive for a certain regulated perfection of representation—the bane of the accomplished technician,—it eliminates detail, and although crowded with contradictions, it comes down to fundamentals. The little craftsmen stop as soon as they feel bored, but while they work they do so with wonderful earnestness and enthusiasm. And after that performance is done and shown to the person nearest in reach, the piece of paper is carelessly tossed aside. It has become valueless in their eyes; it is forgotten like the incidents of a nursery game. It is treasured only by sober "Olympians" who take a pride in the cleverness of their offspring.

Quite a lesson in the conduct of life as might be applied to the artist! Alas, to combine strength and beauty with maturity of expression, we must sacrifice naturalness—at least the finest part of it. Education towards perfection throttles straightforwardness. The red Indian squaw ornamented her baskets and blankets in that childlike fashion. All primitive embellishments of utilitarian articles were made that way, but that naïvete of performance was lost when art became a profession and a money-making device. It has become an ideal that only a few solitary workers cherish and strive to maintain. It is possible only to true greatness of soul. The human mind wavers between two abysses. On one side lies the gulf of unconsciousness from which all life springs and in which all lower manifestations of nature subsist. On the other side heaves the sea of insanity, the extreme of the fullest appreciation of existence, where man loses his identity to interpret another personality. The child thrives in the realm of unconsciousness; the great artist, like the madman who believes himself to be a king or Jesus Christ, becomes one with the work he creates. Shakespeare was Hamlet while he wrote it. Whistler embodied night when he painted his nocturnes. Wagner became elemental when he encaged in sound the rushing musical waters of the Rhine. The child rises slowly from the state of unconsciousness, that resembles the soul state of the idiot whose mind dissolves in the all, to higher stages of development where it can comprehend and interpret individual manifestations of life. Will destroys unconsciousness. Artists depending on strength alone steadily approach the state of utmost dramatic intensity. Few cover the whole range of human thought. Those are the greatest. They remain simple as children but unconsciously in their art become identical with the object of their creation.

This is what the exhibition of children's drawings suggested to me. No doubt, they conveyed other thoughts and sentiments to other minds. And that is the aesthetic value of these abstract pictorial visions.

SADAKICHI HARTMANN.

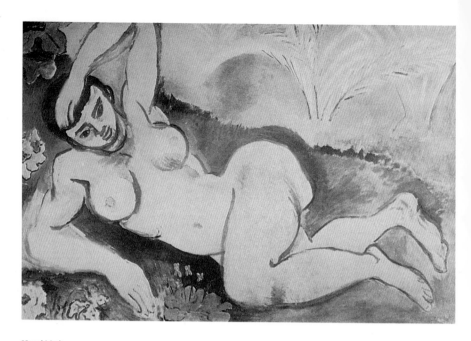

Henri Matisse
Untitled (Blue Nude – Souvenir de Biskrà), 1912
Half-tone reproduction
15.2 x 23.3 cm

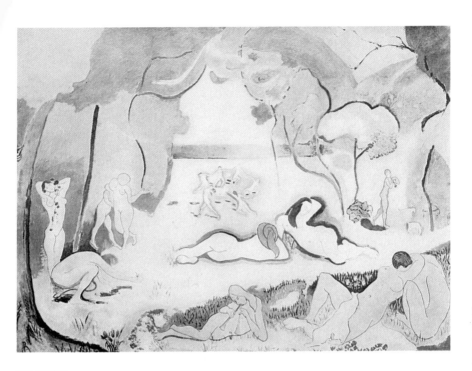

Henri Matisse
The Joy of Life, 1912
Half-tone reproduction
15.2 x 21.2 cm

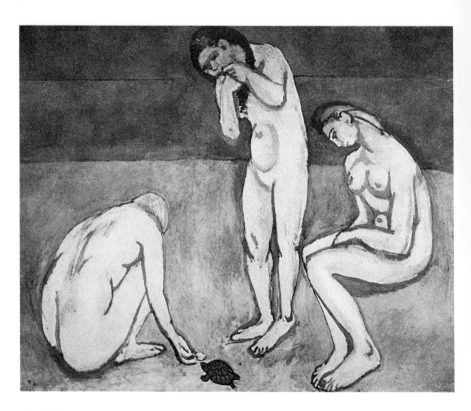

Henri Matisse
Untitled (Bathers with a Turtle), 1912
Half-tone reproduction
15.2 x 18.8 cm

Henri Matisse
Untitled (Still Life in Venetian Red), 1912
Half-tone reproduction
15.1 x 18.3 cm

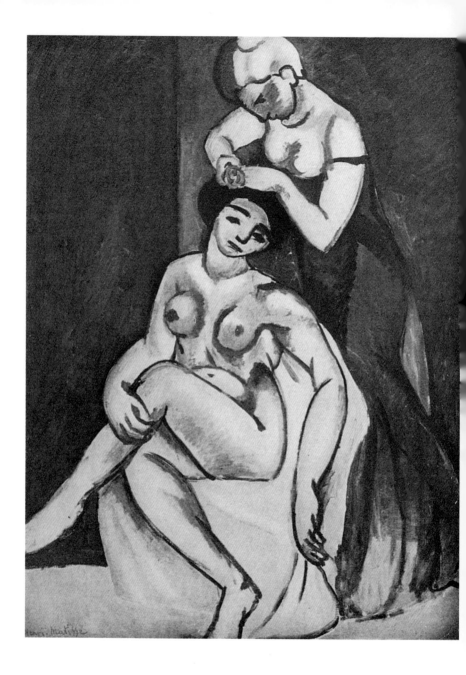

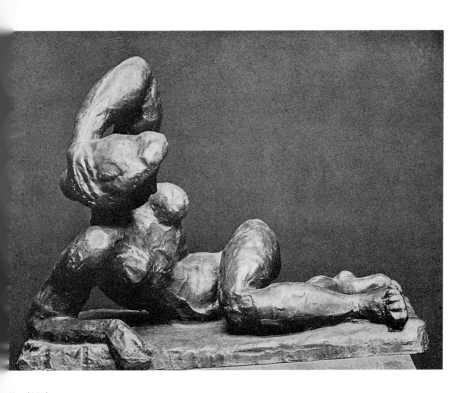

Henri Matisse
Sculpture, 1912
Half-tone reproduction
13 x 15.1 cm

← Henri Matisse
Hair-Dressing, 1912
Half-tone reproduction
20.1 x 15.2 cm

Henri Matisse
Sculpture, 1912
Half-tone reproduction
19.6 x 15.1 cm

Pablo Picasso
The Wandering Acrobats, 1912
Half-tone reproduction
16 x 12.5 cm

Pablo Picasso
Untitled, 1912
Half-tone reproduction
19.4 x 15.1 cm

Pablo Picasso
Spanish Village, 1912
Half-tone reproduction
16.9 x 14.1 cm

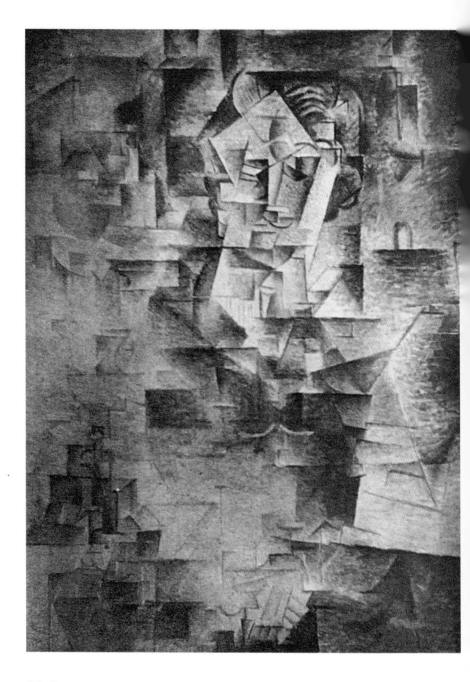

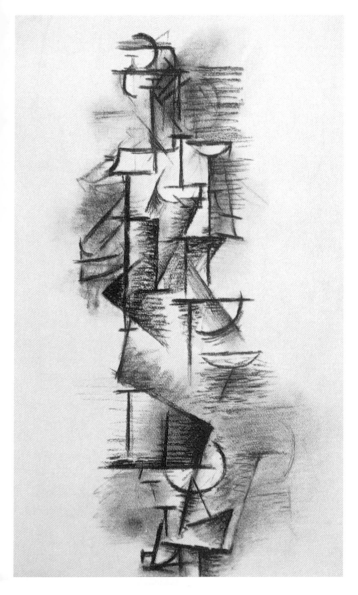

Pablo Picasso
Drawing, 1912
Half-tone reproduction
27.8 x 17.2 cm

← Pablo Picasso
Portrait, M. Kahnweiler, 1912
Half-tone reproduction
21.5 x 15.5 cm

Pablo Picasso
Sculpture, 1912
Half-tone reproduction
19.5 cm x 15.1 cm

Pablo Picasso
Sculpture, 1912
Half-tone reproduction
18.1 x 15.1 cm

EDITORIAL

THIS number of CAMERA WORK contains two articles written by Miss Gertrude Stein, an American resident in Paris.

But while it so happens that one of these articles treats of Henri Matisse and the other of Pablo Picasso; and while the text is accompanied by fourteen reproductions of representative paintings and sculptures by these artists; the fact is that these articles themselves, and not either the subjects with which they deal or the illustrations that accompany them, are the true *raison d'être* of this special issue.

A considerable number of the exhibitions that have been held by the Photo-Secession during the past five years have been devoted to phases of a general art movement that originated in France and which, with a merely chronological appropriateness, has been christened Post-Impressionism.

The development of this movement is the outward and visible sign of an intellectual and esthetic attitude at once at odds with our familiar traditions and undreamed of by most of our generation. So that its attempts at self-expression are more or less puzzling, if not wholly unintelligible, to the average observer who approaches them for the first time. And while this is especially true when the attempted expression is made through an art like painting (in the interpretation of which the average observer is only sufficiently trained to be able to recognize, when he meets it, that which habit has taught him to look for); it happens that the movement found its first expression in the field of painting and that in that field have appeared its most striking, and therefore its most discussed manifestations.

It must, however, be apparent that if the expression came through an art with the raw materials and rough practice of which we were ourselves familiar—let us say through the art of literature, whose raw material is words—even an unpiloted navigator of the unknown might feel his way into the harbor of comprehension.

And it is precisely because, in these articles by Miss Stein, the Post-Impressionist spirit is found expressing itself in literary form that we thus lay them before the readers of CAMERA WORK in a specially prepared and supplemental number.

These articles bear, to current interpretative criticism, a relation exactly analogous to that born by the work of the men of whom they treat to the painting and sculpture of the older schools. So close, indeed, is this analogy that they will doubtless be regarded by many as no less absurd, unintelligible, radical or revolutionary than the so-called vagaries of the painters whom they seek to interpret.

Yet—they employ a medium in the technical manipulation of which we are all at least tyros.

They are expressed in words.

And hence they offer—to all who choose to examine them with an inquiring mind—a common denominator of comprehension; a Rosetta stone of comparison; a decipherable clew to that intellectual and esthetic attitude which underlies and inspires the movement upon one phase of which they are comments and of the extending development of which they are themselves an integral part.

We wish you the pleasure of a hearty laugh at them upon a first reading. Yet we confidently commend them to your subsequent and critical attention.

HENRI MATISSE

ONE was quite certain that for a long part of his being one being living he had been trying to be certain that he was wrong in doing what he was doing and then when he could not come to be certain that he had been wrong in doing what he had been doing, when he had completely convinced himself that he would not come to be certain that he had been wrong in doing what he had been doing he was really certain then that he was a great one and he certainly was a great one. Certainly every one could be certain of this thing that this one is a great one.

Some said of him, when anybody believed in him they did not then believe in any other one. Certainly some said this of him.

He certainly very clearly expressed something. Some said that he did not clearly express anything. Some were certain that he expressed something very clearly and some of such of them said that he would have been a greater one if he had not been one so clearly expressing what he was expressing. Some said he was not clearly expressing what he was expressing and some of such of them said that the greatness of struggling which was not clear expression made of him one being a completely great one.

Some said of him that he was greatly expressing something struggling. Some said of him that he was not greatly expressing something struggling.

He certainly was clearly expressing something, certainly sometime any one might come to know that of him. Very many did come to know it of him that he was clearly expressing what he was expressing. He was a great one. Any one might come to know that of him. Very many did come to know that of him. Some who came to know that of him, that he was a great one, that he was clearly expressing something, came then to be certain that he was not greatly expressing something being struggling. Certainly he was expressing something being struggling. Any one could be certain that he was expressing something being struggling. Some were certain that he was greatly expressing this thing. Some were certain that he was not greatly expressing this thing. Every one could come to be certain that he was a great man. Any one could come to be certain that he was clearly expressing something.

Some certainly were wanting to be needing to be doing what he was doing, that is clearly expressing something. Certainly they were willing to be wanting to be a great one. They were, that is some of them, were not wanting to be needing expressing anything being struggling. And certainly he was one not greatly expressing something being struggling, he was a great one, he was clearly expressing something. Some were wanting to be doing what

he was doing that is clearly expressing something. Very many were doing what he was doing, not greatly expressing something being struggling. Very many who were wanting to be doing what he was doing were not wanting to be expressing anything being struggling.

There were very many wanting to be doing what he was doing that is to be ones clearly expressing something. He was certainly a great man, any one could be really certain of this thing, every one could be certain of this thing. There were very many who were wanting to be ones doing what he was doing that is to be ones clearly expressing something and then very many of them were not wanting to be being ones doing that thing, that is clearly expressing something, they wanted to be ones expressing something being struggling, something being going to be some other thing, something being going to be something some one some-time would be clearly expressing and that would be something that would be a thing then that would then be greatly expressing some other thing than that thing, certainly very many were then not wanting to be doing what this one was doing clearly expressing something and some of them had been ones wanting to be doing that thing wanting to be ones clearly expressing something. Some were wanting to be ones doing what this one was doing wanted to be ones clearly expressing something. Some of such of them were ones certainly clearly expressing something, that was in them a thing not really interesting than any other one. Some of such of them went on being all their living ones wanting to be clearly expressing something and some of them were clearly expressing something.

This one was one very many were knowing some and very many were glad to meet him, very many sometimes listened to him, some listened to him very often, there were some who listened to him, and he talked then and he told them then that certainly he had been one suffering and he was then being one trying to be certain that he was wrong in doing what he was doing and he had come then to be certain that he never would be certain that he was doing what it was wrong for him to be doing then and he was suffering then and he was certain that he would be one doing what he was doing and he was certain that he should be one doing what he was doing and he was certain that he would always be one suffering and this then made him certain this, that he would always be one being suffering, this made him certain that he was expressing something being struggling and certainly very many were quite certain that he was greatly expressing something being struggling. This one was one knowing some who were listening to him and he was telling

very often about being one suffering and this was not a dreary thing to any one hearing that then, it was not a saddening thing to any one hearing it again and again, to some it was quite an interesting thing hearing it again and again, to some it was an exciting thing hearing it again and again, some knowing this one and being certain that this one was a great man and was one clearly expressing something were ones hearing this one telling about being one being living were hearing this one telling this thing again and again. Some who were ones knowing this one and were ones certain that this one was one who was clearly telling something, was a great man, were not listening very often to this one telling again and again about being one being living. Certainly some who were certain that this one was a great man and one clearly expressing something and greatly expressing something being struggling were listening to this one telling about being living telling about this again and again and again. Certainly very many knowing this one and being certain that this one was a great man and that this one was clearly telling something were not listening to this one telling about being living, were not listening to this one telling this again and again.

This one was certainly a great man, this one was certainly clearly expressing something. Some were certain that this one was clearly expressing something being struggling, some were certain that this one was not greatly expressing something being struggling.

Very many were not listening again and again to this one telling about being one being living. Some were listening again and again to this one telling about this one being one being in living.

Some were certainly wanting to be doing what this one was doing that is were wanting to be ones clearly expressing something. Some of such of them did not go on in being ones wanting to be doing what this one was doing that is in being ones clearly expressing something. Some went on being ones wanting to be doing what this one was doing that is, being ones clearly expressing something. Certainly this one was one who was a great man. Any one could be certain of this thing. Every one would come to be certain of this thing. This one was one certainly clearly expressing something. Any one could come to be certain of this thing. Every one would come to be certain of this thing. This one was one, some were quite certain, one greatly expressing something being struggling. This one was one, some were quite certain, one not greatly expressing something being struggling.

GERTRUDE STEIN.

PABLO PICASSO

O NE whom some were certainly following was one who was completely charming. One whom some were certainly following was one who was charming. One whom some were following was one who was completely charming. One whom some were following was one who was certainly completely charming.

Some were certainly following and were certain that the one they were then following was one working and was one bringing out of himself then something. Some were certainly following and were certain that the one they were then following was one bringing out of himself then something that was coming to be a heavy thing, a solid thing and a complete thing.

One whom some were certainly following was one working and certainly was one bringing something out of himself then and was one who had been all his living had been one having something coming out of him.

Something had been coming out of him, certainly it had been coming out of him, certainly it was something, certainly it had been coming out of him and it had meaning, a charming meaning, a solid meaning, a struggling meaning, a clear meaning.

One whom some were certainly following and some were certainly following him, one whom some were certainly following was one certainly working.

One whom some were certainly following was one having something coming out of him something having meaning, and this one was certainly working then.

This one was working and something was coming then, something was coming out of this one then. This one was one and always there was something coming out of this one and always there had been something coming out of this one. This one had never been one not having something coming out of this one. This one was one having something coming out of this one. This one had been one whom some were following. This one was one whom some were following. This one was being one whom some were following. This one was one who was working.

This one was one who was working. This one was one being one having something being coming out of him. This one was one going on having something come out of him. This one was one going on working. This one was one whom some were following. This one was one who was working.

This one always had something being coming out of this one. This one

was working. This one always had been working. This one was alway
having something that was coming out of this one that was a solid thing
a charming thing, a lovely thing, a perplexing thing, a disconcerting thing
a simple thing, a clear thing, a complicated thing, an interesting thing, ;
disturbing thing, a repellant thing, a very pretty thing. This one was on
certainly being one having something coming out of him. This one wa
one whom some were following. This one was one who was working.

This one was one who was working and certainly this one was needin
to be working so as to be one being working. This one was one having some
thing coming out of him. This one would be one all his living having some
thing coming out of him. This one was working and then this one was working
and this one was needing to be working, not to be one having something
coming out of him something having meaning, but was needing to be working
so as to be one working.

This one was certainly working and working was something this one was
certain this one would be doing and this one was doing that thing, this one
was working. This one was not one completely working. This one was not
ever completely working. This one certainly was not completely working.

This one was one having always something being coming out of him,
something having completely a real meaning. This one was one whom some
were following. This one was one who was working. This one was one who
was working and he was one needing this thing needing to be working so as
to be one having some way of being one having some way of working. This
one was one who was working. This one was one having something come out of
him something having meaning. This one was one always having something
come out of him and this thing the thing coming out of him always had real
meaning. This one was one who was working. This one was one who was
almost always working. This one was not one completely working. This
one was one not ever completely working. This one was not one working
to have anything come out of him. This one did have something having
meaning that did come out of him. He always did have something come out
of him. He was working, he was not ever completely working. He did have
some following. They were always following him. Some were certainly
following him. He was one who was working. He was one having something
coming out of him something having meaning. He was not ever completely
working. GERTRUDE STEIN.

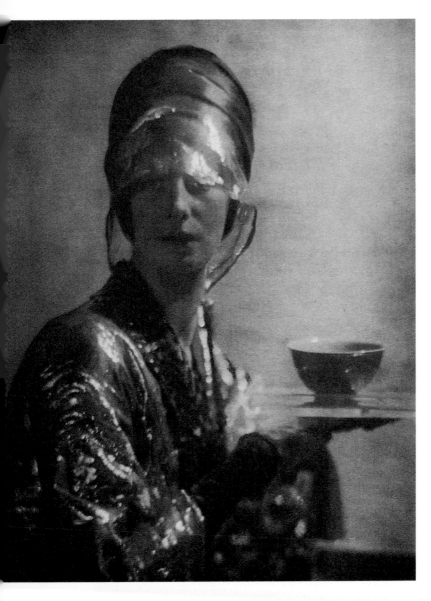

Baron A. de Meyer
The Cup, 1912
Photogravure
21.5 x 16.4 cm

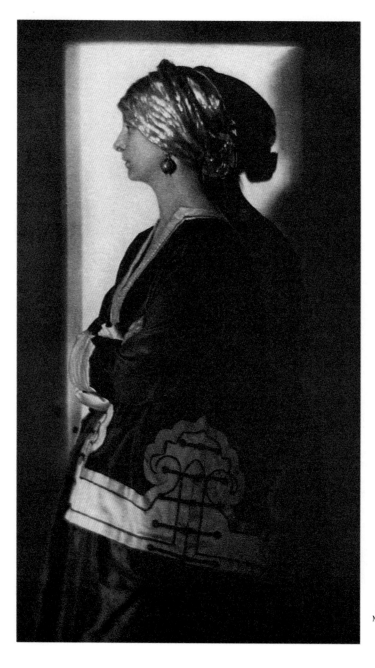

Baron A. de Meyer
The Silver Cap, 19.
Photogravure
23.9 x 13.8 cm

Baron A. de Meyer →
Marchesa Casati, 1912
Photogravure
22 x 16.3 cm

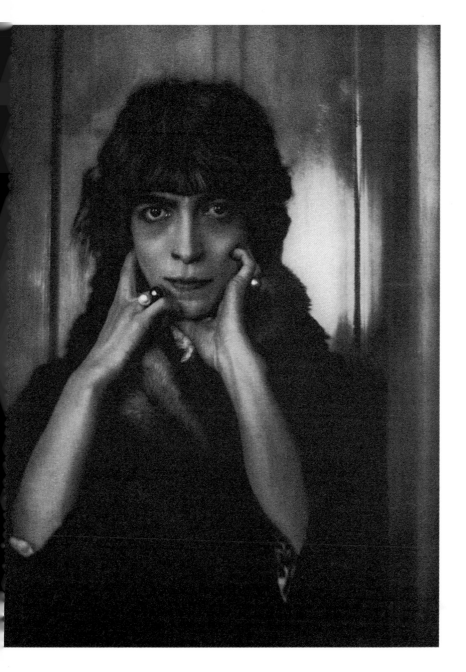

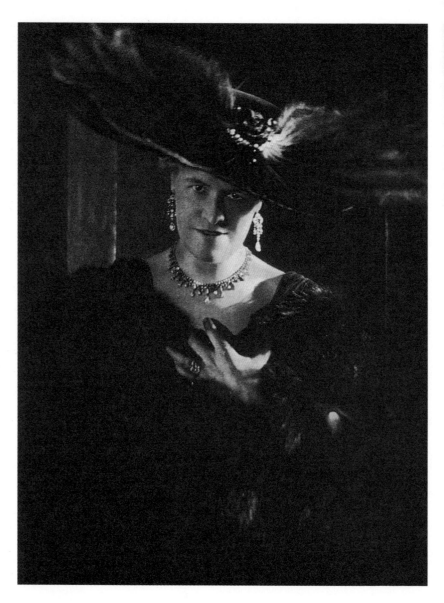

Baron A. de Meyer
Miss J. Ranken, 1912
Photogravure
19.7 x 15.1 cm

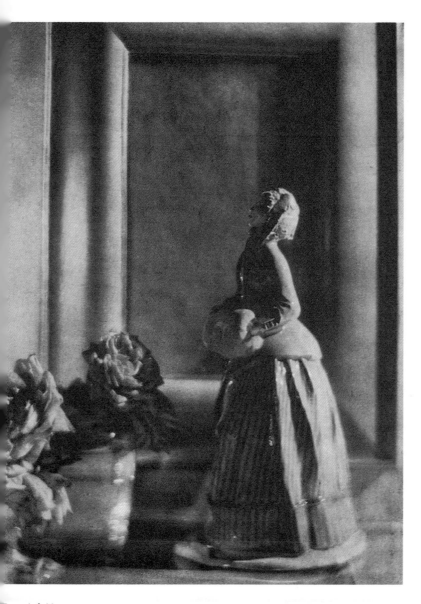

Baron A. de Meyer
The Nymphenburg Figure, 1912
Photogravure
21.9 x 16.3 cm

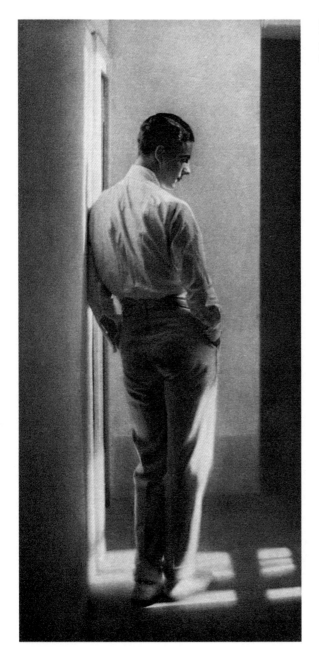

Baron A. de Meyer
Teddie, 1912
Photogravure
22 x 10.5 cm

Baron A. de Meyer →
Aïda, a Maid of Tangier, 1912
Photogravure
22.5 x 16.4 cm

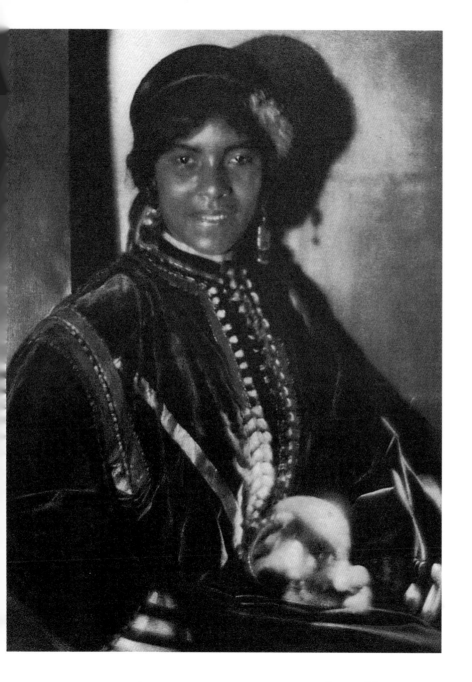

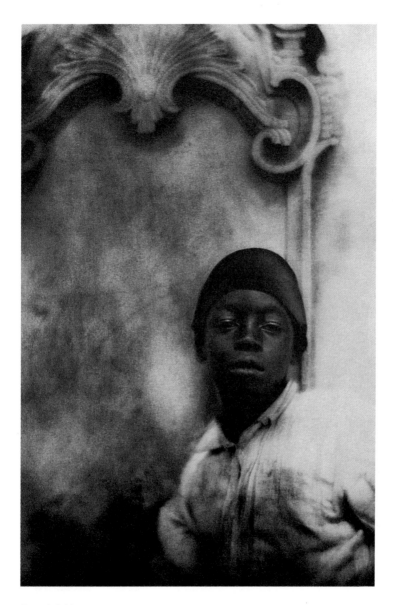

Baron A. de Meyer
From the Shores of the Bosphorus, 1912
Photogravure
23.9 x 15.8 cm

674 · 675

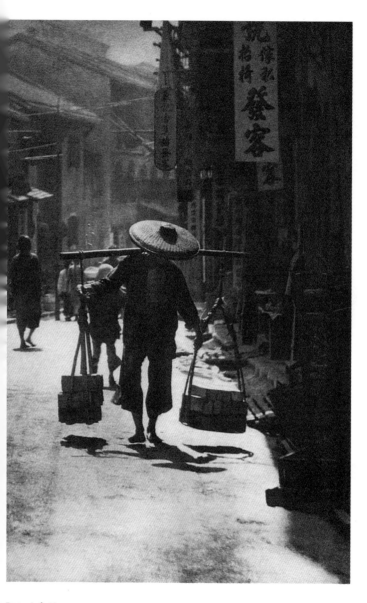

Baron A. de Meyer
A street in China, 1912
Photogravure
23.5 x 15 cm

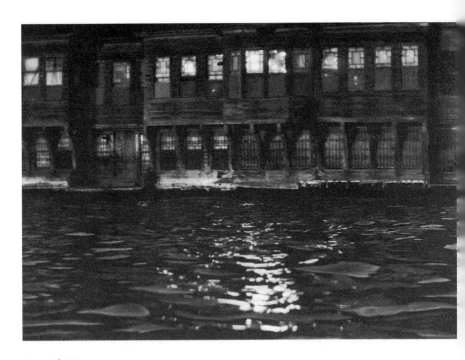

Baron A. de Meyer
Windows on the Bosphorus, 1912
Photogravure
15.3 x 22.1 cm

Baron A. de Meyer →
Mrs. Wiggins of Belgrave Square, 1912
Photogravure
21.9 x 16.2 cm

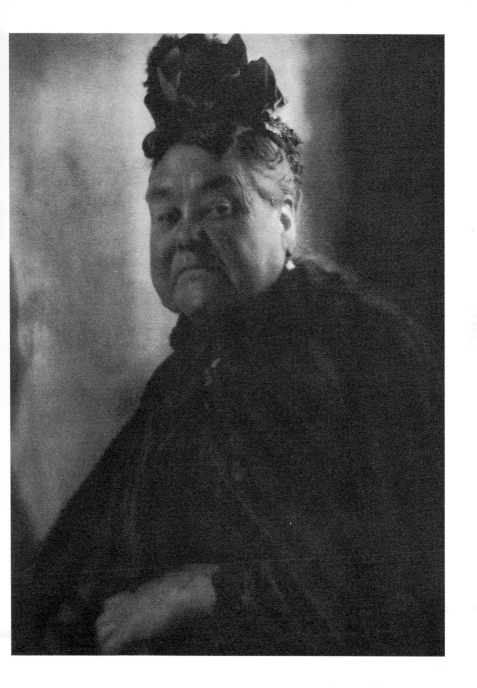

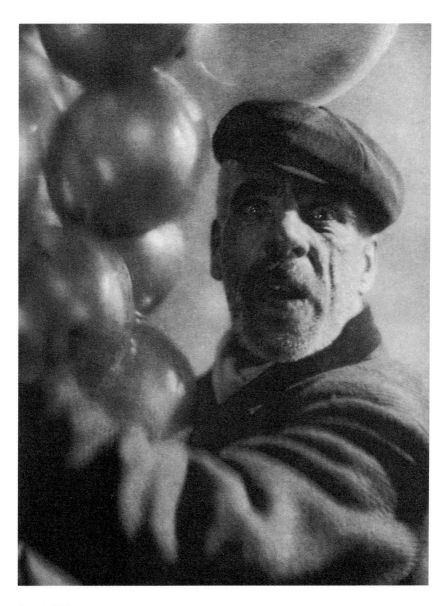

Baron A. de Meyer
The Balloon Man, 1912
Photogravure
21.9 x 16.7 cm

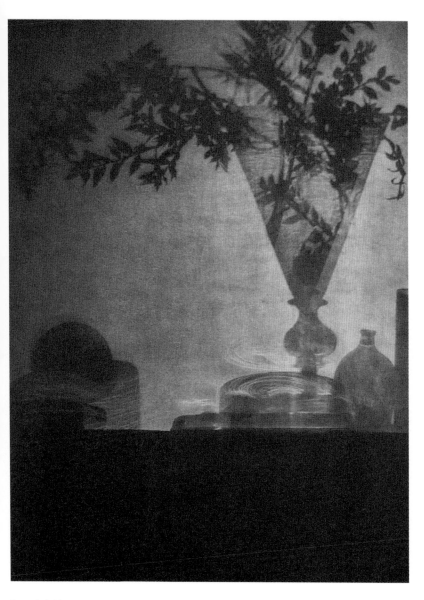

Baron A. de Meyer
Glass and Shadows, 1912
Photogravure
22.2 x 16.6 cm

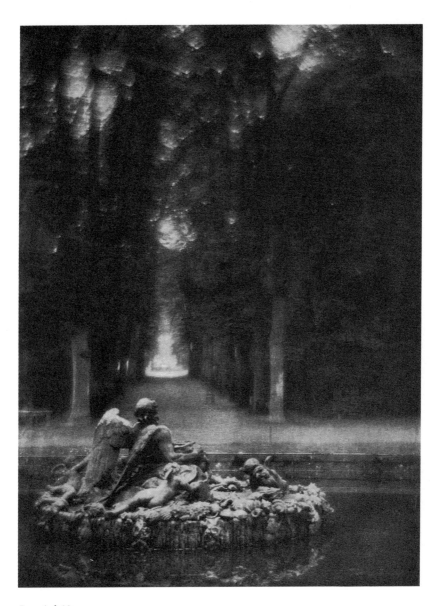

Baron A. de Meyer
The Fountain of Saturn, Versailles, 1912
Photogravure
21.5 x 16.2 cm

A NEW FORM OF LITERATURE *

THE art-loving public has for some time been interested, if not pleased, by what is called Post-Impressionism in Painting and Sculpture, represented most prominently, as far as American knowledge of it is concerned, by the Paris painters Matisse and Picasso.

They are artistically strenuous persons who are passionately attempting to find a way to express more intimately and intensely the emotional-mood-subjective life of all of us than the historical forms in painting and art have been able to do. They attempt to set our dreams and our feelings out on to the canvas, making of our moods and sentiments objective realities.

In America, as far as I know, there is no writer at present who is influenced by the Post-Impressionist movement. In Paris there are writers who are attempting, with less success than the painters, to express those feelings, moods, and mental processes hitherto, as they think, inadequately reproduced in current literary forms.

There is an American woman now living in Paris who is, I think, the only American living who is trying to do in writing what Picasso and Matisse and others are trying to do in plastic art.

Her name is Gertrude Stein. Some years ago she published in America a book which only a very few persons have ever read. It was called "Three Lives," and, in form, it was what most people would call "weird." It was written in a style almost unreadable for its repetitions, its apparent childishness. It had no dramatic climaxes and next to no incidents. It had no sentimentality. It did not deal with any conventional or unconventional moralities.

I read it only because I had had my attention called to it in a special way. If I had come across it unexpectedly I would have thrown it aside as trash, imbecility, or pose, after reading a few pages. But with pain and difficulty I read on; the difficulty continued all the way through the book, but the pain gradually gave way to a kind of pleasure.

I began to see that, somehow, the picture of life was attained in this mass of repetition, simplicity, and apparent inanity. I began to feel the personages dealt with, the mood atmosphere in which they lived, their relations to each other. I felt the human situation, and this much more completely than is at all frequent in conventional novels even of power.

Few of us are aware at any one moment of what is going on within us. We are so active that we do not self-consciously dream and feel. We are not often fully aware of the contents of our mood at the time. This book of Miss Stein's makes us dream about the fundamental mood-realities of our existence. It gives us the sense of the mysteries of our inner lives, when the great simplicities of our inner lives are made prominent to our attention. We long, and fear, and hope, and desire, and when these are deep they are simple, always determining the color and quality of our mood. In action they are obscured and lost sight of. In this unconventional, actionless book they are brought out with mysterious power, and with no apparent art, with apparently childishness in form, and with not attractiveness.

In the current special number of CAMERA WORK, an art and photographic publication, the creator of which is Alfred Stieglitz, he of notorious Photo-Secession fame, Miss Stein has two little essays, one on Matisse and one on Picasso. In the same number are photographic illustrations of the work of these two artists.

These two little bits of writing by Miss Stein, recently done, are in the same line as her book, "Three Lives," but even more purely express the instinct for a new literary form. They would undoubtedly seem absurd to nearly all readers. Few words are used, and these are repeated over and over. To quote would be useless. It would be impossible to get the mood through anything but a long quotation—a very long one.

They naturally seem absurd, because they depart absolutely from the usual ways of criticizing and essaying. Miss Stein has been familiar for years with the work of Picasso and Matisse, and this work has sunk very deep into her imagination.

So when she writes these little sketches she does not formally criticize nor does she even state ideas or conclusions. There is no intellectualism in these essays, no comparisons, no authority or authorities mentioned or implied.

*Reprinted from N. Y. Globe, September 26, 1912.

She does not mention their work or their ideas, what they are aiming at, or how they are doing it. All she does is to try to do in words what they are trying to do in painting; or, rather, not what they are trying to do in painting, but what their moods and deeper dreaming consciousness is which leads them to do what they are trying to do in painting.

In this last paragraph, by the way, I have unconsciously, to a slight degree, imitated a fragment of her style, as far as it involves repetition.

The reader of these two little essays would undoubtedly think them ridiculous, and this no matter how intelligent he is. Perhaps, however, if he has had a good deal of sympathetic acquaintance with Post-Impressionist painting, he may see that Miss Stein is at least making an earnest experiment. He may permanently think she is unsuccessful in it.

But these two little things do call my attention voluminously to the fundamental character of the emotional impulse, with what William James called the fringe of consciousness, which dominates respectively Matisse and Picasso. They set us dreaming about the strenuous inner life of these two artists, and convey the fringe or surroundings they are in as regards society, and the broader human need.

They are intensely human, these little sketches. It is impossible to state what they say. They say nothing. But they try to suggest and partly do suggest a complete and simple mood, in which ideas, feelings, sensations, tendencies of the nerves, of hope, of the imagination are indissolubly combined.

Supposing you had had an experience, say of love, and in an hour of spiritual repose and contemplation, you were sitting in some soothing country place, your inner life all warm, brooding, not thinking, conscious of your love, and conscious of the way it was associated with nature, with work, with food, with the labor movement, with ambition, with life—just conscious of all this, vaguely, but not thinking about it.

Then if you were an artist and could hit upon some form, literary or plastic, in words or in painting, which would be a projection into space of this inner, deeper mood with all its "fringe" of suggestions, you would do what Miss Stein is trying to do in words, and what Picasso and Matisse are trying to do in paint. HUTCHINS HAPGOOD.

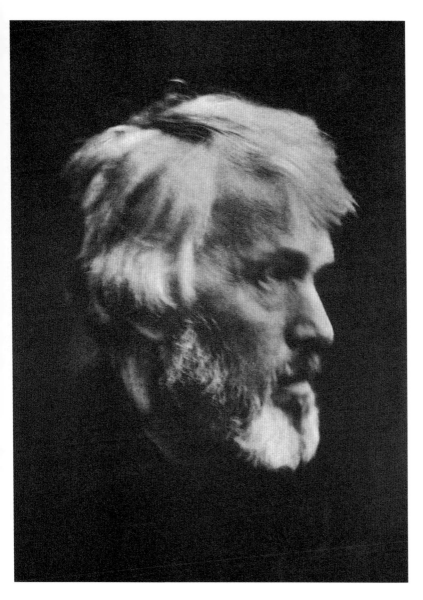

Julia Margaret Cameron
Carlyle, 1913
Photogravure
21.6 x 15. 8 cm

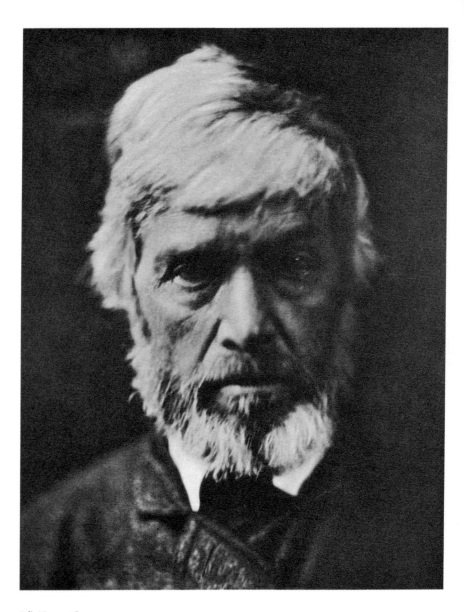

Julia Margaret Cameron
Carlyle, 1913
Photogravure
19.8 x 15.5 cm

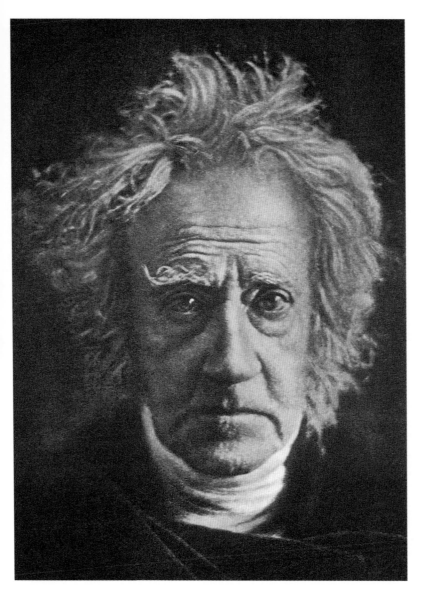

Julia Margaret Cameron
Herschel, 1913
Photogravure
21.4 x 15.6 cm

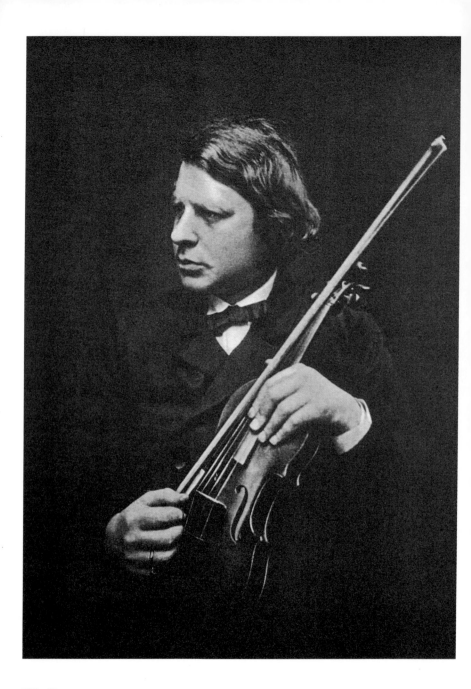

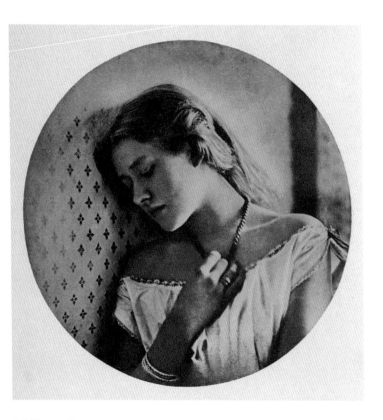

Julia Margaret Cameron
Ellen Terry, at the age of sixteen, 1913
Photogravure
15.5 cm diameter

← Julia Margaret Cameron
Joachim, 1913
Photogravure
20.3 x 15.5 cm

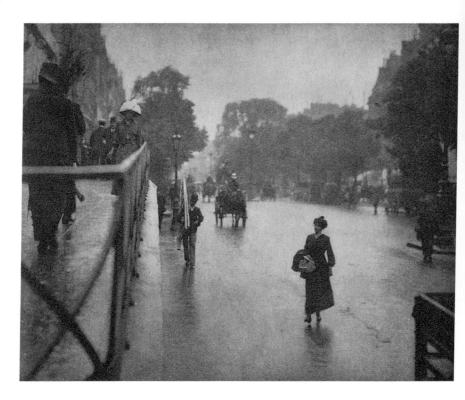

Alfred Stieglitz
A Snapshot; Paris (1911), 1913
Photogravure
13.7 x 17.4 cm

Alfred Stieglitz
A Snapshot; Paris (1911), 1913
Photogravure
13.6 x 16.9 cm

Alfred Stieglitz
The Asphalt Paver; New York (1892), 1913
Photogravure
14.1 x 17.6 cm

Alfred Stieglitz→
Portrait – S. R. (1904), 1913
Photogravure
20.7 x 18 cm

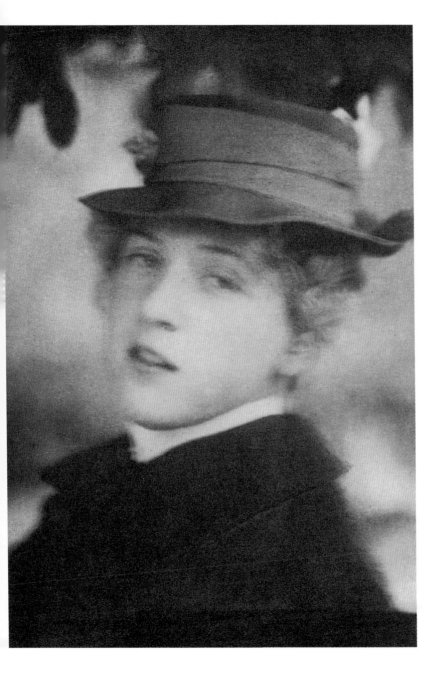

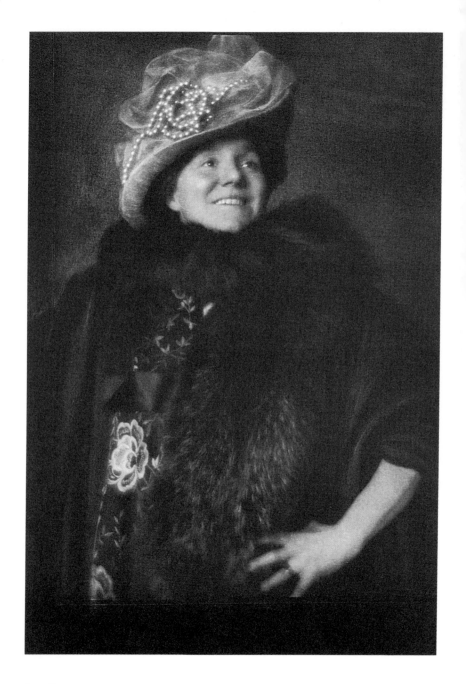

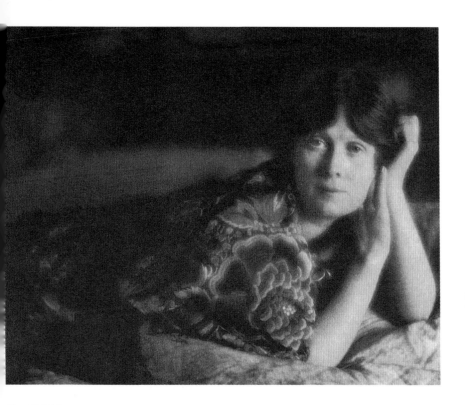

Eduard J. Steichen
Isadora Duncan, 1913
Photogravure
16.7 x 20.5 cm

← Eduard J. Steichen
Vitality – Yvette Guilbert, 1913
Photogravure
24 x 16.7 cm

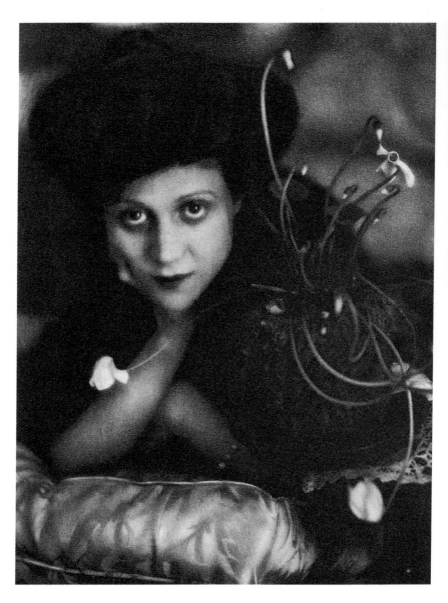

Eduard J. Steichen
Cyclamen – Mrs. Philip Lydig, 1913
Photogravure
19.2 x 15 cm

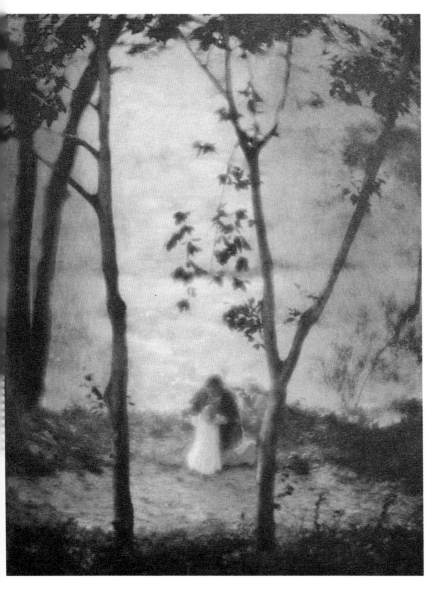

Eduard J. Steichen
Mary Learns to Walk, 1913
Photogravure
20.9 x 16.1 cm

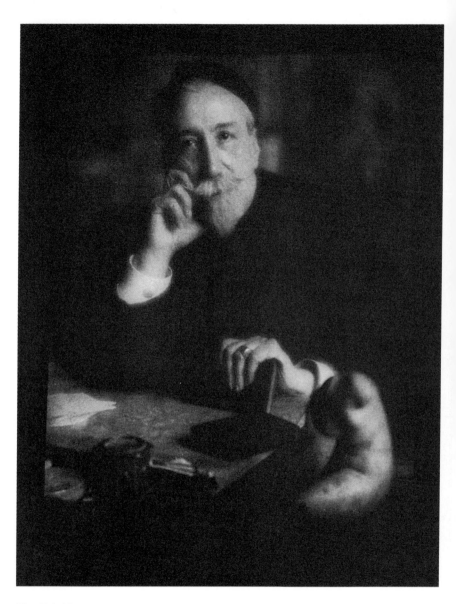

Eduard J. Steichen
Anatole France, 1913
Photogravure
20.5 x 16.0 cm

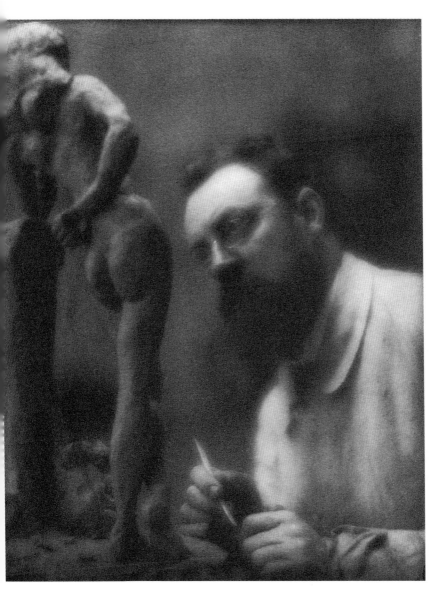

Eduard J. Steichen
Henri Matisse, 1913
Photogravure
21.8 x 17.2 cm

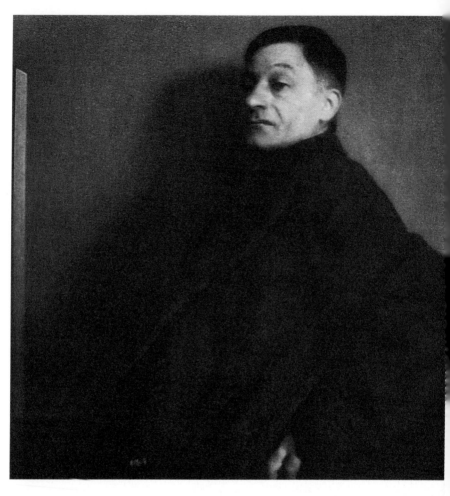

Eduard J. Steichen
The Man that resembles Erasmus, 1913
Photogravure
16.9 x 16.3 cm

Eduard J. Steichen →
Henry W. Taft (William Howard Taft), 1913
Photogravure
19 x 13.1 cm

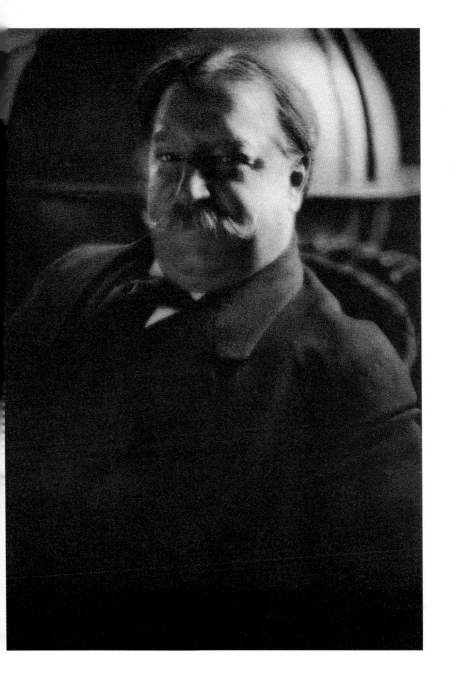

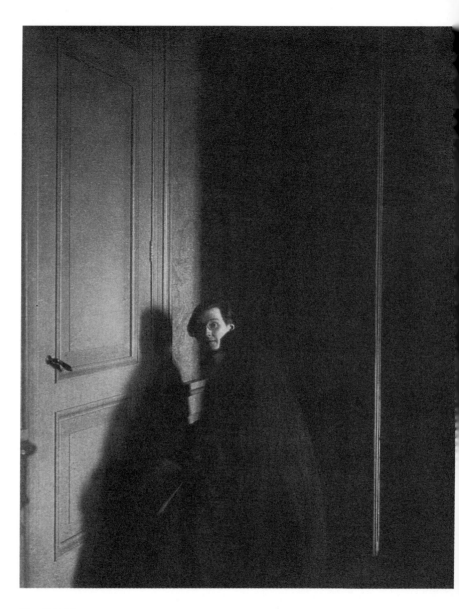

Eduard J. Steichen
E. Gordon Craig, 1913
Photogravure
20 x 16 cm

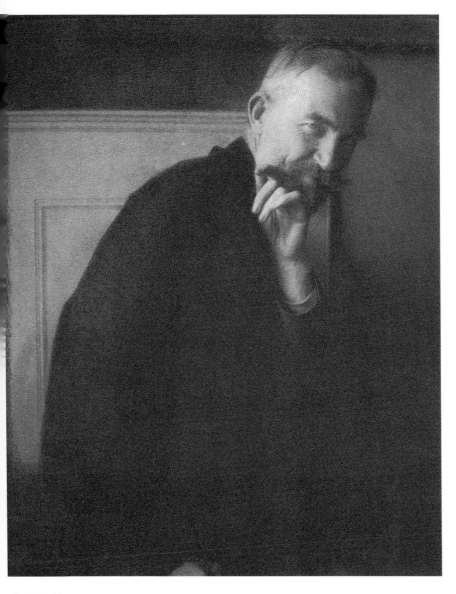

Eduard J. Steichen
The Photographers' Best Model – G. Bernard Shaw
Photogravure
20.1 x 16.3 cm

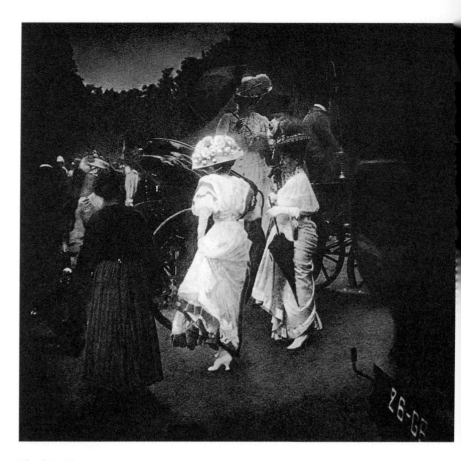

Eduard J. Steichen
Steeplechase Day, Paris;
After the Races, 1913
Duogravure
15.8 x 17 cm

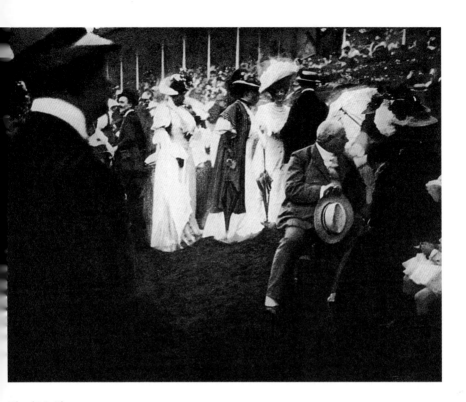

Eduard J. Steichen
Steeplechase Day, Paris;
Grand Stand, 1913
Duogravure
15.7 x 20 cm

Eduard J. Steichen
Nocturne – Orangerie Staircase, Versailles, 1913
Duogravure
16.0 x 20.9 cm

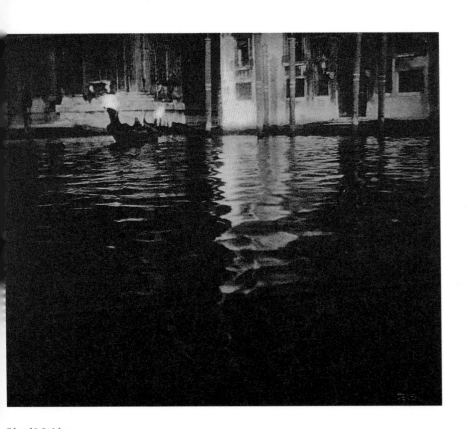

Eduard J. Steichen
Late Afternoon – Venice, 1913
Duogravure
15.6 x 18.7 cm

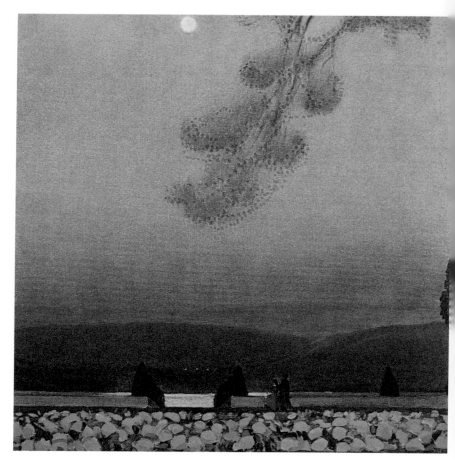

Eduard J. Steichen
Nocturne – Hydrangea Terrace, Chateaux Ledoux, 1913
Three-colour half-tone reproduction
15.2 x 15.7 cm

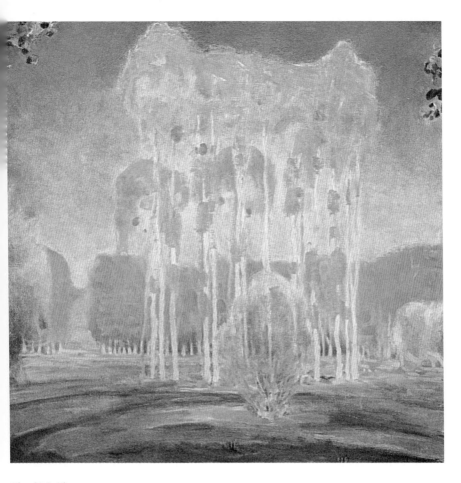

Eduard J. Steichen
Autumnal Afternoon – The Poplars, Voulangis, 1913
Three-colour half-tone reproduction
15.3 x 15.9 cm

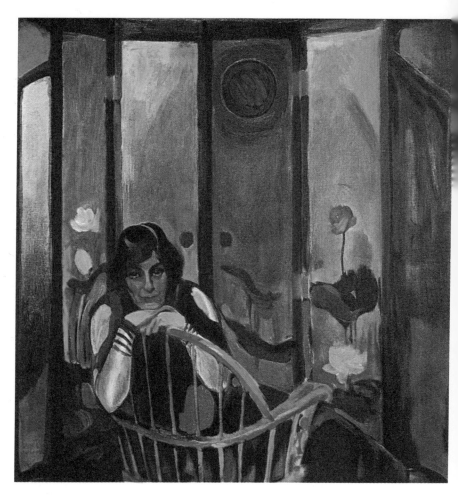

Eduard J. Steichen
The Lotus Screen: S. S. S., 1913
Three-colour half-tone reproduction
16.9 x 16.3 cm

PHOTOGRAPHY AND ARTISTIC-PHOTOGRAPHY

PHOTOGRAPHY is not Art, but photographs can be made to be Art. When man uses the camera without any preconceived idea of final results, when he uses the camera as a means to penetrate the objective reality of facts, to acquire a truth, which he tries to represent by itself and not by adapting it to any system of emotional representation, then, man is doing Photography.

Photography, pure photography, is not a new system for the representation of Form, but rather the negation of all representative systems, it is the means by which the man of instinct, reason and experience approaches nature in order to attain the evidence of reality.

Photography is the experimental science of Form. Its aim is to find and determine the objectivity of Form; that is, to obtain the condition of the initial phenomenon of Form, phenomenon which under the dominion of the mind of man creates emotions, sensations and ideas.

The difference between Photography and Artistic-Photography is that, in the former, man tries to get at that objectivity of Form which generates the different conceptions that man has of Form, while the second uses the objectivity of Form to express a preconceived idea in order to convey an emotion. The first is the fixing of an actual state of Form, the other is the representation of the objectivity of Form, subordinated to a system of representation. The first is a process of indigitation, the second a means of expression. In the first, man tries to represent something that is outside of himself; in the second he tries to represent something that is in himself. The first is a free and impersonal research, the second is a systematic and personal representation.

The artist photographer uses nature to express his individuality, the photographer puts himself in front of nature, and without preconceptions, with the free mind of an investigator, with the method of an experimentalist, tries to get out of her a true state of conditions.

The artist photographer in his work envelops objectivity with an idea, veils the object with the subject. The photographer expresses, so far as he is able to, pure objectivity. The aim of the first is pleasure; the aim of the second, knowledge. The one does not destroy the other.

Subjectivity is a natural characteristic of man. Representation began by the simple expression of the subject. In the development of the evolution of representation, man has been slowly approaching the object. The History of Art proves this statement.

In subjectivity man has exhausted the representation of all the emotions that are peculiar to humanity. When man began to be inductive instead of deductive in his represented expressions, objectivity began to take the place of subjectivity. The more analytical man is, the more he separates himself from the subject and the nearer he gets to the comprehension of the object.

It has been observed that Nature to the majority of people is amorphic. Great periods of civilization have been necessary to make man conceive the objectivity of Form. So long as man endeavors to represent his emotions or ideas in order to convey them to others, he has to subject his representation of Form to the expression of his idea. With subjectivity man tried to represent his feeling of the primary causes. That is the reason why Art has always been subjective and dependent on the religious idea.

Science convinced man that the comprehension of the primary causes is beyond the human mind; but science made him arrive at the cognition of the condition of the phenomenon.

Photography, and only Photography, started man on the road of the cognition of the condition of the phenomena of Form.

Up to the present, the highest point of these two sides of Photography has been reached by Steichen as an artist and by Stieglitz as an experimentalist.

The work of Steichen brought to its highest expression the aim of the realistic painting of Form. In his photographs he has succeeded in expressing the perfect fusion of the subject and the object. He has carried to its highest point the expression of a system of representation: the realistic one.

Stieglitz has begun with the elimination of the subject in represented Form to search for the pure expression of the object. He is trying to do synthetically, with the means of a mechanical process, what some of the most advanced artists of the modern movement are trying to do analytically with the means of Art.

It would be difficult to say which of these two sides of Photography is the more important. For one is the means by which man fuses his idea with the natural expression of Form, while the other is the means by which man tries to bring the natural expression of Form to the cognition of his mind.

MARIUS DE ZAYAS.

THE SKYLARK

Oh, the skylark, the skylark,
The beautiful skylark
I heard in the month of June,
It was nothing but a dark, dark
Speck. And nothing but a tune.
And Oh! If I had some wings
I would fly up to him
And I would look down upon the things
Until the day grew dim.

MARY STEICHEN.*

*Age not quite nine.

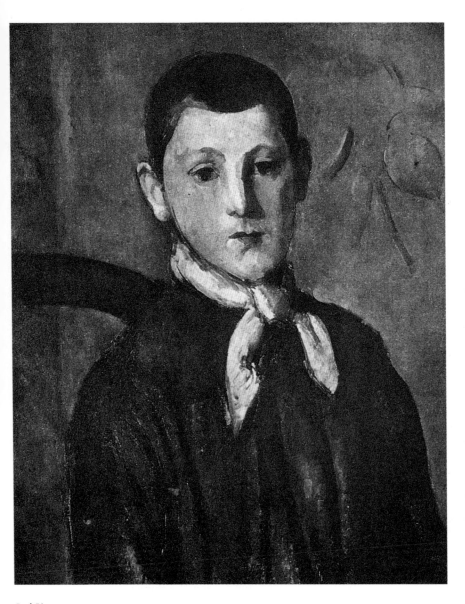

Paul Cézanne
Portrait, 1913
Half-tone reproduction
18.6 x 15.5 cm

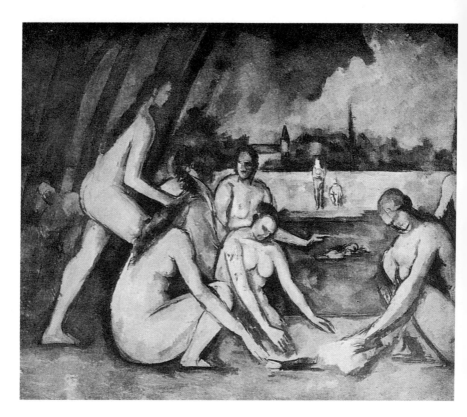

Paul Cézanne
Nudes, 1913
Half-tone reproduction
15.5 x 18.4 cm

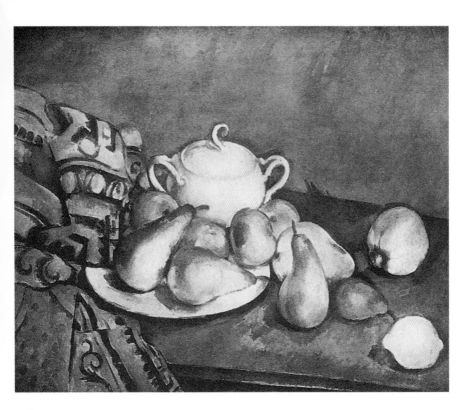

Paul Cézanne
Still-Life, 1913
Half-tone reproduction
15.5 x 19.1 cm

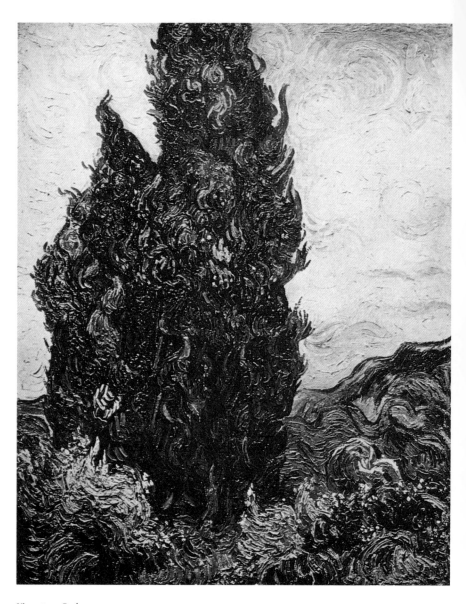

Vincent van Gogh
Landscape, 1913
Half-tone reproduction
19.3 x 15.5 cm

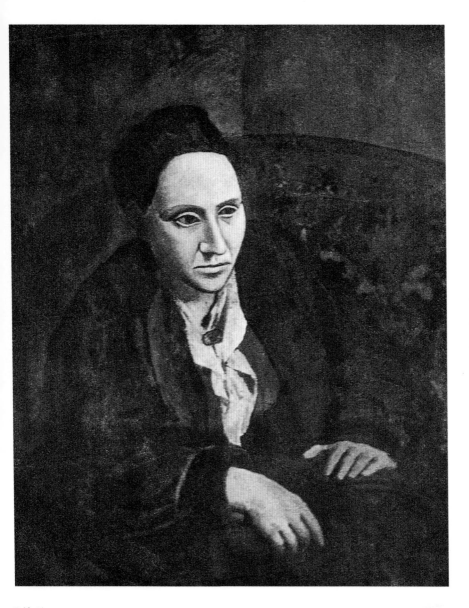

Pablo Picasso
Portrait – Gertrude Stein, 1913
Half-tone reproduction
17.6 x 14.4 cm

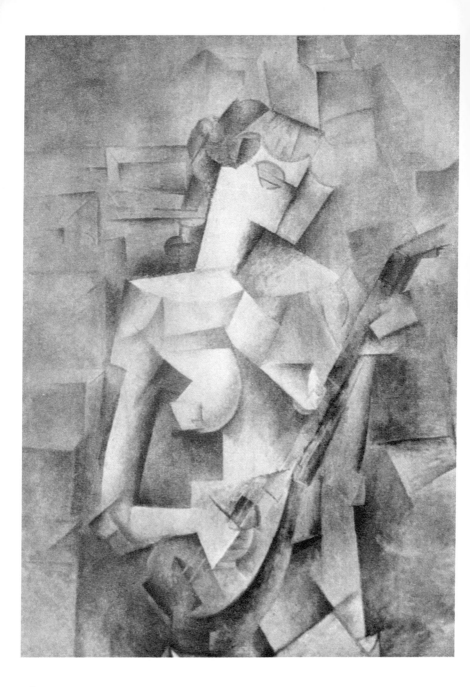

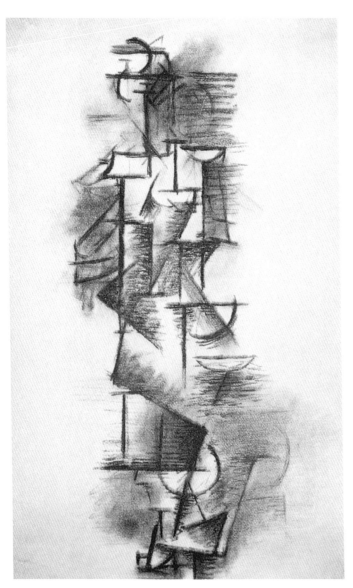

Pablo Picasso
Drawing, 1913
Half-tone reproduction
17.3 x 27.8 cm

← **Pablo Picasso**
Woman with Mandolin, 1913
Half-tone reproduction
20.6 x 15 cm

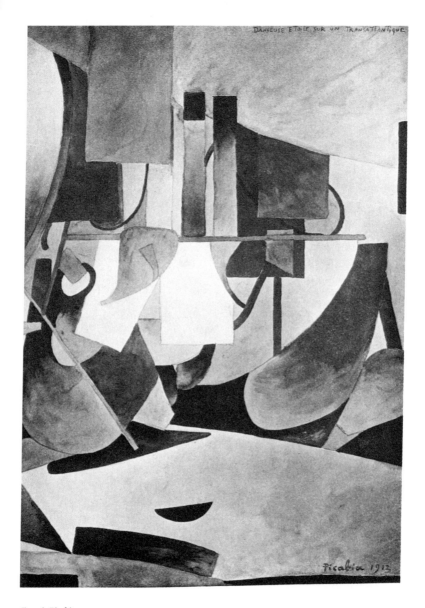

Francis Picabia
Star-Dancer on Board a Transatlantic Steamer, 1913
Half-tone reproduction
21.1 x 15.4 cm

SPECULATIONS

MANY roads are being broken today and along these roads conscious-
ness is pursuing truth to eternity. This is the age of communication
and the human being who is not a "communicant" is in the sad
plight, which the dogmatist defines as being a condition of spiritual non-
receptivity.

Some of these newly opened roads lie parallel and almost touch.
In a large studio in Paris, hung with paintings by Renoir, Matisse and
Picasso, Gertrude Stein is doing with words what Picasso is doing with
paint. She is impelling language to induce new states of consciousness and
in doing so language becomes with her a creative art rather than a mirror
of history.

In her impressionistic writing she uses familiar words to create percep-
tions, conditions, and states of being, never before quite consciously ex-
perienced. She does this by using words that appeal to her as having the
meaning that they *seem* to have. She has taken the English language,
and, according to many people, has misused it, or has used it roughly, un-
couthly and brutally, or madly, stupidly and hideously, but by her method
she is finding the hidden and inner nature of nature.

To present her impressions she chooses words for their inherent quality
rather than for their accepted meaning.

Her habit of working is methodical and deliberate. She always works
at night in the silence and brings all her will power to bear upon the banishing
of preconceived images. Concentrating upon the impression she has received
and which she wishes to transmit, she suspends her selective faculty, waiting
for the word or group of words that will perfectly interpret her meaning to
rise from her sub-consciousness to the surface of her mind. Then and then
only does she bring her reason to bear upon them, examining, weighing and
gauging their ability to express her impression. It is a working proof of the
Bergson theory of intuition. She does not go after words—she waits—and
lets them come to her, and they do.

It is only when the art thus pursues the artist that his production will
bear the mark of inevitability. It is only when the "élan vital" drives the
artist to the creative overflow that life surges in his production. Vitality
directed into a conscious expression is the modern definition of genius.

It is impossible to define or to describe fully any new manifestation
in æsthetics or in literature that is as recent, as near to us, as the work of
Picasso or of Gertrude Stein; the most that we can do is to suggest a little,
draw a comparison—point the way and then withdraw. To know about them
is a matter of personal experience—no one can help another through it.
First before thought must come feeling, and this is the first step toward
experience, because feeling is the beginning of knowledge. It does not
greatly matter how the first impress affects one . . . one may be shocked,

stunned and dismayed, or one may be aroused, stimulated, intrigued and delighted. That there has been an *approach* is what counts. It is only in a state of indifference that there is no approach at all, and indifference reeks of death. It is the tomb of life itself.

A further consciousness than is already ours will need many new forms of expression. In literature everything that has been felt or known so far has been said, as it has been said. What more there may be for us to realize must be expressed in a new way. Language has been crystallized into four or five established literary forms, that up to the present day have been held sacred and intranscendent. But all the truth cannot be contained in any one or any limited number of moulds. As A. E. the Irish poet says of it:

> The hero first thought it;
> To him 'twas a deed:
> To those who retaught it,
> A chain on their speed.
>
> The fire that we kindled,
> A beacon by night,
> When darkness has dwindled
> Grows pale in the light.
>
> For life has no glory
> Stays long in one dwelling,
> And time has no story
> That's true twice in telling.
>
> And only the teaching
> That never was spoken
> Is worthy thy reaching,
> The fountain unbroken.

This is so of all the arts, for of course what is true of one must, to be justifiable, be true of them all; even to the art of life, and perhaps first of all to that one.

Nearly every thinking person nowadays is in revolt against something, because the craving of the individual is for further consciousness and because consciousness is expanding and is bursting through the moulds that have held it up to now. And so let every man whose private truth is too great for his existing conditions pause before he turn away from Picasso's painting or from Gertrude Stein's writing, for their case is his case.

Of course comment is the best of signs. Any comment. One that Gertrude Stein hears oftenest is from conscientious souls who have honestly tried—and who have failed,—to get anything out of her work at all. "But

why don't you make it simpler?" they cry. "Because this is the only way in which I can express what I want to express" is the invariable reply, which of course is the unanswerable argument of every sincere artist to every critic, and again and again comes the refrain that is so familiar before the canvases of Picasso, "but it is so ugly—so brutal!"—But how does one know that it is ugly after all? How does one know? Each time that beauty has been reborn in the world it has needed a complete readjustment of sense-perceptions, grown all too accustomed to the blurred outlines, faded colors, the death in life of beauty in decline. Our taste has become jaded from over-familiarity, from long association and from inertia. If one cares for Rembrandt's paintings today, then how could one have cared for them at the time when they were painted, when they were glowing with life? If we like St. Marks in Venice today, then surely it would have offended us a thousand years ago. Perhaps it is not Rembrandt's painting that one cares for after all, but merely for the shell, the ghost, the last pale flicker of the artist's intention. Beauty? One thing is certain, that if we must worship beauty as we have known it, we must consent to worship it as a thing dead. "Une grande, belle chose morte." And ugliness? What is it? Surely only death is ugly.

In Gertrude Stein's writing every word lives, and apart from the concept it is so exquisitely rhythmical and cadenced that when read aloud and received as pure sound it is like a kind of sensuous music. Just as one may stop, for once in a way, before a canvas of Picasso's and, letting one's reason sleep for an instant, may exclaim: "It *is* a fine pattern!"—so listening to Gertrude Stein's words and forgetting to try to understand what they mean, one submits to their gradual charm. Huntley Carter of the "New Age" says that her use of language has a curious hypnotic effect when read aloud. In one phase of her writing she made use of repetition and the re-arranging of certain words over and over, so that they became adjusted into a kind of incantation, and in listening one feels that from the combination of repeated sounds varied ever so little, that there emerges gradually a perception of some meaning quite other than that of the contents of the phrases. Many people have experienced this magical evocation, but have been unable to explain in what way it came to pass, but though they did not know what meaning the words were bearing, nor how they were affected by them, yet they had *begun* to know what it all meant, because they were not indifferent.

In a portrait that she has finished recently, she has produced a coherent totality through a series of impressions, which, when taken sentence by sentence, strike most people as particularly incoherent. An interesting thing in connection with this portrait is that a record has been kept of the comments and criticisms upon it, which forms in itself a most accurate description of the model. Surely portraiture can hardly go further than this! Each comment upon the portrait was characteristic of the subject and fitted her perfectly as seen from the angle of the critic. In each of the portraits that

Gertrude Stein has done, the quality of the words in it is of the same quality and nature as that in the image. To illustrate this, the words in the following paragraph are strenuous words—words that weigh and qualify conditions—words that are without softness—yet that are not hard words—perilous abstractions they seem, containing somehow agony and movement and conveying a vicarious livingness. "It is a gnarled division that which is not any obstruction and the forgotten swelling is certainly attracting. It is attracting the whiter division, it is not sinking to be growing, it is not darkening to be disappearing, it is not aged to be annoying. There cannot be sighing. This is this bliss."

In the succeeding quotation taken from another portrait is the following: "If it had happened that the little flower was larger and the white color was deeper and the silent light was darker and the passage was rougher, it would have been as it was and the triumph was in the place where the light was bright and the beauty was not losing having that possession. That was not what was tenderly."

Here we perceive a very different personality. What gentle tranquil words. What poise and in their quiescence how much resignation! Of course it is unfair to lop off a piece of anything that is a whole and by offering it, try to assure justice towards it. And this is especially true of the work of Gertrude Stein, for it excels in its unity. To her a portrait is a series of impressions that expresses a total unity. Of course this is a grave assumption for her to make, because it is possibly assuming control of the fourth dimension! If we have any reason to admit the existence of the fourth dimension, we may presume that it is present or will be in human beings. So for any work of art to completely depict a human being in his entirety, it would be necessary for it also to contain the fourth dimension. Perhaps that is why so many of us—feel absolutely up against a blank wall when we are faced by the post-impressionists. We are most of us creatures, aware as yet of only three dimensions, while perhaps here and there among us walks one who has become conscious of the fourth! Can we bear to admit it? But do we dare to deny it?

Many roads are being broken—what a wonderful word "broken!" And out of the shattering of the petrifaction of today—up from the cleavage and the disintegration—we will see order emerging tomorrow. Is it so difficult to remember that life at birth is always painful and rarely lovely? How strange it is to think that the rough hewn trail of today will become tomorrow the path of least resistance over which the majority will drift with all the ease and serenity of custom! All the labor of evolution is condensed into this one fact of the vitality of the individual making way for the many. Remembering this, we can but praise the high courage of the road breakers, admitting as we infallibly must, in Gertrude Stein's own words, and with true Bergsonian faith—"something is certainly coming out of them!"

MABEL DODGE.

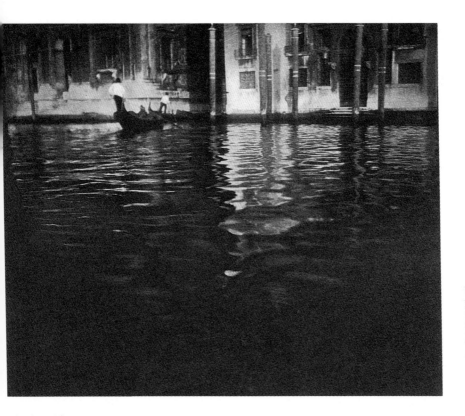

Eduard J. Steichen
Venice, 1913
Photogravure
16.5 x 19.9 cm

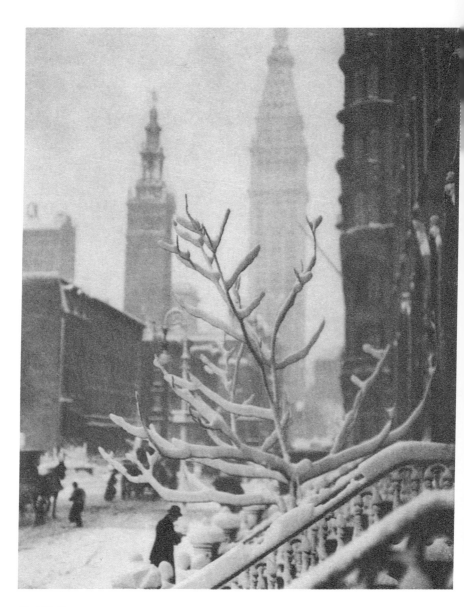

Alfred Stieglitz
Two Towers – New York, 1913
Photogravure
19.5 x 15.9 cm

Annie W. Brigman
Dryads, 1913
Photogravure
15.9 x 20.4 cm

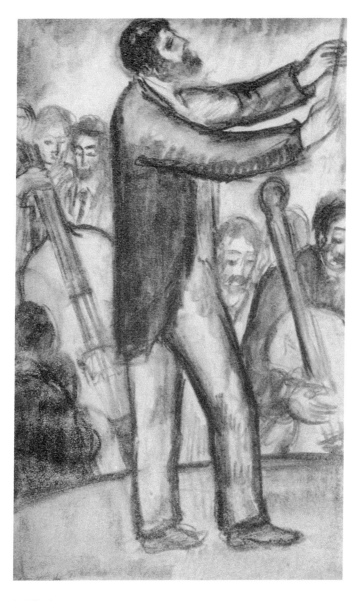

A. Walkowitz
Music, 1913
Collotype
25.3 x 15.5 cm

A. Walkowitz →
Mother and Child, 1913
Collotype
24.7 x 15.8 cm

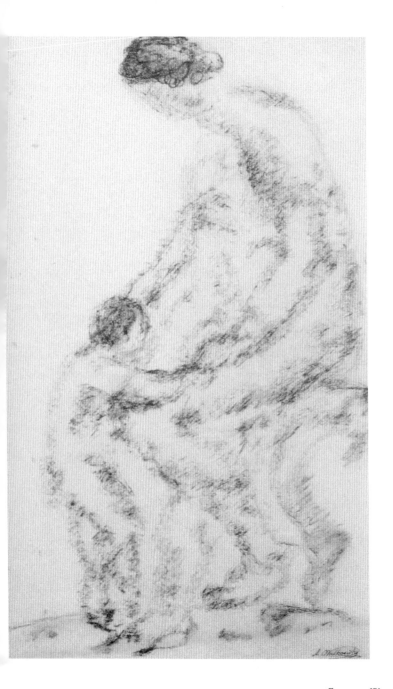

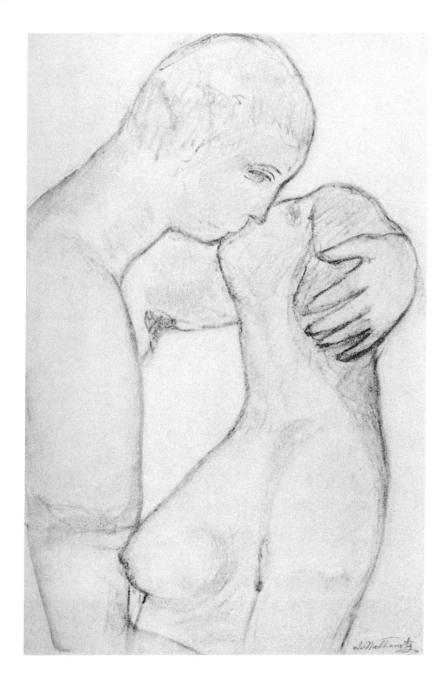

← A. Walkowitz
Kiss, 1913
Collotype
23.5 x 16 cm

A. Walkowitz
Portrait, 1913
Collotype
20.2 x 15.8 cm

A. Walkowitz
Sigh, 1913
Collotype
22.2 x 13.2 cm

A. Walkowitz
From Life to Life, No 1, 1913
Collotype
23.2 x 15.6 cm

A. Walkowitz
From Life to Life, No 11, 1913
Collotype
23.3 x 15.6 cm

J. Craig Annan
A Blind Musician – Granada, 1914
Photogravure
20.3 x 12 cm

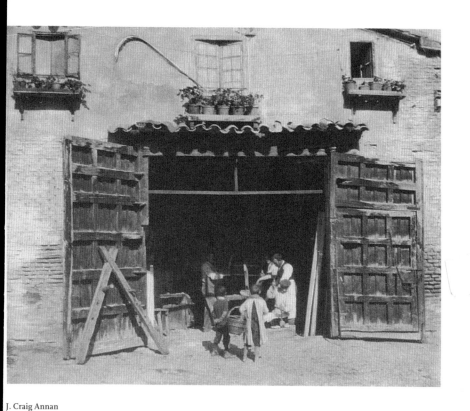

J. Craig Annan
A Carpenter's Shop – Toledo, 1914
Photogravure
14.6 x 18.2 cm

← J. Craig Annan
A Gitana – Granada, 1914
Photogravure
19.5 x 13.7 cm

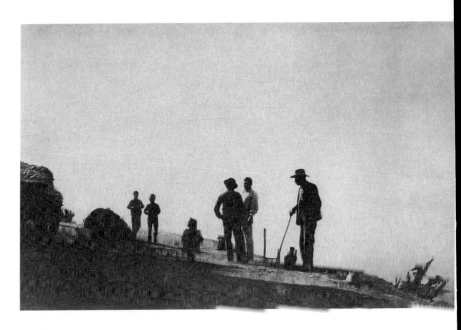

J. Craig Annan
Group on a Hill Road – Granada, 1914,
Photogravure
11.5 x 18.1 cm

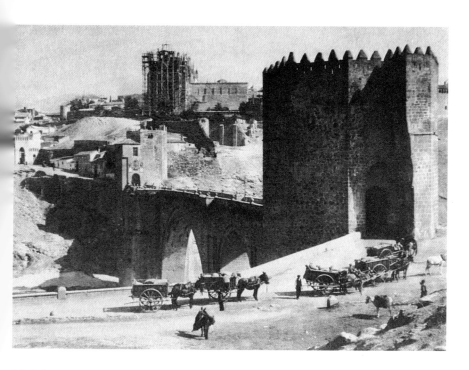

J. Craig Annan
Bridge of St. Martin – Toledo, 1914
Photogravure
12.9 x 18 cm

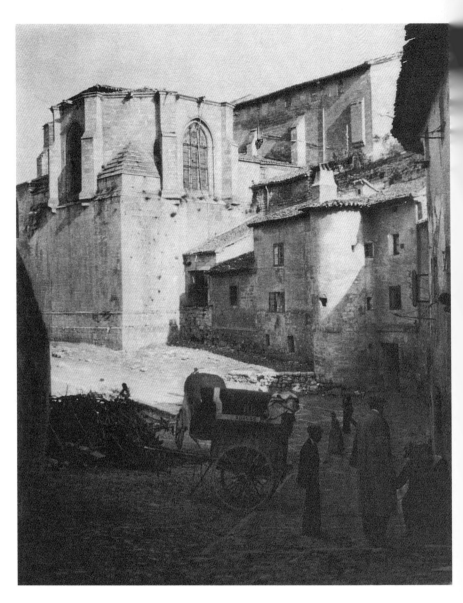

J. Craig Annan
Old Church – Burgos, 1914
Photogravure
18.2 x 14.8 cm

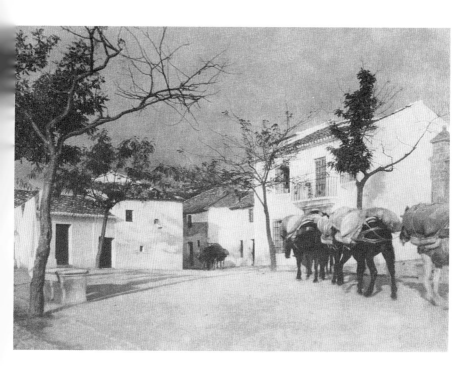

J. Craig Annan
A Square – Ronda, 1914
Photogravure
13.7 x 18.9 cm

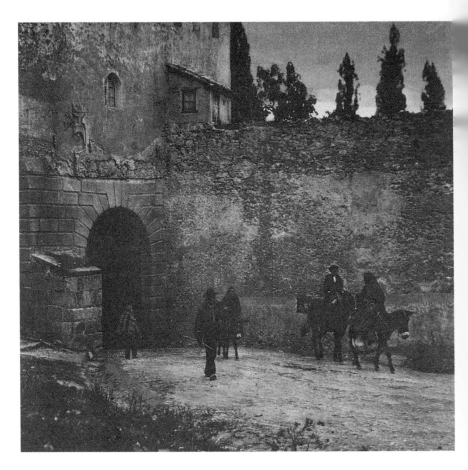

J. Craig Annan
A Gateway – Segovia, 1914
Photogravure
14.5 x 15.2 cm

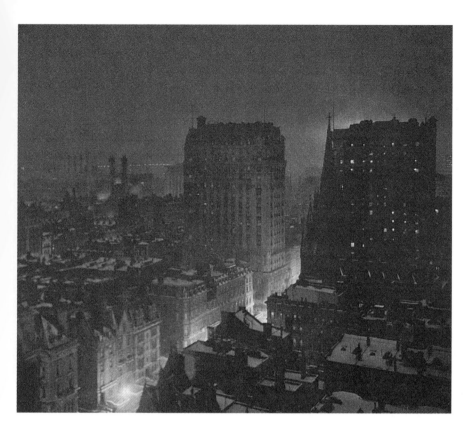

Paul B. Haviland
New York at Night, 1914
Photogravure
15.6 x 18.2 cm

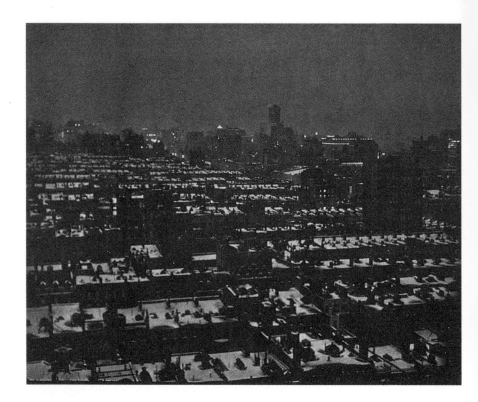

Paul B. Haviland
New York at Night, 1914
Photogravure
14.1 x 17.6 cm

Frederick H. Pratt →
Landscape, 1914
Photogravure
21.2 x 16.1 cm

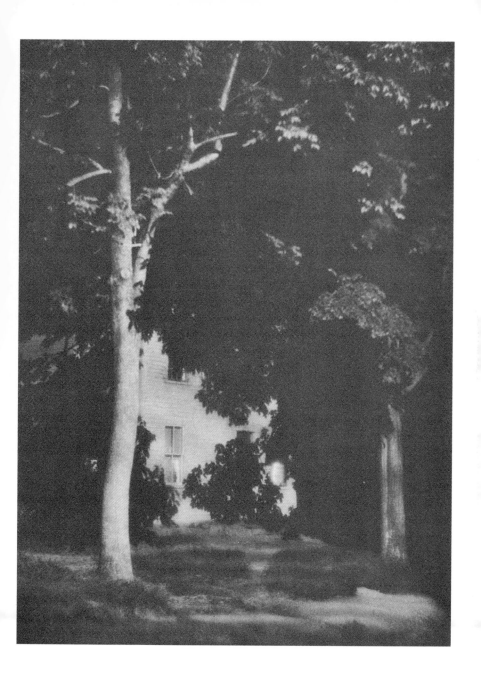

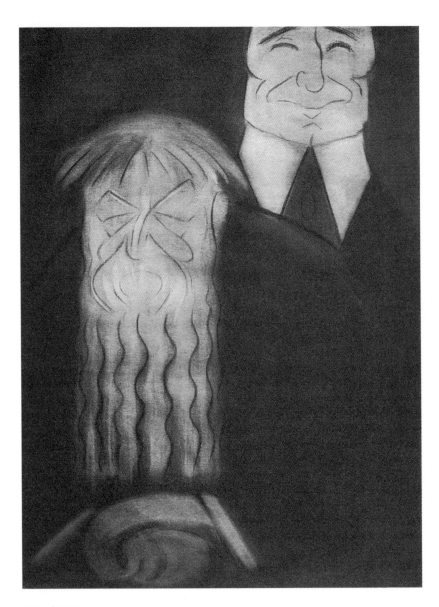

Marius de Zayas
Rodin and Eduard J. Steichen, 1914
Photogravure
21.9 x 16.4 cm

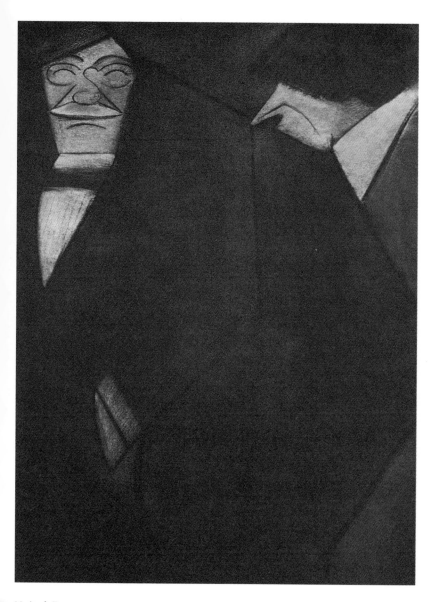

Marius de Zayas
John Marin and Alfred Stieglitz, 1914
Photogravure
22.1 x 16.5 cm

Marius de Zayas
Charles Darnton, 1914
Photogravure
22 x 16.6 cm

Marius de Zayas
Dr. A. A. Berg, 1914
Photogravure
22.4 x 16.7 cm

Marius de Zayas
Alfred Stieglitz, 1914
Photogravure
23.6 x 17.8 cm

Marius de Zayas
Mrs. Eugene Meyer, Jr., 1914
Photogravure
24.3 x 18 cm

Marius de Zayas
Two Friends, 1914
Photogravure
17.6 x 23.5 cm

Marius de Zayas
Theodore Roosevelt, 1914
Photogravure
23.3 x 17.6 cm

Marius de Zayas
Paul B. Haviland, 1914
Photogravure
23.5 x 17.6 cm

Marius de Zayas
Francis Picabia, 1914
Photogravure
24.1 x 18.1 cm

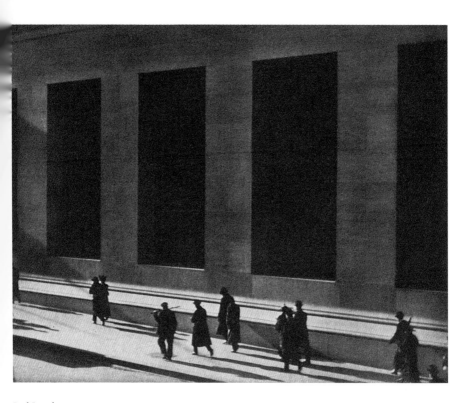

Paul Strand
New York, 1916
Photogravure
12.7 x 16.3 cm

← **Frank Eugene**
The Cat, 1916
Photogravure
2 3 x 17.3 cm

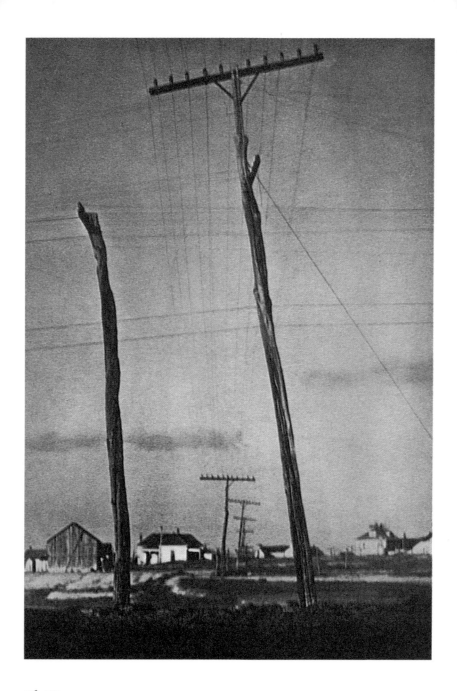

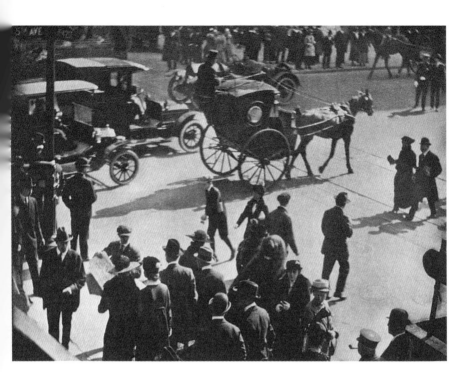

Paul Strand
New York, 1916
Photogravure
12.6 x 16.3 cm

← **Paul Strand**
Telegraph Poles, 1919
Photogravure
20.2 x 13.7 cm

Paul Strand
New York, 1916
Photogravure
12.6 x 16.4 cm

Paul Strand
New York, 1916
Photogravure
13.3 x 16.6 cm

Paul Strand
New York, 1916
Photogravure
21.6 x 10.4 cm

Arthur Allen Lewis
Winter, 1916
Photogravure
21.2 x 16.1 cm

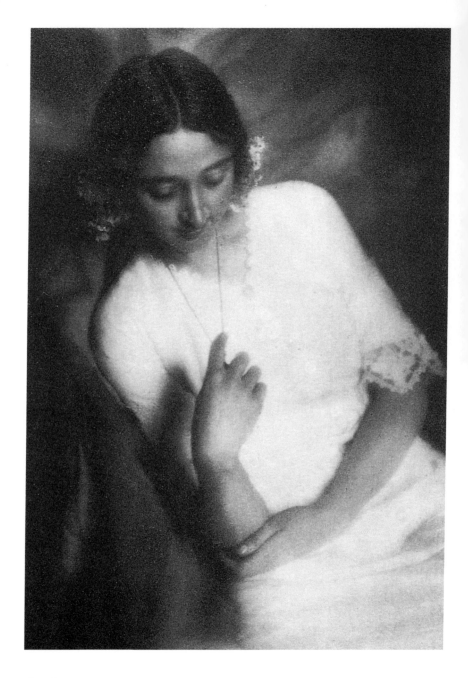

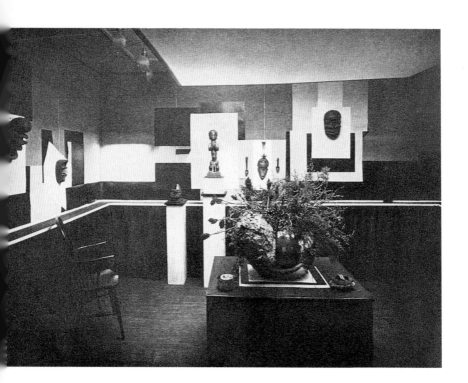

Alfred Stieglitz
Negro Art Exhibition,
November, 1914, 1916
Half-tone reproduction
10.6 x 14.1 cm

← Francis Joseph Bruguière
A Portrait, 1916
Photogravure
16.8 x 11.7 cm

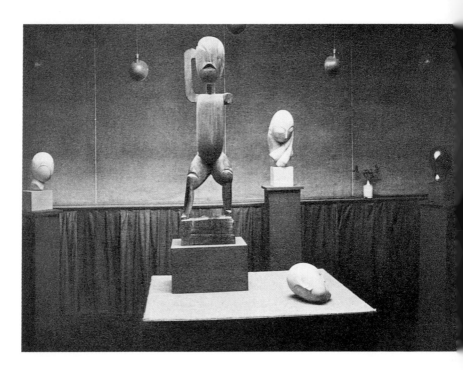

Alfred Stieglitz
Brancusi Sculpture,
March, 1914, 1916,
Half-tone reproduction
10.7 x 14 cm

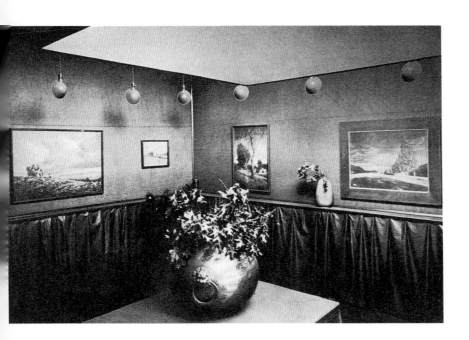

Alfred Stieglitz
German and Viennese Photography,
March, 1906, 1916
Half-tone reproduction
9.8 x 14.7 cm

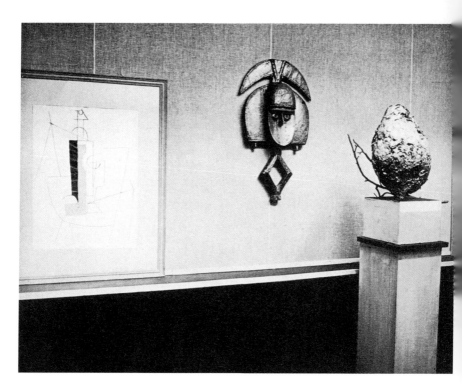

Alfred Stieglitz
Detail: Picasso – Braque Exhibition,
January, 1915, 1916
Half-tone reproduction
11 x 14 cm

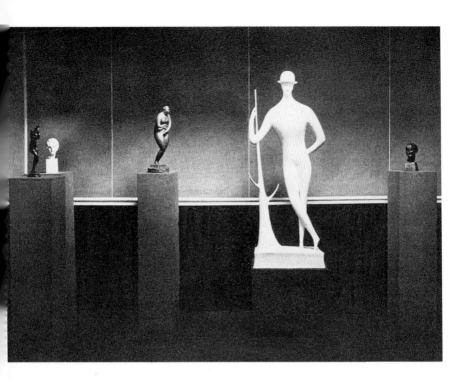

Alfred Stieglitz
Nadelman Exhibition – 2 Rooms,
December, 1915, 1916
Half-tone reproduction
10.3 x 14 cm

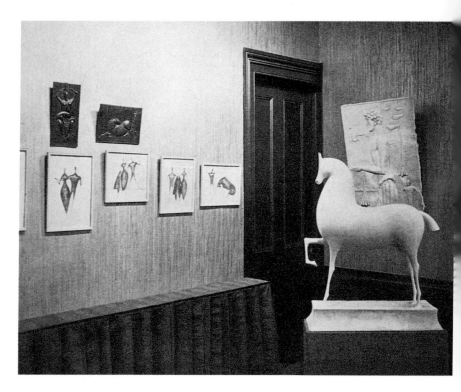

Alfred Stieglitz
Nadelman Exhibition – 2 Rooms,
December 1915, 1916
Half-tone reproduction
11 x 14 cm

Paul Strand →
Photograph – New York, 1917
Photogravure
21.6 x 16.4 cm

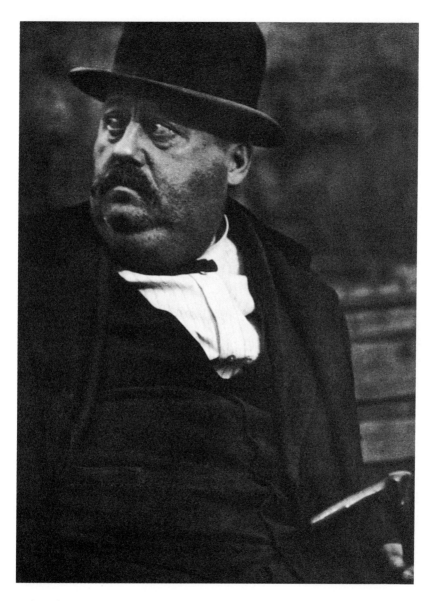

Paul Strand
Photograph – New York, 1917
Photogravure
22.1 x 16.6 cm

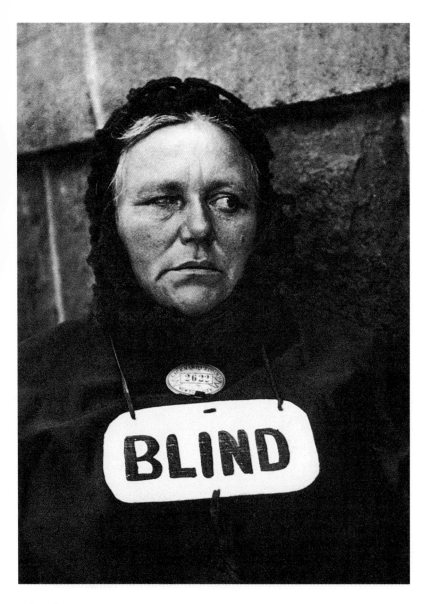

Paul Strand
Photograph – New York, 1917
Photogravure
21.9 x 16.4 cm

CAMERA WORK 49/50, 1917

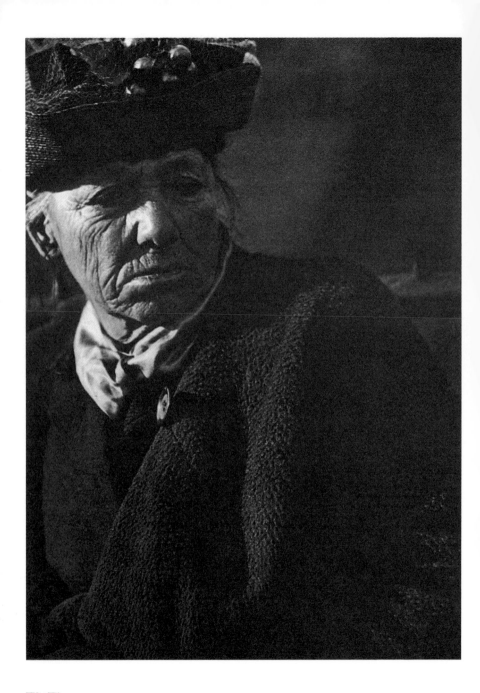

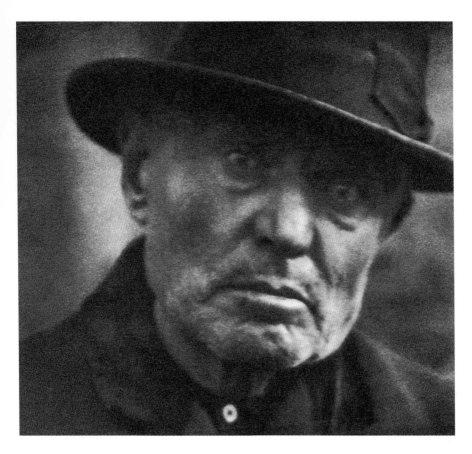

Paul Strand
Photograph – New York, 1917
Photogravure
16 x 17.3 cm

← **Paul Strand**
Photograph – New York, 1917
Photogravure
23.1 x 16.6 cm

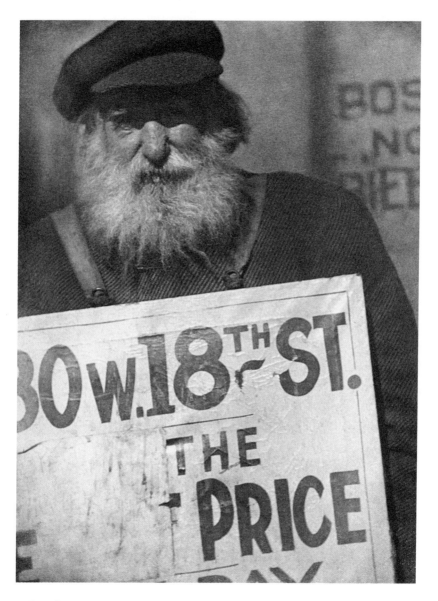

Paul Strand
Photograph – New York, 1917
Photogravure
22.1 x 16.6 cm

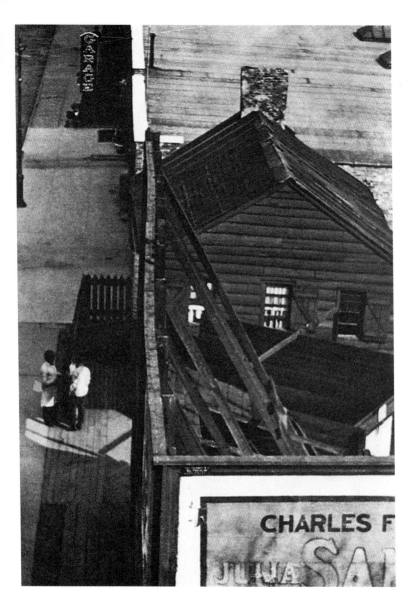

Paul Strand
Photograph – New York, 1917
Photogravure
23.6 x 16.4 cm

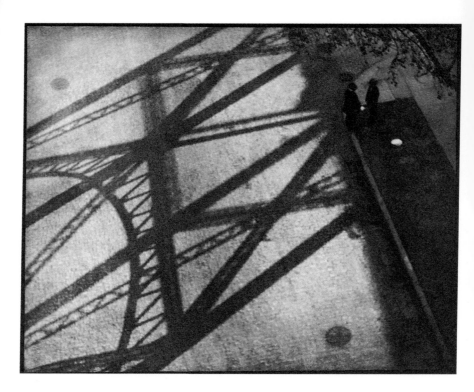

Paul Strand
Photograph – New York, 1917
Photogravure
16.5 x 21.4 cm

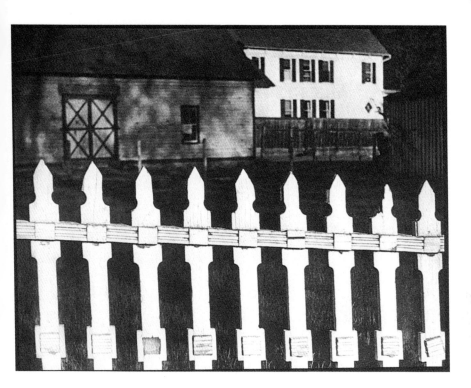

Paul Strand
Photograph, 1917
Photogravure
16.5 x 21.6 cm

Paul Strand
Photograph, 1917
Photogravure
23.8 x 16.5 cm

Paul Strand
Photograph, 1917
Photogravure
22.7 x 16.6 cm

PHOTOGRAPHY*

PHOTOGRAPHY, which is the first and only important contribution thus far, of science to the arts, finds its raison d'être, like all media, in a complete uniqueness of means. This is an absolute unqualified objectivity. Unlike the other arts which are really anti-photographic, this objectivity is of the very essence of photography, its contribution and at the same time its limitation. And just as the majority of workers in other media have completely misunderstood the inherent qualities of their respective means, so photographers, with the possible exception of two or three, have had no conception of the photographic means. The full potential power of every medium is dependent upon the purity of its use, and all attempts at mixture end in such dead things as the color-etching, the photographic painting and in photography, the gum-print, oil-print, etc., in which the introduction of hand work and manipulation is merely the expression of an impotent desire to paint. It is this very lack of understanding and respect for their material, on the part of the photographers themselves which directly accounts for the consequent lack of respect on the part of the intelligent public and the notion that photography is but a poor excuse for an inability to do anything else.

The photographer's problem therefore, is to see clearly the limitations and at the same time the potential qualities of his medium, for it is precisely here that honesty no less than intensity of vision, is the prerequisite of a living expression. This means a real respect for the thing in front of him, expressed in terms of chiaroscuro (color and photography having nothing in common) through a range of almost infinite tonal values which lie beyond the skill of human hand. The fullest realization of this is accomplished without tricks of process or manipulation, through the use of straight photographic methods. It is in the organization of this objectivity that the photographer's point of view toward Life enters in, and where a formal conception born of the emotions, the intellect, or of both, is as inevitably necessary for him, before an exposure is made, as for the painter, before he puts brush to canvas. The objects may be organized to express the causes of which they are the effects, or they may be used as abstract forms, to create an emotion unrelated to the objectivity as such. This organization is evolved either by movement of the camera in relation to the objects themselves or through their actual arrangement, but here, as in everything, the expression is simply the measure of a vision, shallow or profound as the case may be. Photography is only a new road from a different direction but moving toward the common goal, which is Life.

Notwithstanding the fact that the whole development of photography has been given to the world through CAMERA WORK in a form uniquely beautiful as well as perfect in conception and presentation, there is no real consciousness, even among photographers, of what has

* Reprinted, with permission, from "Seven Arts."

actually happened: namely, that America has really been expressed in terms of America without the outside influence of Paris art-schools or their dilute offspring here. This development extends over the comparatively short period of sixty years, and there was no real movement until the years between 1895 and 1910, at which time an intense rebirth of enthusiasm and energy manifested itself all over the world. Moreover, this renaissance found its highest aesthetic achievement in America, where a small group of men and women worked with honest and sincere purpose, some instinctively and few consciously, but without any background of photographic or graphic formulae much less any cut and dried ideas of what is Art and what isn't; this innocence was their real strength. Everything they wanted to say, had to be worked out by their own experiments: it was born of actual living. In the same way the creators of our skyscrapers had to face the similar circumstance of no precedent, and it was through that very necessity of evolving a new form, both in architecture and photography that the resulting expression was vitalized. Where in any medium has the tremendous energy and potential power of New York been more fully realized than in the purely direct photographs of Stieglitz? Where a more subtle feeling which is the reverse of all this, the quiet simplicity of life in the American small town, so sensitively suggested in the early work of Clarence White? Where in painting, more originality and penetration of vision than in the portraits of Steichen, Käsebier and Frank Eugene? Others, too, have given beauty to the world but these workers, together with the great Scotchman, David Octavius Hill, whose portraits made in 1860 have never been surpassed, are the important creators of a living photographic tradition. They will be the masters no less for Europe than for America because by an intense interest in the life of which they were really a part, they reached through a national, to a universal expression. In spite of indifference, contempt and the assurance of little or no remuneration they went on, as others will do, even though their work seems doomed to a temporary obscurity. The things they do remains the same; it is a witness to the motive force that drives.

The existence of a medium, after all, is its absolute justification, if as so many seem to think, it needs one and all, comparison of potentialities is useless and irrelevant. Whether a water-color is inferior to an oil, or whether a drawing, an etching, or a photograph is not as important as either, is inconsequent. To have to despise something in order to respect something else is a sign of impotence. Let us rather accept joyously and with gratitude everything through which the spirit of man seeks to an ever fuller and more intense self-realization.

PAUL STRAND.

THE GEORGIA O'KEEFFE DRAWINGS AND PAINTINGS AT "291"

WHILE gladly welcoming new words into our vocabulary, words which intensify and increase our sense of the complexity of modern life, it is often quite impossible not to regret the lapse of older, simpler ones, especially as such lapse implies that the meaning and force of the words has also become obsolete. I am thinking, in this connection, of a phrase much loved by Lionel Johnson: *the old magnalities*, and I feel sure he used it so often in the hope that others would not willingly let it die. But I have met with it in no other modern writer. Is it because it no longer has significance for us? Have the old magnalities indeed crumbled to dust and ashes, together with all sense of the sublime, the worshipful, and the prophetic? Is it no longer good form, in this avid and impatient age, to mention the things that are God's? Must all tribute, then, go to Caesar? These reflections are forced upon the contemplative mind, and one must take counsel with one's own self in meeting them. And it is in so communing that the consciousness comes that one's self is other than oneself, is something larger, something almost tangibly universal, since it is en rapport with a wholeness in which one's separateness is, for the time, lost.

Some such consciousness, it seems to me, is active in the mystic and musical drawings of Georgia O'Keeffe. Here are emotional forms quite beyond the reach of conscious design, beyond the grasp of reason— yet strongly appealing to that apparently unanalyzable sensitivity in us through which we feel the grandeur and sublimity of life.

In recent years there have been many deliberate attempts to translate into line and color the *visual* effect of emotions aroused by music, and I am inclined to think they failed just because they were so deliberate. The setting down of such purely mental forms escapes the conscious hand—one must become, as it were, a channel, a willing medium, through which this visible music flows. And doubtless it more often comes from unheard melodies than from the listening to instruments—from that true music of the spheres referred to by the mystics of all ages. Quite sensibly, there is an inner law of harmony at work in the composition of these drawings and paintings by Miss O'Keeffe, and they are more truly inspired than any work I have seen; and although, as is frequently the case with "given writings" and religious "revelations," most are but fragments of vision, incompleted movements, yet even the least satisfactory of them has the *quality* of completeness— while in at least three instances the effect is of a quite cosmic grandeur. Of all things earthly, it is only in music that one finds any analogy to the emotional content of these drawings—to the gigantic, swirling rhythms, and the exquisite tendernesses so powerfully and sensitively rendered—and music is the condition towards which, according to Pater, all art constantly aspires. Well, plastic art, in the hands of Miss O'Keeffe, seems now to have approximated that.

WM. MURRELL FISHER.

Index of Artists

INDEX OF ARTISTS

Selected Texts from Camera Work